Modern Art
The Decisive Years 1884-1914

Modern Art
The Decisive Years 1884-1914

by Jean-Luc Daval

SKIRA

M

Contents

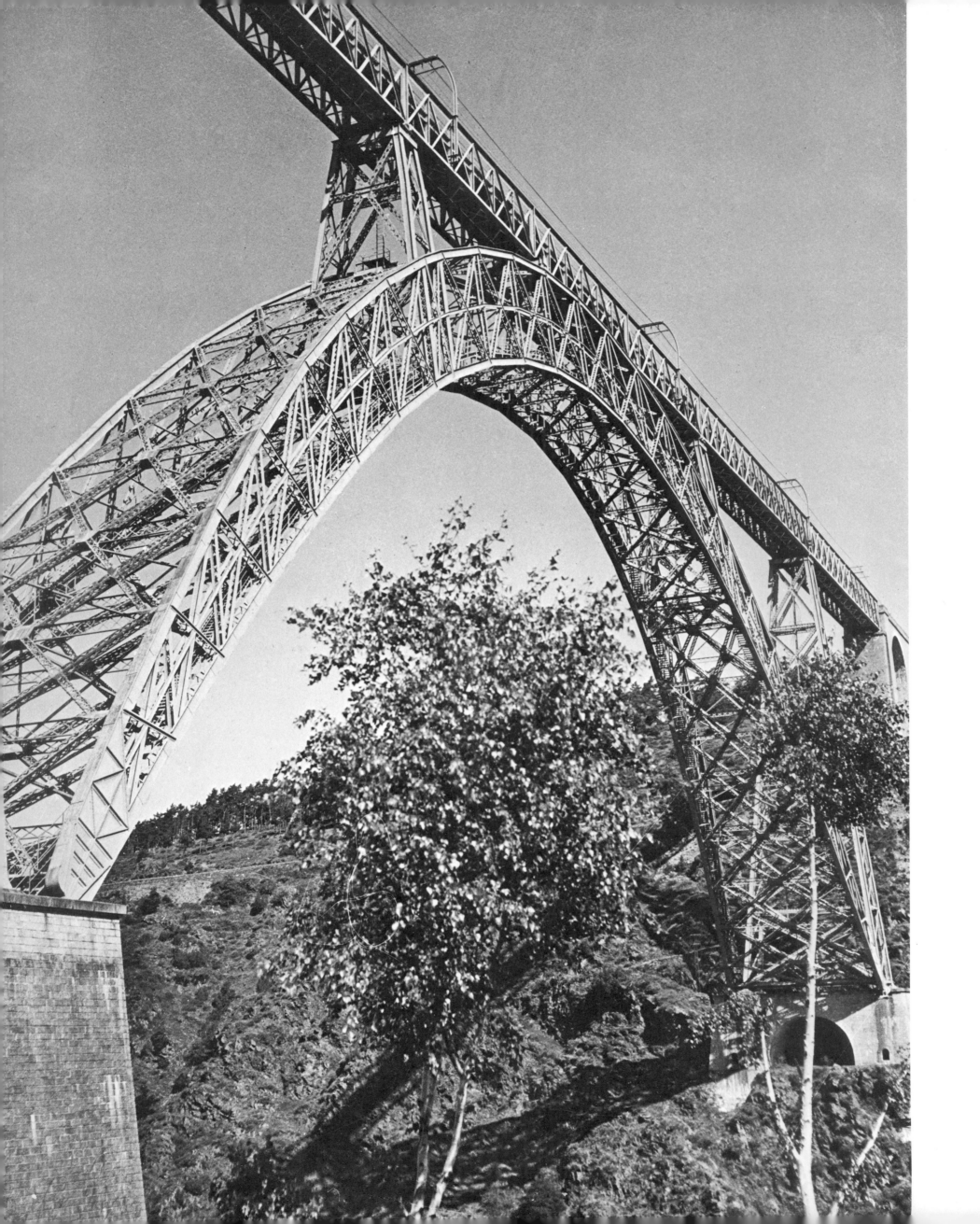

BETWEEN TWO WORLDS

To fly away! Yonder! I feel how drunk
Are birds amid the skies and unknown spume!

Mallarmé, *Sea Breeze*

The three decades from 1884 to 1914 number among the most fruitful in the history of mankind and the history of art. In this key period were worked out the forms of thought, life and creativity that we still practise today. The works of art which it produced have a quality and interest wholly in keeping with the novelty of their expression and significance. They opened the way to the future just as those of the fifteenth century opened the way to the Renaissance.

Since the French Revolution of 1789, men had aspired to freedom, but the necessary apprenticeship had been long and painful. Freed from any ideology since the rise of Realism, Positivism and above all Impressionism, the artist found himself in 1884 on the threshold of unknown fields of activity. Science and technology had turned him away once and for all from the heritage of tradition by giving him a new awareness of the scope and influence of his work. The reality of visual appearances had been challenged by the discovery of the forces governing the universe. The precarious equilibrium of a world dominated by man was broken by the revelations of science on space and movement. This reconquest of the outer world in the context of the rights and duties of the individual called for experiment and audacity. Unsupported by any ideological or philosophical structure, the artist had no other guide but the truth of his personal experience. No period has proved to be so rich, for everything seemed permissible and possible.

Odilon Redon (1840-1916): Eyes perhaps were first tried out in flowers. Lithograph from "Les Origines", 1883.

This ferment of ideas and creative effort gave rise to a large amount of critical writing. But in the very emphasis they laid on the originality and independence of the works produced, the critics sometimes give a distorted picture of this period. Presented as an interacting series of ruptures and conflicts, it is apt to seem in retrospect like a succession of fireworks, profuse and glittering but disorderly.

In the historical perspective of today, this period can be surveyed in a more synthetic manner. Indeed the time has come to study it as one would study any other period of history, going beyond individual differences and seeking out the underlying connections. It is obvious that, while the artists of the fifteenth century are distinguished from each other by their personality and schools, by their sense of form, by their conception of line, light and texture, these differences are nevertheless seen to be superficial when one goes on

to consider their common view of man and his place in the world. The same is doubtless true of contemporary art. Over and above the profusion of "isms," all contemporary artists are faced by the problem of abstraction which, already noted in 1908 by the German critic Wilhelm Worringer, indicates a "discord between man and nature," a disruption of man's comprehension of the world and the break-up of the classical conception of it. This turning point in the history of the twentieth century is still too close to be fully explored, but the profusion of its leafage cannot conceal indefinitely the structure of the tree. If the history of art studies the changes brought about in the systems of representation, creative art itself directly reflects and deflects the course of man's advance and his awareness of the world. This survey has no other purpose but to see as a whole what has so often been broken up into parts.

Between 1884 and 1914 a "civilization of the image" was born. It opens a period in which visual communication has taken over from oral exchanges and literary culture. Pictures have accordingly been given primacy here. They are not meant to illustrate a text, but to impose an order upon it. The clashes between them may throw into relief the originality of their expression; their similarities may help to clarify the artistic and social sources behind them; their sequence may suggest something of the interest and significance they had at the time. Together, in chronological order, they illustrate the extraordinary changes of artistic idiom that took place in these three decades, and afford comparisons that reveal what the most significant works may have in common. We have tried to see this period of history as it unfolded at the time. Those who stand out today as its greatest creators were often misunderstood by their public. To respect the time sequence, we have divided up their output, so that the individual work may be shown at the time it was made, when it began to live in the minds of other men; for its impact can only be measured later, when other artists have reacted to it.

1884-1914: the traditional conception of art was challenged, the individual reconsidered his place in the world and felt the urging of fresh purposes. The repudiations of the past were closely mingled with the promises of the future, and objective and subjective efforts only conflicted to interact more closely at each stage of an accelerated and irreversible evolution.

◁ *Gustave Eiffel (1832-1923): The Truyère Viaduct near Garabit (Cantal), 1880-1884.*

Technical innovation and fear of the future

Science was on the march, triumphing over time and space. The train, steamship, bicycle, motor car and airplane, the telegraph and telephone, all these inventions brought people into closer and more frequent contact with each other, they internationalized human relations. The railway, steadily gaining in speed and power, steadily reducing distances, became a key factor in progress. The world network increased from 190,000 miles in 1875 to 670,000 miles in 1913 and fares were reduced by fifty per cent.

Coal and iron were the instruments of industrial power. The use of metal girders brought about a revolution in building; not only were they cheaper, they were fire and weather proof. They were employed in the construction of exhibition halls, covered markets, department stores, bridges and towers. Sigfried Giedion has aptly remarked that, when the nineteenth century did not feel itself observed, it became daring. Gustave Eiffel stands out as the wizard of iron. The Truyère Viaduct near Garabit in the French Massif Central, finished in 1884, is one of his boldest pieces of engineering, with an arch span of 540 feet, a height above the river of 400 feet and a length of about 2,600 feet. Iron was cheap and lent itself to a new technique: prefabrication.

So light and graceful a structure defied traditional building laws. It was the outcome of long experiment in which bold intuition was controlled by mathematical laws. Eiffel channelled forces and thrusts into the latticed supports of his constructions. Traditional statics were gone and the equilibrium became dynamic and elastic. Having mastered the forces of forms and materials, Eiffel went on to tame the elements of nature and study their reactions in the aerodynamic laboratory which he built at Auteuil. Even the wind, water and seismic movements seemed to be mastered by science, which bade fair to set man free. Aiming at strict design, the builder and engineer achieve beauty. Just as the scientist based his reasoning on objective experience, so the artist built his work on the sensations he actually felt.

Optimism was not always the order of the day. On 27 October 1883, in a satirical Parisian weekly, Albert Robida published his cartoon *The Railway War*. Predicting the worst, this fanciful picture proved to be strangely prophetic: already, in spirit and substance, it illustrates the First World War, which put a tragic end to the dreams of technical and economic domination entertained in Europe and America. Drawing on all the resources of his imagination and ingenuity, multiplying scientific discoveries and technical advances, man made himself master of the earth and oceans, but he acquired awesome powers that threatened to get out of control. Between 1884 and 1914 the peace was broken only by distant conflicts: the Sino-Japanese War of 1894-1895, the Russo-Japanese War of 1904-1905, the Italo-Turkish War of 1911-1912 and the Balkan Wars of 1911-1912. Rivalries between states were chiefly economic. In spite of the shortage of raw materials and the incessant search for commercial markets, the balance of power was maintained by a system of alliances and agreements. The war shown in Robida's cartoon takes place in Mozambique. Africa, Asia and the Far East were in the news. There European armies were carving out colonial empires, to provide for their surplus population and to market their overproduction of goods.

This period of peace and equilibrium, extending from 1871 to 1914, enabled the industrialized countries, in particular France, Great Britain, Germany and the United States, to take stock of the consequences of the industrial revolution. The economy and its development bore hard on foreign policy and created social tensions. The old moral and philosophical structures were shaken by

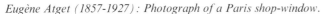

Eugène Atget (1857-1927): Photograph of a Paris shop-window.

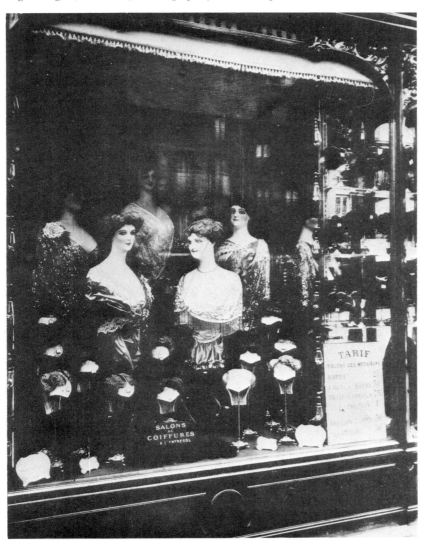

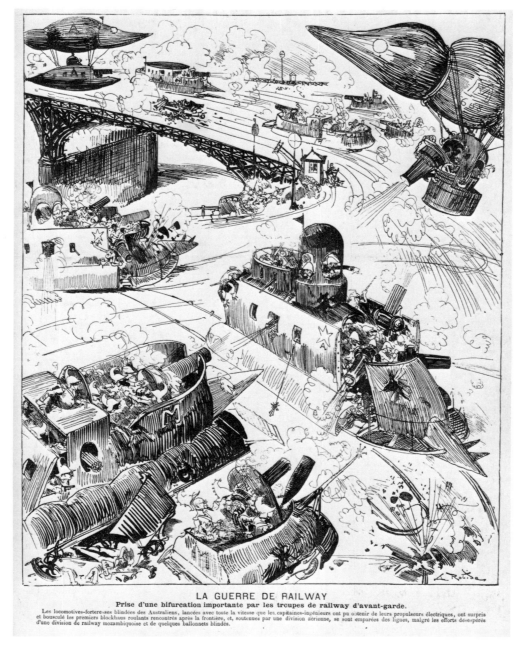

LA GUERRE DE RAILWAY

Prise d'une bifurcation importante par les troupes de railway d'avant-garde.

Les locomotives-forteresses blindées des Australiens, lancées avec toute la vitesse que les capitaines-ingénieurs ont pu obtenir de leurs propulseurs électriques, ont surpris et bousculé les premiers blockhaus roulants rencontrés après la frontière, et, soutenues par une division aérienne, se sont emparées des lignes, malgré les efforts désespérés d'une division de railway mozambiquoise et de quelques ballonnets blindés.

Albert Robida (1848-1926): The Railway War, an anticipation of warfare in the twentieth century
published in "La Caricature", Paris, 27 October 1883.

the new problems that arose and by the solutions they led to. At the same time the individual was torn between his personal aspirations towards freedom and the collective constraints imposed by a society dominated by technology.

The cities grew, spreading chaotically over the countryside. Population movements were speeded up and living conditions changed radically. Peasants became factory workers, exchanging the rhythm of nature for the compulsion of the machine. The craftsman lost his taste for fine work and forgot his ancestral trade, becoming the slave of mass production.

The prerogatives of blood and family gave way to the reign of money. Banks multiplied and flourished, housed in luxurious temples that conveyed the image of their power. Controlling investments and promoting speculation, they conferred an unprecedented prestige on the activities of the stock exchange. The resulting boom was too new and strange a phenomenon to be kept under control. But the economic slump of 1882-1895 was overcome and followed by further capitalist expansion. As a direct result of the concentration of production in pools and cartels, advertising flourished as never before and large department stores with many branch establishments sprang up, completely changing the distribution system. Created to exploit the market and stimulate buying,

they nevertheless failed to absorb the excess production. Industrial rivalry helped to lower prices, but mechanization threw men out of work. The social consequences were disastrous: the spectre of unemployment haunted every working-class home.

The extension of education, the freedom of the press and the participation of all classes in the democratic process gave people a growing awareness of their individual rights. Trade unions were formed, armed with a powerful weapon: the strike. In spite of harsh repression, socialism held out the promise of a better life for the workers. Given legal status in France by the law of 21 March 1884, the trade unions were as yet no match for the power of capitalism, but labour was on the march. Marx's *Das Kapital* was published in French in 1883, in English in 1886, and the Second International was founded in Paris in 1889. Libertarian socialism was at first practically synonymous with anarchism, but the latter soon got a bad name by indiscriminate bomb-throwing. Secularism, racism and anti-Semitism were the fruits of this economic expansion. Canalizing passions, prejudices and political interests, they conveniently diverted attention from economic enslavement. But the thought of revolution struck fear in all Frenchmen, who remembered all too well the harshness and cruelty with which the Commune had been put down in 1871.

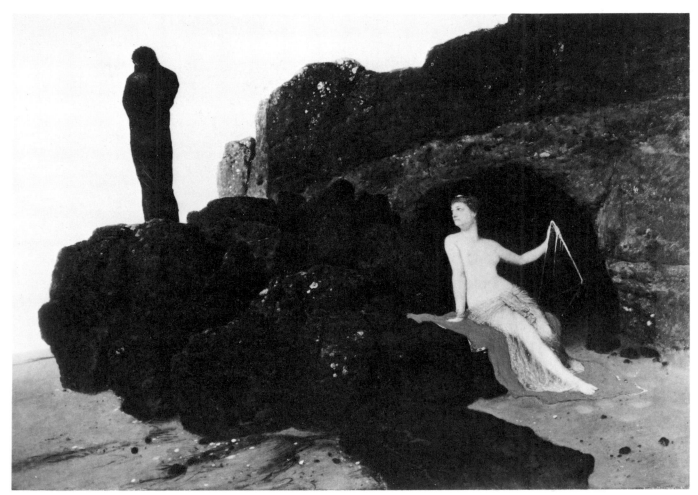

Arnold Böcklin (1827-1901): Odysseus and Calypso, 1883. Tempera and oil.

Odilon Redon (1840-1916): The Grinning Spider, 1881. Charcoal.

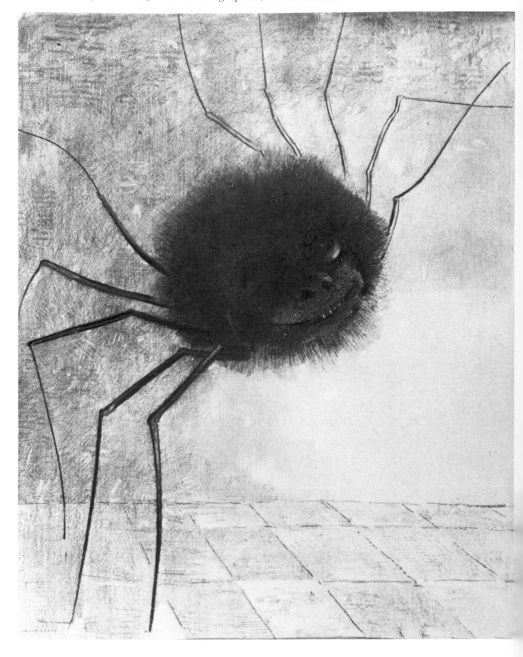

Even before it had been soundly established, Positivism was being contested. Nietzsche and Bergson, soon followed by Freud and Einstein, disturbed men's minds, already puzzled by the immateriality of certain scientific discoveries. Through the technical progress celebrated by the great World's Fairs, time and space were being reduced to a human scale, but at the same time the energies brought into play began to reveal unsuspected realities. As man extended his power over the material world, he discovered a hidden world behind it full of disturbing novelties: science revealed the invisible.

Coal was the prime source of energy and its production grew from 250 million tons in 1875 to 1,250 million tons in 1913. But electricity and oil were coming to the fore, providing new, untapped sources of power whose uses and impact could not yet be foreseen.

The development of photography exhausted the resources of visual appearances. There was no longer any need to delineate them and artists fell back on an inner vision. The myths they had been accustomed to celebrating no longer made sense in this new context; optical reality became meaningless; the omnipotence of movement condemned formal perfection and static equilibrium to the scrap-heap.

Artists and scientists perceived equally well the new phenomena which they sought to illustrate and communicate in their respective disciplines. The machine split human activity into sharply divided sectors and it became impossible to take an overall view of this new reality to which technical progress pointed. To find a place of his own, man had to work out a new image of the world. All previous systems seemed defunct; the creative individual found no other basis of truth but the authenticity of his own phenomenological or spiritual experience, and obedience to his own intuition. Scientists and artists turned resolutely towards the future.

Inspired subjects...

10

The modern world in the making began to frighten those who were building it. The machine threatened to crush the individual who had designed it to satisfy his needs. Nature, more and more, bore the marks and scars of man, who began to feel like a stranger in this mechanical environment from which chance and life were banned. Van Gogh and James Ensor testify to the same impression of anguish and solitude; Redon and Böcklin were equally uneasy before the ominous flight of time. In reaction against the runaway developments of science and technology, the artist fell back on intuition. Faced with a world which the advance of science revealed to be even more mysterious than before, but which technology gave the false impression of dominating, the artist resorted to the irrational or to the dictates of his conscience. It was this age dominated by science that saw the rise of Symbolism and Expressionism. Man's responsibility for his acts begins when his conscience gives them meaning. Here each man stands alone, and each artist probed beyond appearances for an order, a reality, acceptable to his conscience. Ensor and Van Gogh stemmed from the realist tradition of Dutch and Flemish painting. Böcklin and Redon created a dreamworld of their own. For all of them, light was the expression of mystery, suspense and anxiety.

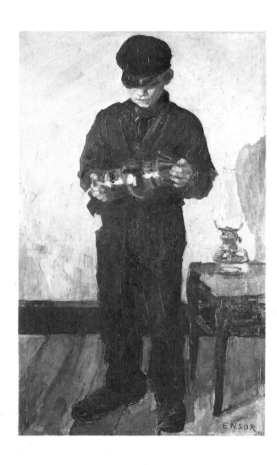

...and themes of everyday life

James Ensor (1860-1949):
The Lamp-Boy, 1880. Oil.

Vincent van Gogh (1853-1890): Weaver. Nuenen, May 1884. Pen and ink.

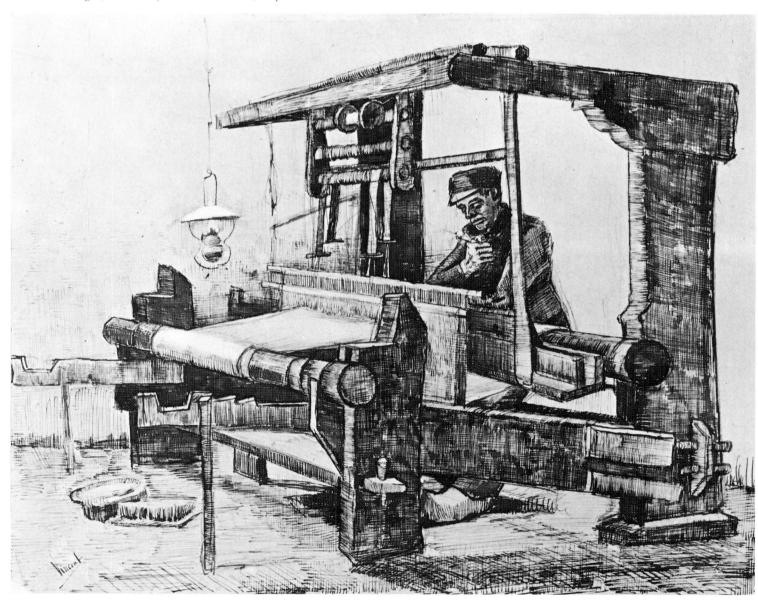

Knowledge was split up into ramifying parts, and so were appearances; henceforth, to rebuild meant first of all to destroy. Symbolism represents an immediate reaction against Positivism, but already other artists were basing their work on a new experience of reality. Official art continued to cater reassuringly for an unimaginative public, while modern art branched out into eager and ceaseless experiment. Turning their back on tradition and fashion, the true creators had never been farther removed from the public or less understood. Conscious of new realities craving expression, they had to destroy the old forms of figurative art in order to bring the new ones to life; and to create a new figuration they had to create a new language. Art oscillated between instinct and intellect, mind and senses, objectivity and revolt, broadening its scope with each individual experience. The artist began to cut the figure of a prophet; he no longer illustrated, he revealed.

Unlike the Salon painters with their tinsel romance, the younger artists debarred from showing there based their work on direct observation of the world, on material and moral realities. Seurat and Van Gogh, whose careers were to be so short and brilliant, both began by drawing and painting men at work, in the fields, in city streets. Marked by the lesson of Impressionism, Seurat as an artist was engrossed by the problem of light. Van Gogh, having shared the poverty and hardships of the miners of the Borinage, could never forget the harshness and tragedy of common life. Seurat believed in science; Van Gogh, though intensely aware of human suffering, never lost his faith in man.

Georges Seurat (1859-1891): Stonebreakers, Le Raincy, c. 1881. Conté crayon.

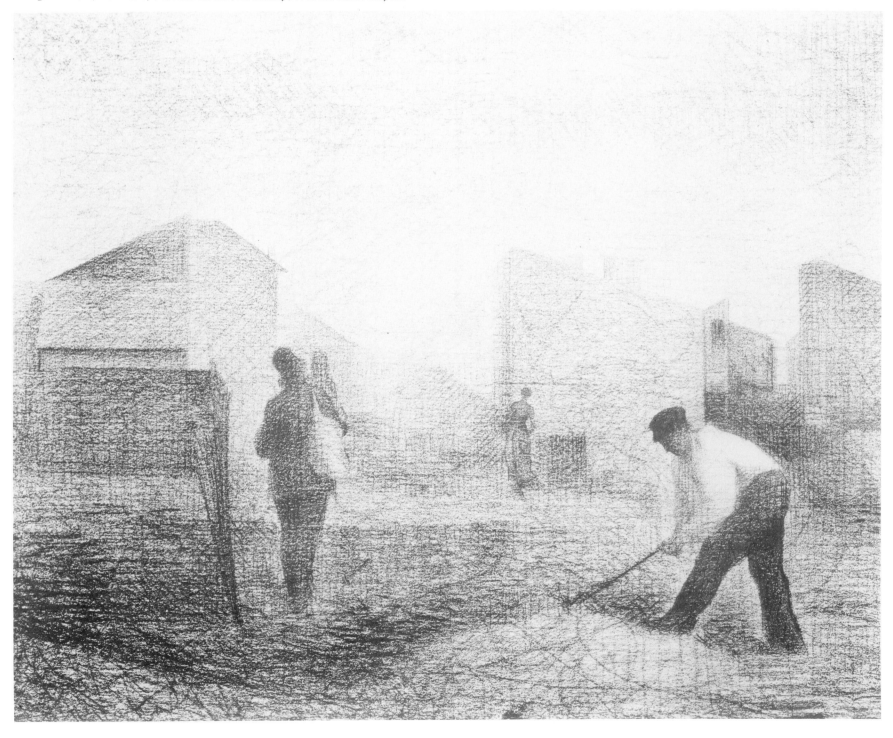

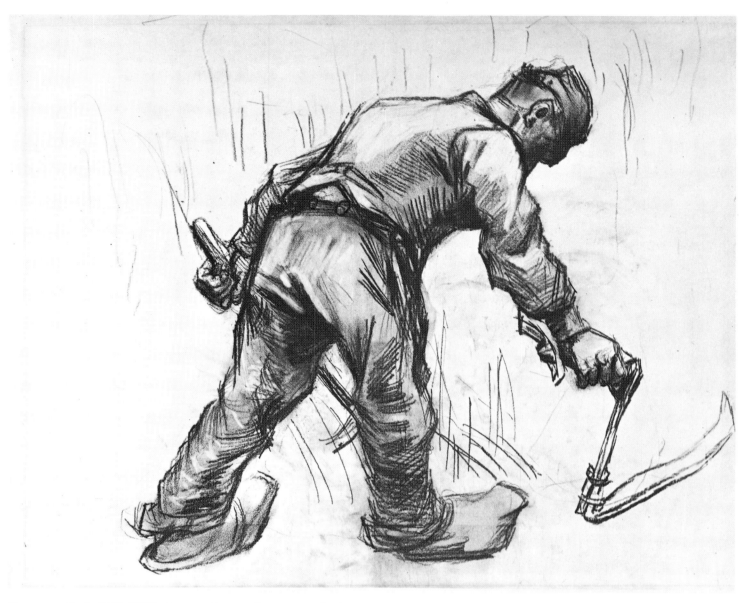

Vincent van Gogh (1853-1890) : Peasant Mowing, Seen From Behind. Nuenen, 1885. Pencil.

Eager to explore the paths of the future, and breaking with previous notions of balance and idealism, art turned away from the visible. Intent on immaterial realities, it had to contend with the doubts, misgivings and anxiety of conscience. Romanticism had opened the way to the exotic; the moderns turned to primitive art in search of a new relation with the world and a renewal of art forms. While society felt its way toward other metaphysical, political and social structures, the artist explored new possibilities of being, shaped and reshaped to convey the vision of the new man. He experimented with them in the fields open to his mind and senses. He tried to work out the means of expression best suited to each component of his language: line, surface, colour.

Every theory and assumption was put to the test and the field of the possible was steadily widened; every work of art became a statement on the nature of reality in which human and pictorial experience merged in the expression of an equivalent to a constantly changing world.

The course followed by modern art is neither a linear nor a logical progression. Each conquest made was in the nature of a provisional or precarious foothold, soon to be displaced by succeeding conquests. Each work stood or fell by the truth of its testimony and the authenticity of its presence. Its importance lay in its immediate significance, and its permanence in the originality of its content.

The contradictions between the many trends and movements which arose in these three decades are more apparent than real. In fact, each work embodies a reality which is not contradicted by the subsequent realities which came into existence on the strength of its own creation. And in spite of all the differences observable in the proliferation of schools, the latter all show in varying degrees the same renewal of contemporary culture, the same impassioned effort to give form to a new conception of space.

At any given moment of history, survivals and prefigurations are blended together; in any art movement, the creative and the imitative may be confused if one goes no further than an analysis of outward indications. By bringing out the abiding significance of the boldest innovations, we have sought to illustrate the way in which modern man has deepened his awareness of the world. Our research is based on works which show a correlation of phenomena; it is limited to those which have aroused a reaction or found an echo down to the present day. All of them have a character at once individual and social.

1884: THE TURNING POINT

Catalogue of the Exhibition of Independent Artists at the Tuileries, Paris, May-June 1884.

From the time of Napoleon I to the outbreak of war in 1914, Paris was the art centre of the world. Only there could artists French and foreign measure their strength and its verdict was final. Only there could they find the climate of freedom, enlightenment and intellectual ferment in which creative art best thrived. Of all the arts, it was painting that occupied first place.

By 1884, twenty-one years after the uproar over Manet's *Déjeuner sur l'herbe* at the Salon des Refusés, and ten years after the first group exhibition organized by Monet and his friends, at which they were dubbed "impressionists" by a facetious journalist, the official Salon had changed very little. Now held yearly, it was still the only large-scale exhibition permitting a real confrontation between painters, sculptors and architects. Theoretically open to all, it was actually, now as always, the sheltered preserve of entrenched academics and conservatives. Entrance to the Salon was severely restricted by a watchdog jury whose members were chosen for the rigid orthodoxy of their views.

The slump of 1882, marked by a stock-market crash of unprecedented proportions, dealt a serious blow to independent picture dealers like Paul Durand-Ruel, who had done so much to promote impressionist painting. In 1884 the uncertainties of the economic situation in France stiffened the intransigence of the official artists, who held their power from the State. The Salon jury showed itself so reactionary that hundreds of rejected artists banded together in Paris to found a Group of Independent Artists, as they called themselves. It was not a group with similar aims and ideas, representing a specific tendency, such as the Impressionists had been; it was a free association of artists in rebellion against officialdom, and it was open to anyone who wished to join. The first "Exhibition of Independent Artists" opened on 15 May 1884 in hutments put up in the gardens of the Tuileries, where the works of 402 artists were displayed. The President of the French Republic, Jules Grévy, had announced that he would attend the opening; but at the last moment he or his advisers decided that it would be unwise for him to encourage by his presence this act of independence—which, as it turned out, was to give a decisive impetus to the liberation of art.

Félix Fénéon, who was to become the spokesman of the new painting, sketched out the background of the Salon des Indépendants in an amusing article in *L'Art moderne* (19 September 1886): "In April 1884 a Group of Independent Artists was organized in Paris, and in May it held an exhibition in the hutments in the Place du Carrousel. As chance would have it, the committee consisted of some madcap fellows, let loose from some vaudeville presumably, who flabbergasted the police superintendent by clamouring for each other's arrest and beating each other up on the street corners at night. In no time at all they ran through the funds. At the general meeting, when it was seen that no accounts could be expected from them, they were dismissed and on 9 June it was decided to found a Society of Independent Artists which, on the 11th, was duly incorporated before a notary."

The man who took the initiative in founding the Society was Albert Dubois-Pillet, a painter who was also an officer in the Republican Guard. A prominent part was played by Odilon Redon, Seurat, Signac, Angrand and Cross, later to be known as the Neo-Impressionists. The first exhibition of the new group was held in December 1884. It was not very successful.

Rejected at the official Salon (where Puvis de Chavannes' *Sacred Grove beloved of the Arts and the Muses* carried the day), Seurat's *Bathers at Asnières* was exhibited at the Salon des Indépendants and catalysed the revolutionary spirit. What came as a surprise was its size (nearly seven feet by ten), its clarity and firmness of expression, rather than its colours. Signac admired it enthusiastically, but he could not help noticing, and regretting, that "because of its ochres and browns the picture was dimmed and appeared less brilliant than those painted by the Impressionists with a palette limited to prismatic colours."

The comparison between Puvis de Chavannes and Seurat is significant. *The Sacred Grove* was acclaimed at the Salon and Puvis was saluted by the critic Joséphin Péladan as "the greatest master of our time," while Seurat was largely ignored. Yet the *Bathers at Asnières* marked the end of everything that Puvis's picture stood for: literary, anecdotal and mythological painting. With Puvis, the subject is everything; with Seurat, it has almost ceased to exist, being reduced to a commonplace scene of daily life. Both artists make play with line, composition and harmony, but the first conceals them behind the myth, while the second makes the most of the expressive possibilities inherent in the image.

"Seurat and Signac are wholly of my opinion, that we must not let ourselves be taken in. Even Puvis de Chavannes must not be allowed to take the lead. And why?... Because he is the reverse of us in art, whatever his talent. His influence being what it is, he and his followers will carry all before them, making art retrogress and impeding our evolution as Impressionists. In any case, we must not lay ourselves open to our enemies, who come forward now disguised as renovators."

Pissarro, letter to his son Lucien, 7 January 1887

Pierre Puvis de Chavannes (1824-1898): The Sacred Grove beloved of the Arts and the Muses (central part), 1884. Oil.

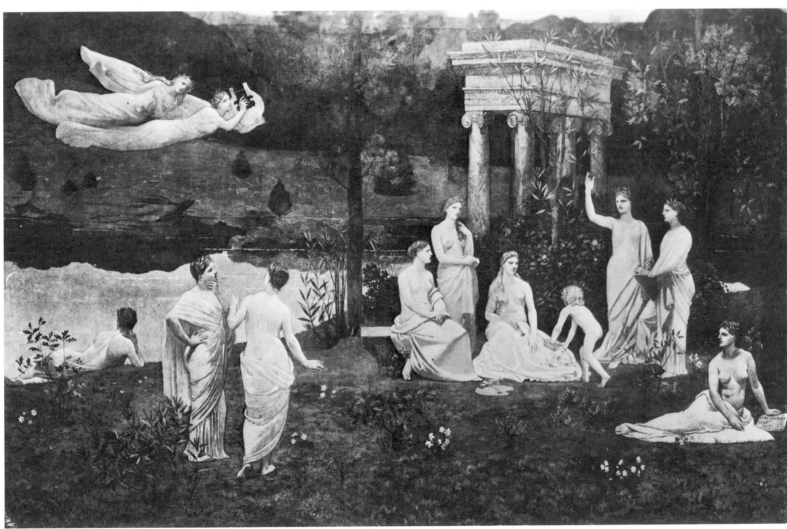

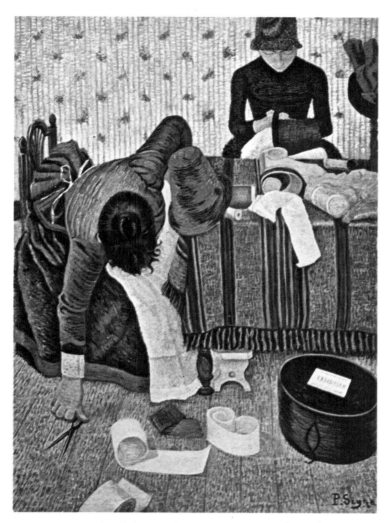

Georges Seurat, however, had nothing of the revolutionary about him. He came of a good middle-class family, he followed the traditional course of instruction. Paul Signac, his closest friend and the theorist of the neo-impressionist group, described Seurat as follows in his book *D'Eugène Delacroix au néo-impressionnisme* (1899), a veritable manual of Pointillism: "Georges Seurat studied art at the Ecole des Beaux-Arts in Paris, but his intelligence and determination, his clear, methodical mind, his pure taste and his painter's eye saved him from the depressing influence of the school. Assiduously frequenting the museums and poring over art books and prints in the libraries, he drew from the study of the classical masters the strength that enabled him to resist this academic teaching. In the course of his studies, he realized that analogous laws govern line, chiaroscuro, colour and composition...: rhythm, measure and contrast. The result of Seurat's studies was his judicious and fruitful theory of contrast, which he put into practice in all his works. He applied it first to chiaroscuro: with the simplest resources, the white of a sheet of Ingres paper and the black of a Conté crayon, a skilfully shaded or contrasted black, he executed some 400 drawings, the finest 'painter's drawings' that exist. Thanks to the perfect mastery of values, one may say that these 'blacks and whites' are more luminous and more coloured than many paintings."

The meeting between Seurat and Signac in 1884 was decisive. Seurat had come to the study of colour by way of an analysis of Delacroix's work and the reading of scientific books on the subject. As early as 1881 he wrote: "Saw *The Convulsionaries of Tangier* [by

Paul Signac (1863-1935): Two Women Trimming and Finishing Hats, 1885. Oil.

Georges Seurat (1859-1891): Bathers at Asnières, 1883-1884. Oil.

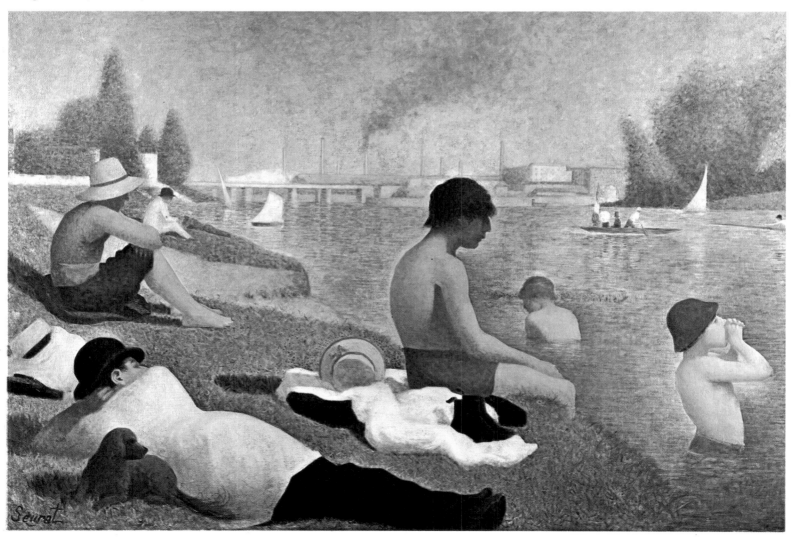

The power of light

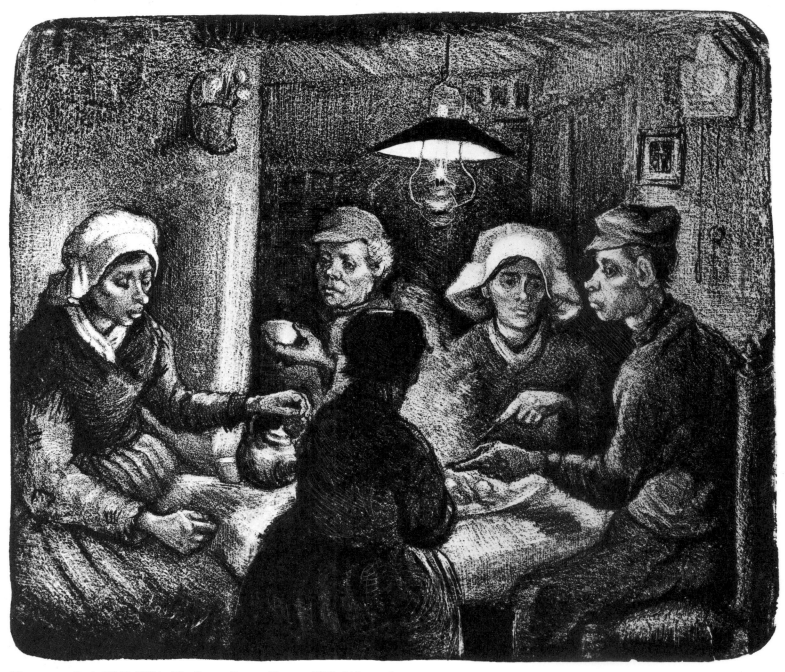

Vincent van Gogh (1853-1890) : The Potato Eaters. Nuenen, 1885. Lithograph.

Delacroix]. The flag is green with a red spot in the centre... The shading and all the rest hatched and vibrant. The cheek-bones, the shading of the turban. This is the strictest application of scientific principles seen through a personality."

Seurat's colour is less pure than that of Signac, who was directly influenced by the Impressionists: Monet, Pissarro, Renoir, Guillaumin. Painting chiefly landscape from nature, Signac used only the prismatic colours: "A few lines from *L'Art moderne* by J. K. Huysmans dealing with Monet and Pissarro and touching on complementary colours, on yellow light and violet shadow, led him to assume that the Impressionists knew all about the science of colour. He attributed the splendour of their works to this knowledge and thought himself acting as a zealous disciple should when he turned to Chevreul's book to study the very simple laws of the simultaneous contrast," wrote Signac of himself.

Pooling their experience, Seurat and Signac in 1885 worked out the principles of what was to be called Neo-Impressionism: they were embodied in Seurat's *A Sunday Afternoon on the Island of La Grande Jatte*.

The study of light absorbed both scientists and artists. After a period of analysis during which they discovered its laws, they set out to put them to good use. The scientists succeeded in harnessing electricity. The painters, having mastered the secrets of colour, now gave their pictures an unprecedented luminous intensity. A mirror of natural light for the Impressionists, the picture became for the Pointillists a source of light in its own right, independent of nature.

Still ignorant of all this research carried out by scientists and painters, Van Gogh was equally fascinated by this problem and studied it on his own.

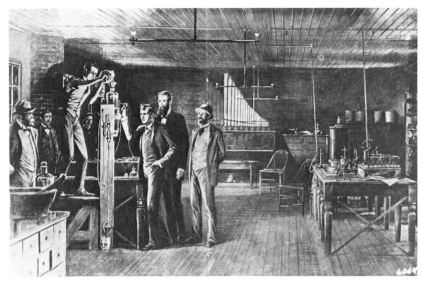

Invention of the incandescent electric lamp by Thomas A. Edison in 1879.

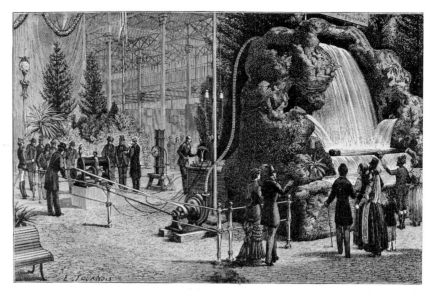

First transmission of electric current over a telegraph wire from Miesbach to the Munich Exhibition by the French engineer Marcel Deprez on 2 October 1882.

It was only after they had searchingly explored the possibilities of black and white that Seurat and Van Gogh turned to colour. And, with both, the luminous power of contrasts already scientifically explained by Chevreul was heightened now by philosophical and symbolic overtones. In a series of six articles on the "Phenomena of Vision" published in *L'Art* in 1880, and cut out and kept by Seurat, David Sutter wrote: "One must look at nature with the eyes of the mind and not merely with the eyes of the body... Science delivers us from every form of uncertainty and enables us to move freely within a wide circle; so that it would be an injury to both art and science to suppose that one necessarily excludes the other. Since all rules are derived from the laws of nature, nothing is easier to learn or more necessary to know. In art everything should be willed."

Also in the 1880s there began to circulate in the Paris studios a French translation of an eighteenth-century Turkish poet, Zumbul Zade, beginning: "Thus spake Mani, the precept-giving painter." The following quotation from it was copied out by both Seurat and Gauguin: "Nothing is black and nothing is grey. What appears black is a compound of several colours and what appears grey is a compound of bright colours which the eye divines... Go from bright to dark and not from dark to bright. Your work can never be too luminous."

To the magic of light for painters corresponded the magic of electricity, which fascinated all their contemporaries, as it gradually brought about a change not only in street lighting but in the conditions of home life. At the same time this new source of energy seemed to be endowed with a power which renewed the hope of man's liberation through science.

In 1878 the Avenue de l'Opéra in Paris became the first street equipped with electric lighting. In 1879 Edison invented the incandescent lamp. In 1881 the first electric tramway went into operation in Berlin. In 1882 the engineer Marcel Deprez demonstrated at the Munich Exhibition the first transmission of electric current over a telegraph wire. In 1886 Hérault discovered aluminium by electrolysis and in 1887 Hertz defined electric waves. The new power unleashed by scientific analysis, the harnessing of the forces that quicken the world, turned men away from a fixed conception of visual appearances.

For moral reasons Van Gogh was less detached from visual observation than Seurat. He wrote in a letter to his brother Theo (30 April 1885): "And as to those few days in which I have painted it now [i.e. *The Potato Eaters*], it has been a real battle, but one for which I feel great enthusiasm. Although I was repeatedly afraid I should never pull it off. But painting is also acting and creating." For him, too, truth lay beyond appearances.

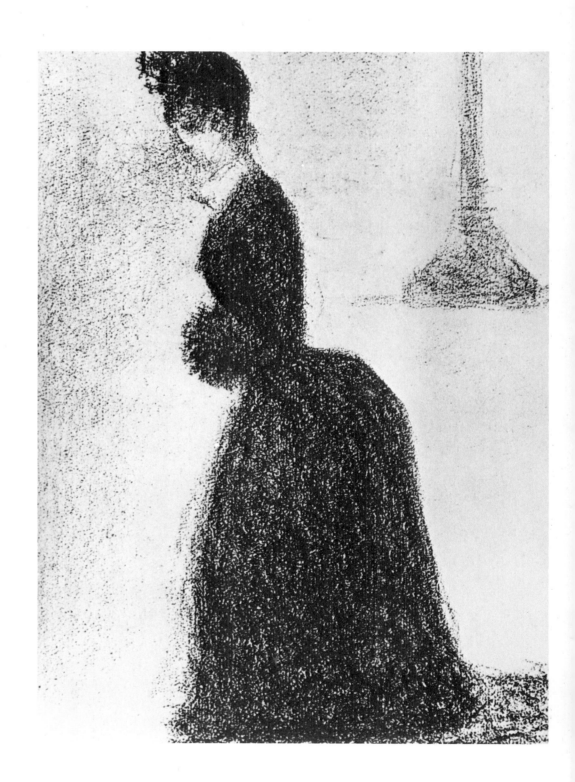

Georges Seurat (1859-1891): Woman Walking by a Street-Lamp. Conté crayon.

The last impressionist exhibition and the Salon des Indépendants

From 15 May to 15 June 1886 the Impressionists exhibited together for the eighth and last time as a group. The exhibition had been difficult to organize, there being strong opposition against Degas and Pissarro who wished to bring in the young painters whom they patronized. Twelve years after their first exhibition, the Impressionists were still far from enjoying any success and could not agree among themselves whether to continue to exhibit as a revolutionary group or to mix their ranks with other artists. This last exhibition was held on the first floor of the Maison Dorée restaurant in the Rue Laffitte, at the same time as the official Salon. On the poster announcing it, however, they refrained from

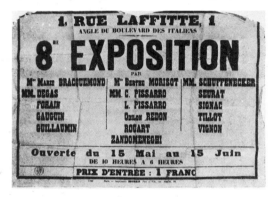

Poster for the eighth and last group exhibition of the Impressionists, Paris, May-June 1886.

using the word "impressionist," though that was the term they were known by in the United States, thanks to the efforts of their dealer Paul Durand-Ruel. In this same year he exhibited 300 of their canvases in New York, where on the whole they were well received by press and public. It was by opening up the American market that Durand-Ruel ensured the success of his business and the future of his painters.

Felix Fénéon, who became the warmest defender of the new painters, was the only critic to point out the significance of the changes taking place in the impressionist movement. He wrote in *La Vogue* (13 June 1886): "Renoir and Monet have kept away

Edgar Degas (1834-1917): The Tub, 1886. Pastel.

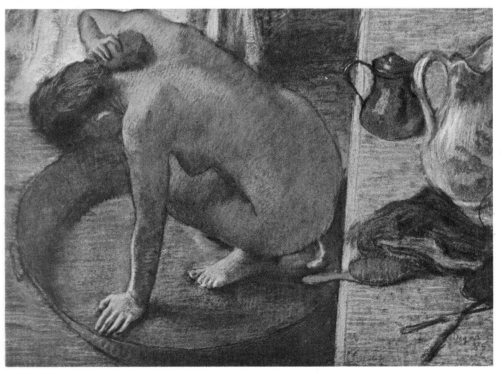

from the Rue Laffitte; so have Raffaëlli, Cézanne, Sisley and Caillebotte. In spite of their absence, the new exhibition shows clearly how things stand: Degas figures in it with characteristic works; Berthe Morisot, Gauguin and Guillaumin represent Impressionism as we have seen it at the previous exhibitions; Pissarro, Seurat and Signac innovate."

A close friend of Seurat and Signac, Fénéon realized how novel and indeed revolutionary their art was. He summed it up in masterly fashion in an article he wrote for the Narbonne paper *L'Emancipation sociale* (3 April 1887): "Monsieur Seurat's innovation is based on the scientific division of the tone. Thus: instead of mixing on the palette the pigments which, when spread on the canvas, will approximate to the colour of the object to be represented, the painter will apply a series of touches to the canvas, some corresponding to the local colour of that object, others to the quality of the light impinging on it, others to the reflections cast by neighbouring bodies, others to the complementaries of the surrounding colours.

"These touches are laid in not with a slashing brushstroke, but with small dots of colour. The advantages of proceeding in this way are:

I. The colours blend together in the spectator's eye: so we have an optical mixture. Now the luminous intensity of the optical mixture (mixture of colours and lights) is much more considerable than that of the pigmentary mixture (mixture of colours and textures)...

II. This mixture in the spectator's eye gives the picture a luminous intensity which makes it more vivid.

III. The modelling which it is impossible to convey exactly with streaks of pigment in the traditional way can be obtained in all its infinite delicacy, since the respective proportions of the dots of colour can be varied infinitely over a very small area.

IV. Skill of hand becomes a negligible matter, since all the material difficulties of brushwork are avoided. It is enough for the executant to have an artist's vision, enough in short for him to be a painter, and not a prestidigitator."

The impressionist exhibition of 1886 marked the final break-up of the movement: its members no longer had anything in common and never again exhibited together as a group. After showing his *Grande Jatte* at the last impressionist exhibition in May-June, Seurat showed it again in August 1886 at the second Salon des Indépendants, which now offered a lively and encouraging alternative to the official Salon. All of Seurat's friends and supporters exhibited with him there, where his *Grande Jatte* stood out as the manifesto of the new painting: Camille Pissarro and his son Lucien, Signac, Angrand, Cross and Dubois-Pillet. Also among the exhibitors that year, for the first time, was the Douanier Rousseau, who thereafter exhibited there regularly; in 1886 he showed his *Carnival Evening*. Naïve art found a welcome at the Salon des Indépendants, testifying to a real cultural emancipation and to an extraordinary evolution in art forms and taste which was to continue uninterruptedly for the next three decades and more.

At the eighth impressionist exhibition Degas's work was not admired and all the critics preferred the more traditional vision of Guillaumin. They were surprised and disconcerted by Seurat. Pissarro, the leading recruit to scientific Divisionism, seemed like a deserter of the impressionist cause and no one yet realized the magnitude of Gauguin's talent, though he showed nineteen canvases.

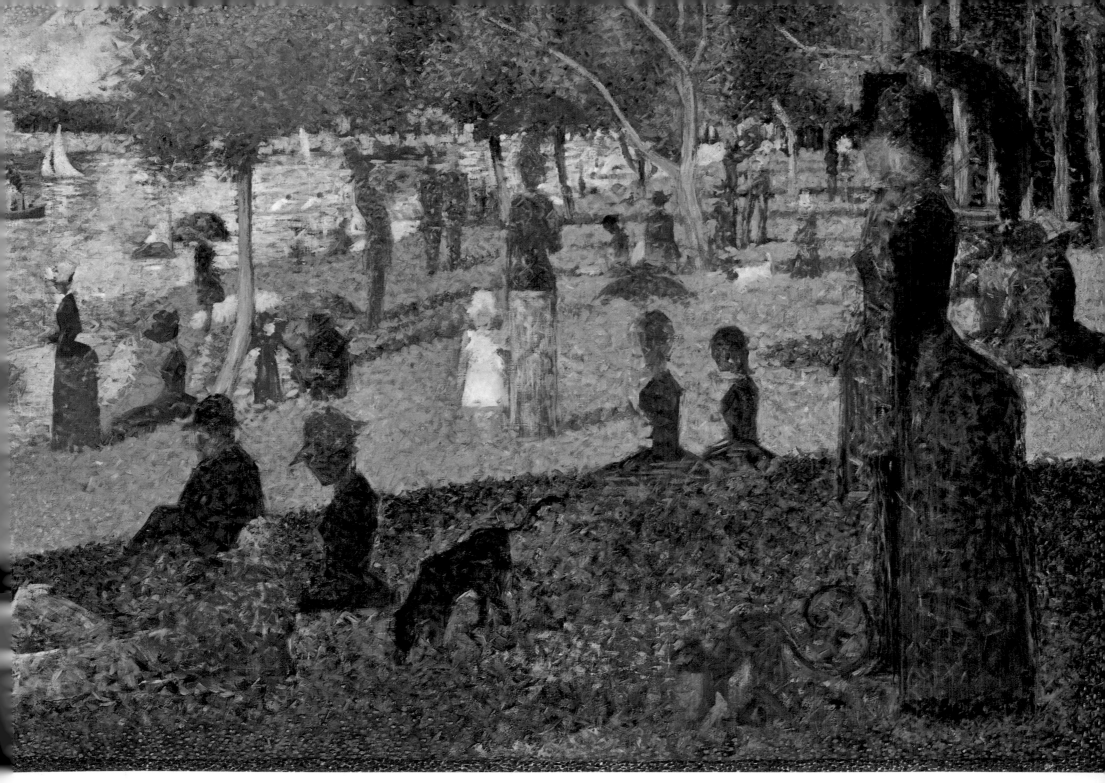

Georges Seurat (1859-1891): A Sunday Afternoon on the Island of La Grande Jatte, 1884-1886. Oil study.

This overall oil study for *A Sunday Afternoon on the Island of La Grande Jatte* (27½ × 41 in.) includes almost all the elements of the final, much larger version (81¼ × 120¼ in.) whose composition is more mathematically exact and more strictly geometrical. After being shown in Paris in 1886 at the eighth impressionist exhibition and the second Salon des Indépendants, the *Grande Jatte* was exhibited early in 1887 at the Salon des XX in Brussels, together with several others by Seurat and Pissarro.

It was the outcome of two years' work. Beginning in the summer of 1884, Seurat made some figure and landscape studies at Asnières, on the Seine, on the west side of Paris, where he had already painted his *Bathers*. In the morning he would work there from nature, with bright pure colours on small wooden panels, in the impressionist spirit. In the afternoon, using these studies, he worked on the composition in his studio, using models to arrive at the rhythm and relation of volumes. The outdoor studies at Asnières were done in oils. For the indoor studies from studio models he used the Conté crayon, with which he worked out every detail before incorporating

it into the composition, in which he refrained from linework in order to focus all his attention on the contrasting colours of surfaces and volumes. He thereby achieved the strictness and grandeur of design necessary to contain his shimmering colours. It is this firmness of construction that distinguishes Seurat from his friends, who were rarely able to go beyond descriptive form. It was reckoned by Félix Fénéon that some 400 preparatory drawings and sketches went to the making of *A Sunday Afternoon on the Island of La Grande Jatte*.

After the passage of a few years however, when he saw the picture again at the posthumous Seurat exhibition held at the Salon des Indépendants in 1892, Fénéon lamented the fact that some of the colours had already begun to fade: "Because of the pigments that Seurat was using at the end of 1885 and in 1886, this picture of historical importance has lost its luminous charm. While the pinks and blues have held their own, the Veronese greens are now sallow and olive-hued, and the orange tones which represented light no longer represent anything but holes" (*Le Chat Noir*, 2 April 1892).

The theories of Neo-Impressionism

In a review of the Salon des Indépendants, published in *L'Art moderne* in Brussels (19 September 1886), Félix Fénéon coined the term that was henceforth to be applied to Seurat and his friends: "The truth is that the *neo-impressionist* method calls for an exceptional delicacy of vision: its dangerous straightforwardness will frighten away all the clever practitioners whose manual skill conceals their visual shortcomings. This kind of painting can be practised only by painters."

In 1899, when he came to sum up the theory and practice of the movement, Signac wrote: "If these painters, who would be better defined as *chromo-luminarists*, chose to call themselves *neo-impressionists*, it was not to curry favour with the public (for at that time the Impressionists were still fighting against odds) but to pay tribute to the achievement of their forerunners and to indicate, beyond the differences of technique, the similarity of their aims: *light* and *colour*. This is the meaning that must be attached to the term *neo-impressionist*, for the technique employed by these painters has nothing impressionistic about it: while their predecessors were all for instinct and instantaneity, they were all for reflection and permanence."

This conceptualization of painting, imposed by the Neo-Impressionists, marks the first step towards abstraction. It rested not only on the mechanical device of dividing colours, which was its most obvious characteristic. *La Grande Jatte* represented a conscious and constructive application of geometry to art which Signac described as follows: "It would seem that, in front of his white canvas, a painter's first concern should be: to decide what curves and arabesques are to pattern the surface, what tints and tones are to cover it. A rare concern indeed at a time when most pictures are all too much like snapshots or vain illustrations."

Signac, who had begun painting while still in his teens, was already friendly with the Impressionist Armand Guillaumin when he met Seurat at the Indépendants in 1884. Having the power to win over his friends by the force of his own convictions, Signac induced Seurat to brighten his palette and himself began a close study of the scientific theories of colour which Seurat had espoused. Signac even called on Chevreul in 1885, but the old scientist, then ninety-nine, was in his dotage and the discussion was fruitless; Chevreul's writings, however, became the Bible of the Neo-Impressionists. Through Guillaumin, Signac met Pissarro; then, in October 1885, at Durand-Ruel's, Pissarro met Seurat and was soon convinced that the scientific division of tones offered a way out of his own difficulties. Both he and his son Lucien adopted the pointillist technique.

After painting *A Sunday Afternoon on the Island of La Grande Jatte*, Seurat raised the question which his friend Gustave Kahn put as follows in *L'Art moderne* (5 April 1891): "If, with the experience of art, I have been able to find the scientific law of pictorial colours, can I not work out an equally logical, scientific and pictorial system enabling me to make the lines of the picture go together in harmony, just as I can make the colours harmonize?"

This problem had in fact been dealt with by a friend of Fénéon, the mathematician Charles Henry, who contributed to several symbolist magazines and who was now to become Seurat's adviser and inspirer. In his *Introduction à une esthétique scientifique*, published on 25 August 1885, Henry wrote: "To speak of science is to speak of freedom... What science can and must do is to spread the agreeable within us and around us, and therefore its social utility is immense in these times of oppression and muffled collisions. It should spare the artist many qualms and abortive attempts, by pointing out the way in which he can find an ever richer store of aesthetic elements. It should provide critics with an expeditious means of distinguishing the ugliness which, though difficult to state, is distinctly felt." The programme of Seurat's large compositions was mapped out, but the scientific use of colour seemed to remain his chief concern.

On the strength of the chromatic and optical laws laid down by Chevreul, Maxwell, Helmholtz and Rood, Seurat constructed a disk on which he assembled the pure colours and the intermediate tones, and which accurately indicated the complementary of any colour or tone. Signac put the visual effectiveness of this chromatic circle to good use in posters, book illustrations and other works.

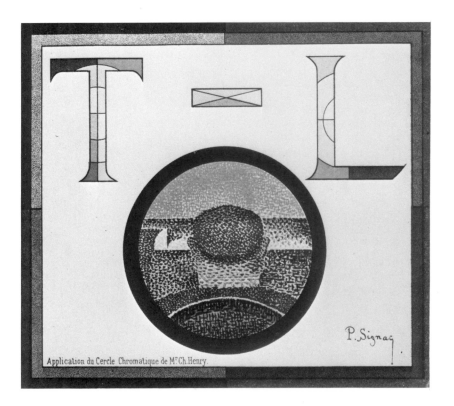

Paul Signac (1863-1935):
Application of Charles Henry's Chromatic Circle
on a programme for Antoine's Théâtre Libre,
Paris, 1888. Colour lithograph.

The crisis of Impressionism

The fact that Monet and Renoir declined to take part in the eighth impressionist exhibition in 1886 must have seemed surprising to outsiders. But since 1882 the group had ceased to exist as a unified force. The financial success of some had aroused the jealousy of others. Too long a venture in common had become distasteful to them all: each felt that his individual personality was being compromised. Above all, each felt the need to find himself anew, to challenge assumptions which he had taken for granted and to which the public had remained hostile. Renoir, painting many portraits, now sacrificed colour to line. Monet played like a virtuoso with the impressionism he had invented, but he could not escape the pitfalls of mannerism when he allowed technique to prevail over invention.

In 1886 Monet and Renoir were invited to exhibit in Brussels with Les XX (The Twenty). This group of young Belgian artists had been formed at the very time that the Salon des Indépendants was being organized in Paris, for the purpose of exhibiting together and making the work of foreign artists better known in Belgium. Led by Octave Maus, a lawyer, journalist and art critic, the Twenty held an exhibition every year, in February, from 1884 to 1893. These Brussels exhibitions provided a fruitful meeting place for painters, poets and musicians; there, each year, the pulse of the European avant-garde could be taken pretty accurately. "The Salon des XX," wrote Octave Maus, "is merely one episode in the great periodical battle between new ideas and routine, a battle invariably won by the former over the latter." In 1886 Monet and

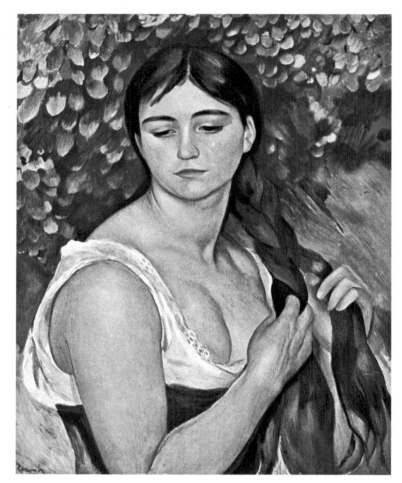

Auguste Renoir (1841-1919): The Braid (Suzanne Valadon), 1886. Oil.

Renoir opened Belgium to Impressionism; Pissarro and Seurat, invited in 1887, converted it to Pointillism.

With the Salon des Indépendants in Paris and the Salons des XX in Brussels, painters were at last in a position to show their work freely, without having to solicit the approval of a jury. The artist was no longer subject to any authority but that which he himself exercised over his own efforts. From now on, the field of possibilities was wide open.

Claude Monet (1840-1926): La Manne Porte, Etretat, 1886. Oil.

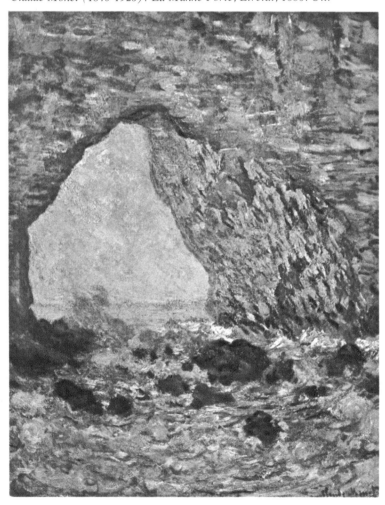

"I don't know whether I'm right, but Monet's current work strikes me as lacking light, I mean the light bathing all bodies both in shadow and in the lighted parts. It looks decorative of course, but there is a lack of finesse and the uncouthness is accentuated. Maybe this is because of our vision, which is evolving towards harmony and requires a less decorative art, though one that still decorates to some extent.

"With Renoir, the same shortcoming. I realize how much he has exerted himself; his refusal to stay where he was is all to his credit. But he has set himself to attend to line alone and the figures stand out against each other without allowing for the colour harmonies. This is incomprehensible. Renoir, not having the knack of drawing and not having the nice tones he once arrived at instinctively, has become incoherent. As for Sisley, he has remained as he was, very skilful, rather delicate, but absolutely false..."

Pissarro, letter to his son Lucien, 14 May 1887

Cézanne: the invention of a new space

In 1883 Cézanne had returned to his native Provence. The changing light of northern France and contacts with his impressionist friends were no longer necessary to him, as they had been in 1874. Impressionism had opened his eyes to colour and nature. The task before him now was to fulfil himself in the light of the South which he rediscovered and recognized as the natural medium of his art. At L'Estaque on the Riviera, in the countryside around Aix and at Gardanne, he began an adventure which remained secret until 1895: from it were to stem Cubism and modern painting. While Seurat renewed Impressionism by placing it on a scientific basis of analysis and construction, Cézanne extended it into a new dimension by embodying the fruits of a searching study of nature in a solid framework of pictorial forms.

Cézanne by no means burned his bridges or broke with his old comrades. Monet and Renoir both paid him several visits in the South and painted some of the same motifs, but his interests and theirs were now very different. True, art remained for all of them a "means of expressing sensations," but Cézanne became more demanding. Impressionism had freed him from the phantasms of his exuberant imagination by teaching him to observe nature closely and he learned the lesson once and for all. He touched on his guiding purpose in a letter to Zola (19 December 1878): "I have begun to see nature somewhat late, and it never fails to be full of interest, but now the problem arises on the level of artistic language."

The impressionist analysis of colour satisfied him so far as the rendering of light and atmosphere was concerned, but seemed to him inadequate as regards the compositional order of the picture, all the more so since he was now confronted by a landscape whose volumetric power fascinated him. "I keep trying to find my way forward," he wrote in 1879, and by 1883, after a further stay at

Paul Cézanne (1839-1906): Gulf of Marseilles Seen from l'Estaque, 1883-1885. Oil.

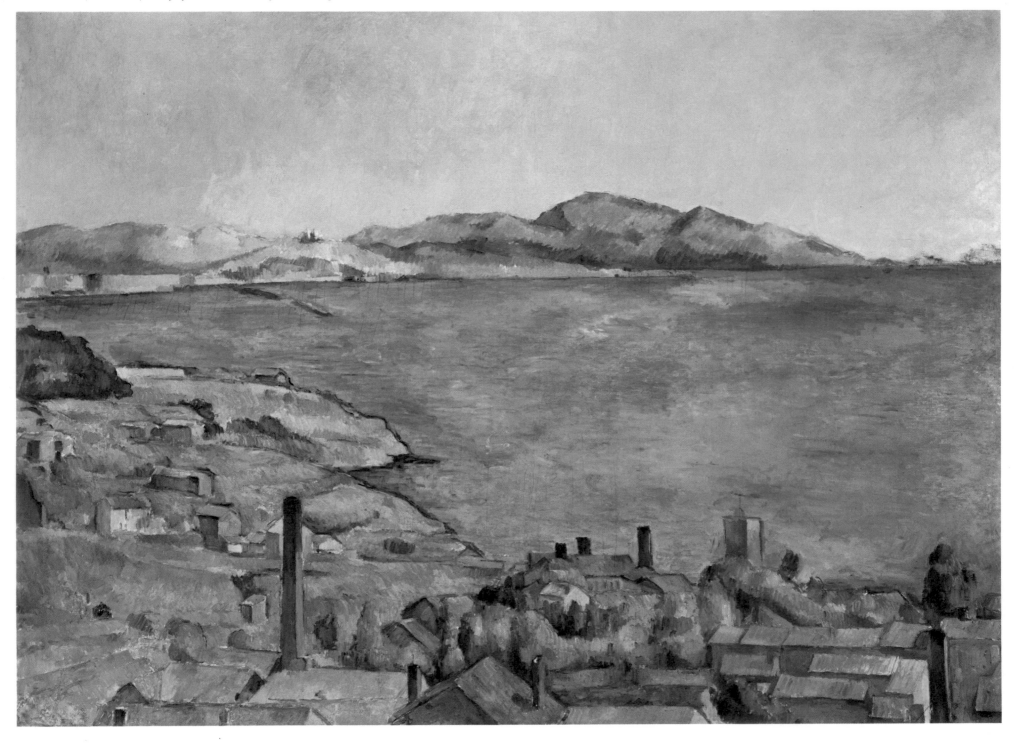

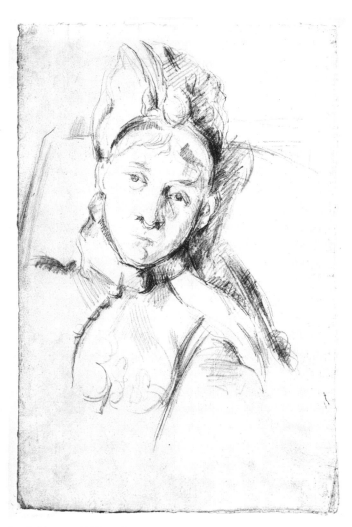

Paul Cézanne (1839-1906):
Portrait of Madame Cézanne, 1883-1886. Pencil.

effect." He rendered this observation by painting the surface of the sea as a vertical plane, without shading, and by deepening the tones of the background mountains, thus bringing the picture recession forward and developing it vertically in the Oriental manner. By emphasizing the picture plane he achieved a force and coherence which he could never again dispense with.

For Cézanne a picture was not only a record of his observations, it was a reconstruction of the world in a specific language. "Art is a harmony parallel to nature," he said: it was between 1883 and 1886 that he reached this conviction. But "nature is not on the surface, it is in depth. Colours are the expression, on that surface, of that depth. They arise from the roots of the world. They are the life of the world, the life of ideas. Drawing, on the other hand, is wholly abstraction. That is why it must never be separated from colour. It is an algebra, a handwriting. As soon as it is touched by life, as soon as it conveys sensations, it becomes colour." With line he shaped his sensation, with colour he unified it. Each plane was merged into the next by that subtle play of colour modulation which gives his art its marvellous mobility.

Whether he took his wife as model or any other object, mattered little: for him, as artist, she was only a mass in space which he fixed in a hieratic immobility very different from that image of life and passion which for Rodin and all the symbolist artists represented woman. For Cézanne, she was a pretext for the adventure of perception; for Rodin, she was the symbol of fluid movement. Paradoxically, the painter accentuated her volumes, while the sculptor concentrated on the dynamic sequence of attitudes: one sought the essence of being, the other sought life.

In his effort to evoke nature Rodin remained a member of the impressionist generation, while Cézanne, departing more and more from nature imitation, opened the way for an art of pure creation. Both, however, were united in their steadfast faith in art.

Auguste Rodin (1840-1917): The Danaïd (detail), 1885. Marble.

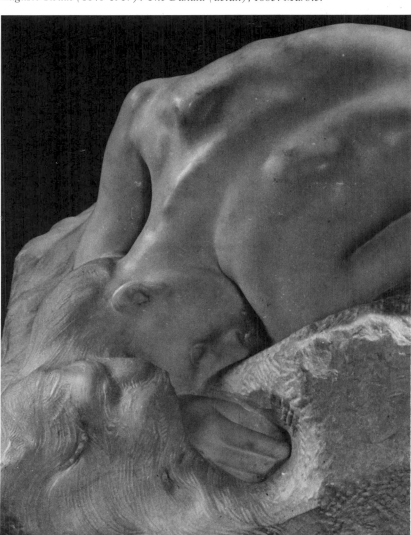

L'Estaque, the path lay clear before him and his response to nature was distinctively different from that of the other Impressionists. The technique of the divided brushstroke enabled him to blend its elements until they dissolved in light, and through colour modulation he brought out the underlying structure of nature. Without renouncing the palette of Monet, Cézanne used it differently: with a broader, thicker stroke of the brush, he followed each plane, bringing out simultaneously what characterized it and what bound it to its milieu, without ever sacrificing the detail to the whole. It was in the conception of space that he wrought his revolution.

To "make of Impressionism something as durable as the art of the museums" (to use his own expression), he had to rediscover the laws of painting. The town of L'Estaque, on the Mediterranean coast near Marseilles, offered him a good theme for his reversal of perspective. Until then, for all Western painters since the fifteenth century, painting had been a window open on the world; since Cézanne it has become "a flat surface covered with colours assembled in a certain order" (the apt definition given in 1890 by Maurice Denis). As he tried "to vivify Poussin by contact with nature," Cézanne developed a new conception of the image and space. He found at L'Estaque how necessary it was to bring out the planes: "It is like a playing card... The sun is so strong that objects seem to stand out in silhouette, not only in black and white, but in blue, red, brown and violet. I may be wrong, but this seems to me the very reverse of modelling" (letter to Pissarro, 1876). And to Zola he wrote from L'Estaque (1883): "Nevertheless, at sunset, from the heights, one has a beautiful view of Marseilles and the islands in the distance, the whole enveloped as evening falls in a very decorative

Gauguin and Van Gogh
Explorers of the inner life

*Paul Gauguin (1848-1903):
Ceramic vase decorated with
a dancer inspired by Degas,
1886-1887.*

The life and work of Paul Gauguin and Vincent van Gogh have long since been shrouded in legend. The nature of their artistic quest brought them together, the irreconcilable antagonism of their personalities put a tragic end to their short friendship; but their encounter left an indelible mark, affecting them both as men and artists. Both of them were outcasts, painters whom society had repudiated, haunted by similar anxieties and sharing similar dreams. In painting both found a goal and a means of escape. They were so totally committed to their art that they did not shrink from sacrificing their lives to it. Their real-life experiences merged with a pursuit of new artistic horizons which was their ultimate form of self-expression and of communication with others. They found fulfilment in the colours of impressionism, but soon went beyond it, setting it on a fresh path in which, to quote Van Gogh, "reality and symbol" were merged with one another.

Unlike Seurat and Cézanne, who based their experiments on tradition, knowledge and objectivity, Van Gogh and Gauguin, the last heirs of the romantic upheaval that had rocked the whole of the nineteenth century, transformed painting into an exploration of the inner life. Both burst upon the artistic scene late in life, as self-taught artists.

In *Avant et Après* (Before and After), a book of memoirs written in 1903—with the express intention, it would appear, of consolidating the legend—Gauguin wrote: "If I told you that, in the female line, I am descended from a Borgia of Aragon, Viceroy of Peru, you would say it wasn't true, and that I was putting it on." Nevertheless, he believed it himself and always tried to emphasize such hints of the Aztec as could be found in his profile. Not much is known about Gauguin's parents, but his grandmother was famous under the name of Flora Tristan. A pioneer of socialism and a "femme fatale," a friend of Proudhon and George Sand, Flora Tristan, a Frenchwoman of Peruvian Spanish extraction, travelled all over the world in the cause of freedom for women, and especially for working people, whose poverty aroused her compassion. She died in 1844, so that she never knew her grandson, but the few years of his early childhood which he spent with her family in South America were decisive for Gauguin's development. His father, a Republican journalist, moved with his family to Peru in 1848 in the hope of settling there with the help of his wife Aline's grand-uncle; he died on the voyage out. For five years as a child Gauguin led an enchanted life in an exotic country from which he was driven by a *coup d'état* but whose memory he would never be able to erase. His mother piously preserved some Peruvian objects whose shapes were to reappear in his work and which made him particularly receptive to archaic and exotic art, at that time still completely unknown in France.

Back in France, Gauguin never lost a feeling of nostalgia for those happy years. Much later he wrote: "I have an unusually retentive visual memory, and I can clearly recall that period, our house, and lots of things that happened..." His life in Paris was wretched compared with what he had known in Lima, and his schoolwork was poor. He took refuge in dreams, and in 1865 at the age of seventeen embarked as a merchant navy cadet on the *Luzitano* sailing to America. Gauguin did not return to civilian life until 1871, when he was offered an opening at the Paris Stock Exchange. In 1873, already a successful businessman, he married

Photograph of Paul Gauguin at Pont-Aven in 1886.

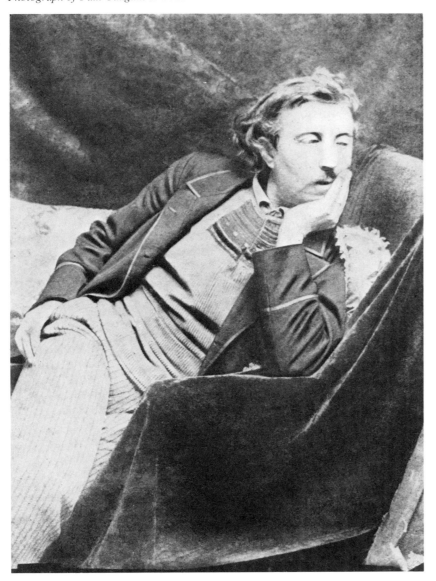

Mette Gad, a beautiful Danish girl, and slipped easily into a bourgeois life which promised to be a highly prosperous one. He also tried his hand at painting, and one of his pictures was accepted at the Salon of 1876. He admired Corot, then the Impressionists, especially Pissarro. In 1874 he saw the first exhibition held by the Impressionists and began to collect their works. In 1879 he spent a few days at Pontoise with Pissarro, who gave him advice and encouragement. Gauguin was earning a comfortable livelihood in stockbroking and spent all his leisure-time painting. He was particularly struck with Pissarro's paintings—he owned nine of them— and with Cézanne's, five of which he bought, including a still life that he used as the background to a portrait of a woman he painted in 1890: a veritable homage to Cézanne. Pissarro taught him how to look at the world around him and to catch its subtleties of colour and atmosphere; he initiated him into the impressionist palette and showed him how to build up a picture with deft, separate strokes of the brush. He also taught him never to work on a subject in which he had no deep personal involvement. Degas, too, aroused his interest with his novel way of cutting off his compositions at the frame.

The stock market crash in 1882 abruptly changed his material circumstances. He left Paris for Rouen where he hoped he might be able to live by his art and apply his talents to decorative work. To Pissarro he mentioned a plan to produce tapestries. The extraordinary popularity of Japanese art at the time gave him the idea of creating everyday objects, which would be more marketable than paintings. Mette, his wife, encouraged him to go to Copenhagen, where her family might be able to help him find another job. He spent several months in Denmark trying to set himself up in business. His dismal failure was exacerbated by the hostility of his in-laws, sturdy Danish burghers with no sympathy for the ways of artists. In June 1885 he was back in Paris: the breach with his wife was complete.

During his isolation in Denmark, Gauguin gained greatly in maturity. On 14 January 1885, in a letter to Emile Schuffenecker, a Stock Exchange colleague who had also turned to painting, he spoke of his preoccupations, which were very different from those of the Impressionists: "As for myself, it sometimes strikes me that I must be crazy and yet the more I think things over at night in bed, the more I believe I am right. For some time philosophers have been speculating about phenomena that seem to be supernatural yet can be *felt*. This word says everything... Work *freely and insanely*, you will make progress and sooner or later your worth will be recognized, if you have any. Above all, don't sweat and strain over a painting—a powerful feeling can be translated immediately: dream over it and seek the simplest form for it." Gauguin parted company with the Impressionists and their art based on nature, because he felt that the truth lay within the core of his own being, not in the external world of nature.

On 15 June 1886 the eighth and last group exhibition of the Impressionists closed its doors. Gauguin had participated with nineteen paintings. But success still eluded him, and his material situation was desperate. At the end of June he went to Pont-Aven and installed himself in the Pension Gloanec, of which he had heard from his friends. Brittany attracted him because life there was cheaper than elsewhere in France; the climate and atmosphere served to enhance his independence, originality and yearning for the primitive.

This was the year in which Van Gogh arrived in Paris. Like Gauguin, he came to painting relatively late. His vocation was

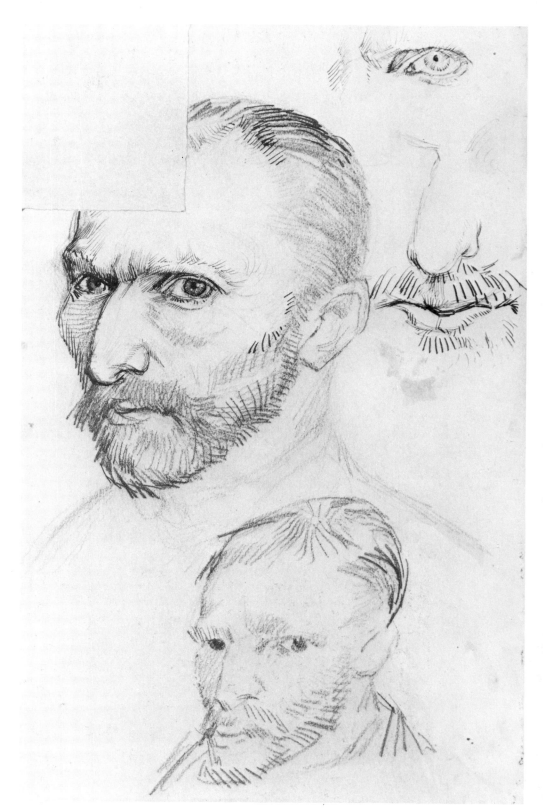

Vincent van Gogh (1853-1890): Pencil studies for a self-portrait, 1886-1888.

all the stronger for being slow to declare itself. Like Gauguin, he escaped the teaching of the Academy and devoted all his powers to what he saw as his ultimate means of communicating with others.

Vincent van Gogh was also singled out by destiny from birth. He was born on 30 March 1853, in Groot Zundert, a small village in Dutch Brabant, where his father was the minister. Precisely a year before, to the day, another Vincent van Gogh had been born, but had not lived. His grave was in the village churchyard, and from the moment he learnt to read the painter could see his own name on a tombstone every day. His earliest impressions were vitiated by the shadow of the dead brother, as were his first relationships with other people. In the very Protestant environment into which he was born, he developed a sense of guilt which could only be assuaged by devotion to others.

Vincent was conspicuous physically, with flaming red hair, a very pale complexion and an irascible temper, and he often took refuge in dreams and the contemplation of nature. As he was an indifferent student and his family poor, he left school early and began to earn his own living at the age of sixteen. Chance rather than vocation brought him into contact with art. His uncle got him a job as sales assistant in an art gallery which he had founded in The Hague and which had become the Dutch branch of an influential Paris firm, the house of Goupil. Vincent discovered the closeness of the ties between himself and his younger brother Theo when the latter came to see him in The Hague in August 1872: a few days later saw the start of the fascinating correspondence that from then on marked almost every day of his life. For Vincent, writing to Theo was a way of working things out for himself, of keeping a diary, and at the same time communicating with the sole being who showed any sign of affection for him, who listened and cared.

In June 1873, Vincent van Gogh, who was a good employee, was transferred to the London branch of the Goupil galleries, where he stayed for two years. He began to take an intense interest in painting and was particularly impressed by Millet and the Barbizon painters. From January 1874 onward, thoughts on art took pride of place in his letters, together with meditations on the meaning of life prompted by his daily readings of the Bible. In the summer of 1874 he experienced his first setback, when he discovered that his London landlady's daughter, with whom he had fallen in love, was already engaged. His dreams were shattered and he began to show signs of instability. He was not destined to a successful bourgeois career.

In May 1875 he was transferred to Paris. Although he visited exhibitions and museums there, he no longer believed in his work at the gallery and took refuge in the Bible. His relations with M. Boussod, the manager, became strained and finally he was dismissed.

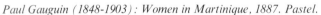
Paul Gauguin (1848-1903): Women in Martinique, 1887. Pastel.

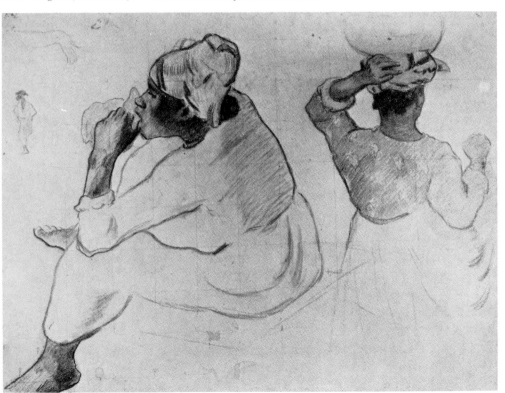

Going back to England, he worked for a time as an *au pair* assistant master at a school in Ramsgate. In June 1876 he was working as an assistant to a minister at Isleworth. In the slums of outer London he came to realize the extent of the poverty and degradation created by industrialization. At Christmas he returned to his family at Etten, in Dutch Brabant, where his father was now pastor. The series of setbacks he had suffered, his social conscience and his need for self-sacrifice combined to convince him that he should follow in his father's footsteps and become a minister of religion. From May 1877 to July 1878, with great determination, he studied theology, Greek, and Latin in Amsterdam. But nothing in his studies bore any relation to the consuming fire inside him: "In any case, it is always better to have an ardent spirit, with all its temptation to do wrong, than to remain blinkered and over-cautious." He wanted to carry his ministry to the poorest of the poor.

In November 1878 he finally obtained a position as a preacher in the coal-mining district of the Borinage, in Belgium. His reaction to the exploitation of the miners was one of unflagging devotion to them. He dressed their wounds, ministered to their spiritual needs and gave unstintingly of himself to the point of exhaustion. But his excessive zeal worried the Evangelical Commission that employed him, and they did not renew his appointment. At Cuesmes in the Borinage, during the severe winter of 1879-1880, he was at the limit of his endurance, at rock bottom: he had failed, missed out, in everything. He was useless, unwanted, rejected even by the Church. In his anguish of mind, he began to draw. He copied Millet and studied both nature and man. "So far I know no better definition of 'art' than this: *art is man added to nature*." Abandoned by all, he became one of the anonymous mass of the poor.

In July 1880 he resumed contact with Theo, who was now working at the Goupil Gallery in Paris. "Instead of giving in to despair, I chose the part of active melancholy—in so far as I possessed the power of activity—in other words, I preferred the melancholy which hopes and aspires and seeks to that which despairs in stagnation and woe... There is something inside me, what can it be?" (letter to Theo, July 1880).

Two months later Vincent had come some way towards finding a reply to his self-questioning: "Well, even in that deep misery I felt my energy revive, and I said to myself: In spite of everything I shall rise again, I will take up my pencil, which I have forsaken in my great discouragement, and I will go on with my drawing. From that moment everything has seemed transformed for me; and now I have started and my pencil has become somewhat docile, becoming more so every day."

It remained for Van Gogh to learn his trade as draughtsman and painter. For five years he experimented unceasingly, in the Netherlands and Belgium, in towns and villages, in the studio and in museums, striving to achieve the mastery he needed if he was to express all that love and tenderness which he could only communicate through his art. As he was destitute and incapable of fending for himself, he was supported by remittances from Theo. At the end of February 1886 Vincent joined Theo in Paris.

Meanwhile Gauguin's hopes of making a commercial success in pottery had been dashed and he was anxious to leave Paris as soon as possible. He felt ill at ease among the painters in his circle, all of whom had been converted to Neo-Impressionism. First Pissarro, then Anquetin and Schuffenecker were swayed by Seurat's and Signac's scientific theories, which were completely at variance with Gauguin's ideas.

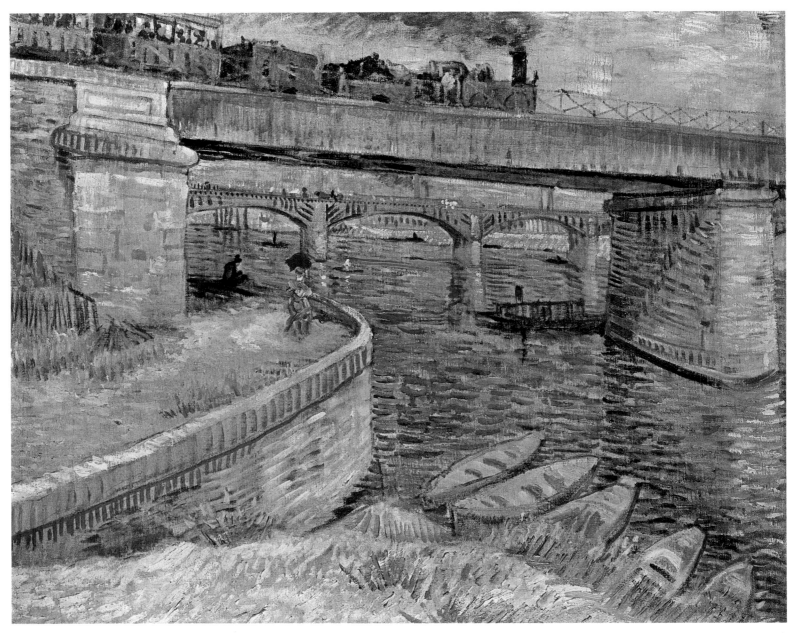

Vincent van Gogh (1853-1890): Seine Bridges at Asnières. Paris, 1887. Oil.

At the beginning of April 1887 he left for Panama with a friend from Pont-Aven, the painter Charles Laval. The beginning of work on the canal through the isthmus and the wild financial speculation that accompanied it had made the journey to Panama relatively easy and fashionable. For Gauguin this voyage to America offered the chance of recapturing something of the magical atmosphere of Peru, which had haunted him since childhood.

In fact, the attempt proved a failure: the reality was a far cry from his dreams. No sooner had he arrived than he realized his mistake: "So the harm is done; now it has got to be remedied. Tomorrow I start work in the isthmus swinging a pick to clear the way for the canal, at 150 piastres a month; and when I have saved 150 piastres, that is 600 francs (a matter of two months), I shall go on to Martinique," he wrote to his wife. And accordingly, on 20 June 1887, he wrote from Martinique, which he had reached much sooner than he dared hope: "At the moment we are in a Negro hut and it's paradise compared with the isthmus. Below us is the sea ringed with coconut trees, above us all sorts of fruit trees, 25 minutes from town."

Gauguin did not stay long at Martinique but he found there what he was later to seek at Tahiti. By August 1887, sick and emaciated, his enthusiasm flagging, he was seeking repatriation. By November he was back in Paris, paying his passage by reverting to his old calling as a sailor. He moved in with Schuffenecker, but he was so difficult to live with that his stay did not last very long. However, the two men still remained friends. His hopes of making money from ceramic sculptures were dashed once more. He was completely destitute in spite of the admiration his Martinique pictures inspired among the younger painters, especially Van Gogh, who persuaded his brother Theo to take an interest in Gauguin's work. But lack of success did not dim Gauguin's faith in his vocation: "I know that this accursed painting business has been the cause of all my torment, but since the harm is done I may as well go along with it and try to make something of it," he told his wife before leaving for Pont-Aven the second time.

Van Gogh had arrived in Paris at the end of February 1886. He joined his brother Theo, who was in charge of the Boulevard Montmartre branch of the important Boussod and Valadon

Gallery (owned by the sons-in-law and successors of Goupil), which had its main premises in the Place de l'Opéra. As Theo enjoyed a certain degree of independence he could venture to show a few works by impressionist painters in the basement of his gallery, despite their lack of official recognition. It was Paris that taught Van Gogh about modern art and colour and put the technique he needed within his grasp. He was eager to make up the time he felt he had wasted; he visited a number of exhibitions, witnessing in particular the affirmation of Neo-Impressionism in the work of Seurat, whose *Grande Jatte* he saw at the last impressionist exhibition and at the Salon des Indépendants. His response was not immediate: "When you see them for the first time you are very disappointed, you find their work ugly, messy and badly painted, badly drawn and poor in colour," he said later. Through Theo he was brought into personal contact with the rising generation of painters, and he worked in Cormon's studio, where he met Toulouse-Lautrec and Anquetin.

In June 1886 the Van Gogh brothers moved into a roomy flat at 54, Rue Lepic, on the slopes of Montmartre; from their windows they had a splendid view of Paris and Vincent made countless sketches of it. He had already rejected academic teaching and was trying his hand at the impressionist use of pure colour. His thirst for authenticity accounts for the fact that he gradually moved towards the style of Seurat and Signac, who used scientific and philosophical arguments to defend and explain their manner of seeing and painting. Together with Louis Anquetin, who became a convert to Pointillism, Van Gogh saw a lot of the neo-impressionist group and tried out their technique of painting the picture entirely in small dots or commas of colour, applied in isolated strokes: hence the name Divisionism (which they preferred to the term Pointillism).

At the beginning of 1887, in Père Tanguy's colour shop in the Rue Clauzel, not far from Rue Lepic, Van Gogh met Paul Signac, the youthful theorist of Divisionism: he often went to work with him at Asnières and Saint-Ouen, in the western suburbs of Paris, where they painted landscapes along the Seine. Pissarro, in whom Theo took an interest, also influenced his approach to things: Vincent was delighted by his simplicity and feeling for nature and acknowledged his genuine artistic and moral authority.

That autumn, Van Gogh became acquainted with Gauguin, whose strong personality impressed him, although he was disappointed to find him opposed to Neo-Impressionism.

Another important new acquaintance made in Paris was Emile Bernard who, at the age of nineteen, had already painted some very bold and experimental works. With his analytical gifts, he had a decisive influence on both Van Gogh and Gauguin during the years 1887 and 1888. Van Gogh and Bernard exchanged paintings, indulged in long discussions and went on painting expeditions together along the Seine banks. Although Bernard's dislike of Seurat's theories was not shared by Van Gogh, Bernard's critical acumen made the Dutchman aware of other problems, such as the use of flat tints and colour symbolism.

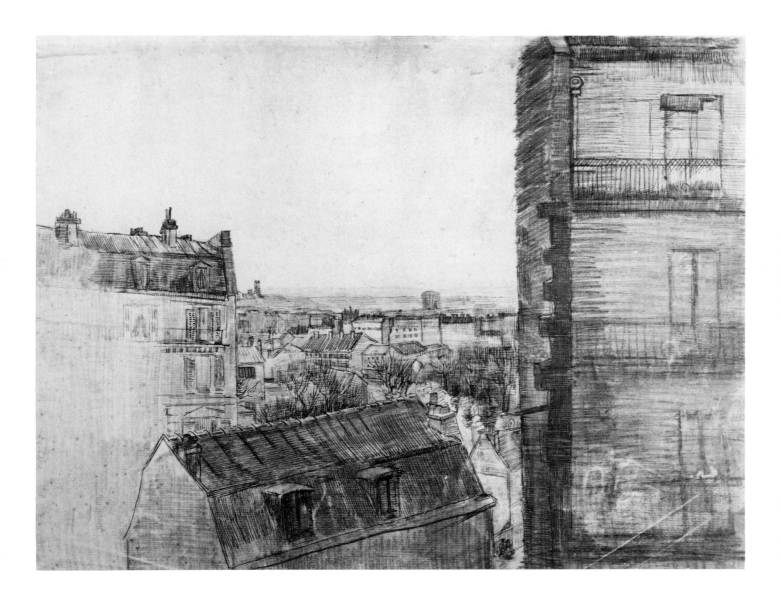

"And mind, my dear fellow, Paris is Paris. There is but one Paris and however hard living may be here, and if it became worse and harder even—the French air clears up the brain and does good—a world of good."

Van Gogh, letter written in English to the English painter H.M. Levens, August-October 1887

"I have seen Van Gogh walk miles under a burning sun to paint a motif that was to his liking; no trouble is too much for him. Rain, wind, dew, snow, he defies them all. At any hour of day or night, he sets to work, to paint a starry sky or a noonday sun."

Emile Bernard, letter to Albert Aurier, 1889

Vincent van Gogh (1853-1890): View of Paris with Notre-Dame in the distance, drawn from his studio window at 54, Rue Lepic, Montmartre, 1887. Pen and charcoal.

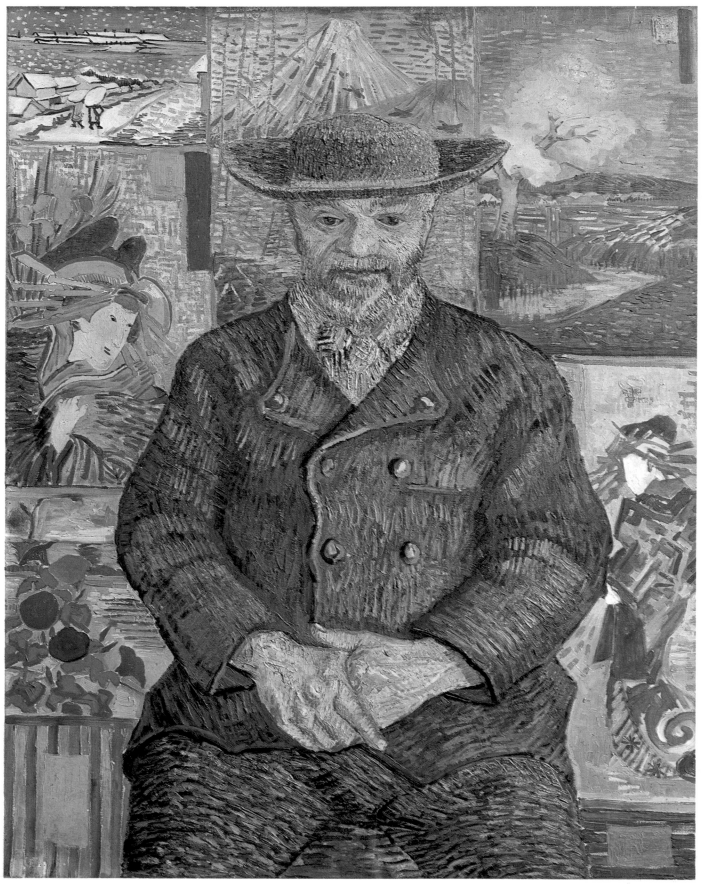

Vincent van Gogh (1853-1890): Le Père Tanguy. Paris, 1887-1888. Oil.

"We like Japanese painting, we have felt its influence, all the Impressionists have that in common: then why not go to Japan, that is to say to the equivalent of Japan, the South? So I think that after all the future of a new art is to be found in the South."

Van Gogh, letter to his brother Theo, Arles, June 1888

Hokusai (1760-1849): Figures in a Landscape.
Woodblock print from the "Hokusai Manga."

Ever since the rise of Whistler, Manet and Degas, artists had been fascinated by Japanese engravings, the vogue for which became more widespread between the first presentation of Japanese art at the Paris World's Fair of 1867 and the great exhibition of masters of the Japanese print at the Ecole des Beaux-Arts in May 1890. In 1862 several Paris dealers began to commercialize Japanese prints and many writers as well as painters took an interest in them—for example, Baudelaire, the Goncourt brothers, Zola, Champfleury, and especially critics such as Zacharie Astruc, Philippe Burty (one of the first great collectors), Ernest Chesneau and Théodore Duret. By 1875 the vogue for Japanese art was influencing fashion and had become a touchstone of good taste. Pierre Loti's novel of Japanese manners, *Madame Chrysanthème* (1887), to which Van Gogh often refers in his letters, marked the apotheosis of the cult.

In 1879 appeared in France the first studies of the masters of Ukiyo-e ("pictures of the floating world," as these genre scenes of popular life were called in Japan). In 1883 Louis Gonse brought out two lavishly illustrated albums on Japanese art, including works by Hokusai, Utamaro and Hiroshige.

In 1887 the first Parisian exhibition devoted entirely to Japanese prints was held at the Tambourin Café in the Avenue de Clichy. It was organized by none other than Vincent van Gogh, the café being owned by Agostina Segatori, whose lover he had been for some time and whom he may have used as the model for his picture known as *An Italian Woman*. Samuel Bing, an art-loving businessman from Hamburg who had visited the Far East about 1880, settled in Paris and opened a gallery specializing in Japanese prints at 22 Rue de Provence: between May 1888 and April 1891 he published in three languages a luxurious, richly illustrated monthly devoted to the arts of Japan, *Le Japon Artistique*. It was Bing who supplied Van Gogh with prints which he resold on commission.

On 28 November 1885 Van Gogh wrote to his brother Theo from Antwerp: "My studio is not bad, especially as I have pinned a lot of Japanese prints on the wall, which I like very much." But before he could turn these to account, he had to go to Paris and be awakened to the problems of colour through the revelation of Impressionism. Emile Bernard and Louis Anquetin, who were hostile to Pointillism, were also fascinated by Japanese prints, which they studied in an analytical spirit. They made friends with Van Gogh and Gauguin, and the critical spirit in which they all regarded Japanese art—in a visual rather than a sentimental or exotic way—enabled them to reinterpret it in terms of their own personality.

Whereas Van Gogh remained descriptive and adhered to the dot technique of Pointillism in the *Interior of a Restaurant*, his *Italian Woman* marked a new approach. It was the Japanese print that showed him how to express himself in bright, unadulterated tones, emphasizing the contours of the vividly coloured forms with an incisive line. To steep himself in the spirit of these prints, he sometimes resorted to making direct copies, one of which was inspired by the cover of the May 1886 number of *Paris Illustré*, a special number devoted to Japan, and two others by Hiroshige, *Plum Trees in Blossom* and *Bridge in the Rain*. An actor portrait by Keisai Eisen from *Paris Illustré*, together with prints by Hiroshige, Toyokumi III and Hokusai, can be seen in the background of Van Gogh's portrait of *Père Tanguy*.

Father Tanguy, a former supporter of the Paris Commune, was a paint merchant in a small way, with a shop in the Rue Clauzel. Generous and enthusiastic, he welcomed and favoured artists whom the public rejected. For a long time he was the only dealer to exhibit Cézanne, Van Gogh and many other unappreciated artists, who were attracted by his impressive collection and his credit facilities. For a while his shop was a real rallying-point.

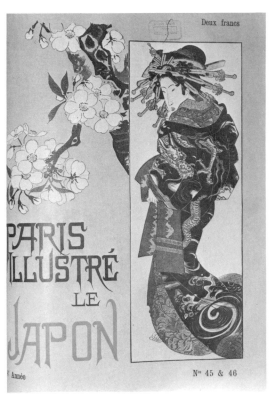

Cover of Paris Illustré, special issue on Japan, May 1886.

Vincent van Gogh (1853-1890) : Thistles, 1888.

"In a word, the Japanese are convinced that nature contains the primordial elements of all things, and according to them there is nothing in all creation, down to the tiniest blade of grass, which is not worthy of a place of its own in the loftiest conceptions of art."

Samuel Bing,
Le Japon Artistique, No. 1, Paris, 1888

"If we study Japanese art, we see a man who is undoubtedly wise, philosophic and intelligent, who spends his time doing what? In studying the distance between the earth and the moon? No. In studying Bismarck's policy? No. He studies a single blade of grass.

"But this blade of grass leads him to draw every plant and then the seasons, the wide aspects of the countryside, then animals, then the human figure. So he passes his life, and life is too short to do the whole.

"Come now, is it not a true religion that is taught us by these Japanese, who are so simple and who live in nature as though they themselves were flowers?

"And you cannot study Japanese art, it seems to me, without becoming much gayer and happier, and we must return to nature in spite of our education and our work in a world of convention."

Van Gogh, letter to his brother Theo, Arles, September 1888

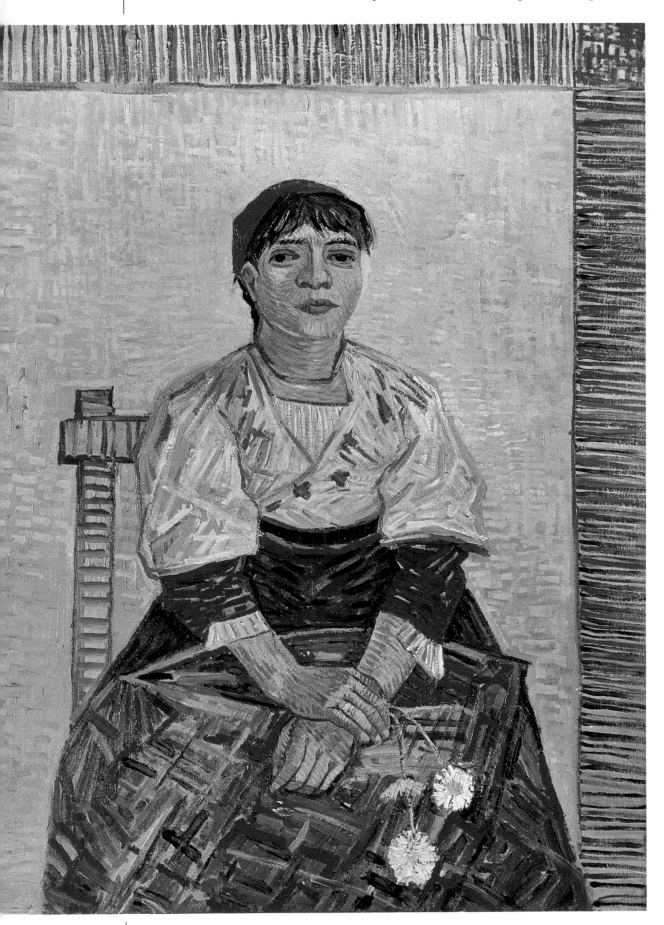

To the Impressionists, the Japanese print seemed to confirm something they had felt intuitively: for Van Gogh's generation it opened up a renewal in the means of expression both in form and colour. Contact with it purified the language of art and extended the range of its vocabulary.

What had chiefly struck Westerners in the Japanese print was its evocative power, which was stronger than its power of representation. The "modernity" of the subjects enchanted them. Van Gogh and his friends studied every aspect of these prints in ever greater depth, from luminosity to colour, from drawing to calligraphy, from framing to composition. From concise delineation of life they progressed to suggestion, for—in the words of Okakura, a Japanese aesthete—"in suggestion lies the secret of the infinite." Like Cézanne in Provence, Van Gogh and Gauguin had a new conception of painting: it must be expressive, recreate the world in a specific language. Side by side with a re-examination of visual possibilities, there was a spiritual search leading from exotic Orientalism to a new kind of awareness. Space, measured visually, gave way progressively to a cosmic, quasi-religious view in which man was no longer the centre of things but a particle lost in the life of the universe.

When Van Gogh left for the South of France and arrived in Arles on 20 February 1888, he achieved a twofold aim: he reached the Orient of his imagination and at the same time he rediscovered colour. "The countryside seems as lovely as Japan with its limpid atmosphere and gay colour effects," he wrote to Emile Bernard. And Albert Aurier, the author of the first article about Van Gogh, published in the *Mercure de France* in January 1890, wrote: "For a long time he toyed with the idea of inventing a very simple, popular, almost childish form of painting that would be capable of appealing to the most humble and unsophisticated people and could be understood by the very simplest among the poor in spirit." Until then the only example of a popular art of this kind was the Japanese print.

On 19 May 1888 the *Revue Indépendante* published an important article by Edouard Dujardin. Writing about Louis Anquetin, the friend of Van Gogh and Emile Bernard, he hailed him as the creator of a new style called "cloisonnism": "At first sight his pictures convey the idea of decorative painting, with heavy outlines and bright colours inevitably recalling folk imagery and Japanese art."

Actually Anquetin had already come under the influence of Emile Bernard, and so would Gauguin before very long. Since February 1888 Gauguin had been at Pont-Aven, where Emile Bernard joined him and they began working together. Bernard's presence was a great encouragement to Gauguin, whose age caused him to be regarded as a figure of some authority. The resolute boldness of his young companion helped him to throw off the shackles of convention and naturalism. On 14 August 1888 he wrote an important letter to Schuffenecker: "One piece of advice—don't stick too closely to nature. Art is an abstraction, draw it away from nature by brooding over it and give more thought to the resultant creation; this is the only way to approach God by doing as our Divine Master did, creating..." These views were illustrated in the *Vision after the Sermon*. It was with an enthusiastic, poetic description of this painting that Albert Aurier began an article in the March 1891 issue of the *Mercure de France*, in which he extolled Gauguin as the leader of the art of symbolism and ideas.

Japanese influence began to make itself felt in Gauguin's work in 1888. It had been barely perceptible in his ceramics. Now it burst forth in his *Vision After the Sermon*, in the tree-trunk cutting across the picture (a compositional device used by Hiroshige in his *Plum Tree in Blossom*, which Van Gogh copied, and the latter used the same device in his pictures of *The Sower*), in the flat, pure, unshaded colours, and even in the figures of the two wrestlers, whose shape and design stem from a sketch by Hokusai. Over and above the style-creating use of flat colours and rhythmic forms, one is confronted here with an abstract picture space which is entirely new. Instead of developing his picture in terms of spatial recession, Gauguin adopts a plunging line of sight and superimposes the picture planes in the manner of the Primitives and the Japanese. It is not too much to say that this is the first painting deriving from Impressionism in which two opposing spaces are combined, that of external reality and that of the inner world.

◁ *Vincent van Gogh (1853-1890): An Italian Woman (Agostina Segatori?). Paris, 1887. Oil.*

△ *Paul Gauguin (1848-1903): The Vision after the Sermon (Jacob Wrestling with the Angel), 1888. Oil*

▷ *Emile Bernard (1868-1941): The Artist's Sister Madeleine in the Bois d'Amour at Pont-Aven, 1888. Oil.*

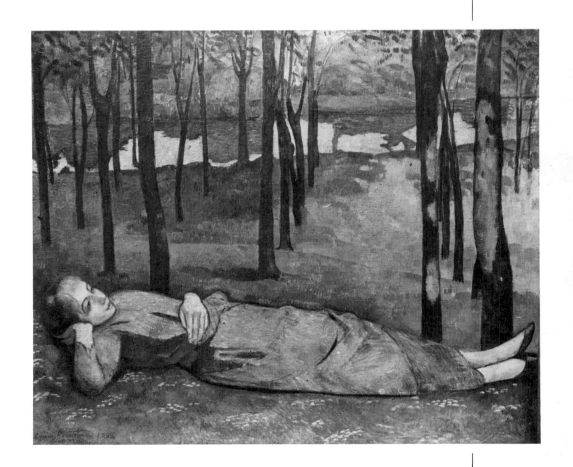

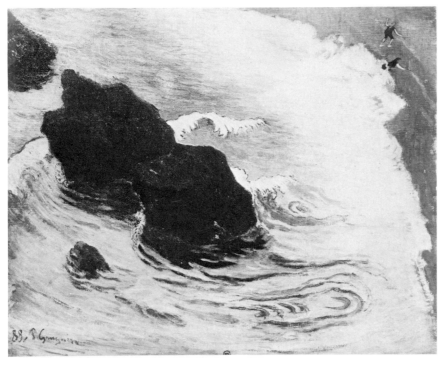

Paul Gauguin (1848-1903): The Wave, 1888. Oil.

Hokusai (1760-1849): The Waves. Woodblock print from the "Hokusai Manga."

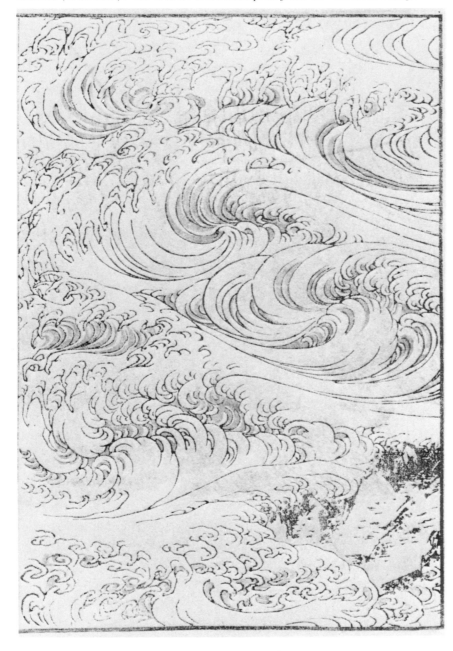

Van Gogh, Bernard and Gauguin were particularly taken with the decorative aspects of the Japanese print, which pointed the way to greater freedom in the use of line and colour. Instead of restricting line to the definition of shape, they freed it by endowing it with a new rhythm and breadth so that it came to express the very movement of life in a kind of calligraphic notation.

Van Gogh found a new outlet and means of expression in spontaneous freestyle drawing. He even adopted the tool used by the Japanese, the sharpened reed pen. Towards the end of June 1888, he wrote: "The Japanese do away with reflections, placing flat tints side by side, limiting the movement and form with characteristic strokes... Black and white are also colours, for in many cases they can be regarded as such, the contrast between them being as striking as that between, say, red and green... The Japanese draw quickly, very quickly, like a lightning flash, because their nerves are finer, their feeling simpler."

Gauguin, too, tried to fathom the secret of that elegant calligraphic technique, often based on the spiral, which was to triumph in Art Nouveau; and he experimented with the effects that could be achieved by the rhythmic treatment of two-dimensional space.

"The *Manga* or *Mangwa*, those thousands of feverish sketches recording what is on the earth, in the heavens and under the water, those magic glimpses of action, movement and the restless life of mankind and the animal world, that delirium, one might almost say, poured out on paper by this great Japanese artist *mad about drawing.*"

Edmond de Goncourt, *Hokusai. L'Art Japonais au XVIIIᵉ siècle*, Paris, 1896

Vincent van Gogh (1853-1890): The Rock. Arles, July 1888. Reed pen.

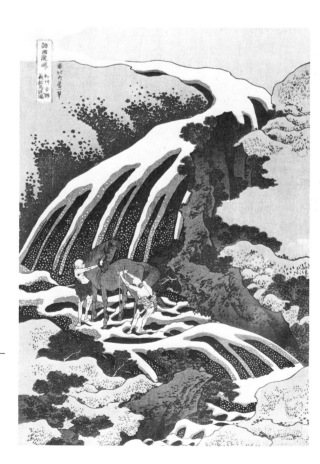

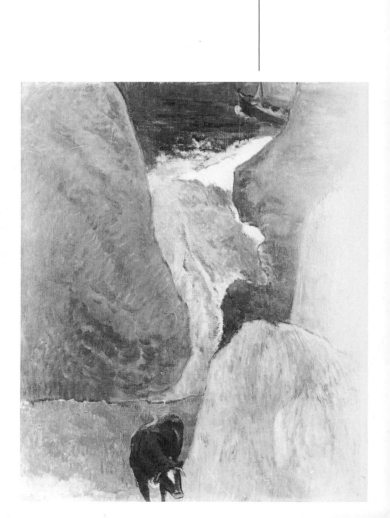

▷ *Hokusai (1760-1849): The Yoshino Waterfall.*
Woodblock print from the "Waterfalls."

▷ ▷ *Paul Gauguin (1848-1903): Above the Abyss, 1888. Oil.*

Van Gogh in the South of France

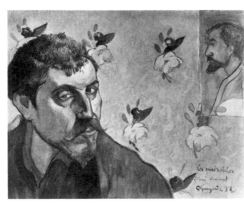

Paul Gauguin (1848-1903):
Self-Portrait dedicated to Van Gogh,
with a profile of Bernard on the wall, 1888. Oil.

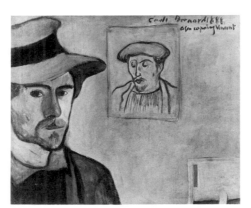

Emile Bernard (1868-1941):
Self-Portrait dedicated to Van Gogh,
with a portrait of Gauguin on the wall, 1888. Oil.

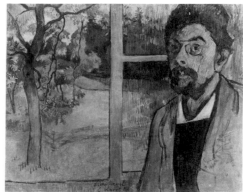

Charles Laval (1862-1894):
Self-Portrait dedicated to
Van Gogh, 1888. Oil.

Vincent van Gogh (1853-1890): Boats at Saintes-Maries-de-la-Mer, June 1888.

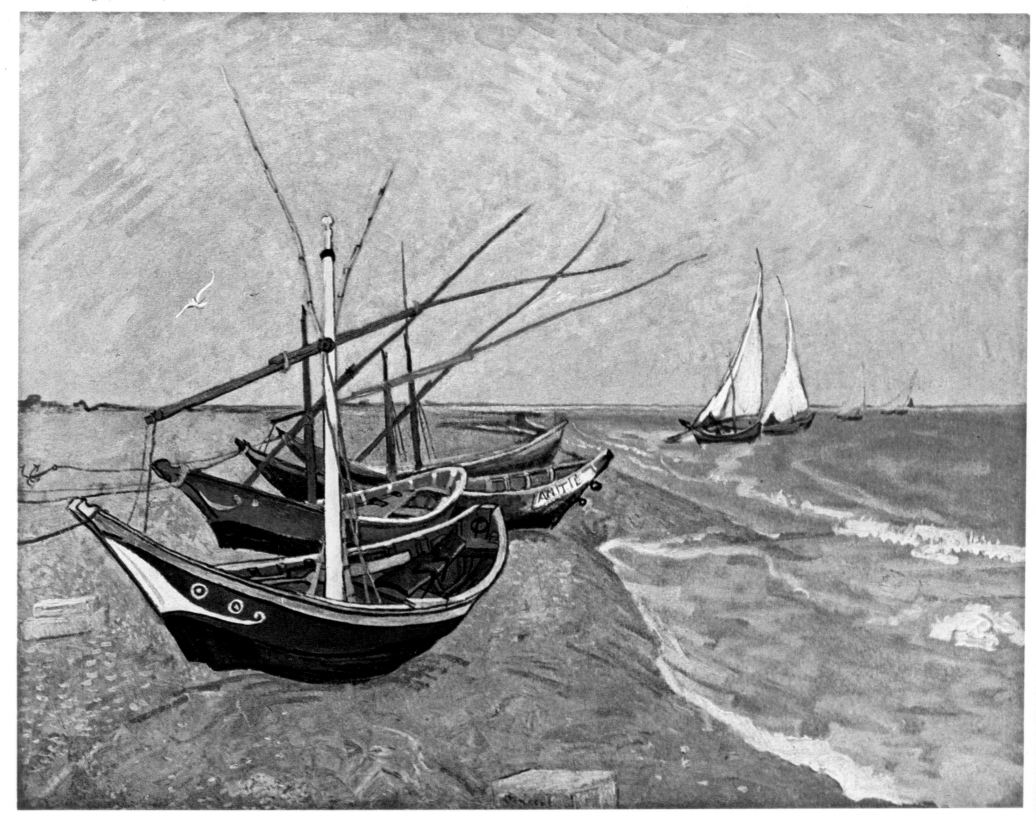

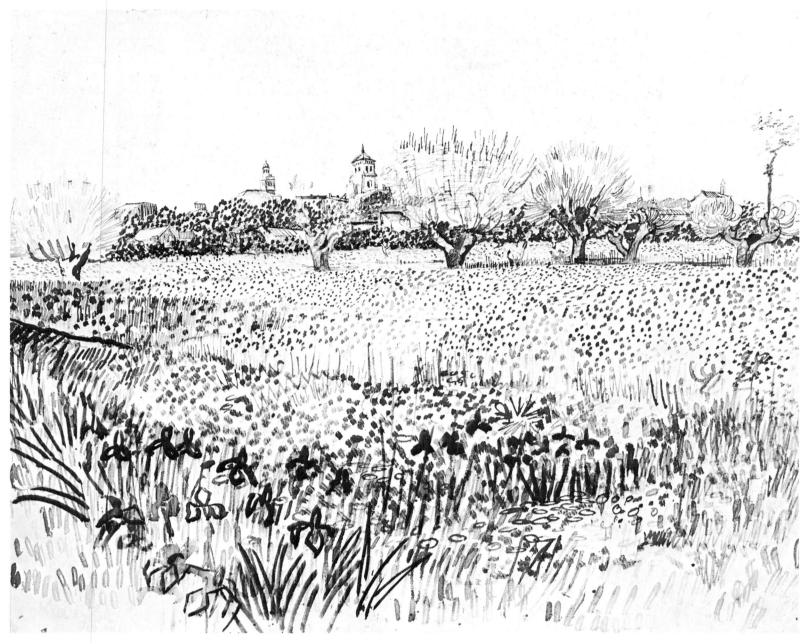

Vincent van Gogh (1853-1890): View of Arles. Arles, 1888. Reed pen.

In May 1888 Van Gogh settled in the small yellow house in Arles that his paintings were to make famous. He hoped to convert the four white-walled rooms with their red-tiled floors into studios that his friends would be able to use too. Under the burning Provençal sun which was to bring him self-fulfilment, he eagerly set to work, hoping to persuade Gauguin, Bernard and Laval to share his enthusiasm, his faith and his ardour.

At the end of June he made a brief trip to Saintes-Maries-de-la-Mer, on the Mediterranean coast, where his style divested itself of every trace of pointillist influence and asserted its own individuality. That summer, in Arles, he developed his favourite genres—landscape and the portrait. He increasingly used broad areas of colour, outlined by strong contrasting strokes and enlivened by vibrant brushwork, and paint laid on thickly in spirited interwoven strokes. "I am beginning more and more to try for a simple technique that need not be Impressionist. I want to paint in such a way that anyone who has eyes can see what I mean." His understanding with his Pont-Aven friends had never been closer, as is witnessed by their frequent letters and exchanges of self-portraits, such as that of Van Gogh himself with a shaven head set against a background of circular strokes. He urged his friends to join him: the example of Pont-Aven convinced him that contacts encouraged progress and he was anxious to end his solitude.

"I have a *wealth* of ideas for work so that, despite my isolation, I have no time to think or feel. I am like a painting machine. I feel this is likely to go on. In my opinion, a living studio can never be found ready-made, but by working and remaining patiently in the same place, we can create it day by day."

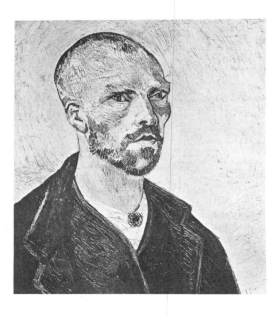

Vincent van Gogh
(1853-1890):
Self-Portrait dedicated
to Gauguin.
Arles,
September 1888. Oil.

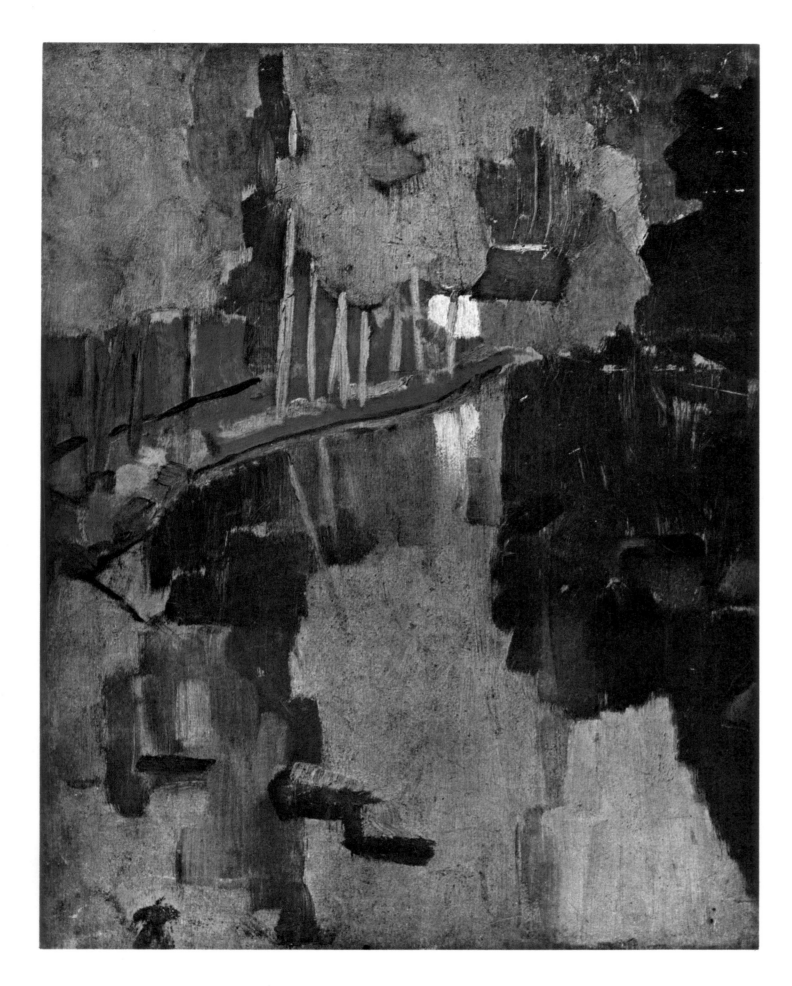

Paul Sérusier (1864-1927):
The Talisman (Landscape
of the Bois d'Amour
at Pont-Aven), 1888. Oil.

To this famous landscape, which he painted under Gauguin's direction at Pont-Aven, Sérusier gave the symbolic name of *The Talisman*. He showed it to his fellow-students at the Académie Julian in Paris, and in its use of flat areas of bright, unshaded colour it was regarded as a manifesto-picture by the younger generation of painters.

"It was in the autumn of 1888 that we first heard about Gauguin from Sérusier, who had just come back from Pont-Aven. After making a great mystery about it, Sérusier showed us the lid of a cigar box on which could be distinguished a landscape [*The Talisman*] which seemed formless because synthetically built up in violet, vermilion, Veronese green and other pure colours, applied just as they come from the tube, unmixed with white. 'How do you see this tree?' Gauguin had asked him as they stood before a patch of the Bois d'Amour. 'It's green, you say? Then put on some green, the finest green on your palette. And that shadow: rather blue? Don't be afraid to paint it as blue as possible.'

"Thus for the first time was presented to us, in paradoxical form, but unforgettably, the fruitful concept of 'the flat surface covered with colours assembled in a certain order.' Thus we were made to realize that every work of art is a transposition, a caricature, the impassioned equivalent of a received sensation."

Maurice Denis, *L'Occident*, Paris, October 1903

Gauguin in Brittany

Installed in the Pension Gloanec at Pont-Aven, Gauguin had long discussions with Emile Bernard, whose spirit of synthesis and clear-headedness helped him to work out his own views. He painted a portrait of his friend's sister, Madeleine, "while I was painting her in the wood known as the Bois d'Amour, lying on the ground in the attitude of a tomb figure. Needless to say, both Gauguin and I turned my sister into a caricature, in view of the ideas we held on *character* at that time" (Emile Bernard, *Souvenirs*). Gauguin was won over to "cloisonnism," with its emphatic outlines and areas of flat colour, but he did not realize how much he owed to his young friend, whereas Bernard made no secret of his admiration for his senior. "He considers Gauguin such a great artist that he is almost afraid of him," Van Gogh said.

The close friendship between Bernard and Gauguin led each of them to include the other in the self-portraits they were sending to Van Gogh. This was an important exchange—even Laval agreed to take part in it—which enabled them to judge at a distance how far the style of each of the others had developed.

Gauguin wrote about his self-portrait dedicated to Van Gogh: "I think it is one of the best things I have done: so abstract that (for one thing) it is absolutely incomprehensible. A brigand's head, at first sight... The eyes, the mouth and the nose are like flowers on a Persian carpet personifying also the symbolic side" (letter to Schuffenecker, 8 October 1888).

When Van Gogh received the portraits, he exclaimed about Gauguin's: "To me it looks decidedly like the portrait of a prisoner. Not a trace of happiness... At last I have a chance to compare my painting with that of my friends" (letter to Theo from Arles).

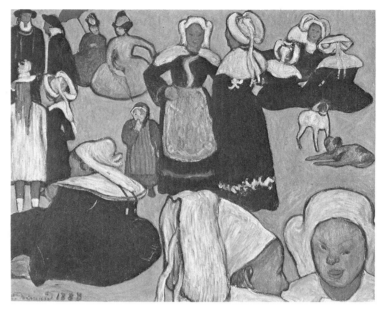

Emile Bernard (1868-1941): Breton Women in the Meadow, 1888. Oil.

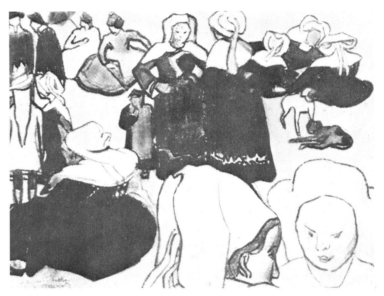

Vincent van Gogh (1853-1890): Breton Women in the Meadow, 1888. Watercolour after the canvas by Emile Bernard.

Photograph of the Bois d'Amour at Pont-Aven (Brittany) in the early 1900s.

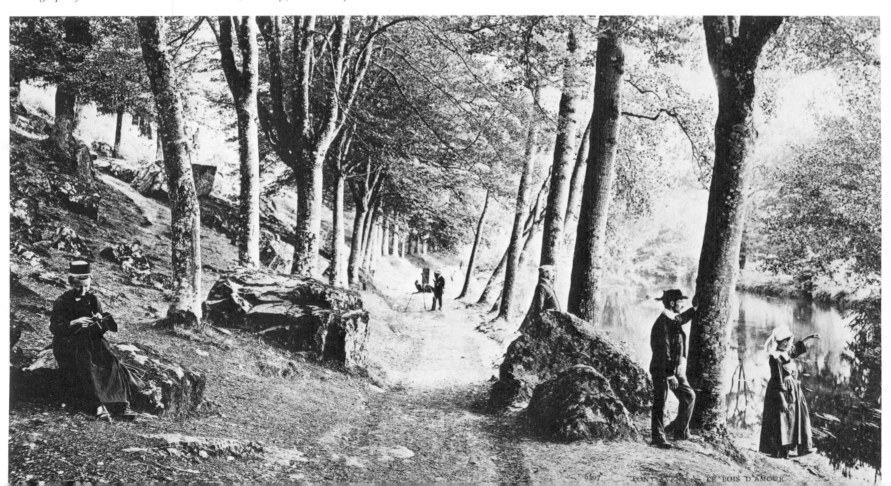

Van Gogh and the "Studio of the South"

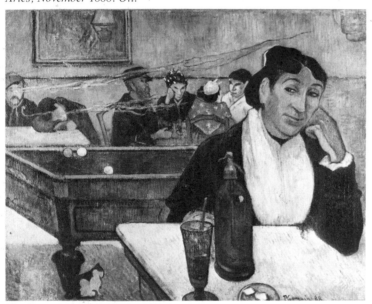

Vincent van Gogh (1853-1890): The Woman of Arles (Madame Ginoux). Arles, November 1888. Oil.

Paul Gauguin (1848-1903): Café at Arles, 1888. Oil.

Vincent van Gogh (1853-1890): Outdoor Café at Night. Arles, September 1888. Oil. ▷

"I have also painted a café, a place Vincent likes very much and I like less. The fact is, this kind of painting is not in my line and local colour, vulgar colour, doesn't suit me. I like it well enough in other painters but always feel misgivings about it myself. It's a matter of schooling and there's no changing oneself."

Gauguin, letter to Emile Bernard, Arles, November 1888

"I believe that a new school of colourists will take root in the South, as I see more and more that artists in the North rely on their ability with the brush and 'picturesque' effect rather than on any desire to express something by colour itself."

Van Gogh, letter to his brother Theo, Arles, October 1888

On 20 October 1888 Van Gogh wrote to his brother to announce the arrival in Arles of Gauguin, who brought with him only a single painting, *Breton Women in the Meadow* by Emile Bernard, of which Vincent made a copy. The two friends exerted a mutual influence: Van Gogh developed a stricter sense of design and composition, succeeded in conveying depth through flat tones, and stressed the affinities and contrasts of forms, while Gauguin's palette took on a warmer humanity and feeling. But both also asserted their individual personalities to show what they could do: Gauguin had never displayed such well-judged control nor had Van Gogh ever used colour to such powerful effect. It was at this point that Van Gogh realized that the relationships between colours were expressive in themselves; and, in the resonant use of colour, Gauguin found a way of going beyond naturalism as he had already done in the case of form.

They confronted each other first in pictures of a café interior and then vied with one another in their portrayals of *Madame Ginoux* and of *Les Alyscamps*. Van Gogh's portrait of Madame Ginoux, the woman of Arles, was dashed off in an hour, whereas Gauguin only had time to do a preliminary drawing of her.

Unlike Van Gogh, Gauguin never worked direct from nature—a difference which became a source of conflict. "Perhaps others have a keener perception than I have for abstract studies, and you may be among them as well as Gauguin... perhaps I shall be, too, when I am older. Meanwhile I feed on nature," Van Gogh wrote to Emile Bernard (October 1888). However, as soon as Gauguin was with him, his tone changed somewhat: "I don't find it unpleasant to try and work from the imagination, as this means I don't have to go out..." (November 1888). But between Van Gogh's *Café* with its whirling rhythm and Gauguin's with its lateral development, there is a fundamental difference of conception. For Gauguin, Provence renewed the influence of Cézanne, whose work he was well acquainted with and whose evolution he followed closely; in his picture of *Les Alyscamps*, the old Roman cemetery in Arles, he even copied Cézanne's parallel brushstrokes.

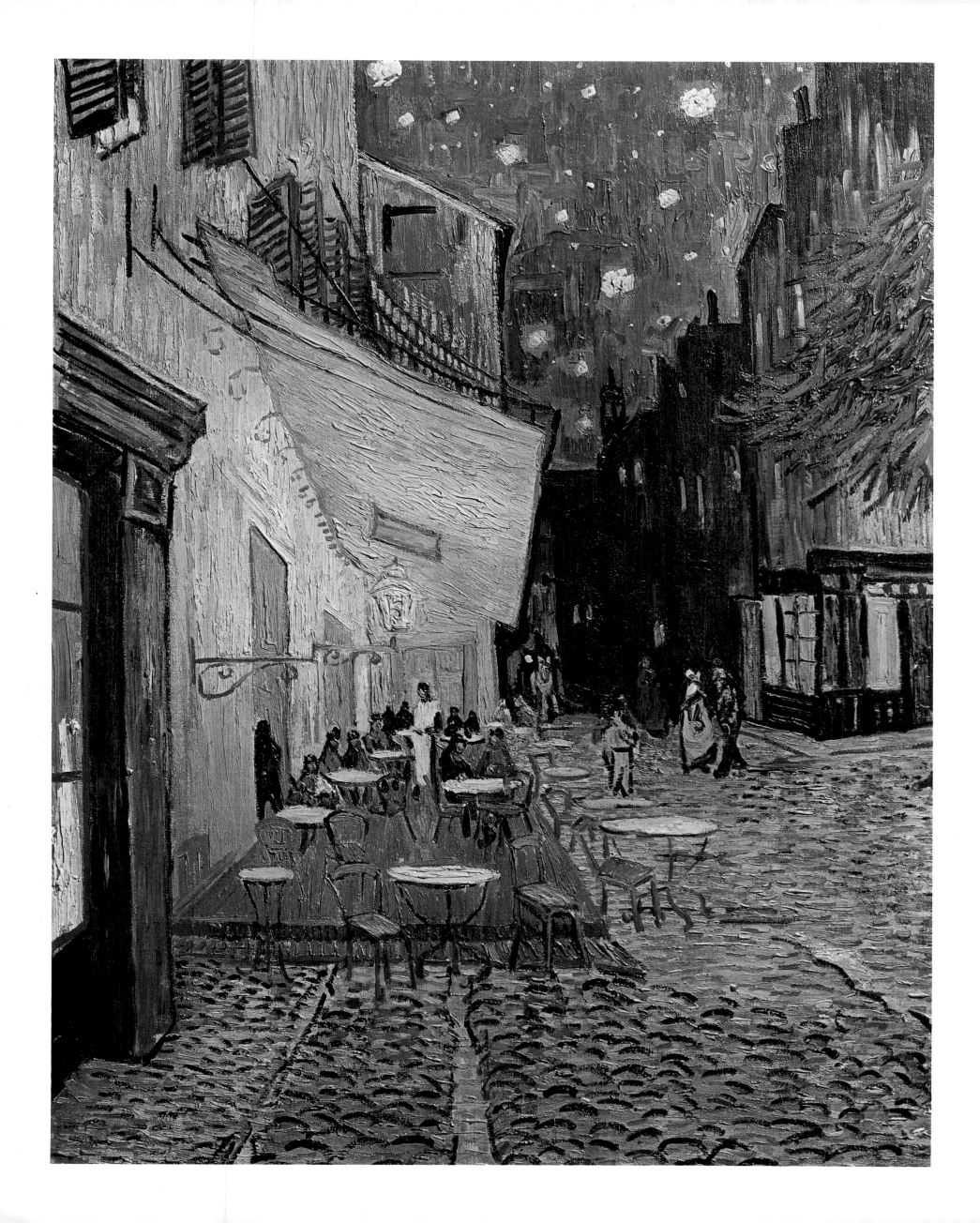

The climax

Van Gogh longed to make his little house in Arles a living centre of creativity, the "Studio of the South"; in this way he hoped to free himself from the loneliness that threatened to stifle him. The discovery of the light and landscape of Arles had liberated him temporarily but, in the autumn of 1888, all his anxieties were renewed. Gauguin, on the other hand, was led to accept Van Gogh's invitation for financial reasons: the house in the South had been offered him in exchange for paintings, and in this way he hoped to save enough money to set out again for Martinique or some other exotic place overseas.

Van Gogh tried at first to win Gauguin over, but he was subdued by Gauguin's commanding personality. "Gauguin interests me very much as a man—very much. For a long time now it has seemed to me that in our nasty profession of painting we are most sorely in need of men with the hands and the stomachs of workmen. More natural tastes—more loving and more charitable temperaments—than the decadent dandies of the Parisian boulevards have. Well, here we are without the slightest doubt in the presence of a virgin creature with savage instincts," he wrote to Bernard (late October 1888).

The flamboyant colours of autumn in Provence were a challenge to the ambitions of both painters, who did a number of landscapes at this time. Gauguin was particularly struck by Van Gogh's painting of *Sunflowers*, and he actually did a portrait of him working on a new version of this canvas. (Van Gogh, on the other hand, never painted Gauguin, who refused to sit for him; he could only depict him through the intermediary of his empty chair.) According to Gauguin—anxious as always to present himself in a favourable light—this portrait of Van Gogh painting sunflowers was the cause of their rupture. "When the portrait was finished," he said later, "Vincent said to me: that's me all right, but gone crazy. That very evening we went to the café. He took a light absinthe. Suddenly he threw his glass and its contents in my face." And Gauguin added that he forgave him, but with this warning: "There might be a repetition of yesterday's scene, and this time if

Paul Gauguin (1848-1903): Van Gogh Painting Sunflowers. Arles, 1888. Oil.

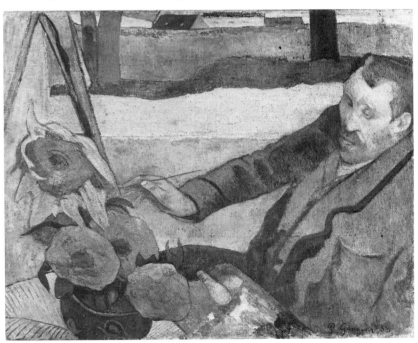

Vincent van Gogh (1853-1890): Gauguin's Chair. Arles, December 1888. Oil.

you hit me I mightn't be able to control myself and might strangle you. Permit me, therefore, to write to your brother and let him know that I am returning to Paris" (*Avant et Après*, 1903).

"Gauguin and I talked... until our nerves were so strained that there wasn't a spark of vital warmth left in us," Van Gogh was to write in 1889, recalling the extreme tension that reigned between himself and his friend, but as early as December 1888 he already saw clearly that "our arguments are terribly electric, sometimes we come out of them with our heads as exhausted as a run-down battery."

Gauguin, for his part, was becoming increasingly uncomfortable. A trip together to Montpellier in December 1888 to visit the famous Bruyas collection failed to relieve the tension. He kept threatening to leave, and Van Gogh's anguish was heightened by the feeling that he was abandoned by everyone, for his brother had just announced his engagement. The dramatic climax that resulted in the final breach between Van Gogh and Gauguin on 24 December 1888 is well known. Van Gogh seized a razor with the intention of attacking his friend—this is Gauguin's account of the affair— but finally turned the weapon on himself and cut off his own ear. It is clear that Van Gogh, desperately afraid of a solitary, empty future, could not bear to see all his hopes dashed with Gauguin's departure. When, in a sudden flash, he realized the evil of what he was about to do, he punished himself for his abortive, though intended, deed. Gauguin confessed his own misgivings (in *Avant et Après*): "Did I behave like a coward at that moment: oughtn't I to have disarmed him and tried to calm him down? I have often searched my conscience, and I have found nothing to reproach myself with."

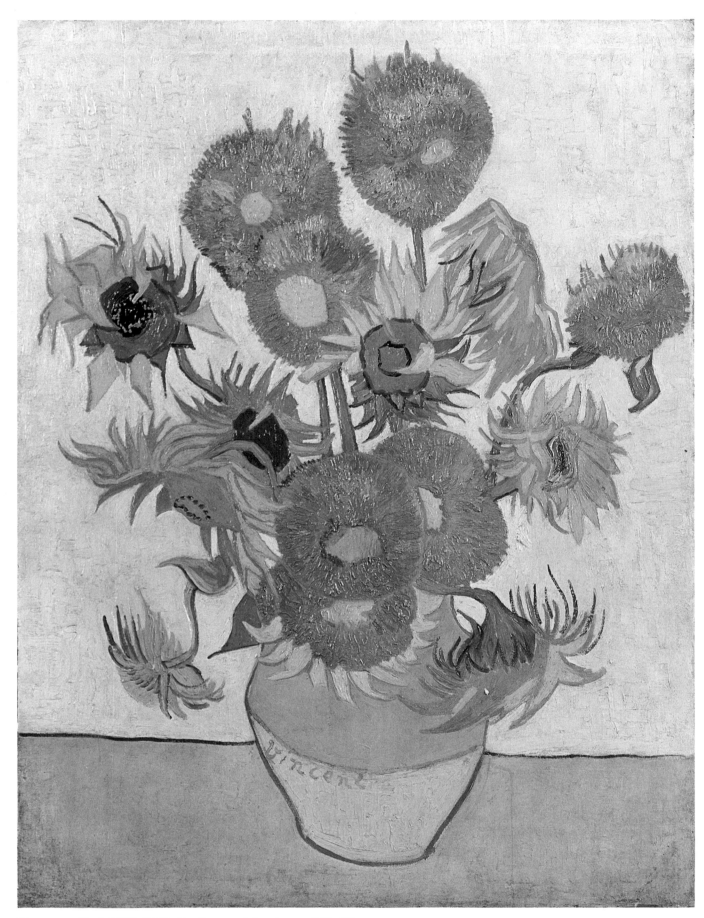

Vincent van Gogh (1853-1890): Sunflowers. Arles, August 1888. Oil.

"I am now on the fourth picture of sunflowers. This fourth one is a bunch of fourteen flowers against a yellow background, like a still life of quinces and lemons that I did some time ago.

"Only as it is much bigger, it gives a rather singular effect, and I think that this one is painted with more simplicity than the quinces and lemons.

"Do you remember that one day we saw a quite extraordinary Manet at the Hotel Drouot, some huge pink peonies with their green leaves against a light background?

As free in the open air and as much a flower as anything could be, and yet painted in a perfectly solid impasto, and not the way Jeannin does it.

"That's what I'd call simplicity of technique. And I must tell you that nowadays I am trying to find a brushwork without dottings or anything else, nothing but the varied stroke. But someday you'll see."

Van Gogh, letter to his brother Theo, Arles, summer 1888

An emotional outburst: the Belgian painter Ensor

Working in isolation at Ostend, James Ensor—a painter of ironical, irrepressible and fiercely independent temperament—raised the use of colour to a rare pitch of exaltation. When Van Gogh was just discovering the symbolic and expressive power of colour, Ensor was already anticipating the garish palette and vehement brushwork of the German Expressionists.

A founder member of the Salon des XX at Brussels, Ensor was not influenced by Impressionism, except perhaps in a minor way by Monet's pictures, to which the Belgian press and public gave a cool reception. Then in 1887, when Seurat showed his *Grande Jatte* in Belgium at the annual exhibition of The Twenty, most of Ensor's fellow-painters were won over to Divisionism. Ensor himself, however, remained unconverted and counterattacked precisely in the field of colour. As he confessed later: "The experiments of the Pointillists left me cold: they were only concerned with the vibration of light and applied their dots and dabs of colour coldly and methodically within cold, correct contours. Such a uniform, excessively restricted procedure makes any further experiment impossible and this gives their work a totally impersonal quality, so that they actually succeed in expressing only one aspect of light, its vibration, without indicating its form. I differ radically from them in my experiments and outlook and, as a painter, I seem to be an odd man out."

"Ah, they must be seen, the masks people wear under our great opalescent skies, and when they walk and move, daubed with cruel colours, wretched and pitiful under the rain, bowing and fawning, terrified figures at once insolent and timid, growling or yapping, with shrill falsetto voices or loud metallic voices, with the heads of macabre beasts and the unexpected, unsubdued gestures of irritated animals. Repulsive humanity ever on the move in cast-off clothes shimmering with spangles torn from the mask of the moon. Then I saw things in a big way and my heartbeat quickened and my bones trembled, and I divined the enormity of these distortions and anticipated the modern spirit. A new world loomed up before me."

James Ensor

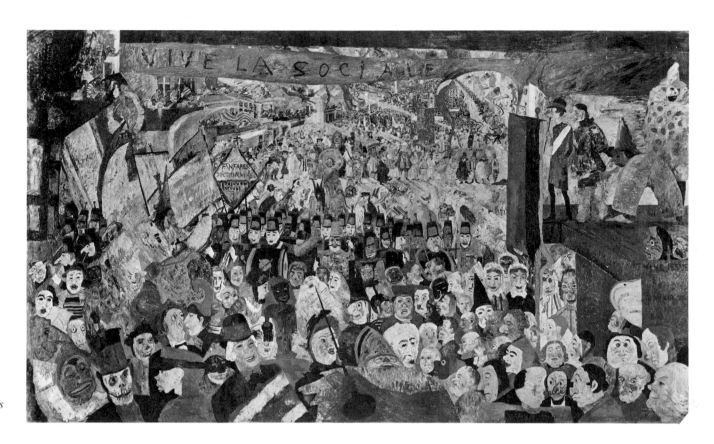

◁ ▷ *James Ensor (1860-1949):*
The Entry of Christ into Brussels
(entire and detail), 1888. Oil.

In 1888, with his *Entry of Christ into Brussels*, he went further than any of his contemporaries at one bound. It is said that, being worried about the cost of covering such a large surface (8 ½ × 14 ft) with the thick pure colours he desired, he asked a house-painter to prepare his colours for him. These have kept perfectly, and echoes of them are often to be found in modern art.

Ensor's personality is an elusive one. Born on 13 April 1860 at Ostend, on the North Sea, of an English father and a Flemish mother, he was deeply marked by his childhood, which was suffused in sea light and steeped in the atmosphere of an unusual home—his mother kept a bric-à-brac shop in which carnival goods rubbed shoulders with exotic oddities brought back by sailors. In a letter, Ensor confided the following evocative memories to a friend: "One night when I was lying in my cot with all the lights on in my room and all the windows, which looked out on the sea, wide open, a huge seabird flew in, attracted by the light, and flopped down in front of me, shaking my cradle. An unforgettable experience, fraught with terror. I can still see that fearful apparition and still feel the impact of that dark, fantastic bird, avid of light. A deep impression was also made on me by the mysterious and marvellous tales of fairies, ogres and wicked giants that an old servant—a wrinkled Flemish woman, a piebald, pepper and salt, grey and silver sort of person—used to tell me, rambling on at great length. And also, even more unforgettable, a dreadful dark attic, full of horrible spiders, of curios, shells, plants and animals from distant seas, pieces of fine china, old clothes of rusty or blood-like hue, red and white corals, monkeys, tortoises, dried-up mermaids, and stuffed Chinamen."

When, as an adolescent, Ensor decided to become a painter, he went to the art school in Brussels to learn his trade but did not stay there long. Back at Ostend, he set to work and gave free rein to his imagination. At the outset, he veered between a realism similar to Courbet's and experiments with light effects in the manner of Turner. Encountering only incomprehension, he grew hard and

cynical. Masks first appeared in his work in 1883 and quickly became his favourite subject, linking him with the great Flemish tradition of Bosch and Bruegel. Ensor's masks, half-way between life and death, between farce and tragedy, are a much more revealing mirror of the unconscious and of hidden desires than the forced real-life masks we make for ourselves each day. For Ensor, the moment of carnival madness lasts from birth to death. Transforming himself into a seer, he opened up a surrealistic, visionary world, in which he juggled with words, colours and images.

Emile Verhaeren, the poet, who was proud to be his friend, wrote a book on him in which he said: "Entry into the realm of masks of which Ensor is king, was a slow, unconscious process, yet a rigorously logical one. It was the discovery of a country, province by province, with picturesque spots succeeding appalling ones and miserable stretches extending or separating areas of madness ... Ensor's art grew ferocious. His terrible puppets expressed terror rather than joy."

Photograph of
James Ensor in 1887.

James Ensor (1860-1949):
Skeletonized Self-Portrait. Drawing.

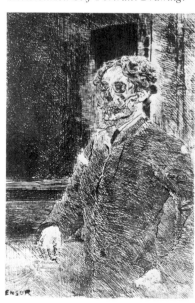

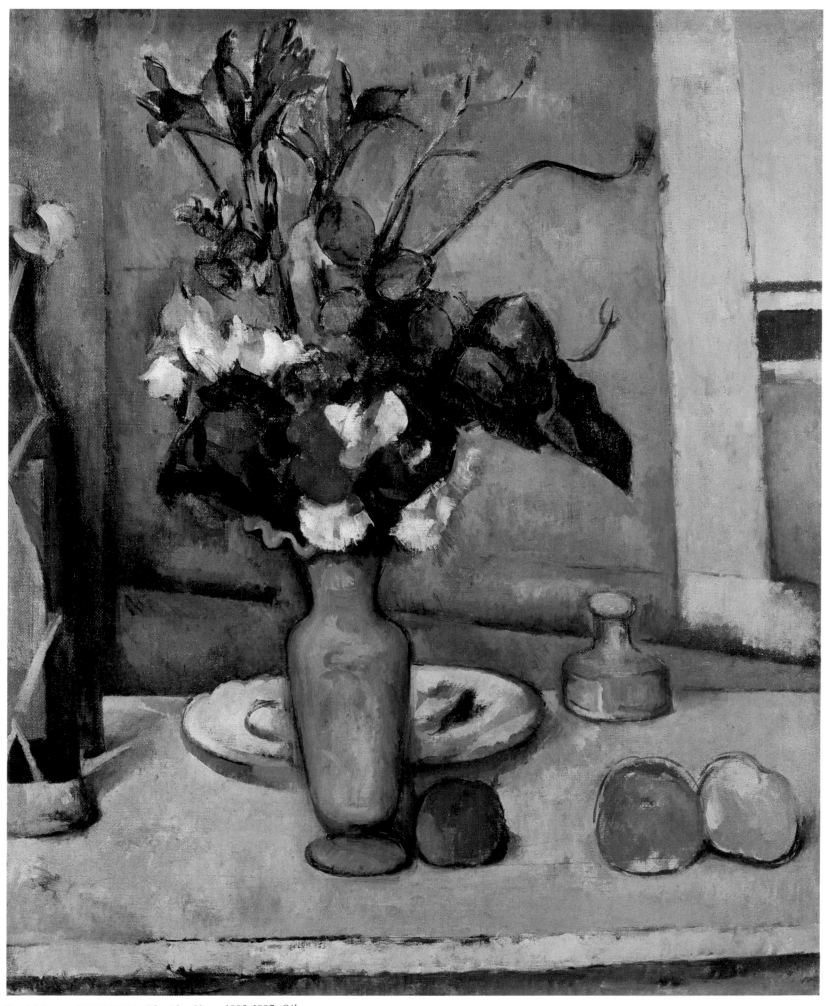

Paul Cézanne (1839-1906): The Blue Vase, 1885-1887. Oil.

THE OBJECTIVE REALITIES OF PAINTING

Once freed from naturalism, modern art veered between two extremes: on the one hand there was an art based on immediate emotional reaction, the revolt of the individual against an order that is alien to him, and the exploration of the unconscious; and, on the other, the expression of a rational experience, of something felt and lived through, conveyed by dint of truthfulness and self-control. Van Gogh, Gauguin and Ensor went beyond reality for the sake of an inner truth whose pursuit meant breaking with tradition; Cézanne and Seurat, in harmony with the present, sought a new way of "being."

In a very fine Cézanne essay in his book *Sens et Nonsens* (1948), the French philosopher Merleau-Ponty wrote: "Cézanne did not feel he had to choose between sensation and thought as between chaos and order. He did not want to separate the fixed objects that appear before our eyes from their fugitive way of appearing; his aim was to paint form as it emerged, order born of spontaneous organization. He did not draw a line between feeling and intelligence, but between the spontaneous order of things perceived and the human order of ideas and science. We see things, agree on them, are rooted in them, and it is on this basis of nature that we build our systems of knowledge. It is this primordial world which Cézanne sought to paint, and that is why his pictures give the impression of nature at its very origin, whereas photographs of the same landscapes suggest the works of men, their amenities, their imminent presence. Cézanne never set out to 'paint like a brute,' but to bring intelligence, ideas, science, perspective, and tradition into contact with the natural world that they are meant to understand—to confront, as he said, science with nature, from which science has emerged." Seurat's attitude was hardly different, even if his motives and approach were more scientific.

Cézanne went into voluntary isolation in his native Provence, refusing to exhibit, considering his works to be below the standard he had set himself. He made only one exception to this veto when he allowed three paintings to be shown at the exhibition of the Twenty in Brussels in 1890, where they appeared side by side with works by Van Gogh and Signac. The sincerity, grandeur and compelling effectiveness of Cézanne's style began to be appreciated by a few progressive spirits when they saw such paintings of his as Father Tanguy managed to display in his shop. Cézanne did not break his self-imposed silence until 1895, when he consented to hold his first one-man exhibition at Ambroise Vollard's Paris gallery.

With great modesty, he explained his attitude to Octave Maus, president of the Twenty, in a letter dated 27 November 1889: "On this subject I may say that the many studies I have undertaken have given only negative results and as I was afraid of criticism that would be all too justified, I decided to work on in silence until the day when I felt capable of defending the results of my experiments theoretically."

It was precisely such a synthesis between work based on perception and the demands of theory that he achieved on entering his "classical" period with the Harlequins and the *Card Players*.

His painting was the fruit of a dual experience wherein the data of the senses were structured by the rational demands of an expressly classical, i.e., balanced, style of painting. He shed increasing doubt on the truthfulness of visual appearances, making a break with that illusionism which the emerging art of photography was beginning to spread so triumphantly. A careful, fascinated observer, scrutinizing nature until his eyes ached and ran, he was disturbed by its uncapturable elements. At every glance nature appears differently, because the spectator had moved. The spatial illusionism of the Renaissance was based on a twofold physical restriction: the immobility of the subject and monocular vision. Cézanne broke with that attitude, feeling too small and weak in face of the vastness and beauty of the world to arrogate the right to impose his will on it. He felt that appearances were deceptive, that reality was uncapturable because it was many-faceted, infinite and alive. Still preoccupied with three-dimensional expression, he now refused to select one visual aspect to the detriment of another that was just as real and just as ephemeral, refused to isolate a particular feature or to confine himself to a particular attitude. Through its own special means—lines, planes, space, composition and colour—art must express the manifold possibilities harboured by nature. He even forsook the vertical for the oblique so that he might better express the living world.

Joachim Gasquet quotes Cézanne as saying, "What I am trying to convey to you is more mysterious, is entwined in the very roots of being, at the intangible source of feeling. But it is precisely this, I think, that constitutes temperament. And only the driving force of temperament can carry anyone to the goal he has to reach. I told you earlier on that, when the artist is working, his brain must be free, it must be like a sensitized plate, simply a recording device. This sensitized plate, however, has been made so receptive by skilful immersion that it can become impregnated with an exact image of things. Long hours of work, meditation, study, joys and sorrows, life itself, have gone to its preparation. A constant meditation on the methods used by the old masters. And then, the environment in which we move habitually ...the sun, hark a moment... The unpredictability of the rays, the movement, the infiltration, the incarnation of the sun throughout the world—who could ever paint it, who could describe it? To do so would be to encompass the physical history, the psychology, of the earth. We are all, things and beings, more or less pieces of the sun's heat, stored and organized, a memory of the sun, bits of phosphorus burning in the membranes of the world. You should hear my friend Marion on that subject. As for me, I want to distil that essence. The meaning of the world, such as it is, lies perhaps in the effort it makes to return to the sun. That is its ideal, its feeling, its dream of God. Everywhere we find sunbeams, striking darkened doors and shades imprisoned by encircling lines. I want to liberate them. The great classic countries, our own Provence, Greece and Italy as I imagine them, are those in which light takes on a spiritual quality and a landscape is the elusive smile of a keen intelligence."

"A harmonious, skilful and flawless manner"

"Seurat is only showing two paintings: a *Circus Sideshow*, interesting as the application to a night piece of a method hitherto employed only for daylight effects; and *Models Posing*, a large picture of supreme and smiling serenity which comes as the most ambitious effort of the new art. Posing in the nude and drawn with colour and light in an indescribably pure style, the young women are set out as follows: one is standing on a towel patterned with petals, her arms extended and hands joined, her eyes slightly pursed from the strain and trance of the pose; to the right in side-view, childlike and delicate, all in spirited curves along the back, belly and nape of the neck, the second is drawing on her stockings; the third, on the left in back-view, her elbows on her hips, is seated on a cushion. For background, the grey wall and half the picture of the *Grande Jatte*, both set off by the chairs and fabrics and by the studio lighting. On the floor and on the stools, plumed hats, half boots, a fan, corsets, oranges and flowers. By a pseudo-scientific twist of fancy, the red sunshade, the straw-coloured sunshade and the green stocking are oriented in the same direction as the red, yellow and green on Charles Henry's chromatic circle. The surge of a calm and glorious rhythm quickens forms and colours, and the sight of this work humbles in one's mind the remembered nudes of galleries and legends."

Félix Fénéon, article on the 9th exhibition of Independent Artists, in *L'Art Moderne*, Brussels, 15 April 1888

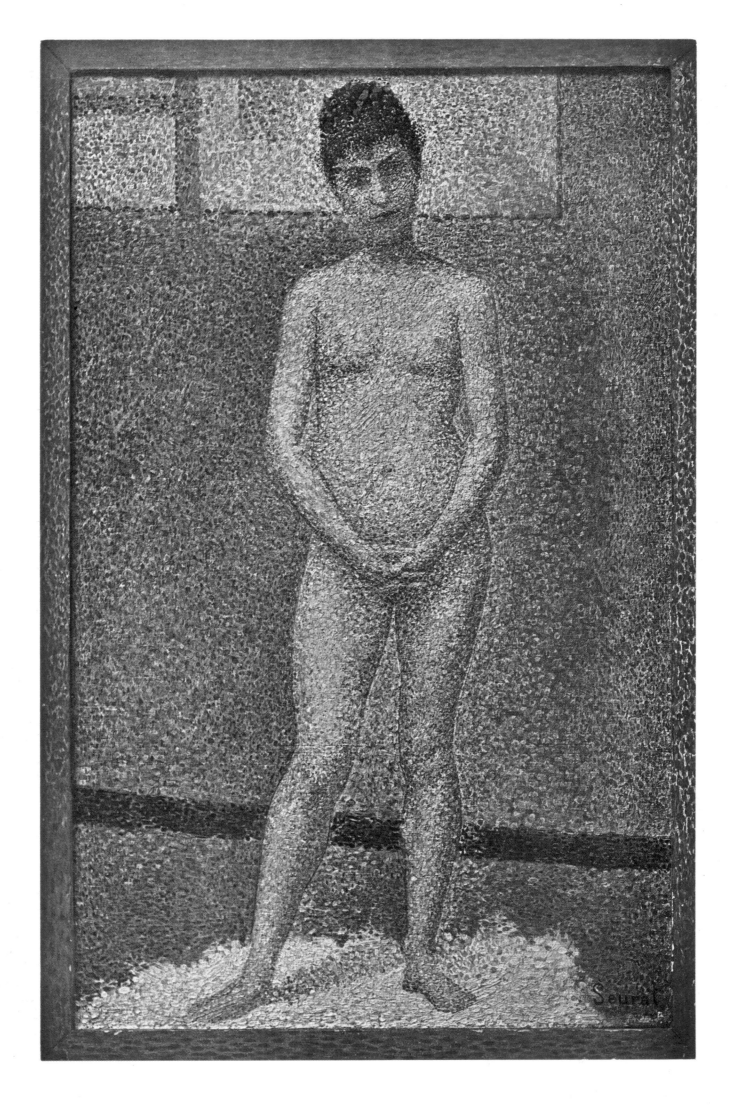

Georges Seurat (1859-1891):
Model Posing in Front View, 1887.
Oil study for "Models Posing."

50

After completing two large outdoor compositions, Seurat, who had an academic training, was impelled to measure himself against his teachers by applying divisionist theories to the most classical of all subjects: the nude. Like so many painters of his generation, he was already attracted by interiors and artificial light, as several drawings show. In his Paris studio in the Boulevard Clichy, using his own painting of the *Grande Jatte* as a background, he began to work on a large-scale composition portraying three nudes, having followed his usual practice of making separate sketches of each figure beforehand in Conté pencil and in oils. This picture, *Les Poseuses* or *Models Posing*, kept him occupied from the summer of 1887 to the spring of 1888.

The study of the nude enabled Seurat to extend his experience of working from life. Whereas in the *Grande Jatte* he had isolated the figures by means of contrast, he now sought to integrate them through subtle transitions into subdued light or faint shadow. Although the outlines are refined and idealized in the manner of Ingres, whom he had always admired and who had returned to fashion with Renoir's "Ingresque" picture known as *The Large Bathers*, the iridescent colour enabled Seurat to blend the various components delicately into the whole. The studio space is treated in perspective, but the profusion of accessories and the density of the atmosphere efface the impression of depth that this would normally have created. Seurat once again asserts his desire for total effect. He shows his model full-face, from the back and in profile, crouching, seated and standing, while the emphatic presence of umbrellas, hats and clothes creates close relationships between the nudes and the figures in the background painting, the *Grande Jatte*, between the interior and the exterior. The grouping is symmetrical, coming within a strictly defined triangle.

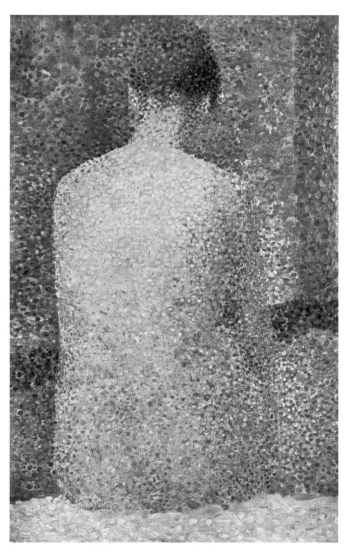

Georges Seurat (1859-1891): Seated Model, Back View, 1887. Oil study for "Models Posing."

"It would be a mistake to suppose that the painter who *divides* gives himself up to the insipid business of riddling his canvas from top to bottom, and from left to right, with small dabs of different colours. Starting from the contrast between two tints, and not bothering about the surface to be covered, he takes his various elements and opposes, graduates and proportions them on either side of the line of demarcation, until he meets with another contrast, calling for another graduation of colours. And from contrast to contrast the canvas gets covered."

Paul Signac, *From Eugène Delacroix to Neo-Impressionism*, 1899

Georges Seurat (1859-1891): Models Posing, 1887-1888. Oil. (Copyright 1979, The Barnes Foundation, Merion, Pa.)

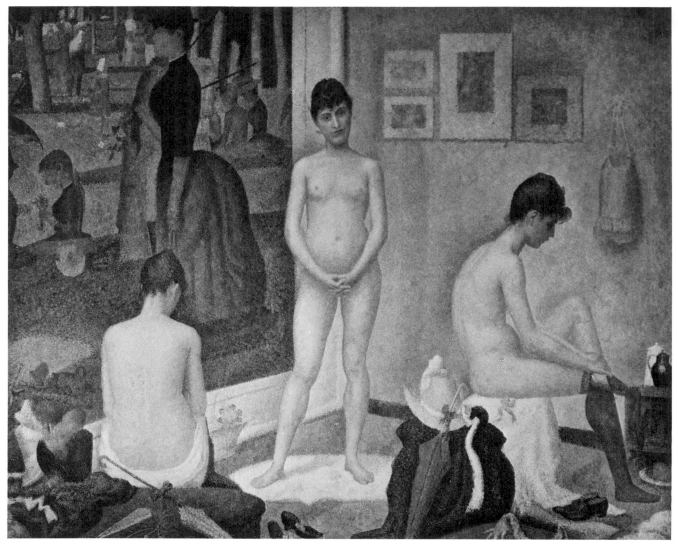

The microstructure of Pointillism, a scientific way of seeing

The achievements of Seurat and Signac in the realm of colour had been based on scientific theories. They now applied a similar approach to composition and rhythm, basing themselves on the work of the French scientist Charles Henry, who had made a study of the symbolic and expressive significance of directions and rhythms. A man of lively curiosity, Henry was interested in all the arts and tried to elaborate a theory that would lead to a synthesis between art and science. Paul Valéry recognized this when he wrote that Henry "singled out the only doctrine that made it possible, at that time, to discuss physics or biology, music or painting, feeling or action, in the same language, posing identical conditions for the phenomena or systems under consideration."

In his *Introduction à une esthétique scientifique*, published in August 1885, Charles Henry, librarian to the Sorbonne and member of the Mathematical Society of France, put forward principles that would be adopted by Seurat and Signac: "There are only two ways of looking at things: to study them in themselves, in their transformations, laws and causes, in a word, objectively; this is the aim of natural philosophy. Or to show them in relation to ourselves, bright or sad, pleasant or unpleasant, beautiful or ugly, subjectively: this is the aim of Art... But metaphysical truth is another matter, and so is scientific

truth. The former, based on *a priori* principles and on a superficial view of things, is sterile; the latter, derived from a knowledge of the way things work, is much more fertile in practical applications, i.e. in ways of modifying nature, and at the same time more profound."

After discussing the progress hitherto made in the knowledge and use of colour, Henry analysed the demands of composition and the expressivity of direction

—problems that the Neo-Impressionists had raised in their desire to create a beauty that would be both scientific and positive.

"The problem of the aesthetic of forms obviously boils down to this: which lines are most pleasing? But a little thought soon shows us that the line is an abstraction: it is the synthesis of two parallel and opposite ways in which it can be inscribed: the reality is in the direction. I don't see a circle; I can only see circles drawn in one direction or another, what are called cycles. The problem must therefore be restated as follows: which directions are displeasing? In other words, which directions do we associate with pleasure and with pain?... In short, we can say: a perception that costs a minimal amount of effort is pleasant... Here we have the crux of

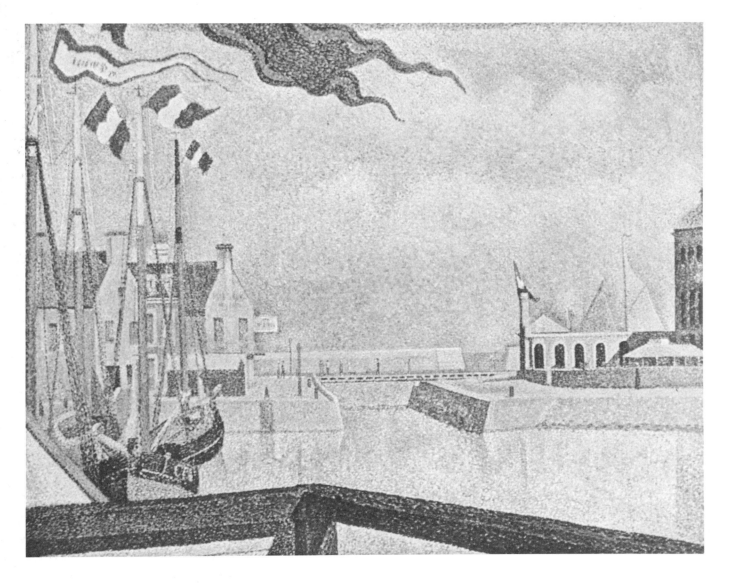

△ *Maximilien Luce (1858-1941): Seurat Painting, April 1890. Lithograph.*

◁ *Georges Seurat (1859-1891): Sunday at Port-en-Bessin, 1888. Oil.*

the simplifying, economic function of science and its relationship to aesthetic sensation. The more complex the equation, the more *beautiful* it is: and as the classification of curves—since Descartes' immortal discovery—comes down to the classification of equations, we can say: the more complex the curves, the more beautiful they are." And Charles Henry goes on to explore the mathematical connotations of rhythm and the expression of time.

In the summer of 1888 there was some dissension among the Neo-Impressionist group as a result of an article by the critic Arsène Alexandre, in which he attacked Pointillism while giving Seurat sole credit for its invention. Signac's anger at this evaporated as soon as Seurat returned from Port-en-Bessin, on the coast of Brittany. There Seurat had painted a series of seascapes in which his feeling for light chimes in perfectly with his concern for scientific construction. Seurat and Signac tended more and more towards abstraction. The latter worked in close collaboration with Henry, who in 1889 published his "chromatic circle" in which he demonstrated the various complements and harmonies of colour. The introduction dealt with the general theory of "dynamogeny," in other words of contrast, rhythm and tempo (Signac, as we have seen on page 22, drew the advertisement for it shortly before publication).

In the investigation of the demands and possibilities of the components of painting, Seurat and Signac were working along the same lines as the best architects of the time, whose daring ideas could be realized only through an understanding and choice of new materials, such as iron and, later on, concrete.

In 1889, after seeing the Eiffel Tower and the Hall of Machines at the Paris World's Fair, Octave Mirbeau wrote: "While art seeks an intimate note or sticks to old formulas, marking time, embarrassed and timid, still harking back to the past, industry strides ahead, explores the unknown, makes a conquest of form... The much heralded and desired revolution is not being incubated in the studios of painters and sculptors, but in the factories." Mirbeau thereby showed that he neither knew nor understood the ideas underlying Seurat's art and that of his friends, even though these had already a far-reaching influence.

The Belgian painter and architect Henry van de Velde, a contemporary of Ensor's, was deeply influenced by Seurat, whose work he encountered at the Salon des XX in Brussels. From 1889 on, he cooperated actively with this *avant-garde* group. Like Seurat, he did not expect Divisionism to provide a solution to his efforts to interpret the outside world; he regarded it as a means of putting his desire for order and harmony into concrete form, and this Van de Velde achieved mainly as an architect. From 1893 on he used the convolutions of Art Nouveau most successfully in his decorative work, but after 1900 he reverted to a much purer style.

William Le Baron Jenney (1832-1907): The Home Insurance Building, Chicago, ▷
1883-1885.

The founder of the Chicago school of architecture, Jenney was born in Massachusetts and trained in Paris at the Ecole Polytechnique and the Ecole Centrale des Arts et Manufactures. After serving as an engineer in the Civil War, he founded his own architectural and engineering firm in Chicago in 1868. His most important work was the ten-storey Home Insurance Building (torn down in 1929). With its iron columns, lintels and girders, it was the first skyscraper to make use of the modern principle of skeleton construction. Among the future builders of Chicago who at one time or another worked on Jenney's staff were Louis Sullivan, Martin Roche, William Holabird and Daniel Burnham.

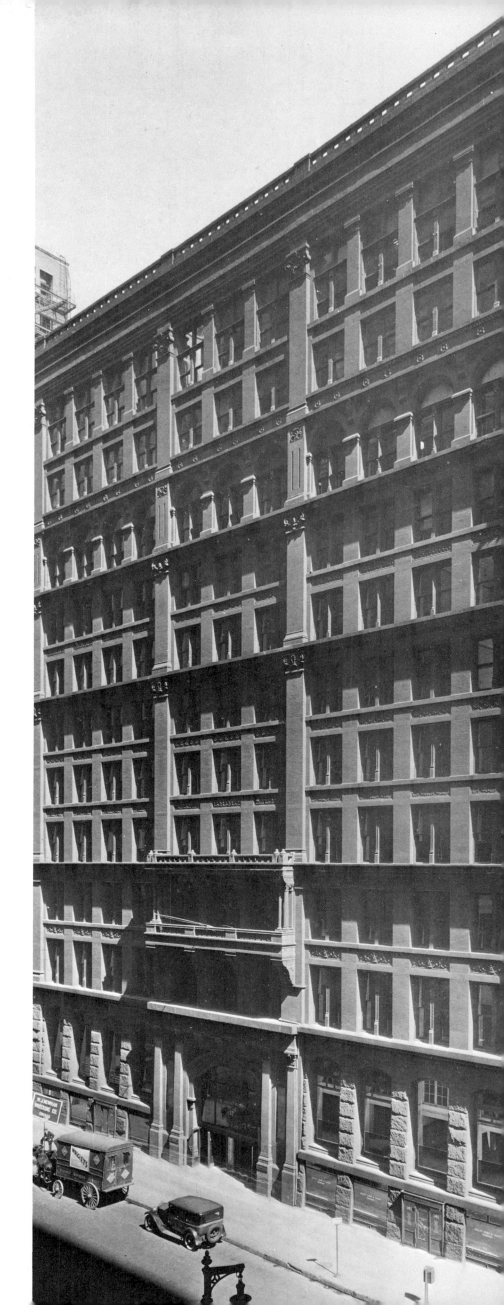

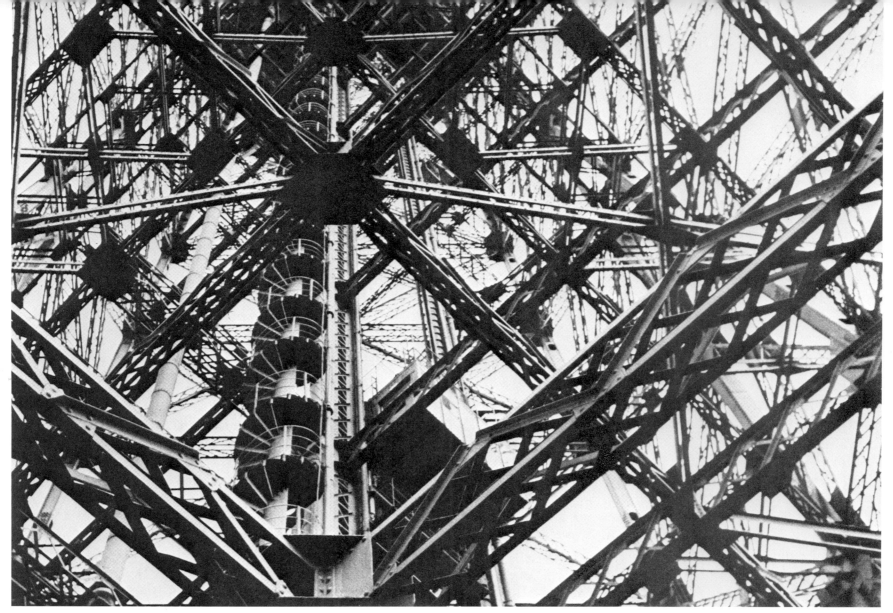

Gustave Eiffel (1832-1923): Steel girders of the Eiffel Tower, Paris, 1887-1889.

"The beauty of the engineer lies in the fact that he is not conscious of seeking beauty."

Henry van de Velde, 1899

The vision of the builders

"To lavish upon [modern office buildings] a profusion of delicate ornament is worse than useless... Rather should they by their mass and proportion convey in some large elemental sense an idea of the great, stable, conserving forces of modern civilization.

"One result of methods such as I have indicated will be the resolution of our architectural designs into their essential elements. So vital has the underlying structure of these buildings become, that it must dictate absolutely the general departure of external forms; and so imperative are all the commercial and constructive demands, that all architectural detail employed in expressing them must become modified by them. Under these conditions we are compelled to work definitely with definite aims, permeating ourselves with the full spirit of the age, that we may give its architecture true art forms."

John Root, Chicago, 1890

Henry van de Velde (1863-1957): Woman at the Window, 1890. Oil.

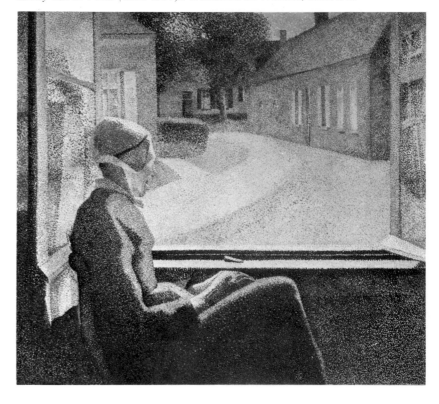

Pointillism and arabesques

Until his death in 1891, Seurat remained the sole leader of the Neo-Impressionists. All the ideas he tried out were taken up by his fellow artists as soon as the pictures embodying them were exhibited. In *The Side Show (La Parade)* he changed his system of composition and treated space in a far more abstract manner. He had wholly adopted Charles Henry's ideas on rhythm and direction, but used them unobtrusively. The abstraction he achieved is demonstrated in the more decorative impression created by his work.

The Side Show, exhibited at the Salon des Indépendants of 1888, was smaller than his previous compositions. It also took less time to paint. After the intimism of the *Models Posing*, Seurat used the theme of the circus as a pretext for exploring ways of depicting artificial light, which appealed to him by its modernity. In doing so, he took up a subject that had become fashionable with Daumier, Manet, and especially Degas.

Here, however, Seurat comes close to the experiments of Cézanne and Gauguin in his attempt to express depth while respecting the flat pictorial surface. He avoided any feature that would involve the distortions of perspective, enlivening his canvas by relating verticals and horizontals in mathematical fashion, dwarfing his figures and giving them a frontality reminiscent of Egyptian art. Although the figures seem stiff, the whole picture draws life and movement from its dynamic, progressive directional relationships and from the use of light, which blends each detail into the whole. While he was working on *The Side Show*, Seurat did numerous sketches in cabarets and theatres until he finally produced *Le Chahut* (the name of a rowdy dance in vogue in the nineties). This painting enabled him to try his hand at the expression of movement and shows an emphasis on decorative features, which have a symbolic significance in this particular context. Here the importance given to the spiral and the elaboration of ornamental effects put the artist among the pioneers of Art Nouveau.

Reviewing the exhibition of the Société des Indépendants of 1889, Fénéon wrote in the September number of *La Vogue*: "Monsieur Seurat knows very well that a line, apart from its topographical role, has a calculable abstract value. In each of his landscapes, the forms are dependent on one or two directional axes which are paired with dominant colours and with which the accessory lines are obliged to contrast."

With *Le Chahut*, Seurat's art, previously noted for its hieratic quality, was completely transformed. In this experiment with oblique lines and juxtaposed movements, he achieved a synthesis in painting of some of the most recent experiments in photography at that time. The emphasis on modernist features in the background is disconcerting; nevertheless their accumulation allowed the artist to achieve an even greater dynamism by means of the spiral. Already a feature of certain decorative and sartorial accessories in *Le Chahut*, the curve was the mainspring of the composition in Seurat's last work, *The Circus*.

Signac shared this preoccupation with the decorative. Apropos of the works he exhibited at the Salon of 1889, Fénéon wrote: "Signac's landscapes, diagonal in orientation, with frequent rectangular intersections and sharp angles would give Charles Henry a marvellous pretext for his measurements." Speaking of a landscape painted at Cassis on the French Riviera, he went on: "...and the possibly Japanese style of this painting owes nothing to Japan, it is simply a logical stage in Signac's development. This attractive work strikes us momentarily as being vaguely related to that majolica ware, the Pesaro type, I believe, in which pure yellows and blues are coated with a tin-enamel producing iridescent flashes of green, red and gold."

A growing concern for decorative effect is apparent in the works Seurat painted in 1890. In *Young Woman Powdering Her Face* he achieves, or lapses into, an artificial effect which comes as a surprise. Yet this picture is an actual portrait: it represents his mistress Madeleine Knobloch (who presented him with a son at the beginning of that year). Every feature of this painting seems to find its justification in mathematical calculations rather than in the expression of emotion.

The decorative tendency of the Neo-Impressionists is even more explicit in Signac's portrait of Félix Fénéon, painted that same year: the *Portrait of Félix Fénéon against a Rhythmic Background of Beats and Angles, Tones and Colours*, to give the picture its full title. Completely steeped in Charles Henry's theories (for he was collaborating closely with Henry and providing illustrations for the books and articles in which Henry set forth his theories), Signac exhibited the portrait of his friend Fénéon at the Salon des Indépendants in 1890. According to Arsène Alexandre, the picture was "not a colourist's whim but an experimental demonstration of the ideas about colour and line which were to be expounded in Charles Henry's next book."

The divisionist artists were increasingly attracted by the symbolist theories set forth by writers like Jean Moréas, Gustave Kahn, Jules Christophe and Félix Fénéon in the literary magazines which these artists read and supported, such as *La Revue Indépendante* and *La Vogue*; and Signac's *Portrait of Félix Fénéon* bears witness to the impact made by these theories. The cyclamen flower the critic is holding in his hand owes its significance to them; and the strange background of abstract arabesques, expressly illustrating certain patterns of rhythm, already anticipates the sinuous lines of Art Nouveau.

While working on this canvas, Signac wrote: "It isn't going to be an ordinary portrait, but a highly composed painting, with very structured lines and tones..." Its spirit and form evoke both the theories of the English Pre-Raphaelites (especially those developed by William Morris in his decorative work) and certain themes from Japanese art. There is a kimono pattern that, according to Françoise Cachin, the author of a recent book on Signac, was the artist's source of inspiration for the spirals in the background of the picture.

But the 1890s heralded the end of the Neo-Impressionist group. Camille Pissarro had come to question the validity of a technique that seemed to hamper his freedom. On 18 August 1890 Albert Dubois-Pillet, a close associate of the group and a generous friend, died of smallpox in the hospital at Le Puy. On 29 March 1891 Seurat—weakened probably by overwork—died of influenza at the age of thirty-two, while working on *The Circus*, a few days after the opening of the exhibition of the Indépendants, which he had played an active part in preparing. By now Pointillists like Henri-Edmond Cross were already evolving towards a freer technique, while Henry van de Velde, the Belgian artist, strayed from the basic principles of Neo-Impressionism to seek new paths. Seurat's art, with its rigorous intellectual basis, was the last bastion against the proliferation of the arabesque which, from

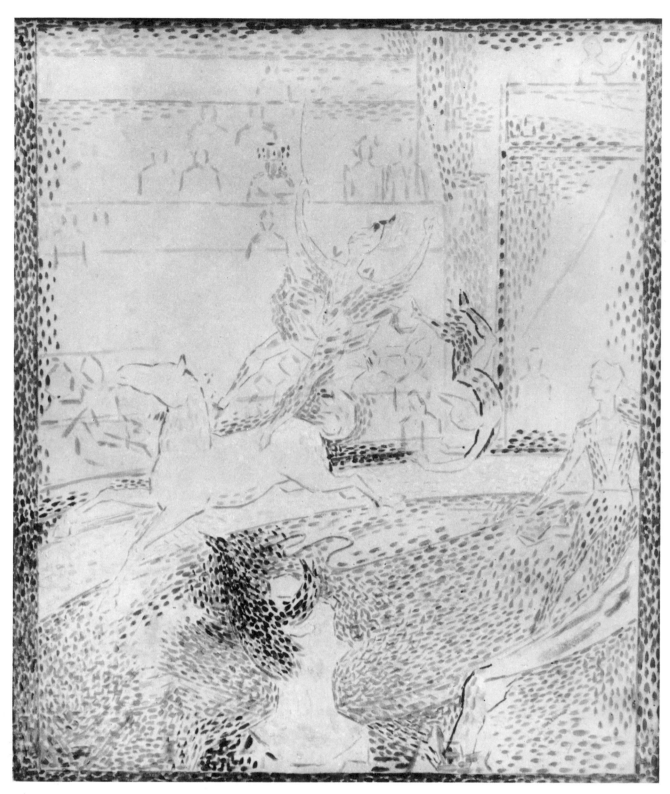

Georges Seurat (1859-1891): The Circus, 1891. Oil sketch.

then on, spread freely. Its ornamental influence was felt in all the arts, from Gaudí's architecture to Gauguin's painting.

The disputes that broke out over the disposal of Seurat's property after his death meant that, despite the retrospective exhibition at the Salon des Indépendants in 1892, his work did not enjoy the widespread influence it would normally have had. It was not until 1905 that the Fauves, and then the Orphists and Futurists, realized its full potentialities and began exploiting them for their own purposes.

Introducing the exhibition of Seurat's work held in 1908 at the Galerie Bernheim, Félix Fénéon, his old comrade-in-arms, wrote: "Scrupulously careful to conform to nature, indeed anxious to restore its processes, he nevertheless achieved works of striking originality that stood apart from all others. For those who approach it in the proper spirit, this exhibition will set the seal on his reputation, which has been growing slowly and quietly, but irresistibly, since 1891. In March of that year, Georges Seurat died. But he had completed definitive works that give the full measure of his powers. A career lasting seven or eight years is admittedly not a long one; nevertheless, the history of art already includes some painters for whom almost as short a span was enough."

The day after Seurat's death, Camille Pissarro wrote to his son Lucien in London: "You can conceive the grief of all those who followed him or were interested in his artistic researches. It is a great loss for art." And writing again to his son on 1 April 1891, he added these prophetic words: "I believe you are right when you say that Pointillism is finished, but I think it will have consequences which later on will be of the utmost importance to art. Seurat has obviously contributed something new."

*"But time is only measurable by movement:
the day, for example, is the interval of time
that has elapsed between two successive
passages of the sun at the meridian... We shall
therefore define rhythm as follows: a change
of direction determining a possible geometric
division along a circumference whose centre
is at the centre of the change."*

Charles Henry, *Introduction to a Scientific Aesthetic*, August 1885

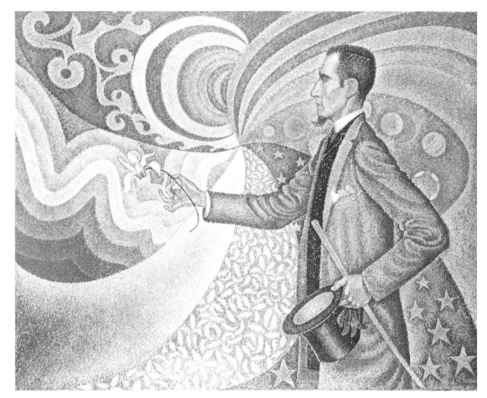

Paul Signac (1863-1935): Portrait of Félix Fénéon against a Rhythmic Background
of Beats and Angles, Tones and Colours, 1890. Oil.

Antoni Gaudí (1852-1926): Gate of Finca Güell, Barcelona, 1887.

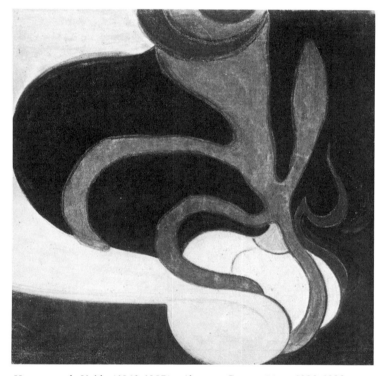

Henry van de Velde (1863-1957): Abstract Composition, 1892-1893.
Pastel.

*"Ornament should be structural and
dynamographic."*

Henry van de Velde

ON THE VERGE OF THE SECOND
INDUSTRIAL REVOLUTION

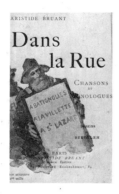

The twenty years following the Paris World's Fair of 1889 were among the most amazing and fertile in the history of mankind. Science and technology made enormous strides, opening up so many new fields of knowledge and communication that everything seemed possible and easy. Following the train and the steamship, the bicycle, the motor car and the airplane reduced distances; the telephone and then the radio offered new means of communication, photography and the cinema recorded the reality of the moment for posterity. The technicians seemed to have conquered time and space, while the research scientists were exploring the world of the micro-organism.

But despite all its achievements, science was still unable to answer such fundamental questions as: *Whence come we? Whither go we? What are we?* These questions, which we all still ask ourselves, make up the title of one of Gauguin's most famous paintings.

Man's environment was in a turmoil of change: industrialization began to leave its mark on the cities and continued to do so at an accelerating pace over the years. Only a few years earlier the urban landscape still had that semi-rural look which we find in the paintings of the Impressionists, and Claude Monet could still regard the locomotive, its huge bulk and its puffings of steam, with the fascination one bestows on a natural phenomenon: for him it was still a novelty.

At the dawn of the twentieth century, painters no longer sought refuge in the country or the radiance of the sky but in the glare of artificial light. Where did their quest lead them? Cézanne and Van Gogh chose solitude, Gauguin went off in search of lands as yet unspoilt by technical progress, while Toulouse-Lautrec plunged into the very heart of city life—the crowds in the Paris streets, the cafés and night life of Montmartre. This was also the world of the various illustrators, caricaturists and songwriters who, with a wit and verve all their own, still conjure up that *fin-de-siècle* atmosphere recreated by Toulouse-Lautrec in such masterly fashion. Caricaturists like Caran d'Ache, Willette, Steinlen, Forain and others poked fun at society and the vagaries of the day with biting wit, poetry and occasional wistfulness reminiscent of Baudelaire's famous lines:

Paris has changed, but in my melancholy
Nothing has budged.

Le Cygne (The Swan)

Songs, especially ballads, enjoyed unprecedented popularity. They became an outlet for the sentimentality of a public increasingly limited in that respect. Toulouse-Lautrec's brush bears witness to it all, exposing and denouncing, but more as an accomplice than a judge.

We know how closely his work was bound up with every aspect of the night life of Montmartre, the familiar forms of the girls who sang and danced there, and the famous Naturalist Quadrille that was one of the main attractions at the Moulin Rouge. This night spot, so dear to the painter, had opened its doors in 1886, and its façade was decorated by Willette. Equally famous is Toulouse-Lautrec's portrayal of his friend Aristide Bruant looking like a sort of *condottiere* of the modern age. A very talented songwriter with an undeniable literary gift, Bruant had taken over the *Chat Noir* cabaret in 1884, changing its name to *Le Mirliton*. He had given the same name to the periodical that he brought out—to quote his own words—"very irregularly twice a month," in which the celebrated *Quadrille de la Chaise de Louis XIII* foreshadowed a type of composition to which Toulouse-Lautrec was to revert again and again.

Ever the realist, Toulouse-Lautrec never succumbed to the excesses of naturalism, but cast the ironic eye of a moralist on a world to which he could never quite belong because of his upbringing and his infirmity.

"I should like to tell you about what I am doing, but it is so special, so 'outlawed.' Of course Papa would call me an outsider... I have had to make some effort, since, as you know very well, I am living the Bohemian life to the hilt, though it goes against the grain and I cannot get used to the milieu. I am made all the more ill at ease on the hill of Montmartre by the inhibiting effect of a whole heap of sentimental considerations that I really must work out of my system if I am to get anywhere" (letter to his grandmother).

The Paris World's Fair of 1889, initially intended as a centenary celebration of the French Revolution, set the seal on the triumph of science and the expansion of capitalism. In the realm of architecture it dramatically illustrated the possibilities of iron and glass in the breathtaking Tower built by Eiffel and in the Hall of Machines; while in the field of technology it satisfied the wildest hopes by showing inventions that ten years earlier would have been thought to belong to the realms of fantasy.

Within the crowded precincts of the Fair, one dazzling surprise followed another. On busy days there were as many as a 100,000 visitors, stunned by the sight of so many daring feats of engineering and fabulous industrial achievements. The Eiffel Tower, built at a cost of 15,000,000 francs and against fierce opposition, dominated the banks of the Seine. It was the focal point of the Fair. Behind it stood the exhibition buildings, consisting of two wings, one housing the Fine Arts, the other the Liberal Arts. In the background rose the mighty Hall of Machines which rivalled the Tower with its glass vaulting, 1,380 feet long, 380 feet wide and 150 feet high, supported by a disconcertingly slender framework of iron girders.

In his book *Space, Time and Architecture* (1941), the Swiss architectural historian Sigfried Giedion describes the Hall of

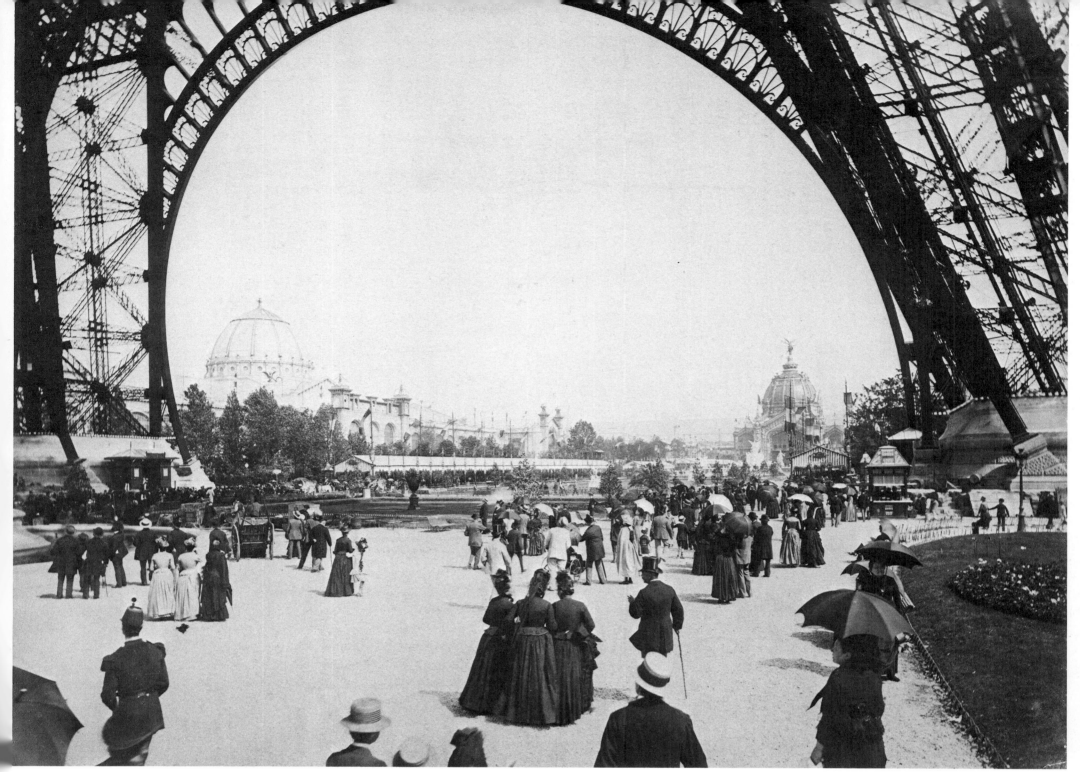

Paris, 1889: Crowd under the Eiffel Tower at the Paris World's Fair.

"I wished to raise to the glory of modern Science
and for the greater honour of French industry an arch
of triumph more striking than those which previous
generations raised to conquerors."

Gustave Eiffel

◁ T.A. Steinlen (1859-1923):
Cover for a book of songs by Aristide Bruant.

Machines—unfortunately torn down in 1910—in these enthusiastic terms: "The aesthetic meaning of this hall is contained in the union and interpenetration of the building and outer space, out of which there grows a completely new limitlessness and movement in keeping with the machines it contains. Each arched truss is made up of two segments. A pin unites them at a pivotal point high above the centre line of the hall. Moving downward, the trusses become increasingly attenuated until they appear scarcely to touch the ground; moving upward, they spread and gain weight and power. The usual proportions seem to be exactly reversed. These triply articulated arches disturb, or rather disrupt, traditional static feelings with regard to the rational relations of support and load... Nothing remains of the quiet stone architecture of the barrel vault. A new sort of movement, penetrating space—as new in kind as that achieved in Borromini's cupolas—is created here... The play of enormous forces is held in equilibrium, an equilibrium that is floating rather than rigid.

"It is the equilibrium of a balance beam daringly poised against continually varying forces.

"A new oscillating harmony is created.

Louis-Ernest Barrias (1841-1905): Allegorical group symbolizing Electricity, adorning the Hall of Machines at the Paris World's Fair of 1889.

"An elastic counterpoise is achieved which absorbs changes in the interior, the exterior, and the foundation... An equilibrium is achieved... Construction passes over into expression."

The wonder aroused by the Hall of Machines, erected by Contamin after designs by Dutert, was reinforced by the vertiginous structure of the Eiffel Tower, which synthesized all the previous experiments by its builder. Composed of four immense pylons merging asymptotically at a height of 1,000 feet above the ground, it triumphs over weight and natural forces alike. In its construction, all the resources of science were employed: its component parts were prefabricated, the pylons were anchored by means of a hydraulic press, its shape and structure were the outcome of numerous studies on wind resistance and its emplacement was calculated in relation to the resistance of the soil. Eiffel's use of lifts was equally remarkable. The principle of mechanical lifts had been known since 1853, but Eiffel achieved the feat of taking 2,300 people per hour up to a height of 1,000 feet, covering the distance in seven minutes. The changing visual impression experienced during this rapid ascent transformed the traditional view of space, and the visitor's sensation of giddiness on arriving at the top of the tower paralleled the new aerospatial experiences resulting from the conquest of the air by the balloon, the airship and, later on, the airplane.

But Eiffel was not only an engineer. With unfailing taste, he invented forms and links that created an impression of stability and strength. It took the Parisians twenty years to appreciate the quality of the tower that was to become the symbol of their city. By 1889 science had progressed to a point at which the imaginary worlds dreamed up by Jules Verne had become practical possibilities: space was multiplied, transformed; the void had become usable; and "infinity" seemed susceptible of measurement by movement.

The break with the outlook of the Renaissance was achieved, and a new world opened up before modern man. As the old way of seeing things became obsolete, the official myths lost their relevance.

Although modest in size, the Oil Pavilion at the World's Fair introduced a new form of energy that was to revolutionize transport. Oil was still used only for lighting, but the invention of the internal combustion engine in 1890 made it one of the most sought after and essential raw materials. The reign of "black

gold" was at hand. It is difficult to list all the technological innovations placed before the public.

Although the sculptor Barrias could find nothing more original than the hackneyed symbol of a goddess to represent the power of electricity, its conquest had startled the world. Edison's phonograph was one of the greatest attractions of the Paris World's Fair, and his discovery coincided with such inventions as the typewriter and linotype and with tremendous advances in the development of the rotary press. Every modern means of communication was already there. In a speech made on behalf of Edison at the Academy of Science in Paris, the French scientist F.F. Gouraud gave a prophetic account of the part which the spoken word and the press would play in the civilization of the twentieth century: "Here is a summary of the uses that can be made of the phonograph. You can dictate correspondence, which can then be transcribed at leisure... You can send your voice through the post by means of the phonogram... Statesmen, lawyers, preachers and orators can practise their speeches... Actors and singers can rehearse their parts and correct their own articulation or pronunciation. Journalists can speak their articles instead of writing them."

Paris World's Fair of 1889: The Hall of Machines by Dutert and Contamin.

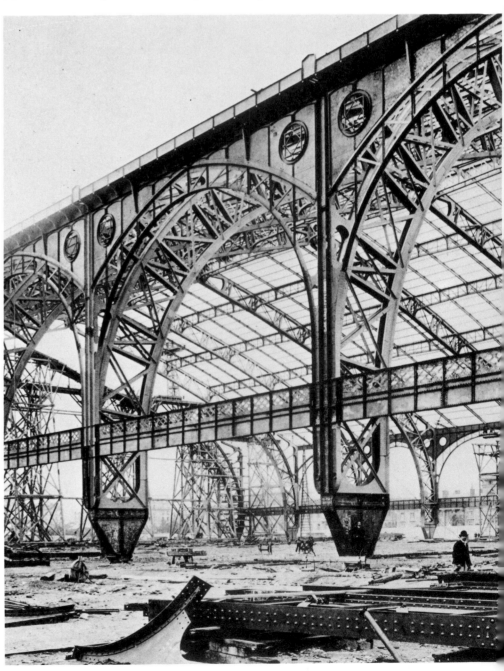

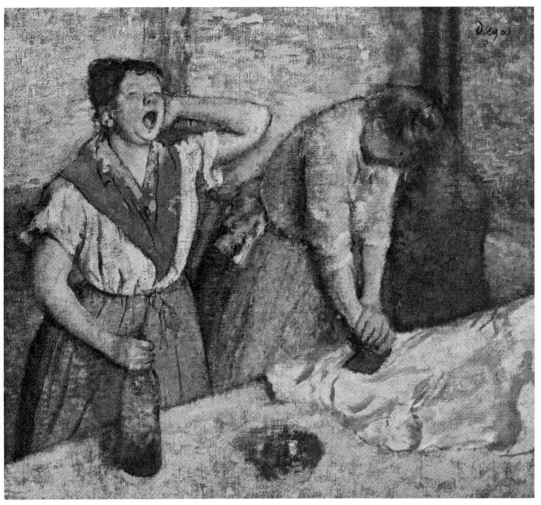

Edgar Degas (1834-1917): Women Ironing, c. 1884. Oil.

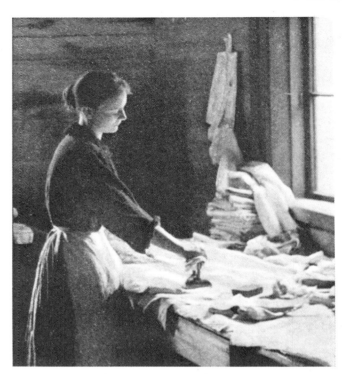

B. Tyszkiewicz: Photograph of a laundress ironing, from "Esthétique de la photographie," Paris, 1900.

"He endeavoured, he dared to endeavour, to combine the snapshot with the endless toil of the studio, to embody the impression in the searching study and immediacy in the steady pursuit of a premeditated purpose."

Paul Valéry, *Degas, Danse, Dessin*, 1938

Photography takes pride of place among the technical inventions that have completely changed our ways of seeing and thinking. By the time of the Paris World's Fair of 1889, it could be described as "a truth machine, a machine of dreams, artifice and wonder"; this was its moment of triumph. Until then painters and photographers had seemed to be vying with one another in copying appearances; now photography had reached such a degree of perfection that artists were freed from the obligation of being descriptive.

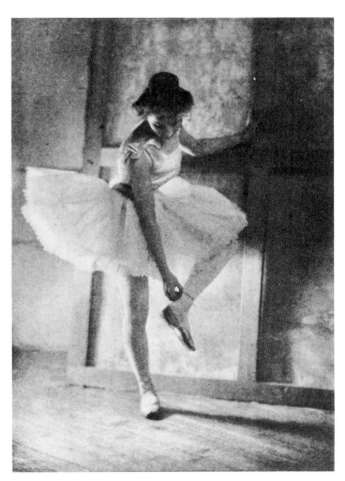

Robert Demachy (?-1938): Photograph of a dancer, from "Esthétique de la Photographie," Paris, 1900.

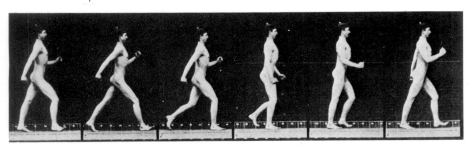

Eadweard Muybridge (1830-1904): Photographic sequence of a boy walking, taken in Philadelphia between 1883 and 1885.

Long restricted to posed portraits or set landscapes, the photographer had hitherto seen his subjects with a painter's eye. Contrary to the view frequently heard today, the contribution of painters like Degas to the modern dynamic way of looking at a scene was more important than that of photographers like Nadar and his colleagues, who had to depend on cumbersome material and plates that were slow to react. However, by 1875 they were equipped to capture the fleeting moment, and their precise analyses of the components of movement were shedding new light on the subject.

In 1877 Eadweard Muybridge, an Englishman working in the United States, succeeded in obtaining snapshots at a speed of one-thousandth of a second, but the cameras were still too heavy and the fragile wet-collodion plates difficult to transport. Muybridge, Eakins and Marey considered photography as a means of analysis and reproduction and succeeded in catching a series of movements and reconstituting them by juxtaposition (which was to lead to the motion-picture camera). They were particularly interested in the movements of men and animals, and the publication of their picture-albums was a revelation.

Then the advent of gelatin-bromide dry plates, first put on sale in 1878, made it possible to use smaller cameras and, above all, cameras without stands. The manufacture of these plates was taken over and improved by George Eastman, an American, who also invented the roll of film on paper and, in 1886, patented a roll-film camera with shutter—the little Kodak, the ancestor of all today's cameras.

In 1888 Eastman put on the market a camera that became all the rage. It took circular pictures, about 2¼ inches in diameter, and had a roll of film sufficient for a hundred pictures. It was in a very light and extremely handy case (6 by 4 inches) and was advertised by the slogan, "You press the button, we do the rest." Thus photography entered into everyday life—anyone could do it and the camera could memorize anything. It was not until the appearance of the small easy-to-handle Kodak that snapshots and uncomposed views became possible. From then on everyone was on the look-out for the unexpected view, the chance event, anything that could be snapped.

"The photographs of Muybridge showed up the mistakes made by all the sculptors and painters who had represented horses moving at various paces. It was then seen how inventive the eye is, or rather how much perception elaborates on whatever it gives us as the impersonal and certain result of observation. A whole series of mysterious operations between the state of *blurs* and the state of *things* or *objects* come into play and coordinate as best they can the raw incoherent data, resolve their contradictions, introduce judgments formed from earliest childhood, impose upon us certain continuities, connections and modes of transformation which we group under the names of *space*, *time*, *matter* and *movement*. So the animal in action was imagined as being as people thought they saw it; and possibly, if we examine acutely enough these representations of the past, we may find in them the *law* of unconscious fabrication which enabled artists to draw moments in the flight of a bird or the gallop of a horse as if they had been able to observe them at leisure; but such interpolated moments are imaginary. To these rapid motions were attributed *probable* patterns and shapes, and it would be of some interest to attempt by a comparison of such representations to define that act of *creation* by which the mind fills up the gaps left by the record of the senses."

Paul Valéry, *Degas, Danse, Dessin*, 1938

Jean-Louis Delton: Ríder photographed in the Bois de Boulogne, Paris, 1884.

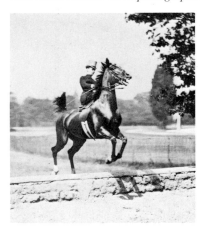 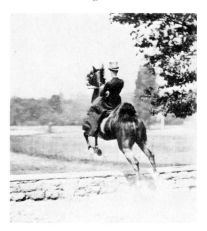 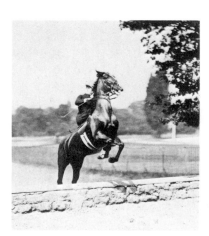 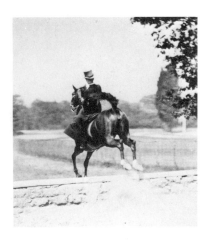

In the guidebook to the Paris World's Fair of 1889, Louis Figuier described the revolution in photography as follows: "The most interesting use of instantaneous photography is the ultra-rapid production of portraits and, in consequence, the facility we now have of photographing people unawares. The shops nowadays are full of *pocket cameras* and *hand cameras*. The exhibitors' stands offer a vast array of these cameras with which a landscape, a building or a portrait can be taken in a split second.

"The *hand camera* has become an increasingly common part of the amateur photographer's equipment. These tiny instruments can be operated in a split second without, so to speak, having to slow down one's pace. Indeed, it is possible to take and keep someone's likeness without a word of warning. The *pocket camera* has a lens that is always ready to function and a dark compartment so arranged that the photographer need only aim at his subject and press the trigger that opens the shutter. It is a loaded gun, ready to shoot at any moment at the hunter's whim."

An even more prophetic article by Louis Figuier described the photographic reproduction processes that would initiate the "civilization of the picture." "One of the principal things to be

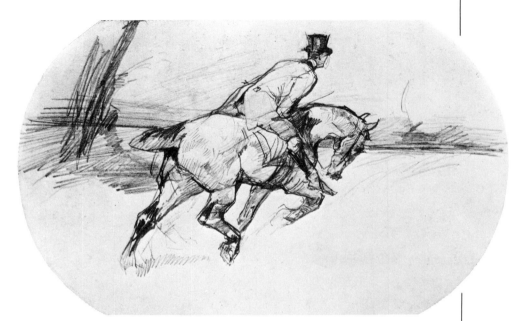

Henri de Toulouse-Lautrec (1864-1901): Horseman Galloping, 1875-1880. Pencil.

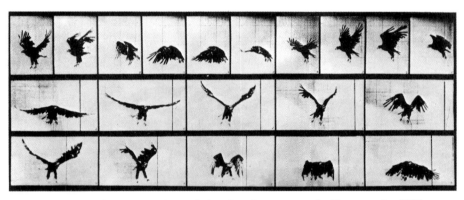

Eadweard Muybridge (1830-1904): Flight of an American eagle. Photographs, 1887.

Etienne Marey (1830-1904): Chronophotograph of a fencer.

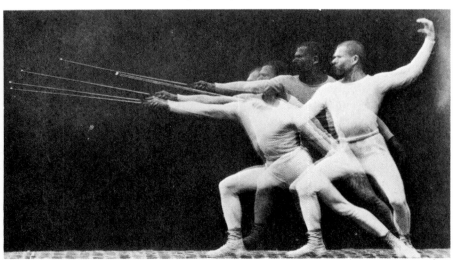

admired at the World's Fair is the progress of photo-engraving, i.e. the use of photographic processes in wood and metal engraving.

"Printers now make considerable use of photography to produce printing plates in relief, made either of zinc or of copper. Books on science, art or industry now are full of photo-engravings that clarify or complement the author's descriptions. Even works of pure fiction have recourse to such illustrations."

Degas, with his unconventional framing, his use of off-centre layouts, his sense of movement and his surprising visual angles had anticipated the photographer's way of seeing things. He sometimes availed himself of the photographic plate to gain a new perspective, but he had already run the gamut of free, instantaneous vision by the time the photographers could enjoy similar independence. While they were taking over his themes and subjects, toning them down somewhat, Degas was attempting to express movement sequentially, by means of juxtaposition, thus anticipating the motion picture.

Lautrec shared Degas's sense of life's richness and was also interested in snapshot photography as a means of extending knowledge. Both had the necessary equipment for any experiments in photography they might need to make, but they also knew that the artist's line had a power of suggestion that photographic precision could never replace. A photograph singles out and captures one stage in the infinite succession of stages involved in a movement; the hand of the draughtsman, linked to the eye's movement, pins down the sum of all the different stages involved.

Gauguin and the 1889 World's Fair

The triumph of industrialization and technology celebrated by the World's Fair coincided with the heyday of colonialism and there were numerous colonial exhibitions and exotic pavilions: for example, those of Japan, the countries of North Africa, and America (with Buffalo Bill and his Wild West Show), not to mention reconstitutions of the temples of Angkor and of Javanese villages.

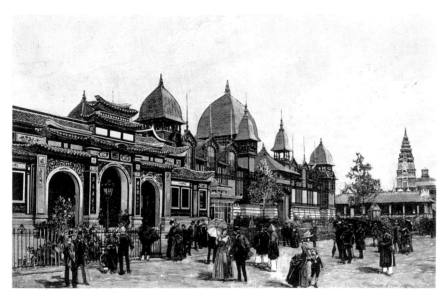

Buildings of the Colonial Exhibition at the Paris World's Fair of 1889.

Many artists were fascinated by the exhibits from these hitherto obscure countries. Vast crowds were delighted and amazed by the folk displays from distant lands. Gauguin was especially struck by the Javanese dancers and fascinated by the examples of Indian art, of which he already knew something from photographs. His subsequent work was deeply influenced by his memories of the 1889 World's Fair, which revived his liking for "primitive" art and aroused his still latent need for escape from European civilization. The mental wounds left by his 1887 journey to Martinique had barely healed when he planned to set off again for Tonkin.

Gauguin also took an interest in the novel architecture of the pavilions, which he discussed with understanding and insight in an article that appeared on 4 July 1889 in *Le Moderniste Illustré*, a paper edited by Albert Aurier, a young critic to whom he had been introduced by Emile Bernard. "As architecture, it is at its earliest stage, in that it lacks a form of decoration in harmony with its character. Why put soft materials side by side with that rough, severe iron? Why, alongside those geometric lines in a new style, all that collection of ancient ornaments updated by naturalism? The advent of the engineer-architect demands a new kind of decorative art, e.g. ornamental bolts, iron corners projecting beyond the broad outline, a kind of gothic filigree in iron. There is something of this in the Eiffel Tower.

"The imitation bronze statues clash with the ironwork. More imitation! It would be better to have iron monsters fastened with bolts.

"And why has the iron to be painted that butter colour? Why is it gilded like an opera house? No, this is certainly not good taste. Iron, iron, and yet more iron!"

This passage shows Gauguin's interest in the relationship between art and decoration and explains his experiments in pottery and sculpture. He did not have the chance to bring about the fulfilment of his expectations for the future himself, but the Nabis, his "spiritual sons," were the instigators of a revolution in design along the lines he advocated.

Although the fine arts also had a place at the World's Fair, they were limited to the officially acceptable. Roger Marx, the critic in charge of the selection committee, had great difficulty in having such controversial artists as Manet, Monet and Pissarro admitted, even though they were already quite well known.

Gauguin and his friends, not being represented at the Fair, decided to organize an exhibition of their own to take advantage of the large number of people flocking into Paris. Schuffenecker discovered a café conveniently located near the art section of the Fair. Its owner, an Italian named Volpini, was in despair because he had wished to decorate his walls with large mirrors but had ordered them too late. So he readily consented to have the bare walls hung with a collection of paintings.

Vincent van Gogh was invited to participate, but Theo—without even consulting him—declined on his behalf, feeling that the whole enterprise was too hasty and unconsidered: "It looks like trying to enter the World's Fair by a back door." After a great deal of discussion, Gauguin and his friends decided to call themselves the "Impressionist and Synthetist Group" and opened their exhibition in the Café Volpini at the end of May 1889.

Breton themes and the spirit of Pont-Aven predominated at the Café Volpini exhibition, which financially was a failure, not a single picture being sold. It was not much noticed by the critics, and unfavourably when it was. Félix Fénéon, who was generally sympathetic to the *avant-garde*, had little appreciation for an exhibition of paintings in a café. He wrote: "Messrs Anquetin, Bernard, Georges Daniel [de Monfreid], Fauché, Gauguin, Laval, Nemo, Louis Roy and Schuffenecker, united for the first time under the banner 'Impressionist and Synthetist Group,' have dotted the walls of the Café des Arts, at the Champ-de-Mars (World's Fair) with a hundred or so items. They have produced a handwritten catalogue with the prices marked, which you will find on the counter. It is impossible to approach these canvases because they are fenced in by bars, beer-taps, tables, the bosom of Monsieur Volpini's cashier, and an orchestra of young Muscovites, whose music, blaring into the vast hall, bears no relation to the multicoloured display" (*La Cravache*, 6 July 1889).

Gauguin never forgave Fénéon for saying in the same article that he was indebted to Anquetin for "impassable contours, flat and intense colours," in other words for the cloisonnist technique. The only favourable comment came from Albert Aurier, who had suggested that they call themselves "synthetists." "In most of the works exhibited, and especially in those by Paul Gauguin, Emile Bernard, Anquetin and others, I thought I detected a marked tendency to synthetism in the drawing, composition and colour, and a quest for greater technical simplicity, which struck me as very refreshing in these days of excessive ingenuity and fakery" (*Le Moderniste*, 27 June 1889).

Despite its commercial failure, this exhibition consolidated Gauguin's influence over Sérusier and the future Nabis.

Brittany
and primitive symbolism

Back at Pont-Aven in the spring of 1889, Gauguin discovered the deep spiritual quality of Brittany. He already loved this remote peninsular province for its climate, traditions and solitude, but now its mystery and its art were revealed to him.

Van Gogh's religious temperament had not left Gauguin untouched, and his recent contacts with the symbolist poets—Mallarmé, Jean Moréas and others—inspired him to undertake a more inward quest. The force and significance of Breton folk art made a deep impression on him. His early memories of Peru and, still more, his acquaintance with Japanese art helped him to appreciate it. He was the first artist of his time to consider primitive art as a system of expression that, although it differed from that used by the mainstream of Western art, was no less valid. He was moved by its archaic forms and powerful content.

At the very moment when science seemed to have freed him from all his uncertainties, man was assailed by metaphysical qualms of unprecedented acuteness. Religion became the burning question of the day in France as a result of the struggle between Church and State over the secularization of the schools. The solutions proposed by positivist and scientific thinkers failed to allay men's worst anxieties. Rebellious and unsatisfied, Gauguin expressed his doubts: "What is man in this immense creation?" (letter of November 1889). The countrified simplicity of Breton art freed him from classical idealism by its revelation of the primitive. Later on, he would confess: "To me, barbarism is a means of rejuvenation." The figure of Christ in the village church at Trémalo and the wayside Calvary at Nizon inspired him directly. Breton statuary had a simplification of form and mass which he himself would perhaps not have ventured to adopt without their example. This influence also brought him back to sculpture, and he carved the famous wood panel, with its invocation to women, *Soyez amoureuses, vous serez heureuses* (Be in love and you will be happy), which he considered to be one of his best works.

In a number of paintings both Gauguin and Emile Bernard turned to religious themes. Gauguin even identified himself with Christ in his *Self-Portrait as Christ in Gethsemane*, while Bernard in his *Christ in the Garden of Olives* portrayed Gauguin as Judas, which did not unduly upset him. Gauguin had spent the early months of 1889 in Paris, where he had done some new pottery. When he was invited that same year to exhibit with the Twenty in Brussels, he had hopes of putting the Neo-Impressionists in the shade and gaining recognition, but once again he met with failure: the Belgian public could not take his pictures seriously. Wholly without means, he returned to Brittany, where he lived and worked with his faithful companion, the Dutch painter Jacob Meyer de Haan, who, with marvellous discretion, helped him to pay his bills at the inn. But Pont-Aven was becoming fashionable, and the Pension Gloanec no longer provided the seclusion Gauguin craved. He did a portrait of a local woman, Madame Angèle Sartre, *La belle Angèle*, but her husband—later to become mayor of Pont-Aven—was horrified by the painting and refused to accept it.

That summer of 1889 Gauguin left Pont-Aven for Le Pouldu, a small village overlooking the Atlantic, set in a much wilder countryside; it was not far from Pont-Aven and he had discovered it around Easter during an outing with Paul Sérusier. The latter—one of his first enthusiastic disciples—joined him at Le Pouldu whence he wrote to his friend Maurice Denis: "I am working very little and learning a great deal: what a lot I shall have to tell you when we see each other again. My drawing in particular is changing completely. My colours are becoming less unruly thanks to a greater division and consequent enrichment of tones."

At Marie Henry's inn where they were staying, Gauguin and his friends decorated the communal sitting-room with sculptures, pottery and paintings. On one of the door panels, Gau-

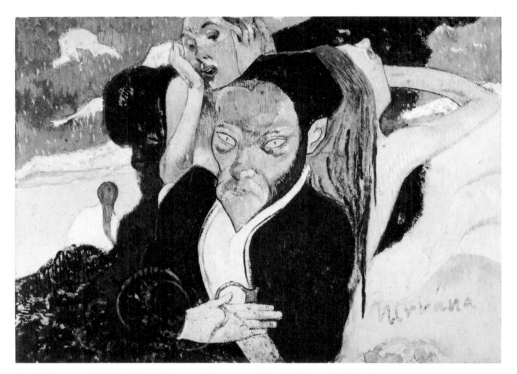

Paul Gauguin (1848-1903): Nirvana (Portrait of Jacob Meyer de Haan), c. 1890. Gouache.

guin painted portraits of himself and Meyer de Haan, on another *Martinique Woman with Sun*, a prophetic foretaste of what he would do later in Tahiti. Besides Sérusier and Meyer de Haan, the artists' colony at Le Pouldu included Laval, Moret, Chamaillard, Filiger, Maufra, Roy and others.

It was at Le Pouldu that Gauguin made his first plunge into the primitive, producing pictures of Brittany with overtones suggestive of Japan, Egypt and all manner of exotic places. Forms and colours were simplified, but the actual content of the paintings became denser, charged with symbols, and rich in contrasts of time and place. In his *Self-Portrait in front of the Yellow Christ* and the complementary portrait of Meyer de Haan, two different times and two different feelings confront one another. The components of the *Portrait of Meyer de Haan*, designated on the canvas by the artist as "Nirvana," are reminiscences of past works by Gauguin and premonitions of future ones. For example, the woman on the left figured in his *Breton Eve* and on the title page of the catalogue of the 1889 exhibition at the Café Volpini; and she reappeared later in *Arii Matamore* and in *Whence come we?*

This yearning for another world, for another form of reality, which inspired so much of the art produced between 1890 and 1900, was discussed by Albert Aurier in his article on "Symbolism in Painting" published in the *Mercure de France* in March 1891.

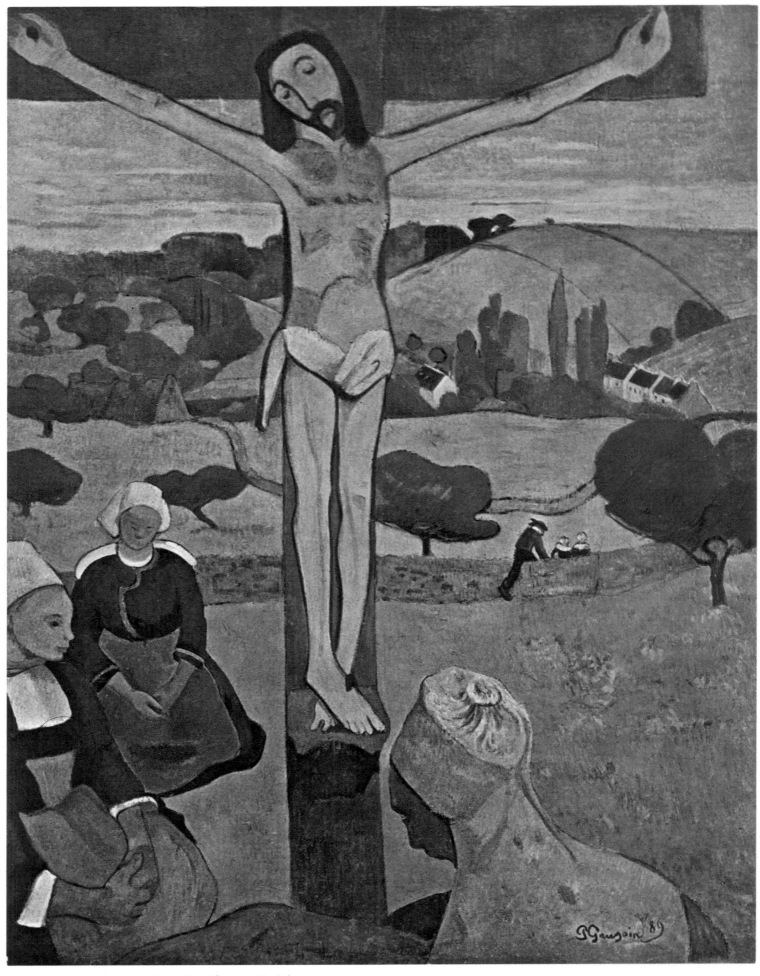

Paul Gauguin (1848-1903): The Yellow Christ, 1889. Oil.

"Today, when in literature we are witnessing—as is becoming obvious—the death pangs of naturalism and a new idealistic, indeed mystic, reaction is taking place, it would be surprising if there were no trend towards a similar development in the visual arts... So a new word ending in —ist must be invented (there are already so many, it would hardly be noticeable!) to describe the newcomers, who are headed by Gauguin: synthetists, idealists, symbolists, whatever you like, as long as we stop applying to them the inept general name, Impressionists...

"Paul Gauguin seems to me to be one of those sublime visionaries. I believe he is the initiator of a new art..."

In fact, dissatisfied now with the verities of Impressionism, a form of art which, in Gauguin's words, was centred "in the region of the eye and not in the mysterious core of thought," painters and poets were anxiously turning to the as yet unexplored realm of feeling. André Breton can perhaps help us to understand this process of investigating the "particulars of the inner life." In 1958, discussing symbolism in the new edition of his book *Surrealism and Painting*, he wrote: "If nowadays there is one commonplace capable in itself of showing up those who are not above using it, it is surely the trick of applying the epithet 'literary' to any kind of painting which seeks to do more than merely present us with an image of the external world or, in the last analysis, merely give pleasure to the eye... Totally opposed to this kind of empty commentary on a tawdry world is a kind of painting that seeks to react to the world in accordance with the artist's inner need. Priority is no longer given to visual sensation but to the deepest yearnings of the spirit and the heart."

Here Puvis de Chavannes, the traditionalist, and Gauguin, the revolutionary, despite their strong stylistic differences, met on common ground. Both sought to paint an invisible reality, beyond visual appearances, but whereas Puvis confined himself to subject painting, Gauguin tried to penetrate to the very foundations of being.

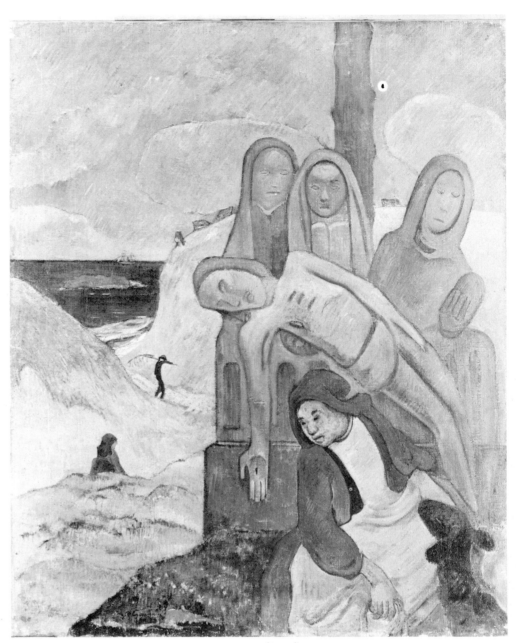

Paul Gauguin (1848-1903): Breton Calvary (The Green Christ), 1889. Oil.

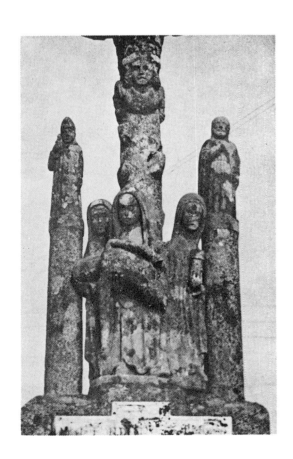

Calvary from Nizon, Brittany. Stone-carving.

Between his return from Arles in December 1888 and his departure for Tahiti in April 1891, Gauguin had numerous contacts in Paris with Symbolist poets and thinkers. Writing in 1903, Maurice Denis, who knew him well, summed up Gauguin's influence on his disciples with great concision, at the same time bringing out the literary influences on the painter's thought: "For Gauguin was not a pedagogue. Yet he was accused of being one, and Lautrec took sly pleasure in calling him a schoolteacher. On the contrary, he was essentially intuitive. His conversation, like his writings, contained apt aphorisms, deep insights, and assertions that, to us, had an amazing logic behind them. I imagine that he did not realize this until later, when, on leaving Brittany—to which his disciples were flocking—when Symbolism in literature was at its height, he went back to Paris and found his own ideas being acutely and systematically set forth by such people as Albert Aurier, for example. Perhaps he was not actually the inventor of Synthetism which, under the influence of the literary world, became known as Symbolism. On this controversial point Emile Bernard is quite categorical. But Gauguin was still the master, the unchallenged master, the man whose paradoxes were collected and repeated, who was admired for his talent, his fluency, his gestures, his physical

strength, his brutal sarcasm, his inexhaustible imagination, his strong head for drink, and his romantic appearance."

Gauguin's ideas triggered off a new daring in the work of a group of young painters studying at the Académie Julian in Paris around 1890: Sérusier, Ranson, Denis, Bonnard, Vuillard and others. Apart from Sérusier, who had been in direct contact with Gauguin since the autumn of 1888, they had all seen his work for the first time at the Café Volpini exhibition in May 1889. In the summer of 1889, Sérusier could still ask, "What part should nature play in one's work? Where do we stop? And from the practical standpoint of execution, should we work from nature or simply look and remember?" But by 1890 Gauguin's spiritual influence on this small group of young painters prevailed.

In his first article, young Maurice Denis, already asserting himself as a theorist, proudly wrote: "Remember that a picture—before being a war-horse, a naked woman, or some anecdote or other—is essentially a flat surface covered with colours assembled in a certain order" (30 August 1890). In thus summarizing Gauguin's ideas, he gave a famous definition of painting whose concision and accuracy were to haunt artists for the next fifty years. Naturalism was definitely dead.

It was at this point that these young painters from the Académie Julian formed a group, calling themselves Nabis (from the Hebrew word for prophet). At Sérusier's instigation, they met every month in costume, carrying episcopal crooks. Each of them had his nickname: Maurice Denis was "the Nabi of beautiful icons," Sérusier "the Nabi of the gleaming beard," Bonnard "the Japanese Nabi" and so on. They also met every Saturday at Paul Ranson's, whose studio was called the Temple, Madame Ranson being known as "the Light of the Temple." Though smacking of both the "in-joke" and the secret society, their meetings were of genuine importance for the future of painting, setting it on the path of spiritual and later even mystic involvement.

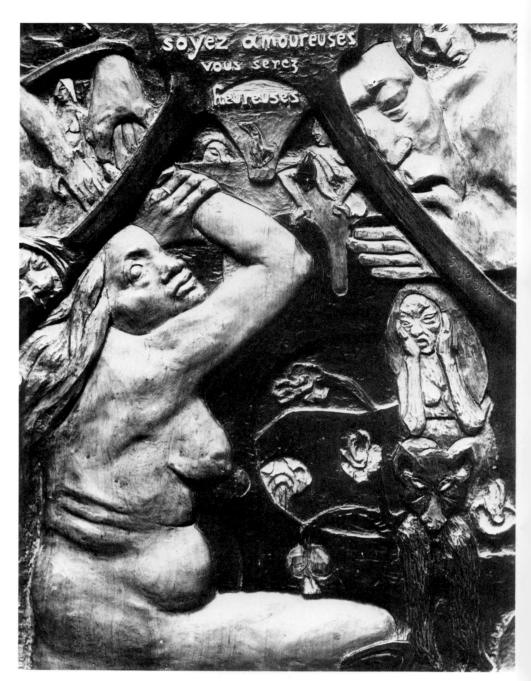

Paul Gauguin (1848-1903): "Be in love and you will be happy," 1890. Wood carving.

"It is the best and strangest thing I have ever done in sculpture. Gauguin (like a monster) taking the hand of a woman who resists, and telling her: *Be in love and you will be happy*. The fox is the Indian symbol of perversity, and in the gaps are some small figures. This wood-relief will be coloured."

Gauguin, letter to Emile Bernard, September 1889

Clothing ideas in visible form

In their battle against the spirit of Positivism, the painters found allies in the writers who reached a wide audience through the various magazines they published. These writers were listed at the end of 1886 in *La Vie Moderne* under the heading "Symbolists and Decadents." They included Verlaine, Mallarmé, Rimbaud, Jean Moréas, Paul Adam, Jules Laforgue, Maurice Barrès and Edouard Dujardin. To these names should be added those of Gustave Kahn, Albert Aurier, Félix Fénéon, Charles Morice, Alfred Vallette and Paul Fort. They set out to be "decadent," as Verlaine understood the term: "I love that word

Decadence, all shimmering as it is with purple... It is a compound of the fleshly spirit and wan satiety and all the stormy splendours of the Late Empire... It smacks of entire peoples exhausted by the drain on their vital energies and collapsing in the flames at the sound of the invading enemy's trumpets."

Foremost among these writers was J.K. Huysmans, whose work conveyed disgust with modern life and the absurdity of a monotonous existence. His novel *A Rebours* ("Against the Grain"), published in 1884, completed the breach with Zola's naturalism, its hero, Des Esseintes, being the very epitome of a hypersensitive "decadent." Huysmans sought refuge from his nihilism by dabbling in the occult until 1892, when he was suddenly converted to Roman Catholicism. He had a great influence on painting: he followed all the Paris exhibitions avidly

and his published criticism was often perceptive, always up-to-date. His judgments on contemporrary art are collected in *L'Art Moderne* (1883) and *Certains* (1889), which show him as an ardent champion of the symbolist painters.

Mallarmé, the eldest of the group, paved the way through both the form and the substance of his writings. He asserted that objects had no reality and that all that could be grasped by the sense was a symbol, i.e. a form capable of leading man to an understanding of the Idea that it reveals and dissimulates at one and the same time, the poet being endowed with the power to deduce its meaning. The Universe is a chaos that both demonstrates and conceals the Absolute.

Sérusier applied this view to painting. "If his art were nothing more than a matter of copying the images he sees by reproducing them on a screen, the painter would be performing a purely mechanical act involving none of mankind's higher faculties: it would mean noting the *impression* without adding anything to it, a mindless activity. Nature understood in these terms is no longer painting."

Every Monday evening the symbolist writers and their friends met at the Café Voltaire in the Place de l'Odéon. Returning to Paris from Brittany in November 1890, Gauguin began attending these meetings and made a great impression on the symbolist poets. Already supporting Puvis de Chavannes, Eugène Carrière and Odilon Redon, they now saw in Gauguin a new and more brilliant incarnation of their theories.

One of the Nabis, the Dutch painter Jan Verkade, recorded his memories of this period: "Although Mallarmé, the poet, deserves to be called the first of the Symbolists, it was actually another man, Jean Moréas, by birth a Greek, who was chosen to initiate the public into the existence of Symbolism. Jean Moréas had already achieved some fame in the literary world, and at the beginning of 1891 had already published a new volume of poetry called *Le Pèlerin Passionné*. On that occasion Mallarmé presided over a banquet given in his honour, which aroused wide interest. From that day, the existence of Symbolism was recognized. For a while, the name of Moréas was on everybody's lips. Even the usually phlegmatic members of the bourgeoisie were greatly intrigued by this remarkable figure and would try to catch a glimpse of him at the Café Voltaire. The meetings held there were very pleasant. All sorts of artistic problems were discussed, without rancour or dissimulation." The same group of poets gave a dinner in Gauguin's honour at the Café Voltaire on 23 March 1891, on the eve of his departure for the South Sea Islands. Since the summer of 1890, he had thought of nothing else but leaving Europe; first he had Madagascar in mind, then decided on Tahiti, where he hoped to take his friends Meyer de Haan and Emile Bernard with him.

The work of Odilon Redon was deeply influenced by the ideas of the symbolist poets. At the time, around 1890, when he attended their meetings at the Café Voltaire, he was known only for his prints and drawings. Born in 1840, he belonged to the impressionist generation, but it was only his juniors, the Symbolists and the Nabis, who appreciated him. Maurice Denis rightly describes him as the "Mallarmé of painting." Redon ventured deeper than anyone else into territory "forbidden" by realism, the realm of dreams and mystery. "My only originality," he wrote in his diary *A soi même*. "consists in letting improbable creatures live like humans, placing the logic of the visible as much as possible at the service of the invisible." In 1881 the poets of the period recognized Redon as a kindred spirit when they saw his charcoal drawings and lithographs displayed first in the office of *La Vie Moderne* and later in that of the newspaper *Le Gaulois*. On 4 March 1882 Emile Hennequin wrote in the *Revue Littéraire et Artistique*: "M. Odilon Redon must henceforth be considered one of our masters... His work is strange; it smacks of the grandiose, the delicate, the subtle, the perverse, the angelic... In art, he passionately looks for new kinds of beauty, strangeness, creation, reverie—new means of expression that are also precious and arresting."

"The sense of mystery arises so long as one keeps to the line of ambiguity, to the dual or triple aspect of things, to the ghost of an aspect, to forms which are on the rise or about to take shape, depending on the viewer's mood. And all these things are more than suggestive since they actually appear."

Odilon Redon

Odilon Redon (1840-1916): Sleep, 1889. Charcoal.

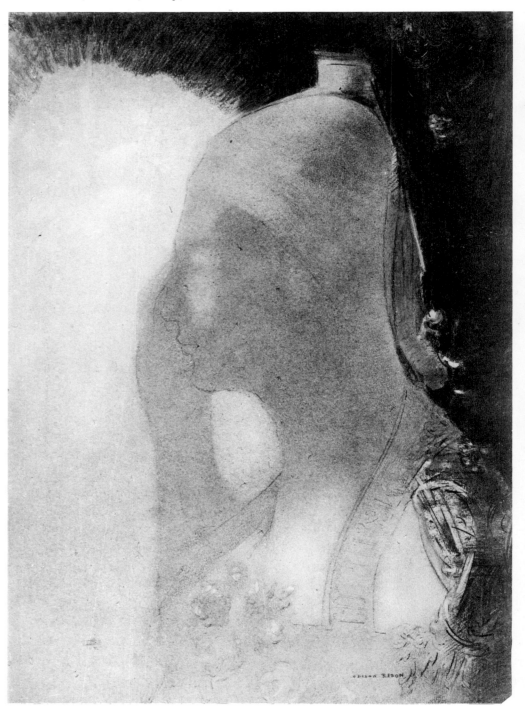

A new generation: the Nabis

The group of painters known as the Nabis first came together in the autumn of 1888 around Sérusier's Breton landscape known as *The Talisman*. They were art students from the Académie Julian or the Ecole des Beaux-Arts and included Denis, Bonnard, Ranson, Vuillard, Roussel, Ibels, Piot and Lacombe, who were later joined by Verkade, Ballin, Rippl-Ronaï, Vallotton and Maillol. In December 1891 they faced the public for the first time with an exhibition at the gallery of the dealer Le Barc de Boutteville. They remained a united group for nearly ten years, meeting "for a monthly dinner, copiously seasoned with paradoxical theories, in the basement of an eating-house in the Passage Brady," Maurice Denis recalls.

Professing to be influenced or at least inspired by Gauguin, the Nabis elaborated far-out theories, which they applied in a variety of ways with numerous incursions into the realm of the decorative arts. In an article on the influence of Gauguin which appeared in the Paris magazine *L'Occident* for October 1903, Maurice Denis explained: "The secret of his ascendancy was that he supplied us with one or two very simple ideas, whose utter truth stared us in the face, at a moment when we were completely untutored. Thus, without ever having pursued beauty in the classical sense, Gauguin almost immediately engaged us in a preoccupation with it. His main aim was to render character, to express the 'inner significance,' even in ugliness. He was still an Impressionist, but he professed to be a reader of the book

Edouard Vuillard (1868-1940): In Bed, 1891. Oil.

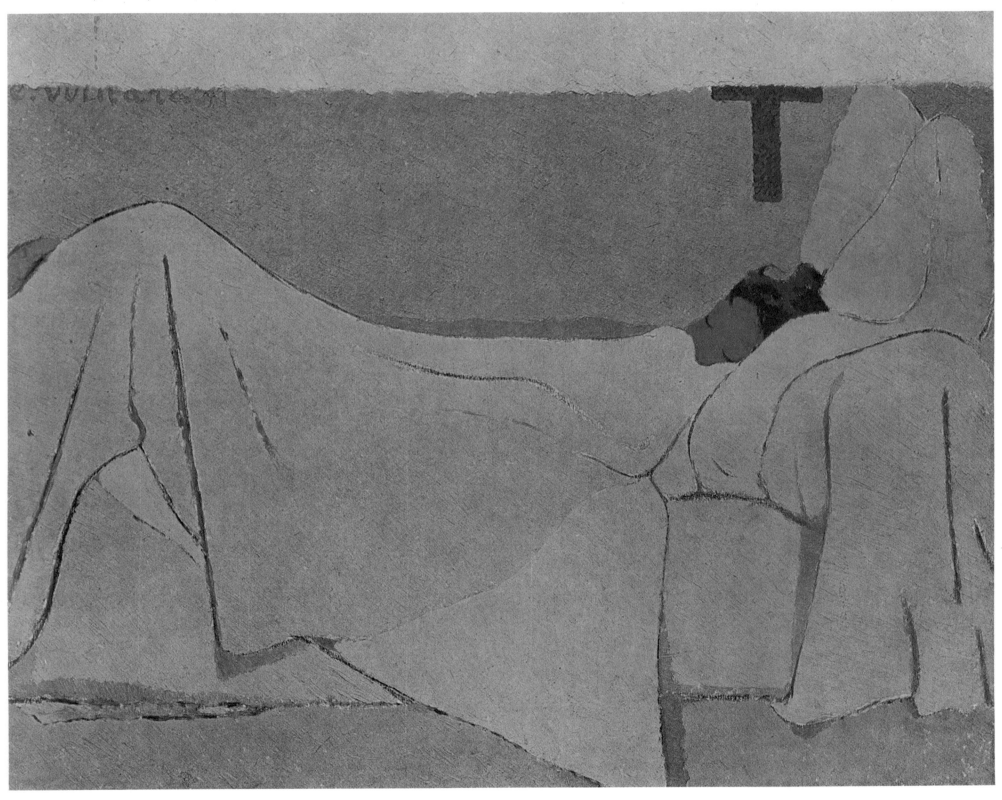

'wherein the eternal laws of beauty are inscribed.' A fierce individualist, he nevertheless subscribed to the most universal and anonymous folk traditions. From these contradictions, we derived a law, a lesson, a method."

In his theoretical writings, Maurice Denis gives a penetrating analysis of the aspirations of the Nabi painters, who were his close companions for a number of years. In May 1909, in an article entitled "From Gauguin and Van Gogh to Classicism," published in *L'Occident*, he told of his early experiments, stressing not only Gauguin's contribution and his aspirations towards a "primitive" art, but also the quest of the younger painters for a poetic transposition of forms and colours. "The critics of the time reproached us with deliberate inarticulacy. And in fact we did act the fool and behave childishly, since it was probably the most intelligent thing to do just then. Ours was an art of savages, a primitive art. The movement of 1890 was the product of both a state of extreme decadence and a ferment of renewal. It was the moment when the swimmer plunges down to the solid rock at the bottom and floats up again."

For the Nabis, Gauguin's example and that of Japanese prints of which Bonnard in particular was so fond opened up the possibility of greater visual freedom. It was, however, Gauguin's manner rather than his subject-matter that attracted them. Gauguin felt himself an outsider in the France of his day and drew his themes from other civilizations, whereas the Nabis, thoroughly at home in Paris, were inspired by the intimate, sheltered atmosphere of French bourgeois life, applying their master's style with subtlety and sensitivity to scenes from the everyday life of a very well-defined period, their own: Paris, the street, drawing-rooms, etc. These scenes are often interpreted with great poetic feeling, employing colours that are at once both flat and delicate to achieve a subtle, almost musical harmony that heralds certain later developments, notably in the work of Braque. The impression of mystery and silence created by the best of their works conceals an astonishing perspicacity, a remarkable awareness of technical possibilities and an uncommon capacity for synthesis.

The works of the Nabis clearly show the link between these artists and the literary avant-garde of the time, the symbolist poets. Artists and writers attended the same meetings in the same cafés, wrote for the same periodicals (the most famous of them, *La Revue Blanche*, made its appearance in 1891) and were swept up into theatrical activities in the wake of the actor and producer Lugné-Poe, a schoolmate of Maurice Denis. The latter, in his reminiscences on "The Symbolist Period," wrote:

"In May 1891 the Théâtre d'Art troupe gave a benefit performance for Gauguin and Verlaine at the Théâtre du Vaudeville: *Chérubin*, a three-act play by Charles Morice, the future editor of Gauguin's book *Noa Noa*; *Les uns et les autres*, a one-act play by Verlaine; and, most important of all, a one-act play called *L'intruse*, which brought the name of Maeterlinck before the Parisian public for the first time ...

"We painted scenery for Paul Fort's Théâtre d'Art and for Lugné-Poe's Théâtre de l'Œuvre. What scenery! And for what plays! From Ibsen and Maeterlinck to *Ubu-Roi*—a whole series of discoveries and revelations. The art of the producer was also transformed, realism being outlawed in favour of the imagination, of scenery with a dreamlike quality."

All this activity in the theatre had its origin in one of the principal tenets of the Nabis: to bring art into everyday life. In

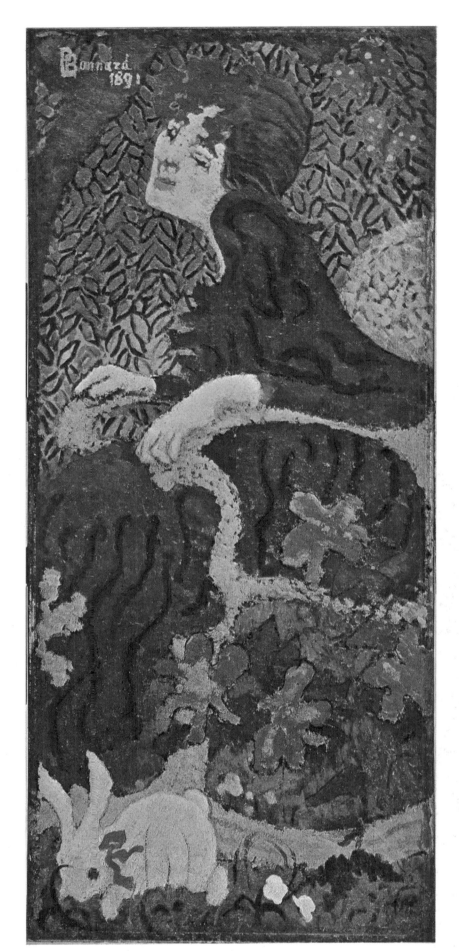

Pierre Bonnard (1867-1947): Woman with a Rabbit, 1891. Oil.

Bonnard's words: "Our generation has always sought the links between art and life." Or, as Bonnard's nephew Antoine Terrasse reports him as saying: "At this period, I personally had the idea of producing everyday objects for a popular market—prints, furniture, fans, screens, etc." And, in fact, a number of the Nabis devoted themselves to ornamental art in the form of tapestries and frescoes.

Whereas the scientific trends that were reflected in painting by Neo-Impressionism had dominated the decade 1880-1890, Symbolism and mysticism were the two most prominent features of the closing years of the nineteenth century. Both the Symbolists and the decadents seemed to oscillate between the most lofty spiritual aspirations and a taste for the licentious—God and the Devil—and they often combined the two.

Thus the symbolist painters and poets either turned to Christianity or were fascinated by the realms of magic and "the beyond." This revival of a certain form of mysticism found a large audience because of its decorative aspect, and it was catered for in the 1890s by two series of annual exhibitions: one was the Salon des XX held by the Twenty in Brussels; the other was the Salon de la Rose-Croix in Paris, sponsored by a group with Rosicrucian ideas for the avowed purpose of "destroying Realism and bringing art closer to Catholic ideas, to mysticism, to legend, myth, allegory and dreams."

The first Rose-Croix Salon opened on 10 March 1892 at the Durand-Ruel Gallery, and in the world of art it was the event of the year. No less than 22,600 people flocked to see it, according to the organizer, Joséphin Péladan, who assumed the title of Sâr or magus and made it his mission to revive the esoteric traditions of the Chaldeans. His activities were financed by an "archon" or chief executive, Duke Antoine de La Rochefoucauld, a

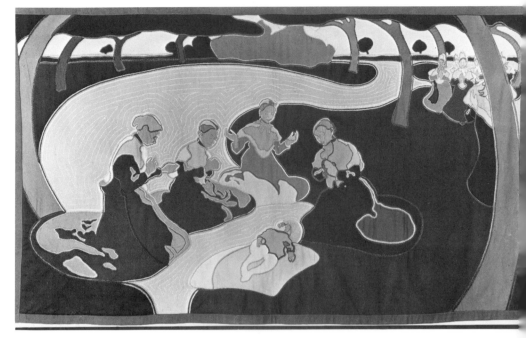

Henry van de Velde (1863-1957): The Vigil of the Angels, 1893. Tapestry.

The Rose-Croix and the Twenty

Ferdinand Hodler (1853-1918): Night, 1889-1890. Oil.

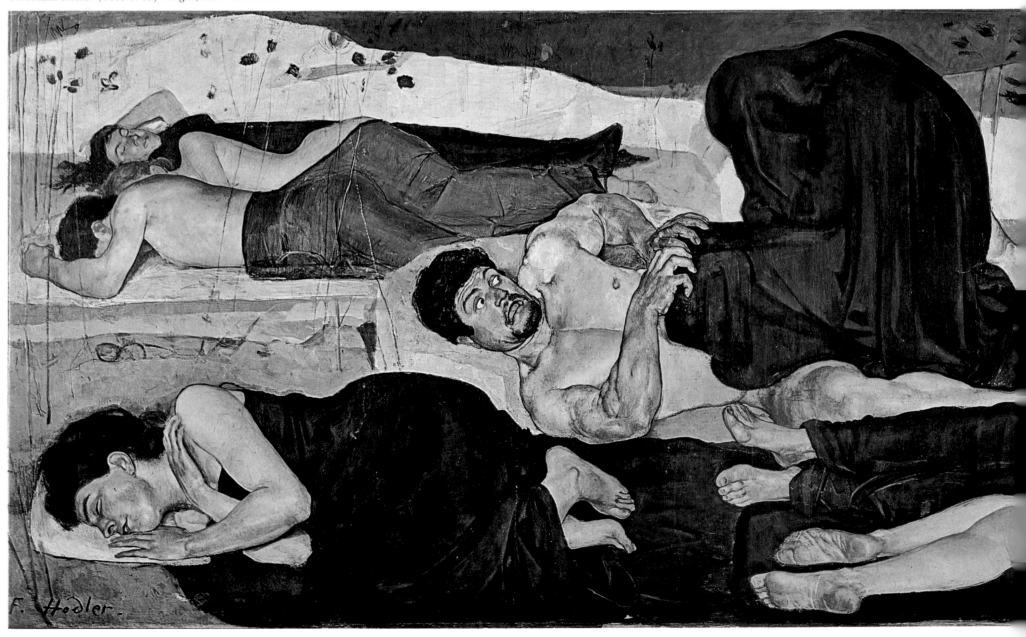

"They have the great merit of having disregarded that silly prejudice, taught in all the schools and so baneful to the artists of the past: that it is enough for the painter to copy what he sees, like a fool, as he sees it; that a picture is a window open on nature, and that art is a matter of accurate rendering.

"For these artists, on the contrary, a picture before being a representation of anything whatever is a flat surface covered with colours arranged in a certain order, and for the pleasure of the eyes.

"In their works they have preferred expression by the pattern, by the harmony of forms and colours, by the texture of the paints, to expression by the subject. It is their belief that every emotion, every human thought, has its pictorial and decorative equivalent and a corresponding beauty. And it is probably to ideas like these that we owe, among other things, the art of the primitives, the Gregorian chant, and the Gothic cathedrals."

Maurice Denis, preface to the catalogue of the fourth Exhibition of Impressionist and Symbolist Painters, Galerie Le Barc de Boutteville, Paris, 1895

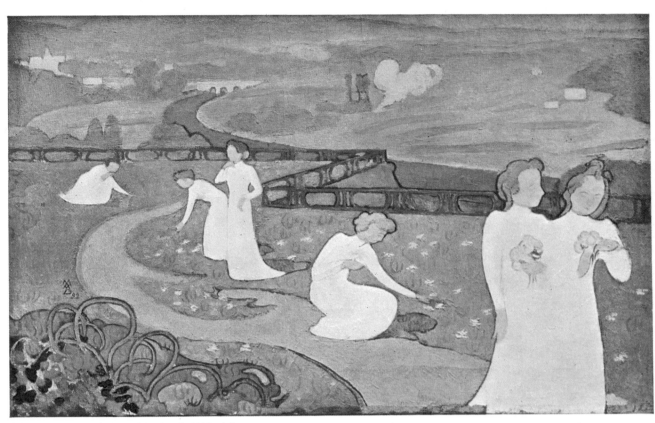

Maurice Denis (1870-1943): April, 1892 Oil.

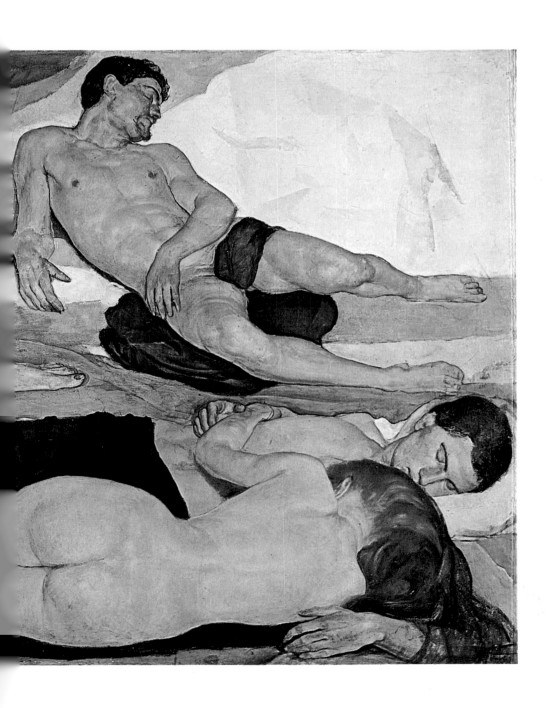

prominent member of aristocratic society converted to Rosicrucianism. Despite the conspicuous absence of some of the great names of symbolist painting, such as Puvis de Chavannes, Odilon Redon and Gustave Moreau, and of Burne-Jones (one of the English Pre-Raphaelite painters and himself a prey to religious anxieties), sixty-nine artists took part, including friends and disciples of Gauguin (Emile Bernard, Filiger and Vallotton) and representatives of European Symbolism such as Hodler, Toorop, Schwabe, Grasset, and—from Belgium—Khnopff, Delville and Minne.

Hodler, a Swiss artist, had scored an enormous success at the Paris Salon of 1891—later at Munich, Vienna and Berlin—with a painting entitled *Night*. In this composition, he developed for the first time the monumental and decorative parallelism that was to be the keynote of his style. In the *Paris* newspaper on 15 May 1891, Arsène Alexandre wrote: "*Night* is the title given by Mr Hodler to a terrifying painting of rigid slumbering figures. Some are untroubled and breathing evenly. Others are haunted by a swarm of evil dreams, oppressive nightmares wrapped in mourning-cloth. The sleepers are working-class types, the drawing is violent and hard, the colour thick and heavy, and yet the overall impression is one of such ferocious energy and asserts the close relationship between sleep and death in such a brutal way that, once seen, this picture can never be forgotten."

At the Salon des XX in Brussels, which welcomed avant-garde art, Pointillism was ousted by Symbolism. The tenth, and last, of these exhibitions was held in 1893, when Octave Maus, the founder of the group, requested its dissolution. From its ashes was born "La Libre Esthétique" in which Art Nouveau would be predominant. Although he had been one of the first Belgian disciples of Pointillism, Henry van de Velde went over to the symbolist camp. Belgium was one of the most fertile terrains for these precursors of Surrealism, and there were a number of exchanges between Belgian Symbolists and the Rose-Croix group.

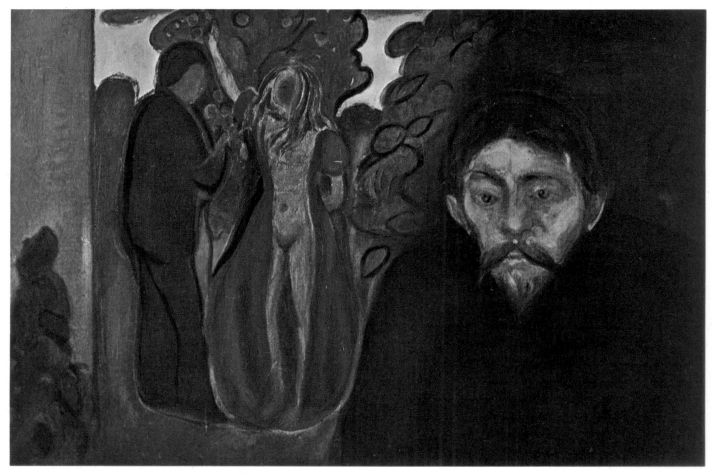

Edvard Munch (1863-1944): Jealousy, 1890. Oil.

The Nabis and the Symbolists of whom we have just spoken overcame their fears and misgivings through the sensitivity with which they approached the problems of pure painting. Among the Nordic artists, however, a wave of despair coupled with a sense of the absurdity of the human lot was sweeping away the last vestiges of complacency. The fundamental questions raised by Kierkegaard and reiterated in the works of Dostoyevsky and Nietzsche and the obsessional neuroses later revealed by Freud are illustrated in brutal fashion in the work of Edvard Munch. There could be no greater contrast to the quiet intimacy and graceful acceptance of, say, Vuillard than the Norwegian painter's shrill and horrifying cry of anguish, which sums up the atavistic fear of Northern man in face of a world seemingly peopled by obscure and hostile forces. For the younger artists of Northern and Eastern Europe, Munch came to fulfil the role of a Cézanne.

The early life of Edvard Munch, who was born in 1863 at Løten in Norway, was marked by tragedy. Tuberculosis carried off his mother and one of his sisters when he was still a child, and he was never to forget the long death-bed vigils, the absence, the silence, and the void. The theme of death became an obsession that was to remain with him all his life, and his strict, puritanical upbringing aggravated his acute sense of isolation. Very soon he was drawn to art as offering the only reply to his anguished self-questionings. In 1885, after art studies in Oslo, he spent a short time in Paris. The following year he exhibited his first important work, *The Sick Child*, in which he introduced us into his world of death-chambers and mourning. In 1889 he returned to Paris where, although he worked in Bonnat's studio, he spent most of his time in the discovery of modern art, notably Neo-Impressionism and Symbolism. This was also the period when the Scandinavian writers, Ibsen and his friend Strindberg,

were making their mark in Paris at the Théâtre de l'Œuvre and in the literary magazines.

In 1892 Munch was invited by the Society of Artists in Berlin to exhibit some twenty pictures there; the exhibition created a scandal. The reaction was so violent that the show had to be closed almost before it opened. The German art world had been dominated by academicians and court painters, but the closure of Munch's exhibition provoked a group of younger artists to found the Berlin Secession. At the instigation of Fritz von Uhde, artists in Munich formed a Secession group of their own. Thus German art found the structures that would enable it to develop in complete freedom, and Munch was thereafter to figure as one of its heroes.

He also exhibited at the Art Nouveau exhibitions in Paris in 1896 and 1897, but there was not the same response to his work in France as there had been in Germany.

In an article on Munch in *La Revue Blanche* in 1896, Strindberg wrote: "Munch, the esoteric painter of love, jealousy, death and grief, is often the subject of deliberate misunderstanding on the part of the axe-wielding critics, who exercise their trade impersonally at so much a head, like executioners." He had in fact had a cool reception from the French press, with the critic of *Le Soir*, for instance, informing his readers of "horrors in which no trace of an interesting conception or satisfactory execution can be discerned."

Munch's themes are like sketches for an autobiography. *Jealousy*, for example, was inspired by a crisis in his life in Berlin when both he and Strindberg fell in love with the same woman, who to crown it all was the wife of a mutual friend. But jealousy actually brought the friends closer: like many artists of this period, Munch had a concept of the Eternal Woman as someone at once angelic and devilish, an intoxicating sexual partner of

demoniacal perversity luring men on to death by erotic means. "In her diversity, woman remains a mystery to man—woman, who is at one and the same time a saint, a courtesan and an unhappy lover," he wrote.

The Cry also had its origin in a personal experience, which Munch described in 1895: "I was walking down the road with two friends. It was sunset, the sky became blood-red and I felt a breath of melancholy come over me. I stopped and leaned on the fence, dead-tired. Over the town and the blackish blue fiord hovered some clouds like spots of blood and tongues of fire. My friends went on their way. I was at a standstill, trembling with anguish. I seemed to hear the immense and infinite cry of nature."

The power of Munch's art resides not only in his themes but also in the dynamic quality of his spatial relationships, his contrasts of values and his strident colours. His drawing is dominated by the spirals that were to play so great a part in Art Nouveau or (as it was called in Germany) Jugendstil; they are swept along by their own sensual movement into a vortex that winds up in indecision and nothingness.

What is often merely playful in the work of many aesthetic artists is brought to a paroxysm of tension by Munch, who paints under the violent stress of emotion. His language is uncompromising, and the quality of his work is directly linked with the truthfulness of the feeling that prompted it. The abyss opens up, and man is merged with the unconscious.

Edvard Munch (1863-1944): The Cry, 1893. Oil.

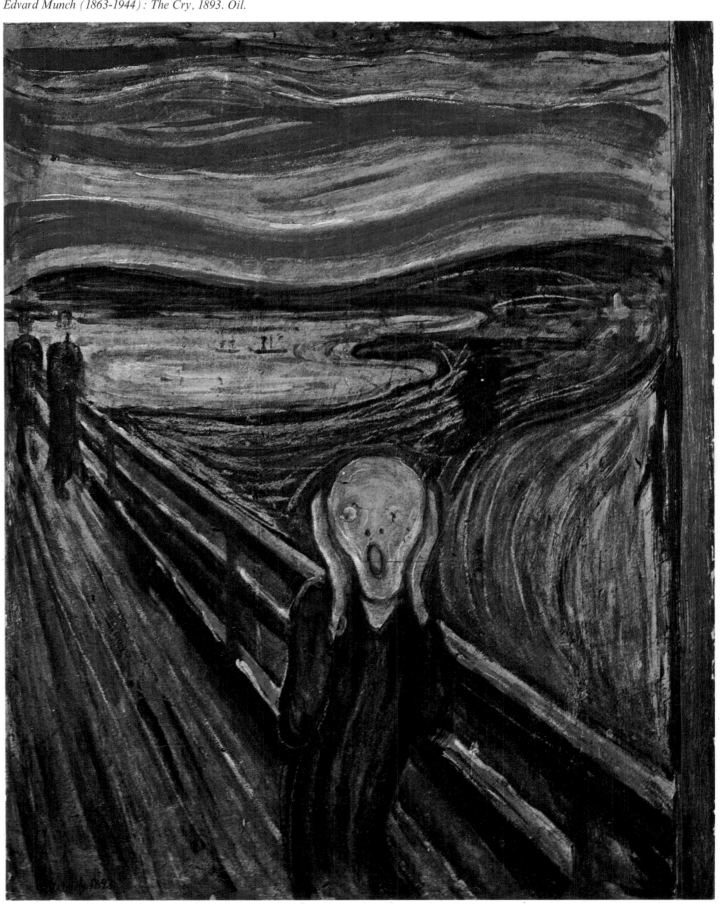

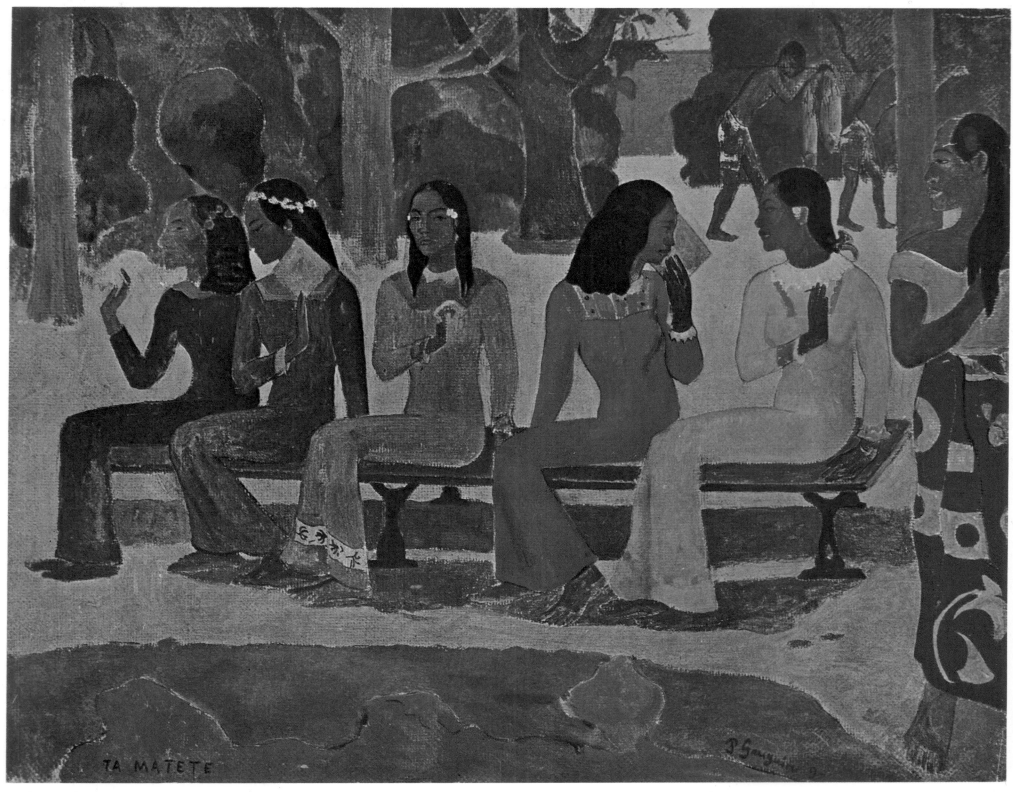

Paul Gauguin (1848-1903): Ta Matete (The Market), 1892. Oil.

Gauguin: from the primitive to the barbaric

"Paul Gauguin seems to me to be one of those sublime visionaries. I believe he is the initiator of a new art, not historically, but at least in our own time." In these words, Albert Aurier justified his long study of Gauguin's work in the *Mercure de France* for March 1891. Gauguin was just then enjoying a brief moment of fame of a kind he was not to experience again: thirty of his works which he had put up for sale in an auction at the Hôtel Drouot had brought him in the respectable sum of 9,350 francs, thanks to a publicity campaign mounted by his literary friends in the leading newspapers.

This well-orchestrated campaign started with an article by Octave Mirbeau in the *Echo de Paris*, which was used by the artist as the preface to the catalogue of his sale. "I hear," wrote Mir-

beau, "that Mr Paul Gauguin is about to leave for Tahiti. His intention is to live there alone for a number of years, to build himself a hut and there to set to work anew on the things that fill his mind. The idea of a man fleeing civilization, deliberately seeking oblivion and silence in order to achieve greater self-realization, to hear more clearly those inner voices too often stifled by the sound and fury of our passions and quarrels, strikes me as both unusual and moving. Mr Paul Gauguin is a most exceptional and most disturbing artist, who does not often submit his works to the scrutiny of the public and is accordingly little known."

On 4 April 1891 Gauguin embarked at Marseilles to realize his old dream of breaking with the West where "the artist cannot work at his art." In the previous summer he had already chosen Tahiti as his destination. "The outlook for our children is a bleak one, even with a little money, in this rotten and wretched Europe of ours. The Tahitians, on the other hand,

living happily in their remote South Sea paradise, only know the good things in life. For them, to live is to sing and to love" (letter to Schuffenecker).

On 8 June, after a voyage of sixty-three days, Gauguin arrived at Papeete, the port town and capital of Tahiti. The island had been ceded to France in 1880 and he found life there too Europeanized; he was won over, however, by the ways of the natives and went to live in a hut by the sea. In July he wrote to his wife: "I have now been here for twenty days and have already seen so much that is new that I am quite confused. It will be some time yet before I can produce a good picture, but I am setting about it gradually by studying a little each day … The silence at night in Tahiti is the strangest thing of all. It is unique—not even the cry of a bird to disturb one's sleep. Here and there a large dry leaf may fall to the ground, but fails to convey the idea of noise. It's more like a ghost rustling by… Ever and always this silence. I can understand why these people are capable of sitting for hours on end, for whole days, looking mournfully at the sky without saying a word. I feel that all this will become part of me."

Later, in *Noa Noa*, a kind of diary of his mental life and preoccupations in Tahiti, he wrote: "Civilization is receding from me little by little. I am beginning to think simply, to have less hatred for my neighbour—better still, to love him."

As he gradually grew poorer, however, he was tempted to give it all up, but (as he wrote to Sérusier) "on the other hand, I want to stay on. I haven't finished my work; indeed, I have barely started it, and I feel I can make a good job of it … I hardly dare discuss what I am doing here, my paintings scare me so much, and I know that the public will never stand for it. It is ugly from every point of view and I will only really know what it means when you have seen it all, back in Paris … What a religion this ancient South Sea religion is! Truly marvellous! My head is bursting with it and people are going to be frightened by all it suggests. If they dreaded my earlier works, what are they going to say about the new ones!"

He was fully aware of the revolution he was bringing about in his art by endowing the form with such "primitive" intensity and the colour with its full charge of symbolism and truth. He absorbed the exotic environment, let himself succumb to the "natural" life-style of the natives, fathomed the mysteries of the objects in everyday use among them, penetrated the secrets of a religion wholly based on cosmic impulses, and observed his native wife Tehura in her daily life.

In March 1892, when he was lying sick in Papeete Hospital, he happened to be given a book to read called *Voyages aux Iles du Grand Océan* (Paris, 1837). Written by J. A. Moerenhout, consul of the United States and then also of France in Tahiti, this book contains a valuable account of the native customs, language and religion, and it gave Gauguin ideas and subjects for many paintings. In a notebook he copied out some of the legends recorded by Moerenhout and decorated them with drawings and watercolours; to this illustrated manuscript he gave the title *Ancien culte mahorie* ("Ancient Maori Worship") and it was later published in a facsimile edition (Paris, 1951).

Despite his desperate financial situation and precarious state of health, he remained convinced that he had found the ideal place for his art. "I am hard at work, now I know the soil and its smell, and the Tahitians—in spite of the highly enigmatic way in which I portray them—are real Maoris, not stage Orientals. It

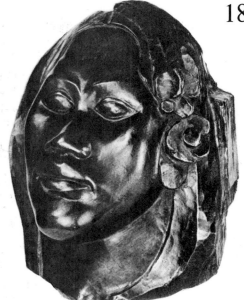

"Gauguin is the painter of primitive natures: he loves and possesses their simplicity, their suggestive hieratism, their rather awkward and angular naïveté. His figures have the untutored spontaneity of virgin flora.

"It was therefore logical that he should exalt, for our eyes to feast on, the profusion of this tropical vegetation where a free and paradisiac life luxuriates under happy stars; and is conveyed here with a prestigious magic of colours, yet with no unnecessary ornament, no redundancy, no Italianism."

These comments by Achille Delaroche, quoted by Gauguin in his book *Avant et Après* (1903), emphasize the importance of Oceanian primitivism. Turning away from realism, Western artists went in search of different ways of life and expression. In Tahiti Gauguin was struck as much by the ethnic type and native lifestyle as by the climate and local crafts. Tahiti for him was a return to pure nature and non-

Paul Gauguin (1848-1903): Bronze mask of a Tahitian woman after the original wood carving of about 1892.

civilization; there, he found, works of art were less abundant than in other islands. Stone is scarce and the absence of minerals limits the making of tools; ceramic ware is also scarce. While it is impossible now to know what pieces of native work Gauguin came across or collected, it is safe to say that they were wood carvings: elements of oars and pirogues or posts and friezes adorning huts. Oceanian art was best known to him through such everyday objects as basketwork, hand-woven fabrics, utensils and tattooings. As for *tikis*, the figures of the gods, there were few to be seen in Tahiti where the Maori religion had no longer been practised since the death in 1830 of the last high priest.

has taken me nearly a year to understand these things," he wrote to his wife Mette in Copenhagen. But in May 1893 he took ship again and sailed back to France, leaving behind Tehura and his child. He arrived in Marseilles on 3 August, reaching Paris three days later.

During this first stay in Tahiti (June 1891-May 1893), Gauguin painted some sixty pictures, and when he ran out of canvas he turned to sculpture, often taking his inspiration from the grain of the wood. Utterly destitute on his return, he had to find some way of exhibiting his work in Paris. At the urging of Degas, who bought one of his Tahitian pictures, *The Moon and the Earth*, the Durand-Ruel Gallery agreed to exhibit his most important works from Tahiti. The exhibition opened in November and had a mixed reception. Pissarro noted bitterly (23 November 1893): "He is always poaching on other people's preserves; today he is pillaging the South Seas." In Paris Gauguin took up again with his symbolist friends, including Mallarmé and also Charles Morice, with whom he had previously been on bad terms. Morice agreed to collaborate with him on a book about Tahiti, "which will be very useful in making my pictures understood." This book was *Noa Noa* (definitive edition, Paris, 1929).

Between writing *Noa Noa* and making woodcuts for it, he had little time for painting. However, late in 1893, he did produce a particularly daring portrait of his mulatto mistress, Annah the Javanese; in the effectiveness of its forms and colours, this picture was the fruit of his accumulated experience.

An unexpected legacy of 13,000 francs from his uncle Isidore Gauguin set him on his feet again and in April 1894 he went back to Brittany. But his money was soon spent. He broke his ankle in a brawl and returned penniless to Paris, where he found that Annah had left him, taking the contents of the studio with her. There was nothing for it but to sail away again.

A Tahitian version of Manet's *Olympia*, of which he had made a copy before his departure in 1891, *The Spirit of the Dead Watches* was one of Gauguin's personal favourites among his own canvases. How much store he set by it can be seen from a letter to his wife, written from Tahiti on 8 December 1892:

"Naturally, many of the pictures will be incomprehensible and you will have plenty to amuse you. So that you can understand and, as they say, act smart, I'll give you an explanation of the most difficult one, which is also the one I'd like to keep for myself or sell for a lot of money. The *Manao Tupapau*. I painted a girl in the nude. In that position, a trifle can make it indecent. But I wanted her that way, the line and movement interested me. A European girl would be embarrassed to be found in that position; not so, the woman here. Then I add a touch of fear to her features. This fear has to be conveyed, if not explained, and indicates the character of the model, a Maori girl. These people by tradition are very much afraid of the spirit of the dead. I have to account for her fear with a minimum of literary devices, such as were used in the past. So I proceed as follows. Overall harmony, sombre, sad, frightening, resounding in the eye like a death knell: violet, dark blue and orange-yellow. I do the bedding in greenish yellow: (1) because this native woman uses a different kind of bedding from ours (beaten tree-bark); (2) because it evokes a suggestion of artificial light (Kanaka women never sleep in the dark) and yet I don't want the effect of lamplight (too common); (3) by linking the orange-yellow and the blue, this yellow completes the musical harmony. There are a few flowers in the background, but as figments of the imagination they should not be real, so I make them look like sparks. For the Kanakas, things that glow in the night are emanations of the spirit of the dead; they really believe this and are frightened by them. To complete the picture, I paint the ghost simply as a little old woman; because, not being familiar with the repertoire of French ghosts, the girl can only associate the spirit of death with an actual dead person, i.e. someone like this... Finally, the painting has to be done very simply, because of the artless, childlike nature of the subject."

When he speaks of it in *Noa Noa*, it is difficult to know whether it was the experience described that suggested the picture to him or the picture itself that brought out the poet in him:

"I lit some matches and looked ... Motionless, naked, lying flat on her stomach on the bed, her eyes huge with fear, Tehura gazed at me but did not seem to recognize me. I waited a few moments, feeling strangely hesitant. Tehura's terror seemed to communicate itself; it was as though a phosphorescent light streamed from her staring eyes. I had never seen her so beautiful, and never had her beauty seemed so moving. Standing there in a twilight that could well be haunted by dangerous apparitions, by equivocal forms, I was afraid that the slightest gesture on my part would provoke her to a frenzy of terror. How could I tell how she saw me at that moment? Did she perhaps take me, with my troubled face, for one of those demons or spirits, the *tupapaus* that, according to the legends of her race, haunt people as they lie awake at night? Could I even tell what she really was herself?

"Finally, she came to her senses ..."

In the notebook he wrote for his daughter Aline, he again describes *The Spirit of the Dead Watches*, but less dramatically: "Let me recapitulate. The musical part: undulating horizontal lines; harmonies of orange and blue, linked by yellows and purples; their derivatives, lit by greenish sparks. Literary part: the Spirit of a living girl linked with the Spirit of the dead. Night and Day.

"This account is written for those people who always want to know the *why* and the *wherefore*.

"Otherwise, it is simply a study of a South Sea nude."

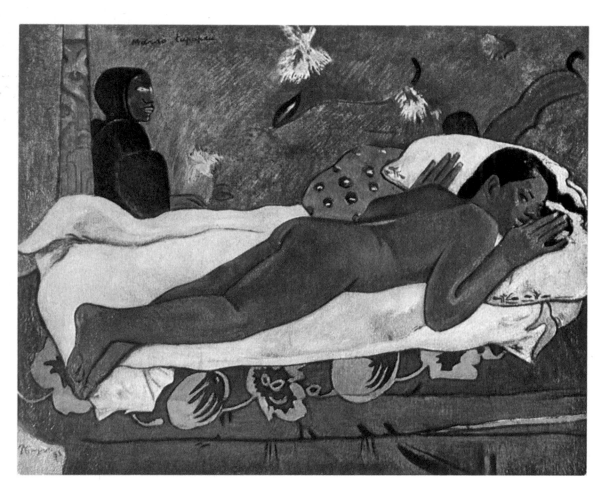

Paul Gauguin (1848-1903):
Manao Tupapau (The Spirit of the Dead
Watches), 1893. Oil.

The spell of the imaginary

About the time when Gauguin felt the urge to go into exile in order to find his bearings in an "alien" world, Gustave Moreau, who interpreted the most ancient myths of Western civilization in a modern way, bringing out their symbolism, was at the height of his career in Paris, being appointed Professor at the Ecole des Beaux-Arts in 1892.

Jean Lorrain, a poet of symbolist leanings, describes Moreau as follows in his *Souvenirs*: "A visionary like none other, he made the land of dreams his own, but from the madness of his dreams a sense of anguish and despair found its way into his works. A master sorcerer, he cast a spell over his period, enthralled his contemporaries, and brought a tinge of idealism to the sceptical and practical *fin-de-siècle*. Under the influence of his painting, a whole generation of young men have grown up doleful and languid, their eyes obstinately turned to the past and the magic of other days; a whole generation of men of letters, especially poets, have become nostalgically enamoured of slender Salomes glittering with jewels, of Muses carrying blood-drained severed heads..."

Though Moreau and Gauguin differ in style, they have the same awareness of the evocative possibilities of painting, of the music of forms and colours. The following statement by Moreau could well have been made by Gauguin: "If one thing predominates in my work, it is the lure and the ardent yearning towards abstraction. While I am certainly interested in human feelings and passions, I am less concerned with expressing emotion than with making visible, as it were, those inner flashes that are of uncertain origin but have something divine about them and, when interpreted in terms of pure painting, open up magic horizons."

Like most of the artists of their time, Gauguin and Moreau surrendered to the blandishments of eroticism, using it as a vehicle for new forms. In their works, mysticism and sensual appeal merge in a wish-fulfilling dream in which every principle and every taboo are flouted. Art becomes a means of liberation, and dreams make it possible to illustrate realities repressed by social and moral taboos.

It is no mere coincidence that Sigmund Freud's studies were starting to appear just then, among them being *The Interpretation of Dreams*, published in 1900, which showed the importance of the dream as the disguised realization of unacted desires.

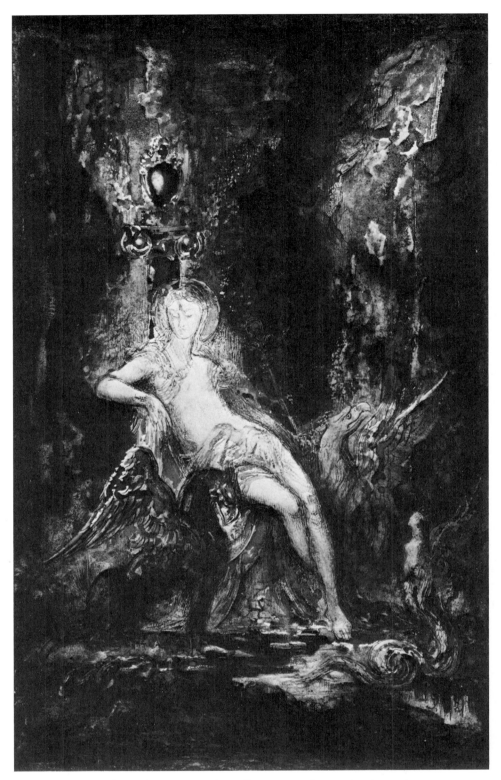

Gustave Moreau (1826-1898): Fairy with Griffins. Watercolour, undated.

"Nude female forms: golden, bronzed, of hues at once sombre and ardent. They have been burnt by the sun, but imbued with it also. The sun is within them, radiating from them, and these forms of darkness conceal the most intense degrees of luminous warmth. At first, by this light, the soul may seem to you transparent of these creatures ever quick to laugh, ever bold to take their pleasure, nimbly, vigorously, amorously, like the great enfolding flowers around them—of these indolent and unruly, loving and frivolous, stubborn and fickle girls, gay in the morning and all day long, sad and trembling as soon as evening falls and all night long: so light may dazzle just as it illuminates. The sun unveils all secrets except its own. These dark foci of glowing life, the Maoris, beneath an appearance of frankness and plain-dealing, have secrets of their own perhaps, deep in their souls. Already, between the architectural majesty of their beauty and the childlike grace of their gestures, there lies a divergence."

Charles Morice and Paul Gauguin, *Noa Noa*, 1901

Georges Rouault, who was Gustave Moreau's pupil at the Ecole des Beaux-Arts in the 1890s, records in his *Réflexions et Souvenirs* the master's answer to the following question:

— *Do you believe in God?*
— *I believe in Him alone. I believe neither in what I touch nor in what I see and only in what I feel. My brain and my reason seem to be ephemeral and of dubious reality. My inner feeling alone appears to me eternal and unquestionably certain.*

Pictorial sculpture

Medardo Rosso (1858-1928): Evening Impression on the Boulevard, 1893. Wax.

Auguste Rodin (1840-1917): Bronze statue of Balzac on the Boulevard Raspail in Paris.

Under the impact of Positivism, the growing secularization of life and the worship of machinery, the nineteenth century reduced sculpture to a minor role and limited it to classical forms and subjects—busts, public and funerary monuments, and official allegories. There was no room for monumentality in middle-class life. Finding no place for his work in architectural design and deprived of patrons, the sculptor became an outcast among artists or put his talents in the service of commemorative programmes that only deflected him from his true preoccupations. Only a few, notably Rodin in France and Medardo Rosso in Italy, overcame the difficulties in their way and succeeded in creating a style. Long after the painters they arrived at an impressionist vision by rejecting static forms and rendering movement in the full glow of light, essentially by means of modelling. Arriving in Paris in 1884, Medardo Rosso began in the 1890s to enjoy a considerable success.

Rodin's *Balzac* was the great art scandal of the 1890s in Paris. Through his friendship with Zola, Rodin was commissioned in 1891 by the Société des Gens de Lettres to design a Balzac monument. With characteristic thoroughness he first consulted every possible source that might help him to recreate the physical and moral image of the great novelist; he even sought out Balzac's tailor in order to ascertain his exact measurements! In 1893, after being blamed for incurring a delay, he submitted his design: it was judged to be "artistically inadequate" and dismissed as a "colossal foetus." Undaunted, Rodin went ahead on his own and finally presented his Balzac statue at the Salon of 1898, where it was again condemned. One of the few dissenting voices was that of the young sculptor Bourdelle, who said: "Here he shows us the way." The Society of Men of Letters refused the statue and Rodin refunded the money he had received. Not until 1939 was his *Balzac* finally set up in Paris on the Boulevard Raspail.

IN SEARCH OF A NEW ART

Writing of his visit to Chicago in 1893, the French novelist Paul Bourget had some surprising things to say: "There is so little oddity or fantasy in its buildings and streets that it seems the work of some impersonal, irresistible power, as mindless as a force of nature, in whose service man has been nothing but a submissive agent. This power is precisely the passion for business ... which gives this city a touch of tragedy and, to my mind, poetry."

Once freed from its dependence on stone, architecture was also freed from historical models. Until then, emphasis had been

Daniel Burnham (1846-1912) and John Root (1850-1891): The Reliance Building, Chicago, 1890-1895.

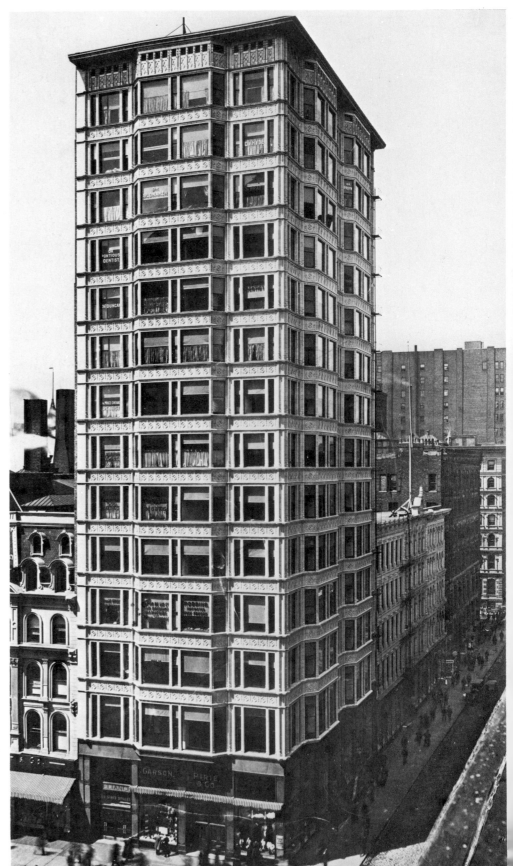

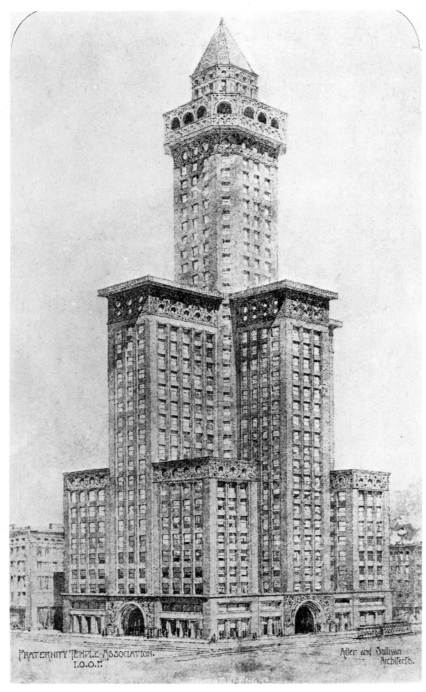

Louis H. Sullivan (1856-1924): Design for the Fraternity Temple, Chicago, 1891.

From the end of the 1880s, the city of Chicago grew enormously in economic importance, with a corresponding increase in size. The invention of the skyscraper by William Le Baron Jenney brought a revolutionary solution to its problems of growth. No other city at that time could be compared to Chicago, where the proliferation of apartment blocks and office buildings led to the adoption of new and unprecedented building techniques. Masonry walls disappeared, to be replaced by metal structures enclosing the interior space by means of large glass bays leaving no corner in darkness. The new techniques for the construction of office buildings were also used for private apartments from 1890 onwards. Each unit was a free space that could be divided up as its user wished. With the discovery of pure volume, a new style was born.

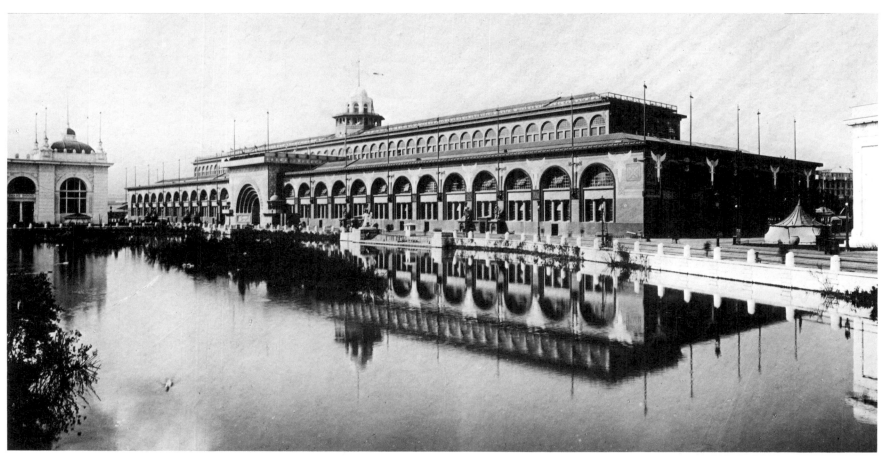

Louis H. Sullivan (1856-1924): The Transportation Building at the World's Columbian Exposition, Chicago, 1893.

laid on façades, which were expected to recall illustrious examples from the past; in Chicago, the architects were content to think in functional terms, to use the forms that the purpose of the building required. They had to build fast and economically: the geometry of the whole corresponded to the requirements of the structure, at the same time giving the façades harmony and regularity.

Apart from considerations of mass and weight, the essential aim was to meet the economic and social requirements of the building through an understanding of the active role of the skeleton frame, with almost a free choice of width and height. The new architecture was conceived in terms of planning and profitability.

The Chicago architect John Root died in 1891, but the last work he designed was not completed until 1895. This was the Reliance Building on State Street, a fifteen-storey tower block dominated by large horizontal "Chicago windows." This building was to have a marked influence on many contemporary architects in the United States.

Louis Sullivan, a native of Boston who began his career in Chicago in 1875, was just as daring in his innovations, while remaining attached to the historical tradition of decoration. He had a remarkable sense of pure volume, which he expressed in a striving for verticality—modern in spirit, yet owing something to Gothic—through the skilful handling of the iron skeleton frame.

The architectural revival in Chicago came to an abrupt halt, however, as a result of the World's Columbian Exposition of 1893. In his book *The Autobiography of an Idea* (1922-1923), Sullivan made the following comment: "The damage wrought to this country by the Chicago World's Fair will last half a century." And in fact the Exposition did mark a reversion to European influence and "mercantile classicism." Once again the

façade and the decorative features were to prevail over the serviceable and functional elements. It was as though the Americans were afraid of offending against the canons of French taste by going too far in a direction of their own. Paradoxically, the Venetian gondoliers were the biggest attraction at the Exposition, for all its professed modernity; specially imported for the occasion, they dazzled the public in a setting of stucco buildings purporting to illustrate the history of architecture. And because Sullivan had resisted the temptation of stone or plaster ornaments, his Transportation Building—though elaborately decorative—marked the beginning of his unpopularity.

The young Frank Lloyd Wright, who was working at the time with Louis Sullivan, was approached by Daniel Burnham after the Fair with a proposal that he should go to Paris and complete his studies there. In his *Autobiography* (1932) Wright records the following conversation: "'Another year and it will be too late, Frank,' said Uncle Dan... 'Yes, too late, Uncle Dan. It's too late now, I'm afraid. I am spoiled already. I've been too close to Mr Sullivan. He has helped spoil the Beaux Arts for me, or spoiled me for the Beaux Arts, I guess I mean.'" To this Daniel Burnham replied: "The Fair is going to have a great influence in our country. The American people have seen the 'Classics' on a grand scale for the first time... I can see all America constructed along the lines of the Fair, in noble 'dignified' classic style. The great men of the day all feel that way about it—all of them."

In Chicago, Europe discovered America, while America decided to imitate Europe. And just at the time when Horta, Berlage and Van de Velde were seeking to give a new direction to European architecture, a new material appeared that was to revolutionize both form and decoration in building: reinforced concrete.

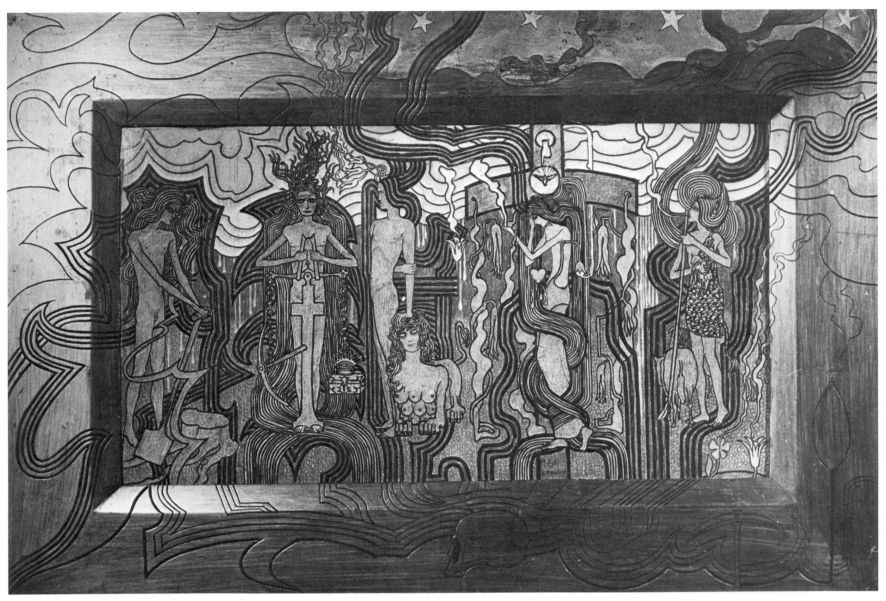

Jan Toorop (1858-1928): The Song of Time, 1893. Pastel and black chalk.

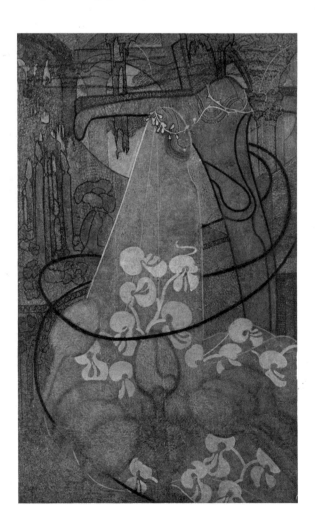

Intent on rejecting a reality which disturbed them, many artists of the 1890s—including even so cool and caustic a painter as Félix Vallotton—surrendered to the fascination of sinuous lines and spirals. This new refinement of design, this new taste for eddying or swirling movement, for subtle and sophisticated harmonies whose justification was their very novelty, were seen at their most characteristic in the exhibition rooms of the Brussels group known as Les XX (The Twenty) and in the pages of their art magazine *L'Art Moderne*. Brussels became the rallying point of the promoters and defenders of Art Nouveau. Among them were two Dutch artists, Jan Toorop and Johan Thorn Prikker, who in an outburst of mystical symbolism were carried to the very threshold of a lyrical abstraction rich in ambiguous and esoteric overtones which aroused a considerable response throughout Europe. For by now art had been internationalized and was to remain so, every innovation being eagerly taken up by others and turned into the fashion of the moment.

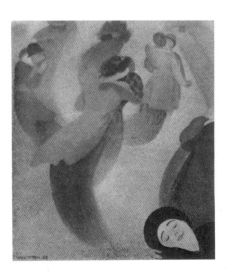

◁ *Johan Thorn Prikker (1868-1932): The Bride, 1892-1893. Oil.*

▷ *Félix Vallotton (1865-1925). The Waltz, 1893. Oil.*

Henri de Toulouse-Lautrec: Jane Avril, 1893. Lithograph.

A concern for decoration is characteristic of artistic experimentation in the closing years of the nineteenth century. Subject matter had become a problem and artists began to concentrate on new stylistic possibilities, on the actual calligraphy of their art. At the same time they wanted to renew contact with the public and to influence everyday design. The desire to give the artist aesthetic responsibility for factory-made articles and to evolve a new style of decoration is characteristic of the fin de siècle movement variously termed "Art Nouveau," "Jugendstil," "Modern Style," etc.

England was the first country to consider the production of consumer goods that would avoid the vulgarity of those produced by industry. William Morris was the originator of this revival, but his successors did not share his nostalgia for the old crafts or his hatred of industrialism. The Scottish architect and designer Arthur Mackmurdo founded the Art Workers Guild in 1884 and from 1888 the Arts and Crafts Exhibition Society held exhibitions all over Great Britain at which the minor arts and decorative handicrafts took on unusual distinction and modernity through the novelty of their forms and design. In addition, the Japanese—still extremely influential—had shown that it was possible for everyday objects to be works of art, just as they had introduced Western painters to the use of flowing lines and flat colours.

Thus "applied art" was born in Europe. It had a great vogue in Brussels, creating quite a stir on its appearance at the first exhibition of the Libre Esthétique, which in 1894 took over from the Salon des XX.

Brussels also witnessed the birth of a movement for the renewal of architecture, the most notable figures being Victor Horta and Henry van de Velde. The concept of "design" was born from this meeting of mind and machine. Two directions seemed possible: the effacement of structures by elaborate decoration or their assertion in a balanced whole. In the manufacture of everyday objects as in architecture, the problems paralleled those that had arisen in painting, notably that of asserting a self-contained artistic presence divorced from any consideration of accurate delineation or lifelikeness.

The Hôtel Tassel, a town house built in Brussels at 12, Rue de Turin by the Belgian architect Victor Horta, marks the starting point of the new European architecture. While the builder respected tradition in the siting and the layout of volumes, he entirely renewed the form and structure of the house by making use of modern means of construction and by meeting the requirements of modern life. The Hôtel Tassel is an object lesson in the principle of organic and functional architecture: the needs define the volume, and the technical possibilities determine the form. Setting the rooms out on different levels and providing new and unusual sources of lighting, Horta focused the interest on the staircase which governs movement and sets the rhythm of the interior; he thus used for a private home solutions which had hitherto been reserved for office and administrative buildings. Far from concealing his structural materials, iron and glass, he made them conspicuous; witness the wrought-iron handrails of the staircase and the elegant, free-standing columns supporting the staircase, with capitals in the form of a vase with floral motifs sprouting from it. The pattern of the floor mosaics is set by the so-called whiplash line or Horta line. The façade windows are emphasized by an increased height and a broader curvature which provide better lighting inside.

In the plant-life elements that inform all the decorations, and in the prominence he gave those elements, Horta created here the prototype of Art Nouveau. Yet a satisfying equilibrium is maintained, for the ornamentation remains in the service of an essentially rational and functional structure. Sensibility is guided by intelligence.

Built by Victor Horta, the Hôtel Tassel in Brussels was soon recognized all over Europe as a new and inspiring contribution to modern architecture:

"This is the first of those famous modern dwelling-houses which fit their owners like a faultlessly tailored coat. It houses the man for whom it was built in the most perfect manner conceivable—as perfectly as the mussel shell does the mussel. It is most simple and logical... altogether new and delightful. But—and mark this—there is not the faintest echo in it of any of the historical styles... It has the pure charm of lines, curves and surfaces, and it is quite personal..."

Ludwig Hevesi, *Wiener Tageblatt*, 11 November 1898

Victor Horta (1861-1947): Staircase in the Hôtel Tassel, Brussels, 1892-1893.

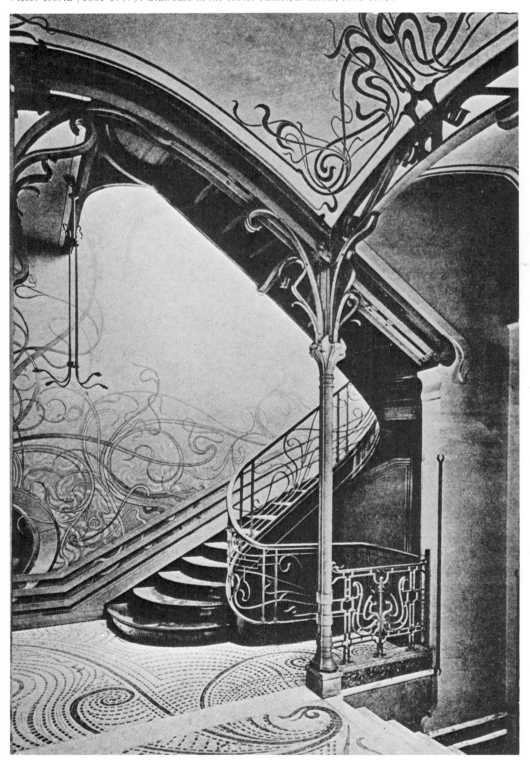

The era of the illustrated poster opened in France with Jules Chéret. In the catalogue of the Retrospective Museum at the Paris World's Fair of 1900, these words occur: "The renaissance of the French poster dates from the invention in 1866 of printing presses capable of using very large lithographic stones. Credit is due to Jules Chéret for having created almost single-handed the whole charming art of the illustrated poster, which so enlivens our street hoardings."

Visual advertising had existed in every epoch, but the technical revolution in printing and graphic processes, lithography in particular, was necessary before the modern illustrated poster could invade the streets. Drawing attention from the outset to current and forthcoming events, shows and new publications, the poster became essential before long for the promotion of industrial products as well.

It was in London in 1859-1866 that Chéret took his first steps in colour lithography. Dubbed "the Watteau of the streets" by Degas, he had produced about a thousand posters by 1886. Much of Paris was being rebuilt at the time, and blank walls and hoardings were soon bedecked with his colourful messages. An elegant draughtsman with a sense of life and movement, Chéret caught the eye of the public with his brilliant style and glowing colour, dispensing not only charm but also accurate information at one and the same time.

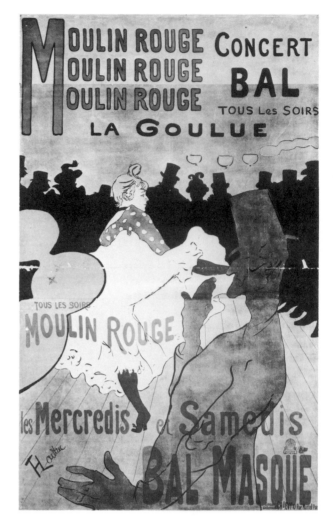

Henri de Toulouse-Lautrec (1864-1901): Poster for the dancer La Goulue at the Moulin Rouge, 1891.

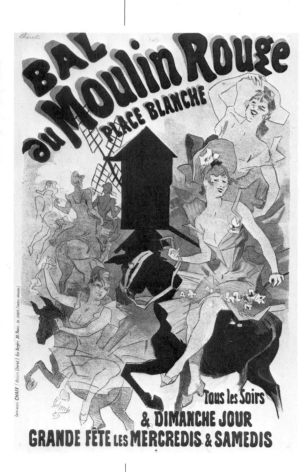

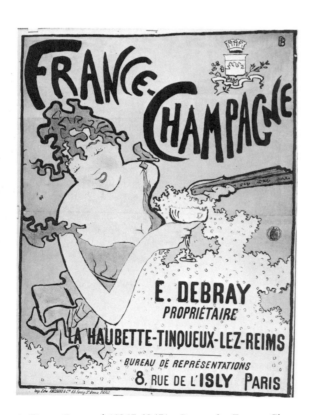

"Art is only a means given to man by which he may convey his personal understanding of nature, translate his thoughts or set down an impression. And if the artist contrives to show us clearly and simply what he has felt or experienced, what does it matter how it was done? If his attempt is abortive, are we supposed to lay the blame on his means, that is to say on his art, when in fact the fault lies with the way he went about his work?

"Why should the art of the poster-maker be thought inferior? Because it is too easy? But then what is an easy art, what is a difficult art?

"The realities of life are too harsh for our high expectations. The poster offers the crowd all that dazzles, all that creates illusion; and panaceas for regaining youth and health; and drinks and spirits that intoxicate and help us to forget; and the tinsel of fabrics and jewels that give us a feeling of wealth and power; and the artificial lights that prolong the too brief day in fairyland illuminations; and the vain pleasures of night life when we live out our deceitful dreams.

"Faith is dead, commercialism reigns, and the poster glows with colour, sure of success in an age when everything is for sale."

A. Demeure de Beaumont, *The Belgian Poster*, 1897

△ *Pierre Bonnard (1867-1947): Poster for France-Champagne, 1889.*

◁ *Jules Chéret (1836-1932): Poster for the Bal du Moulin Rouge, 1889.*

The Paris World's Fair of 1889 extended the importance of the poster, which became a feature of daily life. This new medium could not fail to interest the painters of the time, already preoccupied with instantaneous expression and incisive line, and—to quote Bonnard—"the relationships of art with life." A poster designed by Bonnard himself for France-Champagne in 1889 was already imbued with the spirit of Art Nouveau. The lettering was painted in with the brush, which added to the liveliness of the overall effect. It attracted a great deal of attention when it was posted up in 1891, and it awakened Toulouse-Lautrec's interest in a form of expression to which he would later make a substantial contribution. "The new-style lithography was in the air, and he at once adopted it as a rapid and direct means of expression. He quickly invented a special technique for his own use, a special way of handling the lithographic pencil and the colours, as well as the use of spatter work, often applied with a toothbrush, that was seized on by a number of imitators," Maurice Joyant reports. His first poster for the Moulin-Rouge appeared in 1891. Francis Jourdain later wrote of the sensation it caused: "This remarkably original poster was, I remember, wheeled down the whole length of the Avenue de l'Opera on a handcart, and I was so taken by it that I followed along." More effective than Chéret's his style was not content with suggestion but frankly provocative. With his exceptional gift of observation, Toulouse-Lautrec gave style to everything he saw.

Posters soon became so popular that a host of enthusiastic collectors sprang up—so many that special printings had to be made for them. In 1890 the poster was still mainly associated with show business and literature, but it was not long before the world of industry realized its vast possibilities. Here it was Chéret, the Nabis and Toulouse-Lautrec who paved the way, followed by Mucha and Steinlen. In this type of advertising, it was not simply a matter of informing and showing; the characteristics and uses of the product had to be conveyed. People had to be tempted, a need for the product had to be created by suggestion: thus, in *Confetti*, Lautrec conjures up a festive atmosphere, while the jealousy of Steinlen's kittens speaks louder than words.

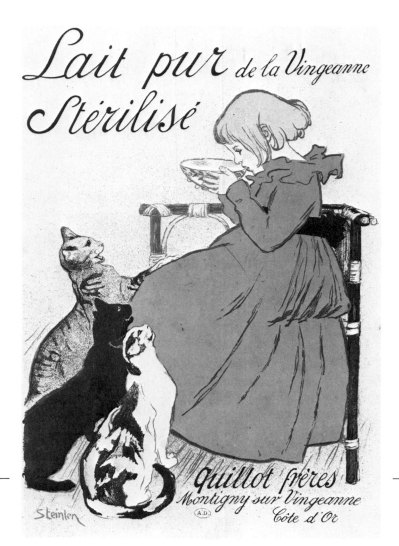

Théophile A. Steinlen (1859-1923): Poster for sterilized milk, 1898.

Alphonse Mucha (1860-1939): Poster for Sarah Bernhardt in Dumas's "La Dame aux Camélias," 1896.

The typographic poster using striking colours and lay-out had developed considerably in the English-speaking countries. But the real triumph of the illustrated poster in these countries may be said to date from the advent of Beardsley. In 1900 Scotson Clark wrote: "During the winter of 1894, the artistic poster was practically unknown in the United States. The only things of this kind—some of them excellent and highly original—were the small-sized posters by Edward Penfield. At the end of 1893 and the beginning of 1894, however, the name and work of Aubrey Beardsley started to be famous and popular and although he was very well known in England, his transatlantic fame was even greater. The smallest town had its Beardsley posters. As for the big cities, their streets were crammed with them. Poster artists began to realize that there was a new type of design using only a few colours and all the more effective because of it. They accordingly adopted Beardsley's style. Of all those who tried it, Bradley was undoubtedly the one who approached it most closely and he was enormously successful."

Will Bradley was the principal American poster designer, and for him the only other designer who counted was Edward Penfield, who drew the posters for *Harper's* magazine. In the Chapbook (1896), Bradley pays him this tribute: "Penfield's work is highly personal. The thought, the expression and the style are his alone. No matter what the pose, no matter what the idea, behind it there is life, there is draughtsmanship and very good draughtsmanship too. This makes him a master. And a master of gouache in particular."

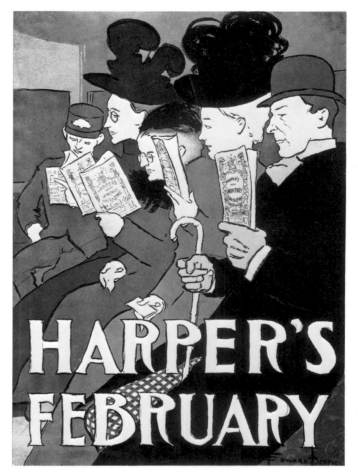

Edward Penfield (1866-1925): Poster for Harper's Magazine, New York, 1890.

Aubrey Beardsley (1872-1898): Poster design (not used) for The Yellow Book, London, 1894.

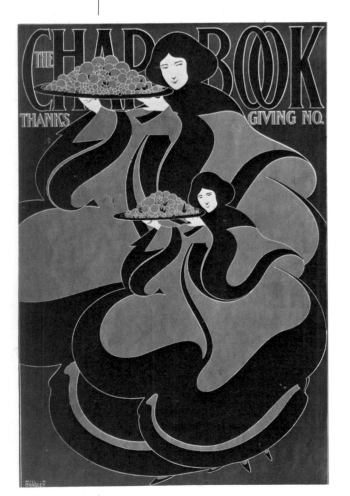

Will H. Bradley (1868-1962): Poster for the Thanksgiving number of The Chapbook, Chicago, 1894.

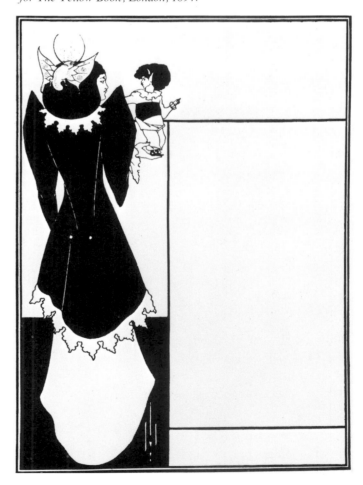

Toulouse-Lautrec's vitriolic line

In 1893, when Toulouse-Lautrec held his first one-man show at the Goupil art gallery (where his friend Maurice Joyant had succeeded Theo Van Gogh as manager), he anxiously waited for Degas, the artist he most admired, to look in and pronounce favourably on his work—which Degas duly did. The thirty paintings in the exhibition abundantly showed the inspiration of Paris life, and in particular the night life of Montmartre.

Unlike the majority of contemporary artists, Toulouse-Lautrec was primarily interested in people, in the expressions on their faces, the way they held themselves. Lautrec possessed that "modernity" demanded by Baudelaire, and he expressed it in the most natural way. Nothing would seem to have predisposed this descendant of one of France's most illustrious families to painting, if successive fractures of both legs, which left him a cripple, had not set him apart at an early age from the world of the aristocracy and its traditional activities. Though he went for instruction in his craft to the leading academic teachers of his time, Bonnat and Cormon, it was Montmartre—where he settled in 1887—that gave him his subject matter and his style.

As a draughtsman, he was fascinated by the outline that defines a silhouette, and his infirmity may have helped to enhance his preoccupation with rapid movement. He lived among people who felt themselves rejected by society, sharing with them the hectic round of nocturnal pleasures in which they sought to forget their misfortunes and misgivings. He had a knack of entering into the moods and passions of others. His virtuosity was incredible, permitting him to catch a telltale expression, attitude or gesture, with a flick of the wrist. The "decadents" of the nineties considered that, in a crumbling world, there were only two avenues of escape: mysticism or riotous living. Lautrec's domain was that of the unavowed and unacknowledged; the borderline between good and evil, beautiful and ugly, no longer existed for him, only the reality of sensation and expression.

With disconcerting facility, he assimilated every feature of the art of his period. For a time, during his studies with Cormon, he had been attracted by Neo-Impressionism, but as a draughtsman he could not be satisfied for long with its systematic approach and strict, formal composition. He appreciated the novelty of Degas's lay-outs and unusual viewpoints, as well as the silhouettes and flat colours of Japanese prints.

His world was that of the cabaret, circus and music hall; his models were singers and dancers—Aristide Bruant, Yvette Guilbert, Jane Avril, La Goulue, Loïe Fuller—as well as the inmates of Paris brothels. He did not paint his models in isolation but caught them, with the immediacy of a snapshot, in their habitual activities and environment. He also painted his boon companions in the night haunts of Montmartre: his cousin Dr Tapié de Céleyran, Dujardin, Sescau, Guibert, and others. Through their presence and his own, he gave a new dimension to his compositions, making the spectator an integral part of the scene so that both viewers and viewed figured as actors in the same situation. Lautrec worked on the spot in the actual places he depicted, boldly seizing the unbalanced attitude that synthesizes movement, the atmosphere that evokes a particular feeling.

The practice of lithography finally freed him from divisionism. The line progressively became the principal agent of his painting.

When he repeats it one or more times, it is to darken an area or to give definition to a haphazard passage. Artificial lighting serves to enhance the denaturalized effect that is his aim.

Throughout his life, he painted the same subjects, the same sort of people. Starting in 1889 at the Moulin Rouge, he depicted such cabaret performers as La Goulue and Valentin le Désossé, then went on to the music halls under the influence of his admiration for Yvette Guilbert and Jane Avril. In 1892, he decorated a brothel in the Rue d'Amboise and then drew inspiration from the one in the Rue des Moulins for his largest canvas *In the Salon*. On everything he casts the same amused, sardonic glance, seeing the feelings, passions and vices he lays bare simply as fresh opportunities for painting with detachment and irony. He is quite at home among all sorts of people that his aristocratic upbringing had taught him to despise.

With his rapid incisive line, Lautrec could hardly have failed to become one of the greatest poster-artists of his period. In 1891 he painted his first evocative poster for the Moulin Rouge.

Henri de Toulouse-Lautrec (1864-1901): Poster for Jane Avril at the Jardin de Paris, 1893.

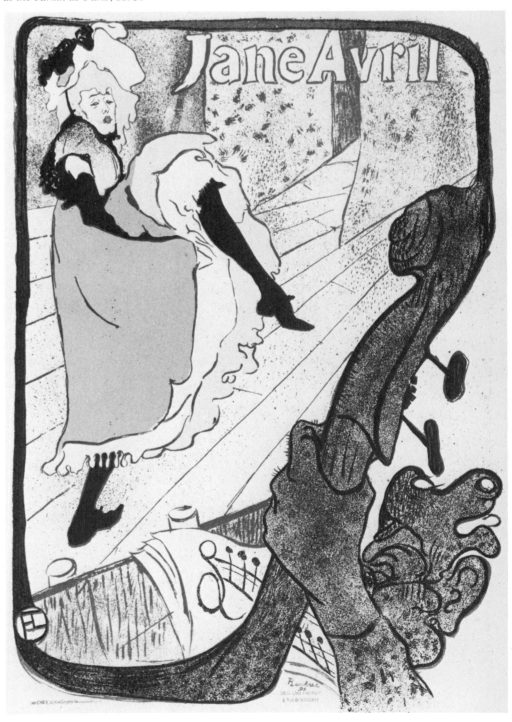

put it off until later. But, for heaven's sake, don't make me so hideously ugly!... Tone it down a bit!... A number of people who have come to see me have uttered wild cries on catching sight of the coloured preliminary sketch ... Not everybody sees only the artistic side ... and *really*!!!" However, soon afterwards she thanked the painter for his illustrations to the book Gustave Geffroy was writing about her.

Lautrec did not look for the unexpected—he found it. His unerring eye penetrated every disguise, the images captured by his brush were truthful and unadorned. He avoided the slightest tendency towards idealism, and the great impact of his paintings resided in the fact that they presented a lively and varied spectacle in themselves. Romain Coolus, one of his companions on the town, has left us this unusual portrait of the painter: "Paradoxical as it may seem, Lautrec was a charming person. Side by side with a delightful simplicity, he had a remarkable shrewdness of expression. Nothing escaped his inquisitive eye, and he gobbled up his contemporaries like a wolf."

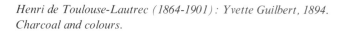

"But not a single figure by Lautrec is smiling... He himself worked with his teeth clenched, too much so for him to smile. Even when he set out with the studied intent of rendering the natural pose or attitude of his models, he always ended up by bringing out whatever was most peculiar or personal about them. Sometimes, and indeed I have no objection to saying often, he seems to be exaggerating: but look closely and you will find that he never goes beyond nature."

Thadée Natanson, *Peints à leur tour*, Paris, 1948

Henri de Toulouse-Lautrec (1864-1901): Yvette Guilbert, 1894. Charcoal and colours.

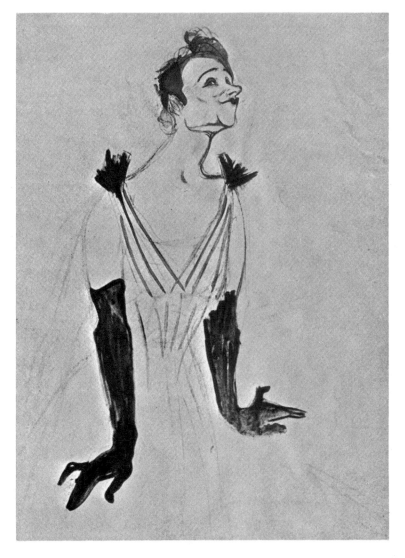

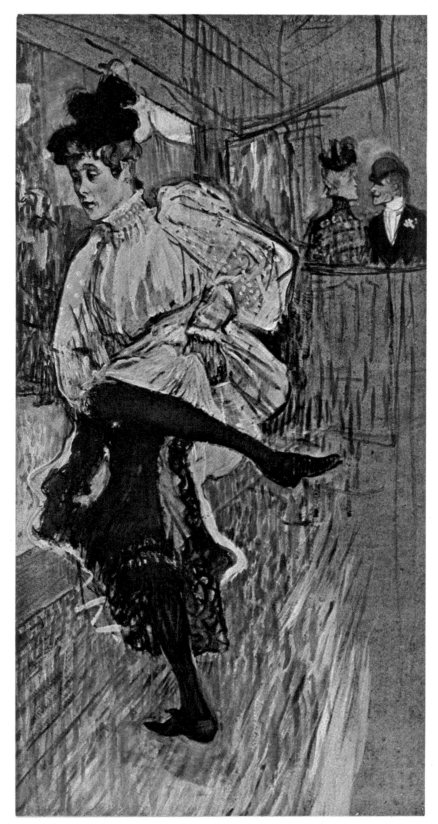

Henri de Toulouse-Lautrec (1864-1901): Jane Avril Dancing, c. 1892. Oil.

It was a great success, and his frank distortions and electrifying, gesticulatory line found a ready response among the public and the stars of the music halls. Before she died, Jane Avril—of whom Maurice Joyant used to say that "she dances like an orchid in delirium"—confessed that, in spite of her successful career as a dancer, singer, actress and journalist, "It is to Lautrec that I owe my fame, which dates from the appearance of his first poster of me." Singers and other night-club entertainers vied with one another to avail themselves of his talent. The correspondence between Yvette Guilbert and Lautrec is significant. In 1894 she wrote: "I told you that my poster for this winter had been ordered and was almost finished. So we must

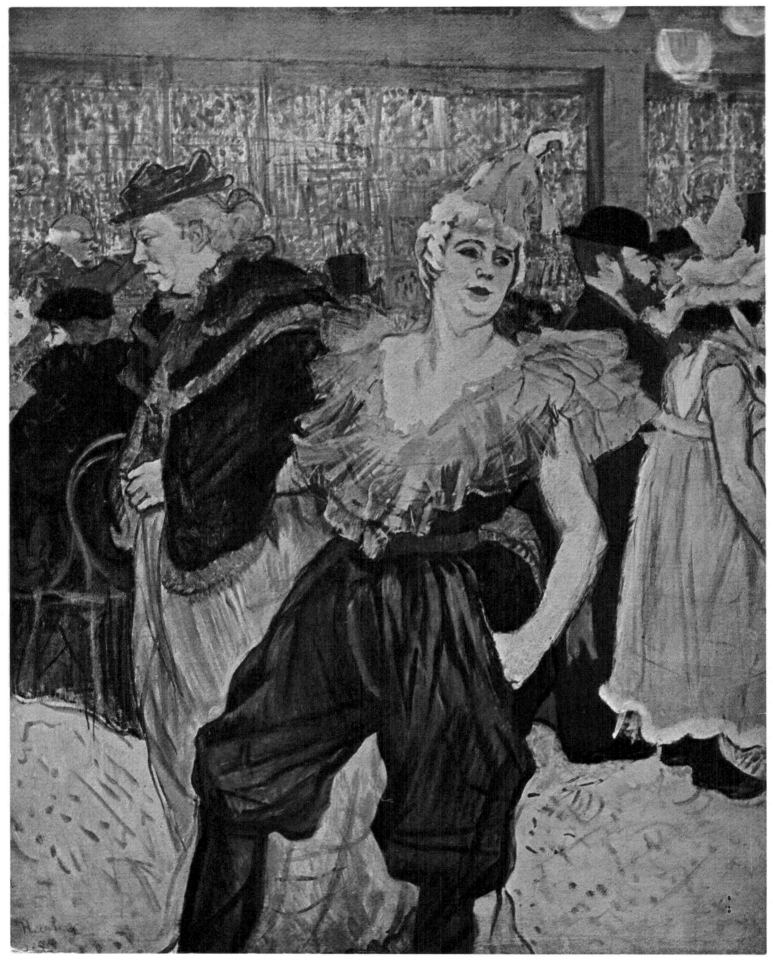

Henri de Toulouse-Lautrec (1864-1901): The Clowness Cha-U-Kao, 1895. Oil.

"Here is a philosopher who speaks a new language, but he has done his homework thoroughly, he has studied what he sets down and he sets it down in striking terms. He has seen the painted, sagging, ruined women whom he shows us and who are like the open sores of a rotten society which we have to live with. Far from trying to gloss over these sores, he displays them in broad daylight, he exposes them in all their crudity. He does likewise for the gay dogs and fast livers, shown up in all their degrada-tion, burnt out by absinthe, the cast of their ravaged faces reflecting its green glow. He does not see with a cheerful eye, but with an unsparing one.

"It may be asked whether this world, the women of the town and the dissolute characters he pictures, are worth the uncommon amount of art he expends on them. Monsieur de Lautrec thinks they are, and what we know of him shows that he is in full possession of the truth."

Ernest Maindron, *Les Affiches illustrées*, Paris, 1886-1896.

The libertarian spirit and anarchy

The names of the artists, men of letters and critics who fought for the freedom to create and for the recognition of their art and ideas could not fail to be closely associated with the libertarian, occasionally anarchist, but always liberal spirit that flared up in France in the later nineteenth century. Social revolution was in the air; one public scandal followed another, and flagrant cases of injustice were continually being brought to light.

In addition, artists were excluded from the money-worshipping society of the period: the middle classes, traditional in outlook and on their guard, disliked novelty and rejected an art that was inclined to be disconcerting. As in the days of the Impressionists, artists also had to struggle for recognition and such success as they had was only fragmentary.

All over France, the news of the failure of the Panama Canal Company in 1888 was greeted with consternation. Some 85,000 subscribers, mostly small savers, were ruined; a third of the 1,300 million francs subscribed had gone on advertising and on the bribery of the press and politicians. The Government tried to stifle the affair, but by 1893 it was impossible to do so any longer; 104 members of parliament and cabinet ministers were implicated in the scandal. A committee of inquiry was set up, but it was excessively slow and named only a handful of culprits when at last it completed its work in 1898.

At the same time, social unrest was growing and the workers were gradually organizing. The army, in the Thiers tradition, had been keeping order in a brutal way, suppressing riots but not succeeding in stifling the feelings of the people. Political and financial scandals prepared the way for the formation of a "workers' group" in the French parliament. Class consciousness was aroused by the intransigence of the property-owning sector of society, which grew increasingly repressive. In Paris, on 1 May 1891, some street demonstrators were killed and some workers arrested.

This climate of injustice and scandal could hardly have failed to intensify anarchist and libertarian feeling, which had been kept alive by a number of intellectuals and artists. On 5 May 1891 there appeared the first issue of *L'En Dehors*, "a magazine that places itself outside all laws, all rules and all theories. . ." The contributors included such names as Félix Fénéon, Emile Verhaeren, Octave Mirbeau, Georges Lecomte and others. After the first six months, those responsible for running it had incurred a total of six years' imprisonment and 13,000 francs in fines. The founder, Zo d'Axa, fled to England, while Fénéon discreetly filled in for him. At the rallying cry of Léon Léger, "Stop talking and act," the anarchists opened their reign of terror.

The next few years were marked by countless acts of terrorism and protest. On 11 May 1892 there was a bomb explosion at the dwelling of the judge who had sentenced the demonstrators of 1 May 1891, a week later another bomb went off at Lobau barracks, and on 27 May the third blast of the series occurred at the home of the Attorney General who had demanded the death

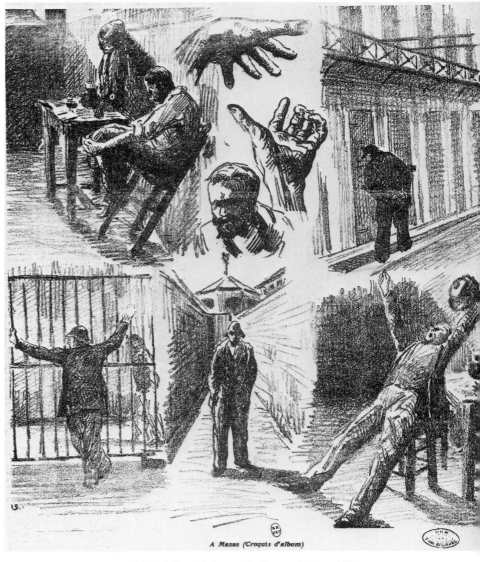

Maximilien Luce (1858-1941): Félix Fénéon at the Mazas Prison, 1894. Album sketch.

penalty at the trial of the demonstrators. The police opened a file on Félix Fénéon, even though he was an official at the War Ministry. On 30 May 1892 Ravachol, the terrorist responsible for the bomb attacks, was arrested. On 25 April a bomb was tossed into the Restaurant Véry, causing two deaths. On 10 July Ravachol was guillotined. In collaboration with Emile Henry, Fénéon continued to run the anarchist paper *L'En Dehors*; he was also associated with *Le Père Peinard*, an anarchist magazine founded by Emile Pouget in 1889, to which Pissarro, Luce and Willette contributed drawings.

On 9 December 1893 an anarchist named Vaillant made a bomb attack on the Chamber of Deputies, which reacted by adopting the so-called "infamous laws," which suppressed the freedom of the press and banned subversive associations. Anarchy thus stood condemned. At the beginning of 1894, Jean Grave, director of an anarchist periodical called *La Révolte*, was arrested, Emile Pouget fled to London and Pissarro to Belgium, and Octave Mirbeau and Paul Adam also left France. On 10 January 1894 Vaillant was sentenced to death; it was the first time for years that someone who was not actually a murderer had incurred the death penalty. A week after Vaillant's execution, a bomb thrown by Emile Henry went off at the Terminus Café at Saint-Lazare Station. On 4 April Laurent Taillade, a

frequent guest at the dinners of the Symbolist group, was injured in another bomb attack, and on 25 April Fénéon was arrested and transferred to Mazas Prison. On 21 May the bomb-thrower Emile Henry was executed, and on 24 June Sadi Carnot, President of the French Republic, was assassinated in Lyons by the anarchist Caserio. On 27 July the painter Maximilien Luce was arrested as a self-proclaimed anarchist. "With Luce's arrest, fear gripped the illustrators, sculptors and painters of Montmartre. Even the most moderate supporters of anarchy talked of fleeing the country." Free-thinkers were threatened by the adoption of a further "infamous law."

If so many artists were sympathetic to anarchism, it was not because they had a taste for violence but because they wanted to defend the fundamental principle of liberty.

In August 1894 the committal proceedings against the anarchists—thirty of them—were concluded. Fénéon's retorts at this "Trial of the Thirty" are still famous and gave rise to roars of laughter in court with their caustic, dead-pan wit. Charles Henry and Mallarmé both gave evidence in his favour. In the end, all the accused were acquitted. Fénéon then became a staff writer on the *Revue Blanche*, which continued to be the most lively organ of liberal ideas and avant-garde art. Félix Vallotton was an assiduous contributor to this famous periodical. With Steinlen, another Swiss artist, he defended the anarchists in his illustrations; this was done purely in a spirit of protest and freedom, since neither he nor Steinlen was directly involved in the anarchist movement. Steinlen employed a naturalist approach rather like Forain's—though politically Forain himself was a reactionary—while Vallotton, under the influence of the Nabis, found a wide audience through the originality of his woodcuts which demonstrated a remarkable gift for synthesis and simplification.

At the instigation of Fénéon, the *Revue Blanche* became the rallying point for the partisans of Dreyfus. The Dreyfus case broke on 15 October 1894 and plunged an already troubled France into one of the most serious moral crises it had ever experienced, inflaming the whole country. "On the occasion of the New Year festivities, we had the cashiering of Captain Dreyfus, accompanied by the noble spectacle of the servile inaction of certain people and the lynch-mob frenzy of others ... Let us hope that we have seen the last of this purge mania; perhaps people need only imagine that all will be clean henceforth," Fénéon wrote in the *Revue Blanche* for 1 February 1895, after Dreyfus had been convicted and deported to Devil's Island. And, from 1897, the whole staff of that journal did everything in their power to obtain a reversal of the verdict pronounced against Captain Dreyfus three years earlier. On 14 January 1898, in Clemenceau's paper *L'Aurore*, Zola published a sensational article entitled *J'accuse*, in which he took the general staff of the army and the judiciary to task. He was found guilty of libel, but public opinion was aroused. The affair took a political turn, dividing France into two opposing camps. Passions were unleashed and exacerbated. A retrial was held at Rennes in September 1899, but it did no more than admit extenuating circumstances, and Dreyfus had to wait until 1906 for his rehabilitation. It was only then that the ashes of Zola, who had died in 1902, were transferred to the Pantheon in Paris.

From the moment *J'accuse* appeared, Zola had the wholehearted support of the *Revue Blanche*: "It is intolerable that those booted individuals to whom the nation has delegated the handling of its defence should—simply because the apparatus of force with which we have entrusted them happens to be in their hands—misconceive their role to the extent of believing they are our masters when they are no more than our agents.

Félix Vallotton (1865-1925): Emile Zola. Drawing.

"For it is quite untrue that the Jews are one race and the rest of the French another, and that it is dangerous for the two races to mingle and live side by side. A difference in race, even if it were as profound as this one is superficial, can never in equity warrant the persecution of any man. For, in democratic law, there can be no question of some unknown factor men have in their blood; what they have in their minds and wills, which is recognizable, is the only thing of interest to us from the social point of view" (*La Revue Blanche*, 7 February 1898).

The violent feelings aroused by the Dreyfus case were unprecedented, some people considering him as a traitor of the most loathsome kind, whereas for others he was the innocent victim of an oppressive and retrograde system.

Georges Méliès, the cinematographer, made a film about the case in the autumn of 1899. In a sense, this was the first newsreel, even if the eleven scenes were filmed in the studio. Not caricatural in the least, it is the testimony of a wholehearted supporter of Dreyfus. Despite some scenes of violence (as yet there was no censorship in this respect), it had a huge success in the fairground booths of Paris and also abroad. From that moment, the cinema became a memory-bank of events as well as a means of expression and protest that would go on extending its scope.

Félix Vallotton (1865-1925): The Anarchist, 1892. Woodcut.

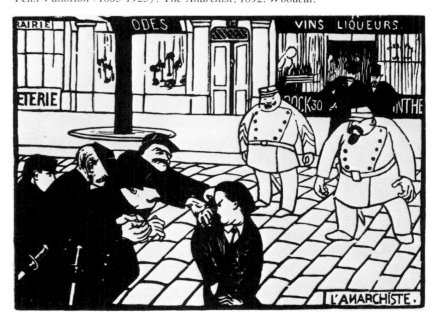

The painters of the Revue Blanche

"Among those recognized today, there is probably not a single painter and not a single writer of any real merit who does not owe a large debt of gratitude to the Natanson brothers and Félix Fénéon," wrote André Gide, referring to the editors of the *Revue Blanche*, the illustrated fortnightly that at the end of the century was the mouthpiece for avant-garde thought and opinion in France, ranging from the defence of anarchism and Captain Dreyfus to all that was most topical in the world of art and letters.

The first few issues had appeared in Brussels, then in Paris, and it was not until 15 October 1891 that the new, definitive *Revue Blanche* got under way, with Alexandre Natanson as editor in chief. Two brilliant figures succeeded one another as editorial assistants: Lucien Muhlfeld and Félix Fénéon. The founders of the magazine, the Natanson family—Alexandre Natanson, Alfred Natanson and his wife Marthe, and above all Thadée Natanson and his beautiful and witty wife Misia (who was a constant inspiration to painters and even posed for posters)—were soon at the very heart of artistic life in Paris. They enlisted the most distinguished contributors: from Mallarmé to Apollinaire, from Clemenceau to Léon Blum, and from Chéret to Vallotton, including all the Nabi painters.

Symbolist circles were catered for by a number of magazines, but the *Revue Blanche* swiftly took the lead, together with the *Mercure de France* which, under the editorship of Remy de Gourmont, defended orthodox Symbolism, whereas the Natanson brothers' team set out to be revolutionary. Though they all defended it on philosophical grounds, anarchy had no place either in their subject matter or in their life-style: their idea of revolution went no farther than liberating language and opposing tradition. Muhlfeld, one of the editorial assistants, wrote: "Anarchy seems to me a praiseworthy and necessary destruction of existing laws . . . it is primarily a state of mind, not so much communist as individualist. I see that the anarchism of our contemporary literature is above all a desire to loosen up and let the mind expand."

And the painters who contributed to the *Revue Blanche* were often among those who sought to express a kind of *joie de vivre* in intimate scenes of everyday life. They continued to evoke their feelings, but like their literary colleagues they were careful about the form in which they did so.

From 1893 on, they all designed covers for the *Revue Blanche*: Vuillard, Roussel, Denis, Ranson, Bonnard, Vallotton, Toulouse-Lautrec and Serusier. Memorable exhibitions were held in the offices of the magazine, which also undertook the publication of such works as the Album of 1895.

Thadée Natanson (1868-1951) later wrote two delightful and lively books containing reminiscences of his friends: *Peints à leur tour* (1948) and *Le Bonnard que je propose* (1951).

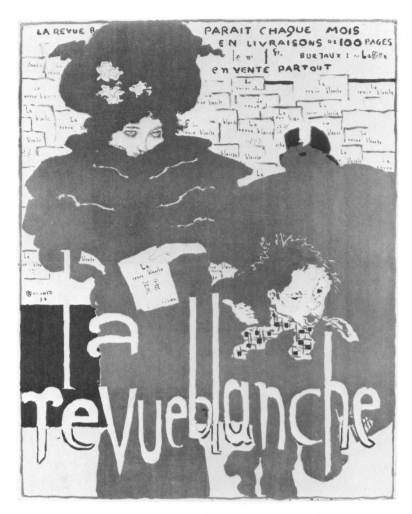

Pierre Bonnard (1867-1947): Poster for the Revue Blanche, 1894.

Pierre Bonnard (1867-1947): Poster for an exhibition of Painter-Engravers at the gallery of Ambroise Vollard, Paris, 1896.

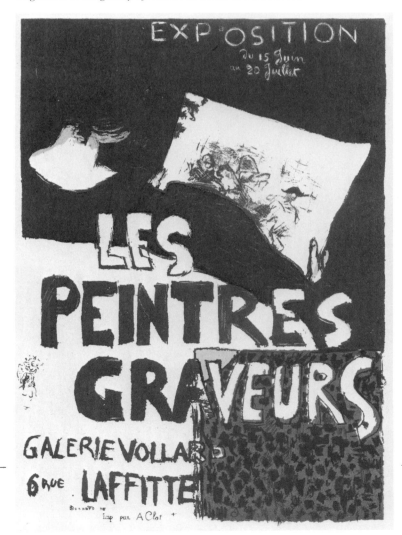

Printmaking, as a medium basically dependent on the requirements of reproduction and illustration, had declined noticeably during the nineteenth century, as artists gradually left the job to specialized illustrators. Technical skill steadily grew more important than quality of expression. The advent of photography and especially the potential increase in its public, once the invention of the half-tone block made it possible to use it in printing, would have spelt the end of printmaking if painters had not, round about 1890, rediscovered its power and originality. Freed from the trammels of traditional book illustration, it once again became an autonomous means of expression. The modest price, the large number of copies that could be run off, and the ease with which they could be circulated made prints a uniquely powerful means of communication and a vehicle much favoured by painters for the transmission of their ideas. When artists began habitually to number and authenticate the copies run off the press, they showed their recognition of the print as an original art form.

Freed from all descriptive functions, printmaking gave birth to a new type of art book, in which publishers were to take special pride. Printmakers and poets had collaborated in the past, but with the advent of Symbolism their collaboration became especially close. Aware of the expressive potentialities of their medium, artists could now match the images of the poets with their pictorial equivalents. This brought a new category of collector into the ranks of the bibliophiles.

The technique of intaglio engraving—etching or dry point— was the first to attract the painters. With the support of the publisher Alfred Cadart, who in 1862 founded the Société des Acquafortistes, Manet, Whistler and Bracquemond took up etching and extended its scope, using it for contemporary subjects in a contemporary way. With the foundation in Paris of the Société des Peintres-Graveurs in 1889, artists began to take a

Odilon Redon (1840-1916):
Frontispiece for André Mellerio's
book "Le Mouvement idéaliste
en peinture," Paris, 1896.

fresh interest in printmaking, since they now had an agency to pull, circulate and exhibit their efforts.

Some of the Impressionists, including Degas and Pissarro, had already tried their hand at prints, but they were more interested in pictorial expression than in technical problems and soon gave up etching for the technique of lithography, which had been invented at the end of the eighteenth century. This method of flat-surface printing is based on the way water is repelled by grease, which is applied by means of ink or special pencils on a

Pierre Bonnard (1867-1947): Woman with
an Umbrella. Lithograph in black and
pink published in the Album de la
Revue Blanche, 1895.

particular kind of limestone block from Solnhofen in Germany. The lithograph differed little in appearance from the drawing until its use in posters widened its scope, notably through the introduction of colour.

In 1889 Gauguin did an etching of Mallarmé and some lithographs, which he showed that same year at the Café Volpini exhibition. The process of lithography was used with notable success by the Nabis and Toulouse-Lautrec, following in the footsteps of Odilon Redon, who had achieved some extraordinary effects with his magical handling of black. "Here, blacks and whites collide with tragic violence; elsewhere there is a slow penetration of shadow and light" (Claude Roger-Marx, *La gravure originale au XIXe siècle*). This technique also suited Bonnard and the Nabis, whose rather different treatment shows the influence of the Japanese print. With a rapid, elusive line, juggling with the flat tints and the tonal relationships demanded by the choice of colours for printing, they opened up a bright, spontaneous world in their illustrations for book covers, programmes, advertisements and posters, and in individual plates. Mallarmé said: "Name an object, and you have destroyed three-quarters of the enjoyment of the poem, which consists in the pleasure of discovering bit by bit; to suggest, that is the desirable thing"—words which throw some light on the procedures followed by a Bonnard, a Vuillard or a Lautrec in their lithographs.

Art dealers and publishers encouraged new work by issuing the albums of prints that were such a feature of the period. *L'Estampe originale* appeared in 1893; the art critics Roger Marx, Marthold and Mellerio respectively launched *L'Estampe nouvelle* (1896), *La Lithographie* (1897), *L'Estampe et l'Affiche* (1897) and *La Lithographie en couleurs* (1898); there were also the albums of prints published by the *Revue Blanche* and *La Plume*.

In 1896 Ambroise Vollard entered the field of publishing. In his memoirs, the art dealer recounts: "Painter-engraver is a term that has been abused by being applied to professional engravers

who were anything but painters. My own idea was to commission prints from artists who were not professional engravers. This might seem to be a gamble, but in the event it proved a great artistic success ... All these prints, some in black and white, some in colour, with a number of others not listed here, made up the series of *Les Peintres-Graveurs*, of which two albums were printed, each in an edition of a hundred copies ... Both albums sold rather badly. I had started a third series, but it remained incomplete. Although collectors showed little interest, painters were increasingly attracted by this new way of expressing oneself."

Edvard Munch (1863-1944): Portrait of Stéphane Mallarmé, 1896. Lithograph.

This period also witnessed a revival of the woodcut, a technique used in the West since the Middle Ages and also associated with the Japanese print. The artist obtains an engraving in relief by cutting away, with a penknife or chisel, the parts between the lines of a drawing on a wood block, which then has only to be inked with a roller. This method of engraving was particularly

Paul Gauguin (1848-1903): Illustration in the manuscript of Noa Noa, 1893. Coloured woodcut.

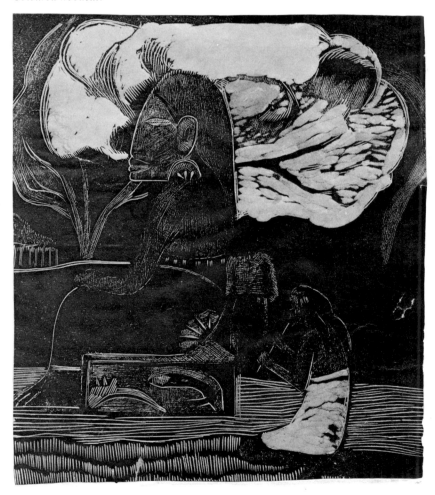

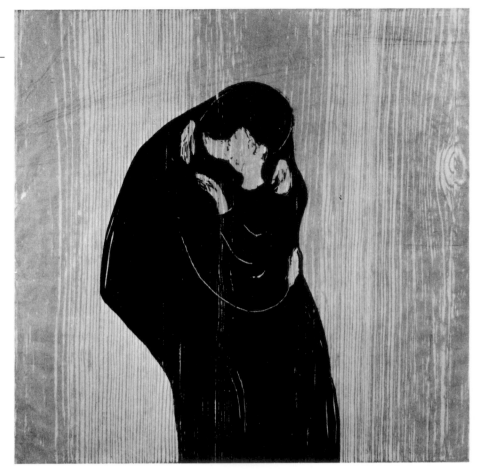

Edvard Munch (1863-1944): The Kiss, 1897-1902. Woodcut.

popular in England. The Pre-Raphaelites' taste for the Gothic and for manual work brought back the woodcut; but it was Beardsley who, despite his early death at the age of twenty-six, succeeded in giving it a dazzling immediacy by adapting it with verve and sensitivity to the undulating Art Nouveau style. "The armorial engraver and the medieval carver lend their precise art to the whim of this young *decadent*. He is a master in black and white. His drawings are posters all ready to be pasted up on the walls of London. Surely illustrations and posters are *the* art of our time," wrote Jacques Emile Blanche.

One of the greatest virtuosos of wood-engraving in France was Félix Vallotton. His sets of woodcuts are veritable little one-act dramas in which the cold, incisive drawing makes splendid use of violent contrasts between black and white, and they have remained justly famous. His chosen subjects include *The Brawl, The Anarchist, The Assassination,* and *Laziness;* the action is seen with a penetrating gaze, at once impassive and sardonic, leaving the spectator hovering between surprise and disquiet. In a more realistic manner, the German artist Käthe Kollwitz, a woman with a deep and generous sympathy for human suffering, went in first for etching and then for woodcuts, because of the expressiveness of these techniques and the possibilities they offered for a wide dissemination of her work. Morally committed to the wretched of the earth, she illustrated the struggle against oppression, poverty and pain with great power.

But it was Gauguin and Munch who added the greatest lustre to the art of the woodcut. Manipulating shading and line, they created contrasts of form, value and colour that are magical in their evocative power. In both, the figures are sometimes deliberately indistinct, like envoys from another world. Each in his own fashion—one lyrically, the other more tensely—gets down to basic realities. Gauguin first attempted wood-engraving in the illustrations for his book *Noa Noa.* "Inspiration, which is always mysterious, goes hand in hand with an exceptionally novel

and daring decorative sense. Black dominates these woodcuts, rubbed in some parts to create a violent contrast of light, with a few strong incisive lines to suggest forms" (Marcel Guérin, *L'œuvre gravé de Gauguin*). The highly original technique he employed in these woodcuts was to make an enormous impact on the painters of the early twentieth century, notably the young Fauves such as Matisse, Derain and Vlaminck, who owe a great deal to him. Much later, in a letter to Daniel de Monfreid, Gauguin himself said: "It is precisely because this kind of engraving goes back to primitive times that it is interesting, since in general wood-engraving (like illustration) is becoming more and more akin to photo-engraving, which is a disgusting state of affairs... I am certain that my woodcuts, which are so different from anything else being done in that line, will one day be valuable." Gauguin's woodcuts from Tahiti date from both his first and his second stay there.

The Norwegian artist Munch also tried his hand at engraving in Berlin in 1893, using copperplate. In the technique of the print intended for wide circulation, he not only found the answer to his wish to "lay the foundation of an art that gives something to people, an art that grips and moves them, an art created with one's own heart's blood," but also a way of satisfying his overriding desire to achieve communication, for "basically art is born of the need man feels to communicate with his fellows." But in the technique of copperplate engraving he also faced the challenge of a strange, hostile medium with which he could wrestle.

It was in Paris that Munch first learnt the technique of lithography. He picked it up in the workshops of Clot and Lemercier, who were also printers to the Nabis. At the same time he started work on his woodcuts; these were exhibited in Paris at the Bing Gallery, whose proprietor was a notable disseminator of Japanese art and an enthusiastic promoter of Art Nouveau. The German critic Julius Meier-Graefe, an associate of the Bing Gallery and a partisan of the Impressionists, had been interested in Munch's work since 1892 and published eight of his prints in an album in 1895. In Paris, Munch was in touch with Gauguin's circle and with the symbolist group, but these contacts did nothing to modify his highly complex literary and psychological view of things. Although in one sense Munch came close to the spirit of Art Nouveau, in another he drew away from it through the all-pervading sense of drama and doom in his work, which constitutes a moral judgment on man and his destiny. In this, he was akin to the German Expressionists.

In their woodcuts, Munch and Gauguin succeeded in bringing out the qualities of the material itself—they preferred the penknife to the chisel—thus doing away with any illusionary effect of light. In the violence of their technique, both convey a sense of exasperation, wild and lyrical in one case, accusing and anguished in the other.

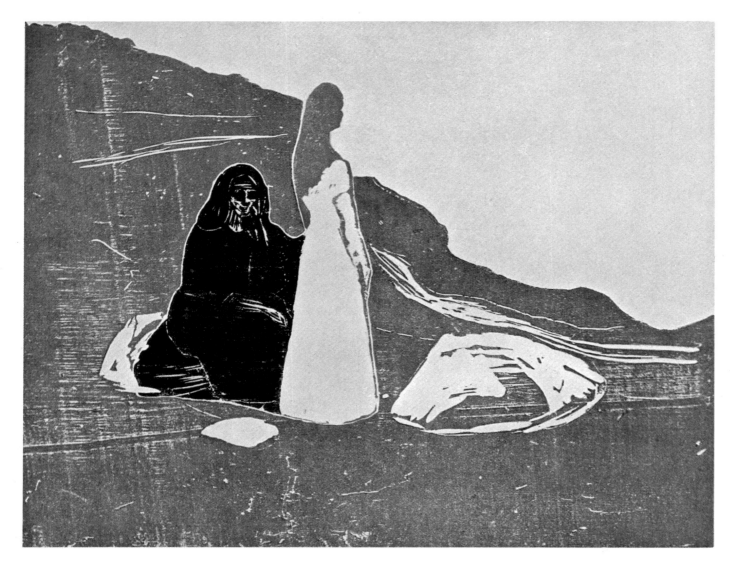

Edvard Munch (1863-1944): Women on the Seashore, 1898. Woodcut.

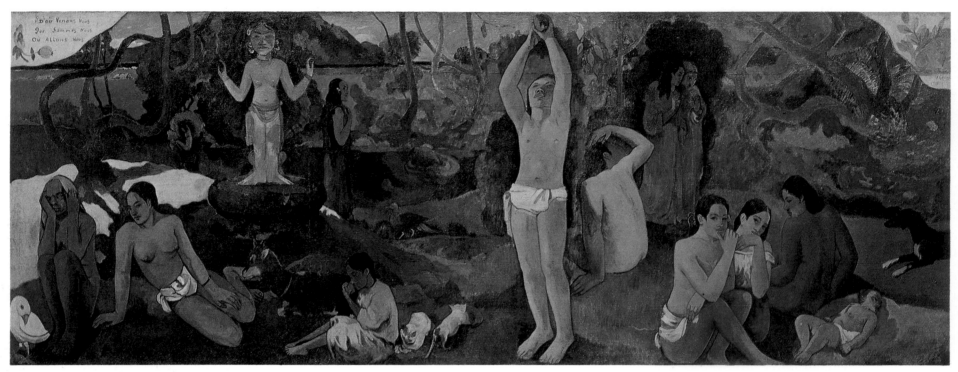

Paul Gauguin (1848-1903): Whence come we? What are we? Whither go we?, 1897. Oil.

The testament of Gauguin:

Whence come we?
What are we?
Whither go we?

*Paul Gauguin (1848-1903):
Self-Portrait, 1902-1903.
Pencil.*

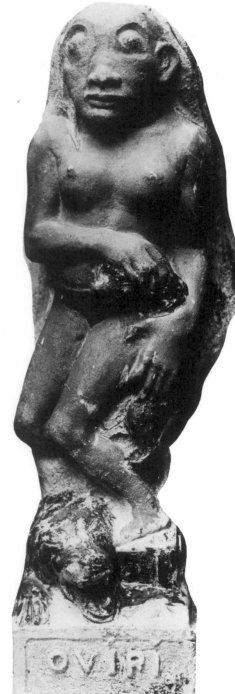

*Paul Gauguin (1848-1903):
Bronze statue of Oviri
(The Savage Woman),
1894-1895.*

"Where does the making of a picture begin, where does it end? At the moment when extreme feelings come to melting point on the deepest level of one's being, at the moment when they burst and one's whole mind comes forth like lava from a volcano, does there not occur an uprush of the suddenly created work, fierce and forceful if you like, but also grand and apparently superhuman? The cool calculations of reason have not presided over that uprush, but who knows when in the depths of being the work originated? Unconsciously perhaps. Have you noticed that when you copy a sketch you are pleased with, done in the space of a minute's, a second's inspiration, you can achieve no more than an inferior copy, especially if you start correcting the proportions, the shortcomings which the thinking mind presumes to detect. I sometimes hear people say: the arm is too long, etc. and so on. Yes and no. No especially, considering that as you make it longer, you move away from lifelikeness in the direction of fable, which is no bad thing: provided of course that the whole work is instinct with the same style, the same will. If Bouguereau were to make an arm too long, then, certainly, what would he be left with, inasmuch as his vision, his artistic will, lies in that alone, in that stupid precision which rivets us to the chain of material reality."

Gauguin, letter to Daniel de Monfreid from Tahiti, March 1898

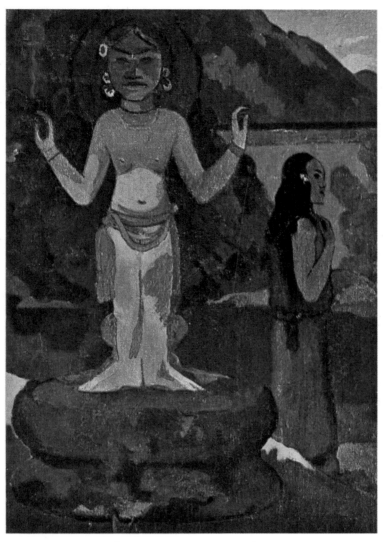

Paul Gauguin (1848-1903): Whence come we? What are we?
Whither go we? (detail), 1897. Oil.

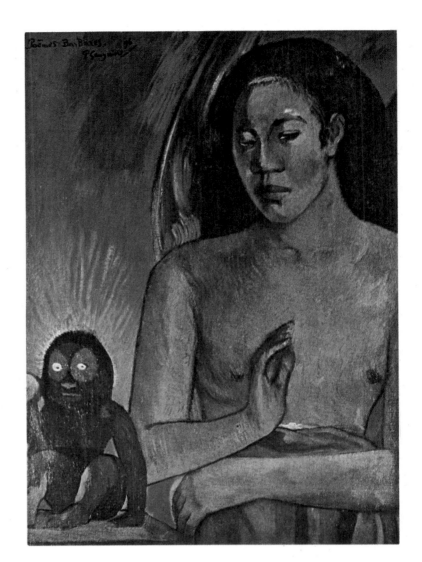

Paul Gauguin (1848-1903): Barbaric Poems, 1896. Oil.

"No doubt about it, the savage is a better man than us. You were mistaken when you told me one day that I was wrong to say I'm a savage. It is all too true: I am *a savage. And civilized people feel it instinctively: for in my work there is nothing surprising or baffling except this 'savage in spite of myself' element. That is why it is inimitable. A man's work is the explanation of that man. And in it are two kinds of beauty, one resulting from instinct and another that will come from study."*
<div align="right">Gauguin, letter to Charles Morice from Atuana, April 1903</div>

In March 1895 Gauguin again left France for Tahiti, once more drawn by the mirage of the primitive life. He never saw Europe again. In Paris the public had stubbornly continued to ignore his work, and an auction sale of his pictures on 18 February of the same year, with a catalogue preface by Strindberg, had been a failure: out of forty-nine canvases offered for sale, he had had to buy back thirty-nine.

Reaching Tahiti in July, he avoided Papeete and settled on the west coast in a splendid Tahitian hut, but he soon fell prey to repeated attacks of illness and bouts of depression. One of the first paintings he did was his *Self-Portrait near Golgotha*, an outright identification with the martyrdom of Christ. He took up other biblical subjects as well, transposing them into a Maori context.

The chief work of this second Tahitian period, the largest and most famous—*Whence come we? What are we? Whither go we?*—is a veritable summary of his message, his mystic credo. It is a spiritual testament in which he recapitulates his themes, his technical expertise and his metaphysical questionings. All his hope and faith in a happy life are shown here, transposed in a very natural way into the Tahitian setting. This quest for a kind

of happiness that can only be found in deep harmony with nature appears in several paintings of this period, for example, in the *Sacred Grove* by Puvis de Chavannes and in Cézanne's series of *Large Bathers*. Whereas in Cézanne's work it takes the form of a pantheistic hymn to the glory of painting, and in Puvis de Chavannes it becomes the harmonious vision of an Arcadia that can only exist in men's minds, Gauguin creates an entirely new world of his own imagining, aglow with blue mysterious light, where men, set free from the bonds of civilization, may rediscover the fundamental rhythms of life. His work seems to be an answer rather than a question, the vision of a world to which, as he is all too aware, he himself can never accede.

In 1897 a letter from his wife in Copenhagen announced the death of their daughter Aline. This unexpected news reduced him to despair: "Her grave over there, and the flowers, all nothing but sham. Her grave is here, close to me; the only living flowers are the tears I shed for her," he wrote back to his wife, and this was the last letter she was to receive from him. Poverty, trouble with the authorities, heavy drinking and illness drove him in 1898 to an abortive suicide attempt. Then, for a few years more, Gauguin clung to life simply to go on painting.

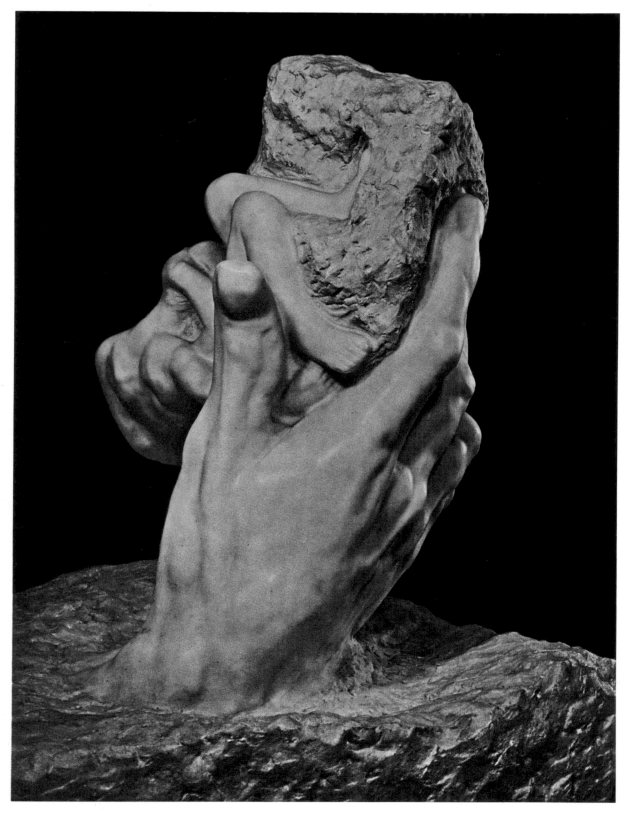

Auguste Rodin (1840-1917): The Hand of God, c. 1896. Marble.

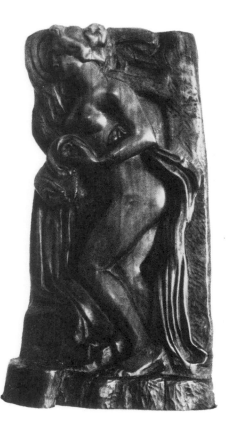

Aristide Maillol (1861-1944):
The Spring, 1896. Wood carving.

In general, this introspective art, intent on probing the inner life, expressing moods and recreating the dark and disturbing realms of the imagination and of dreams, was not exempt from a certain symbolist mannerism. In the forms of expression taken by Art Nouveau, poetic invention was often confined to the subject matter, which was not interpreted in properly pictorial terms. Even so gifted an artist as Ferdinand Hodler did not escape the tyranny of the idea to be illustrated, despite his undeniable resources as a painter, which indeed were almost comparable to those of Van Gogh. Hodler, like Gauguin, attempted to establish new relationships between man and nature. Without making his figures part of a "primitive" world, he wanted them

to rise from the very fabric of the earth, quickened by its breath and its rhythm; but they are often immobilized by anguish, by an oppressive awareness of the human predicament, and dazed by their confrontation with the infinite. To a lesser extent than Gauguin, but to a greater extent than the Symbolists, Hodler reestablished a spiritual contact with the sources of life, even if he felt it to be dominated by emptiness and the unknown.

As well as being troubled about the hereafter, the artists of the time brooded over the origins of man and of the world. The subject of birth became a means of expressing a new relationship between man and nature. Unlike the Impressionists, who anchored the human presence in the landscape by the play of light,

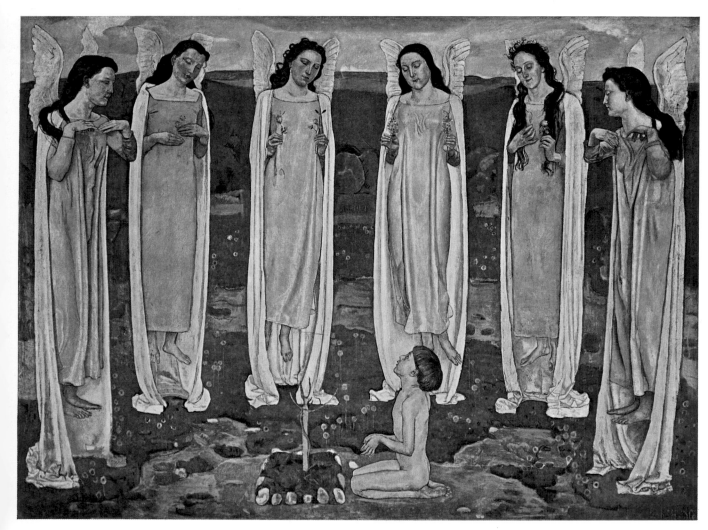

Ferdinand Hodler (1853-1918): The Chosen One, 1893-1894. Tempera and oil.

"Whence come we?"

George Minne (1866-1941): Two Kneeling Men, c. 1897. Pencil.

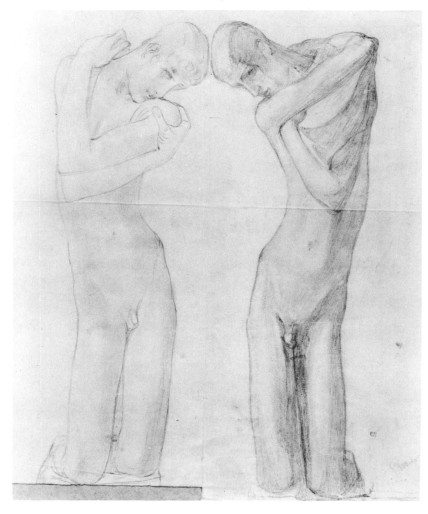

the Symbolists made it soar from the very fabric of the earth. The figures of adolescents drawn and carved by the Belgian sculptor George Minne stand anxiously outlined in a swaying movement of withdrawal into the self that was already to be seen in Hodler's paintings. In the work of Rodin, the relationship between the figure and the earthly elements is even more significant. The vivid play of light over his richly modelled surfaces gives his work an Impressionist look. In particular, it underlines the spiral evolution of interpenetrating masses and is a sculptural version of the arabesques found in the painting of the period. From his very first sculptures, Aristide Maillol, who had started off as a painter in the Nabi style and was still drawn to rhythmic patterns and symbolic overtones, broke with this divisionist treatment of mass and introduced a simple, monumental form of expression.

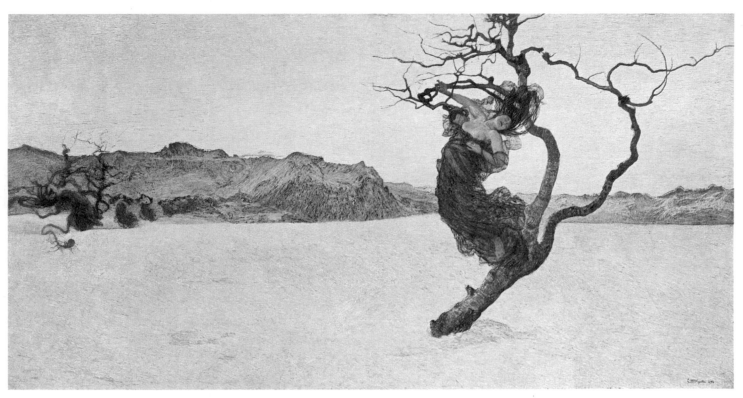

Giovanni Segantini (1858-1899): The Unnatural Mothers, 1894. Oil.

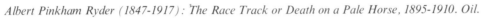

Albert Pinkham Ryder (1847-1917): The Race Track or Death on a Pale Horse, 1895-1910. Oil.

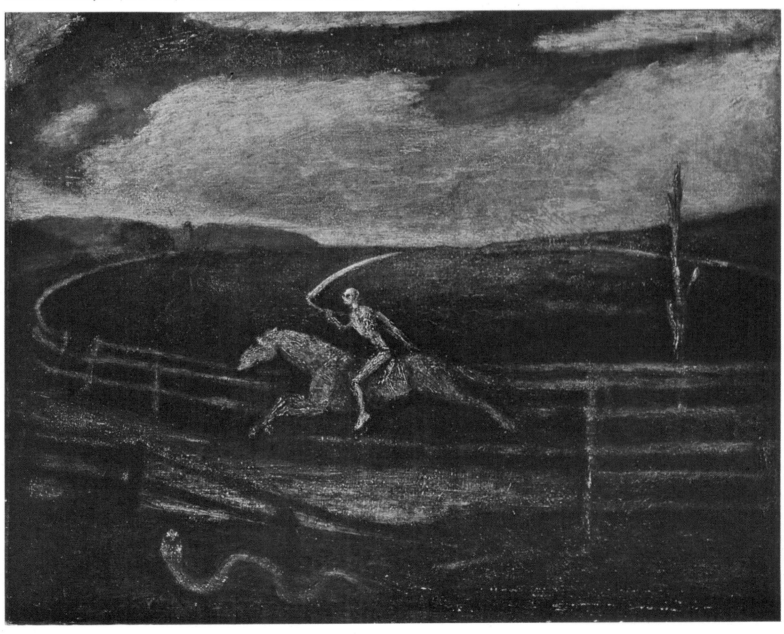

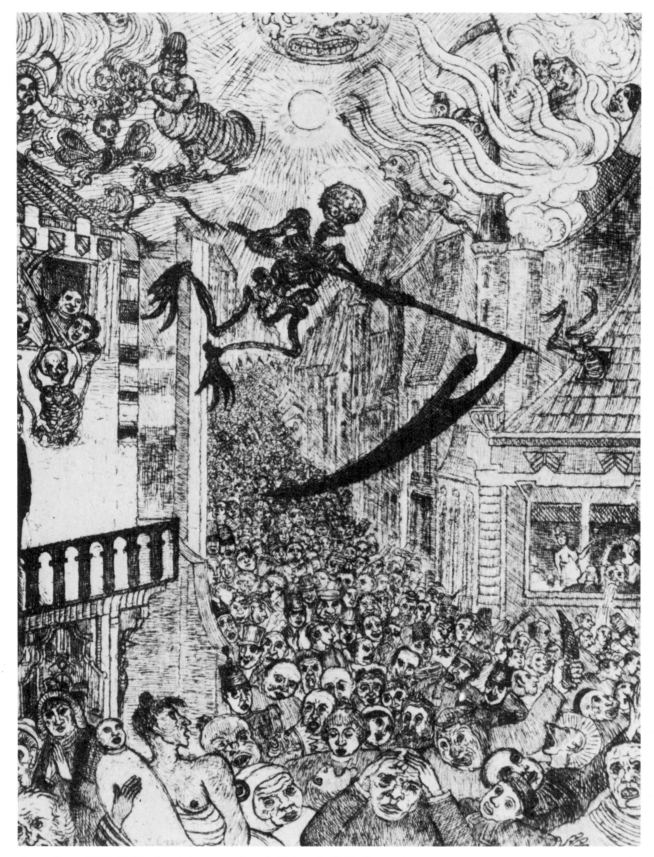

"Many of his copperplates reproduce certain of his paintings, and some of his drawings too have been reinterpreted in engravings. When, however, with burin in hand, he conceives the idea of some entirely new composition, the wind of his weird imagination blows more violently than ever over his excited brain... Nothing in the outcome is unwholesome, turbid, shady or ambiguous; all of it, on the contrary, is straightforward, sincere, ferocious, brutally frank. There are no hidden meanings. There is a plain show of goods."

Emile Verhaeren, *Ensor*, 1908

James Ensor (1860-1949): Death Driving a Crowd of Mortals, 1896. Copperplate engraving.

Almost as if the close of the century was bound to tip over into disaster or else bring absolute happiness, much of the art of the 1890s seems to be questioning the meaning of life and death. The thought of death, of what might lie beyond the grave, haunted men's minds. The triumphs of science and technology had pushed back the frontiers of knowledge and perception, but in doing so had aggravated the prevailing sense of panic in face of a civilization in turmoil. At the same time it was an age of pitiless self-exploration: once detached from society, a man might gain in individuality, but he would also have to come to terms with that unknown entity, the self, in all its nakedness.

Whereas Gauguin, living only for his art, believed in a return to the primitive facts of life, Munch, the Scandinavian, did not believe that any accommodation was possible between man and the world. Humanity is a hopeless outsider and the horizon is blocked by a wall on which the moving shadow of the fear of living is thrown. And Munch was not alone in his gloom. The Belgian artist Ensor sees humanity as a piece of flotsam, a caricature of itself, submerged in an indifferent crowd, and marked down for death, while Ryder, an American, was haunted by man's lonely struggle against incomprehensible forces. And in Segantini nature, grown arid, becomes a setting for vengeance.

Strange imaginings

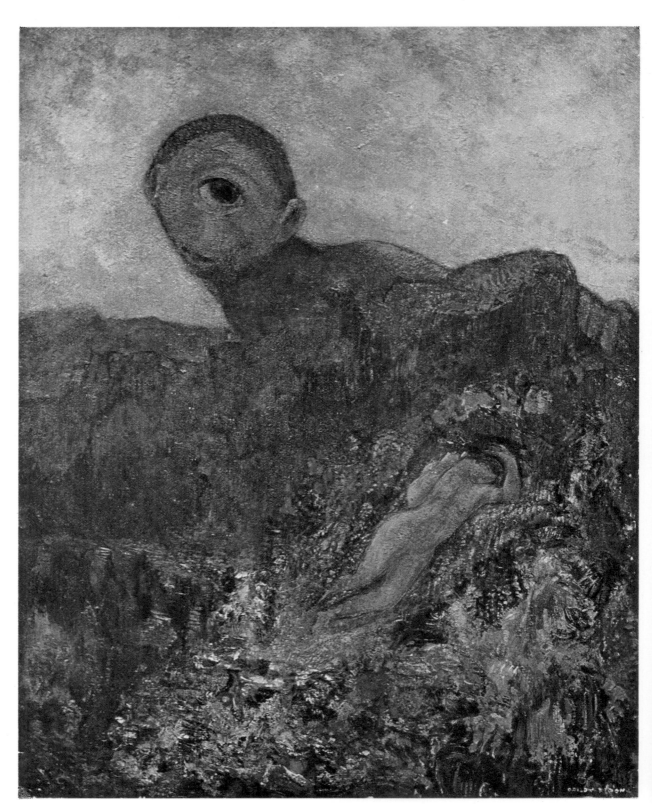

Odilon Redon (1840-1916): The Cyclops, 1895-1900. Oil.

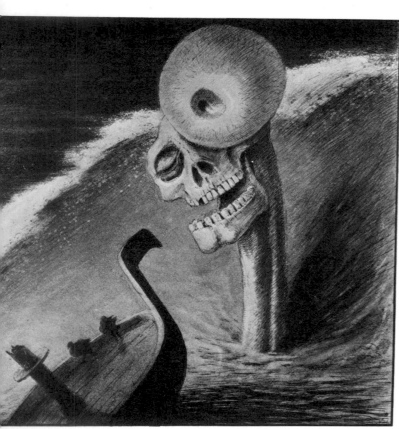

Alfred Kubin (1877-1959):
Fright, 1900-1903.
Ink wash.

The new free and personal approach to technical problems inspired painters to explore the world of the imagination in ever increasing depth. Thus the turn of the century brought with it an explosion of Symbolism in subjects that were purely visionary, sometimes tinged with drama, sometimes lyrically foreshadowing the visions of the Surrealists.

After a long period devoted to black-and-white lithography, Odilon Redon after about 1890 gradually returned to colour and to painting, adapting it to the exploration of mysterious and esoteric dream-worlds. His art was greatly appreciated by the younger painters, and in 1901 Maurice Denis placed Redon in the foreground of his *Homage to Cézanne*, Bonnard admired the way he succeeded "in uniting two almost opposite qualities, extremely pure pictorial matter and extremely mysterious expression"; but Redon and Bonnard had no real affinity except on the level of pictorial freedom. In his remarkable drawings, the German artist Alfred Kubin also demonstrates a sense of the bizarre. While Redon's apparitions are fairylike, those of Kubin have a nightmarish quality. With its drama and fantasy, Kubin's work heralded the revolt of the Expressionists.

The mask and the void

"It was inevitable that he should end up with the symbol, the very epitome of sensation and feeling," Emile Verhaeren said of Khnopff's art. Fernand Khnopff was one of the principal representatives of the amazing upsurge of Symbolism that, in the wake of Félicien Rops and under the influence of Gustave Moreau, characterized Belgian painting at the turn of the century. His work, and that of other artists of similar tendency, used the symbol as a veil lightly covering a gaping void of which they were profoundly aware, a product of ideas and feelings made bearable by rationalization.

Pairs of eyes opening on emptiness and blind profiles were among the images with which they crystallized an inner turmoil from which they could escape only by means of an exaggerated formalism. In fact, it was through technique that these voyagers in the realm of the imaginary sought to free themselves from their anguish, yet suggest its presence. The need for precision and clarity in rendering the dark realms of the unknown became in itself both an aim and a refuge until, with only its form left to justify it, this kind of art soon developed an obsession with decorative effects.

"It was no longer a matter of *sensation*, i.e. the object perceived without volition, but of the *idea* we derive from it, a pure concept that the artist endeavours to express uniquely," wrote the French critic André Mellerio, one of the earliest champions of the idealist movement in art that reached its peak in the 1890s.

In fact, what these painters were seeking in their flight from the reality transmitted by their senses, which they knew could not be captured in its entirety, was a veritable "surreality." Thus they had recourse to what Puvis de Chavannes, whom they greatly admired, called "spectacle": "For every clear idea there exists a pictorial equivalent whereby it may be expressed," wrote Puvis. "But the ideas that come to us are very often confused and disturbed. They must therefore first be disentangled so that they can be examined, in their pure state, by the inner eye. A work of art is born of a kind of confused emotion in which it is contained like the animal in the egg. The thought contained in that emotion has to be worked on, and I work on it until I can see it quite lucidly and until it is as sharply defined as it is possible for it to be. Then I look for the spectacle that will translate it with precision. . . This, if you like, is Symbolism."

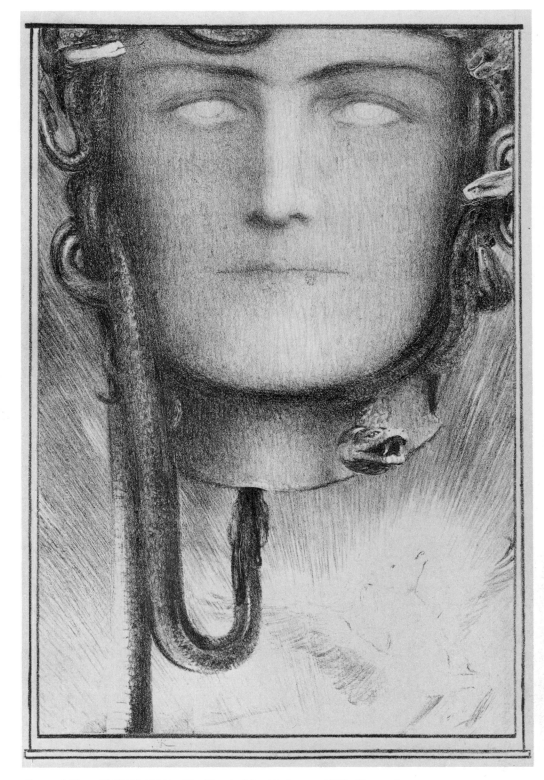

Fernand Khnopff (1858-1921): The Blood of the Medusa, c. 1895. Charcoal.

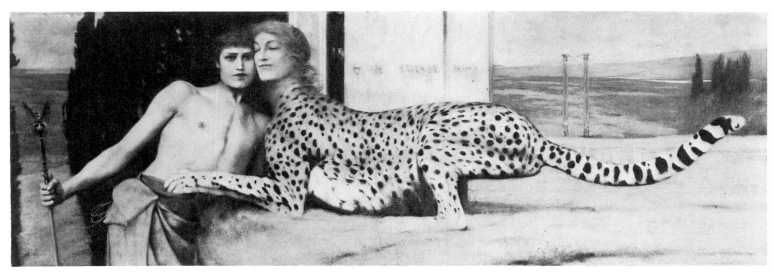

Fernand Khnopff (1858-1921): Art (The Caresses or The Sphinx), 1896. Oil.

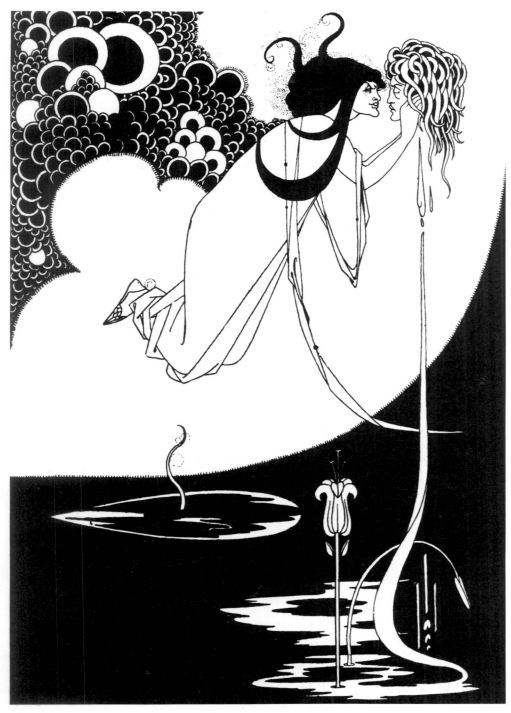

Aubrey Beardsley (1872-1898): The Climax, illustration for Oscar Wilde's "Salome," 1894.

ed the mask as a mirror of inward realities. In the monstrous, fantastic dreams of the German artist Klinger, and the feverish imaginings of the English artist Beardsley, the poetic image is converted into the language of psychoanalysis. This kind of visual soul-searching was paralleled by the investigations that psychoanalysts such as Freud were conducting into the troubled world of dreams and the part played in it by sexuality. A form of artistic expression employing the symbols, masks, allusiveness and soulfulness that are all to be found in the many-sided Art Nouveau movement could not fail to gain an international audience, to which magazines, books, exhibitions and posters all contributed. By rallying artists from all over the world, the exhibitions of La Libre Esthétique in Brussels (1894 to 1914) fostered the first contacts, which, with the help of further group exhibi-

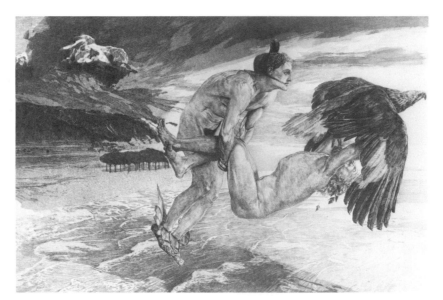

Max Klinger (1857-1920): Brahms-Phantasie, Op. XII: The Abduction of Prometheus. Etching.

Félicien Rops (1833-1898): Pornocrates, 1896. Etching and aquatint.

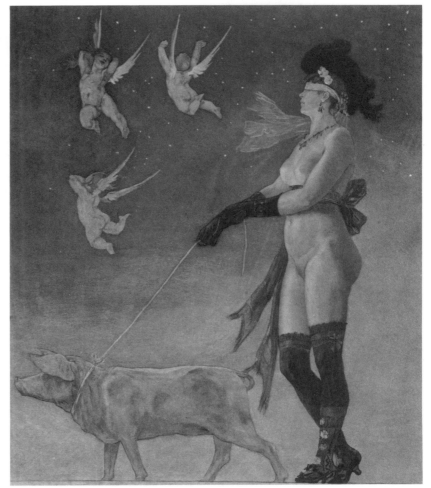

Hence the choice of subjects combining a visionary element with spiritual tension to produce an erotic imagery in which woman is assigned an ambiguous role: on the one hand, an idealized figure, an inaccessible reflection of spiritual purity and, on the other, "she who ushers in the envoys delegated to our souls by all the vices" (J. K. Huysmans).

On the stage it was Sarah Bernhardt—as the Empress Theodora, the Lady with the Camelias, Gismonda, or Medea—who triumphantly exemplified this contradictory image of woman, a creature seductively ethereal and depraved in turn. From 1894, this image was entrusted by her to a young Slav painter, Alphonse Mucha, who turned her into the "Byzantine" figure that was to appear on posters on the walls of every capital in Europe.

The Symbolists often used the idea of the mask. "A mask always reveals more than a face," said Oscar Wilde, thereby underlining the expressive powers of the mask without denying its potential as a means of escape through mystery. From Khnopff to Ensor, from Mucha to Beardsley or Kubin, in Belgium, France, England and Germany, a host of painters regard-

"Some comments on this art style may be in order. Its starting point is the observation of nature. But while he does observe nature, and for this or that motif takes the cue which it gives him, and plucks from plant life the secret of the stem's delicate undulations and graceful curves, the artist has made a point of putting down nothing that directly recalls nature. In inventing the pattern of a decoration, he does follow the hidden law by which plant life is governed in the growth of its unchanging and ever harmonious forms, but with the same strict observance he refrains from tracing out any motif or any curve that one might recognize as a natural motif imitated."

Thiébault-Sisson, *Art et Décoration*, Paris, January 1897

Alphonse Mucha (1860-1939): Poster for Sarah Bernhardt in Euripides' "Medea," Paris, 1898.

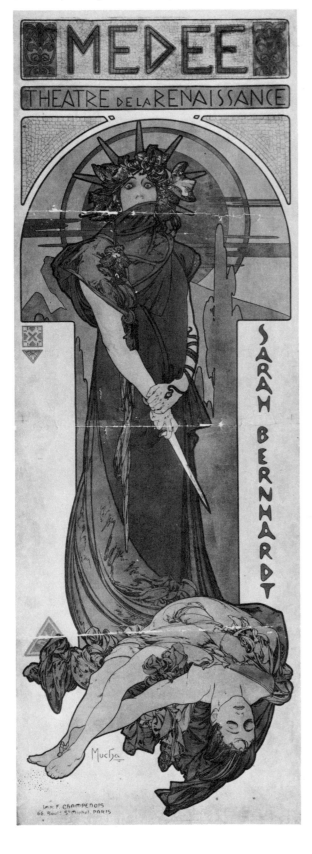

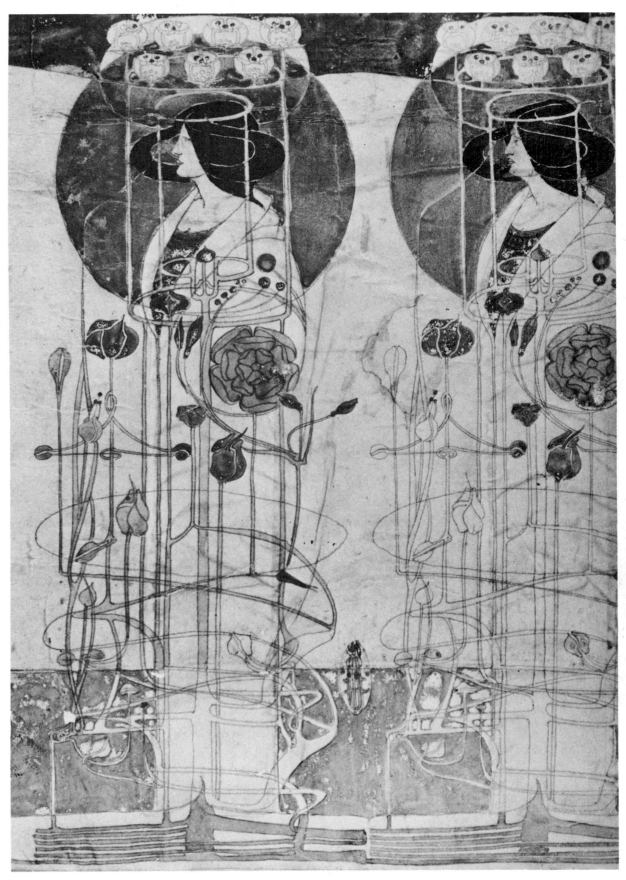

Charles Rennie Mackintosh (1868-1928): Part of the preliminary design for the mural decoration in Miss Cranston's Buchanan Street Tearooms, Glasgow, 1896-1897. Watercolour over pencil.

tions, such as the Venice Biennale, developed into a large-scale movement. The first Biennale was held in 1895, and its committee included artists from all over Europe.

Germany and Austria were also important centres for the dissemination of Art Nouveau, and the relevant exhibitions in these countries were extremely successful. Conceived in a spirit of opposition to official art, these exhibitions, known as Secessions, had a great influence on the younger generation: those of Munich (1892), Vienna (1897) and Berlin (1898) all helped to spread the vogue of Jugendstil (the German term for Art Nouveau).

Forms take wing

The part played by art magazines, including the ephemeral but typical *Revue d'Art*, at the end of the century was a highly important one. They encouraged constant contacts, and thus a wide dissemination of ideas, and brought the various types of creative art together. One of the most important of the French periodicals was *Art et Décoration*, which was founded in 1897 and supported the new movement in decorative art, deploring the lack of understanding shown for it in France. In the first number a long article was devoted to the Belgian architect Horta, who was regarded as the leading innovator and whose originality was demonstrated fully.

"For him, there is no such thing as the standard house. None of those he has built resembles any of the others except in the scrupulous care with which they have been planned, the felicitous use of every nook and cranny and of the most bizarre irregularities of the site, in the elegance of their façades, the unity of the decorative principle employed, in which the use of harmonious curves plays the major part, and in the care taken to have direct light in all the rooms by distributing them round a central point, a living focus into which great waves of daylight flow, bringing a general feeling of cheerfulness.

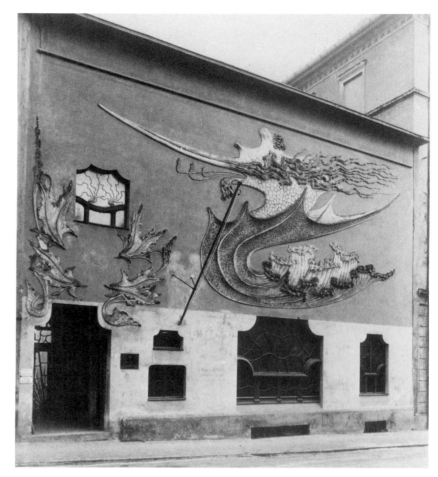

August Endell (1871-1925): Façade of the Elvira Photo Studio (destroyed), Munich, 1897.

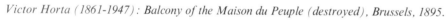

Victor Horta (1861-1947): Balcony of the Maison du Peuple (destroyed), Brussels, 1895.

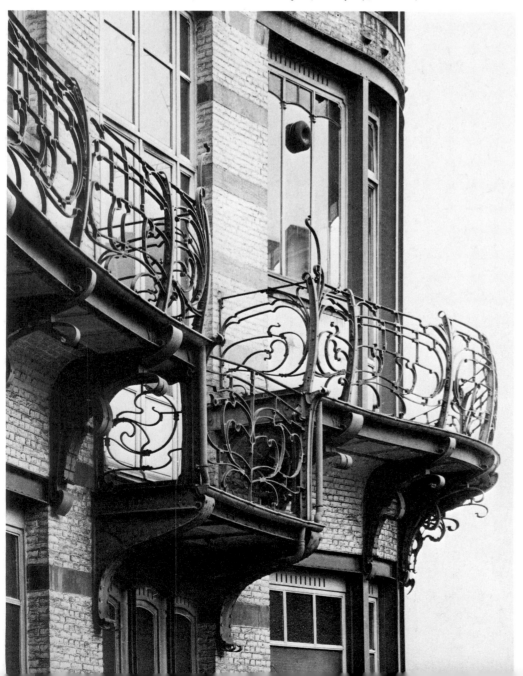

"I must stress the sophisticated ingenuity with which the artist has designed, for each of his creations, so much exquisite ironwork, furniture, stained glass, carpets and light-fittings, not just sketching them in pencil but making actual models of them, the better to guide him in their execution" (Thiébault-Sisson, *Art et Décoration*, January 1897).

Brussels was one of the great centres of Art Nouveau; the annual exhibitions held by the Libre Esthétique group continued to bring works from different countries together, and architects from all over the world came to Belgium to see Horta's buildings. In addition, an exhibition of applied art, held in Liège in 1895 by *L'Œuvre Artistique*, was attended by Mackintosh and Horta, and visited by Guimard before his meeting with another great Belgian architect, Henry van de Velde, in the same year.

Turning away from the exaggerated decorative features of Art Nouveau, Van de Velde initiated a return to pure form. His experiments were destined to have worldwide repercussions. In 1900 he was invited to Germany to organize art-teaching in Berlin and then at Weimar, and his ideas on art and education were later to play a leading part in the establishment of the Bauhaus. At the age of thirty, after several years devoted to painting, Van de Velde decided to take up artistic craftwork, inspired by the achievements of William Morris and his disciple Walter Crane, and by the ever growing interest among the artists of the period in the problem of the right way to live: "From now on, art is no longer going to be an end in itself but a means; an inner means of self-fulfilment, an external means of response to a firmly established ideological programme," writes the Belgian critic Robert L. Delevoy.

Van de Velde produced numerous works relating to every aspect of building, as well as furniture and everyday utensils.

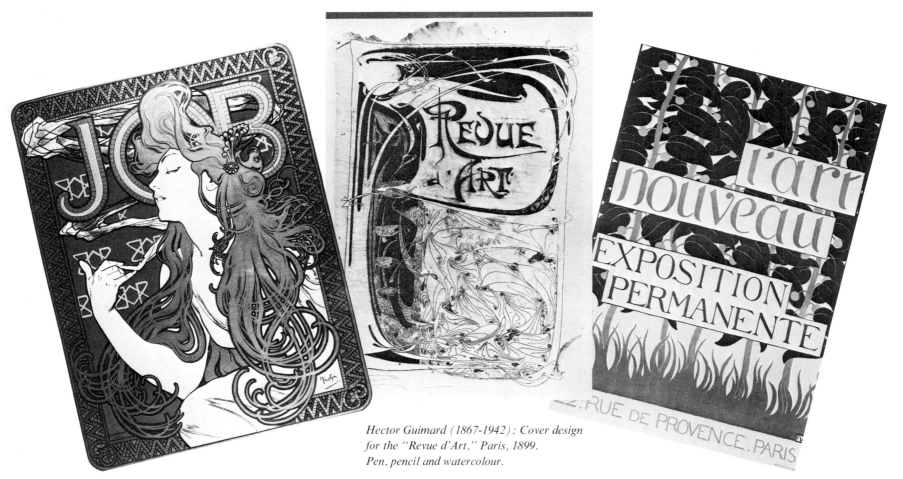

Alphonse Mucha (1860-1939): Poster for
Job cigarettes, Paris, 1896-1897.

Hector Guimard (1867-1942): Cover design
for the "Revue d'Art," Paris, 1899.
Pen, pencil and watercolour.

Félix Vallotton (1865-1925): Poster for
the Galerie Bing, Paris, c. 1895.

Seeking, with rare intensity and keenness, to link "being and living," he became the main promoter of Art Nouveau in Europe in the first quarter of the twentieth century. He set forth his views and aims in many books.

Contrary to what Van de Velde had assumed, however, Europe also was greatly in favour of "charm, that delicate luxury often added to rude necessity," as Horta described it. This "charm," though often bordering on what we now call "kitsch" (the sign of a surfeited and blasé generation), also gave a new impetus to the art of living. The French architect Guimard, one of the chief implementers of the overall view of architecture, explored the possible uses of new industrial products. Although he took his inspiration from "the work of nature," which contained three absolute principles, "logic, harmony and feeling," he did not ignore the progress of science: "We know that this particular piece of iron, although only half the weight of the kind used in the old days, is sufficiently strong to support a given load and thus adequate for our purpose and our programme." But "this piece of iron has to be placed tastefully, it has to be handled logically and methodically, for only in that way can you perceive its true beauty" (talk given in the offices of the *Figaro*, Paris, 12 May 1899). In the Metro entrances which he was commissioned to design in 1899, Guimard confirmed his concept of architecture and gave concrete expression to his desire for harmony.

In Germany and Austria the ideas of Art Nouveau enjoyed a similar success. In 1897, in Munich, Endell built the famous Elvira Photo Studio (destroyed in 1944) whose plain façade was decorated with a huge abstract design that served as a prelude to the exuberant baroque undulations of the hall and to the inner staircase in the manner already tried out by Horta.

Hector Guimard (1867-1942): Main Gate of the Castel Béranger, Paris, 1894-1898.

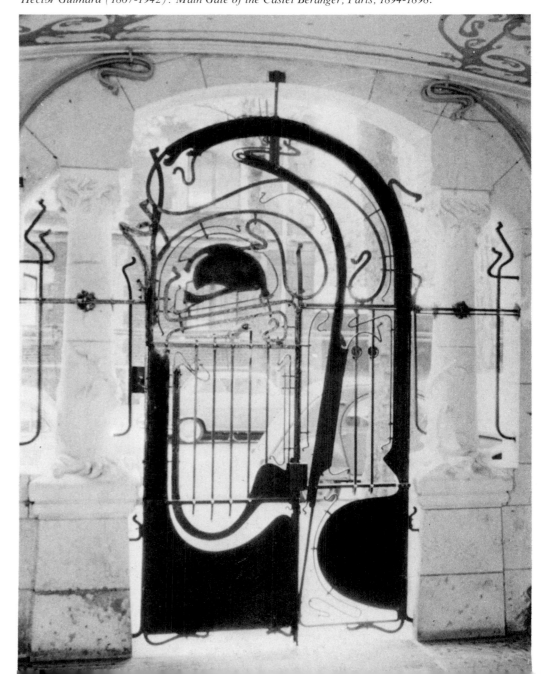

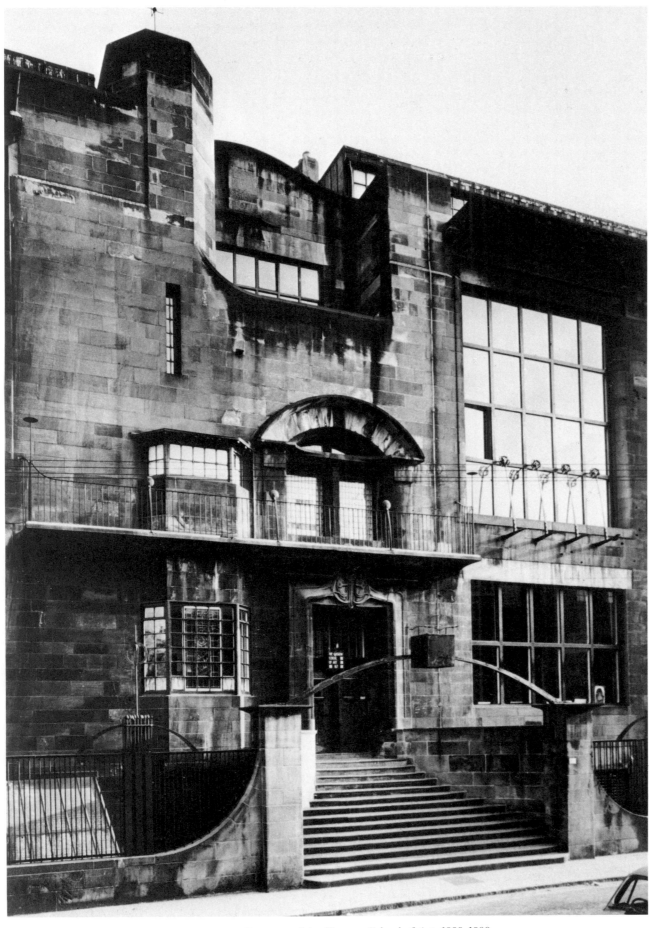

Charles Rennie Mackintosh (1868-1928): Main Entrance of the Glasgow School of Art, 1898-1909.

"At the same time two decorative principles stand confronted. One is based on the use of the straight line; this is the School of Mackintosh. The other is based on the winding line and its association with the flower; this is the Hôtel Tassel in Brussels and the house built by Gaudí in Barcelona. Everything flows from the speculations of the mid-nineteenth century. The two antagonistic principles, one intent on trying to link the structures by the surface unity of their decoration, the other on the contrary linking them through a strict respect for the interaction of counterbalancing units, both stemmed from experiments carried out before 1880, all over the world.

"After that the clannish discussions as to the priority of this or that builder or the predominant role of this or that group, are quite pointless."

Pierre Francastel, *Art et Technique aux XIX⁺ et XX⁺ siècles*, Paris, 1956

Hector Guimard (1867-1942): Métro entrance in Paris, 1900.

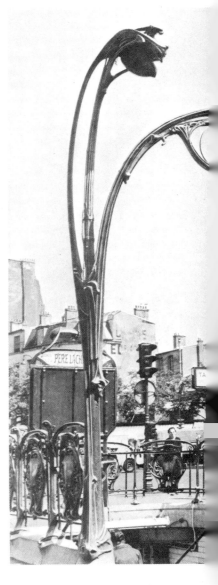

"The day will come when the monuments set up in public gardens will represent not men or animals, but imaginary forms which will fill the heart of man with exuberant enthusiasm and an inconceivable delight."

Die Jugend, Munich, August 1898

Undoubtedly influenced by Gothic and by medieval art in general, and fond of the shimmering abstraction of Moorish interiors, the Catalan architect Gaudí was thoroughly at home in this period of ornamental explosion as an inventor of exuberant and grandiose structures and a master craftsman of unusual materials. Whether using wrought iron or stone, he moulded them with a vivid imagination and combined them with colour and pattern to arresting effect. Working in Barcelona from the late 1870s on, he made himself familiar through the art magazines with the outstanding achievements of his time, but breaking away from any concern with functionalism he went ahead and expressed himself with untrammelled freedom. All his buildings bear the mark of his unmistakable style, with roofs, pinnacles, balconies and chimneys setting off the sinuous line of walls and façades.

With Gaudí, who worked on the site in the manner of a medieval building foreman and not in a comfortable office, the patterns of Art Nouveau spread throughout the urban setting. His work remains the isolated achievement of a creative mind of extraordinary fecundity and exuberance.

In Scotland, by way of contrast, there arose under the inspiration of Charles Rennie Mackintosh a group of decorator-architects who evolved from a profuse ornamental style to a great austerity of forms. The Glasgow School of Art, built from 1898 to 1909, is characteristic of his functional straightforwardness. Thanks to his very pure plastic sense, Mackintosh was one of the first modern designers to achieve that simplicity and geometry which were to triumph so signally in the art of the cubist painters, from 1906-1907 on.

Antoni Gaudí (1852-1926):
Entrance Gate of the
Güell Park, Barcelona,
1900-1914.

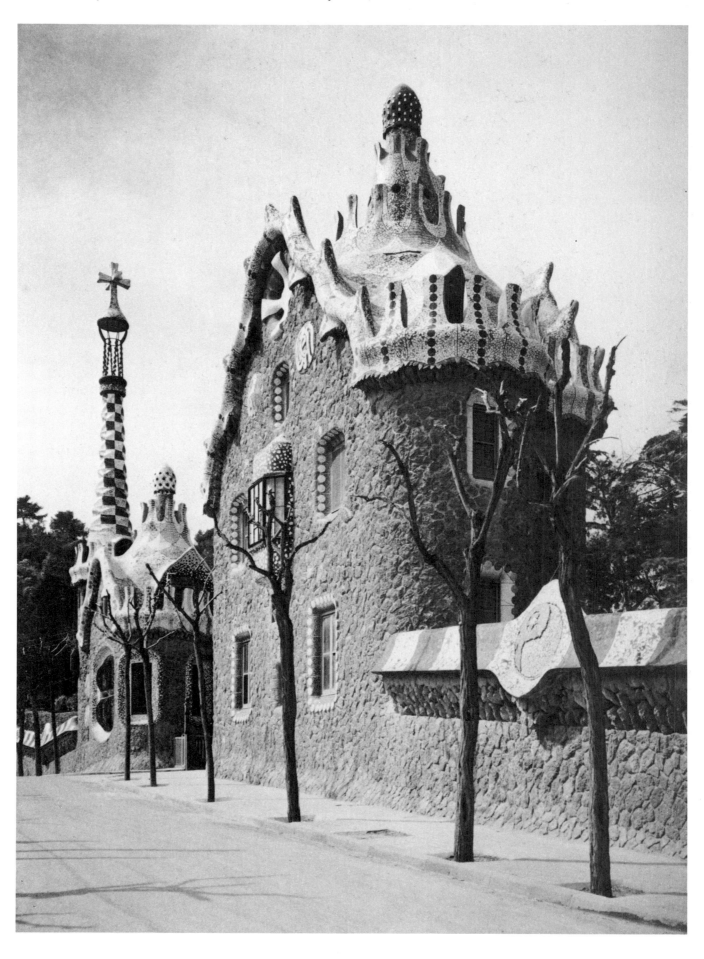

Moving pictures

Metal and ivory object, 1900.

At the end of the nineteenth century, artists were confronted with a further revolution in the photographic image—the addition of movement. It would have been difficult, in those early days, to foresee the tremendous importance of the recently invented and as yet unperfected cinematograph for the world of art, since it was still considered as no more than a simple technical process. And yet, by reaction or assimilation, the cinematographic picture was, directly and indirectly, to transform the whole of the traditional practice of art.

Research by Muybridge and the physiologist Marey to find out how the continuity of movement could be captured on a photographic plate had led to the breakdown of the picture into a series of successive split-second images; a parallel project aimed at developing a projector that would be capable of reconstituting drawn or photographed movement. When the research workers put the results of their two separate investigations together, the ensuing projection sessions were immensely successful. One of the great surprises of the World's Columbian Exposition in Chicago in 1893 was the triumphant demonstration in the Zoopraxographical Hall—forerunner of the cinema theatre—of the work of Muybridge and of Anschütz, the inventor of the *tachyscope* (a device run by electricity).

Thomas A. Edison, who was just then trying to perfect the phonograph, which could already reconstitute sound and words, also took an interest in motion-picture photography. In 1891 he took out patents on a camera called the *Cinematograph* and on a viewing device called the *Kinetoscope*. The great inventor also produced films with 600 perforated frames in his New Jersey laboratory, but, sidetracked by other ideas, failed to perfect the system he had created.

As so often happens with inventions, several inventors who had been working on the idea of motion-picture photography perfected their inventions at one and the same time, but it is the Lumière brothers from France to whom must go the credit of producing the first film in the sense in which we understand the word today.

On 13 February 1895 their invention, born "of a night of frenzy and migraine," namely a camera taking cinematographic views and a projector, combined in one apparatus, was patented in Paris under the number 245 032. Its name, the projection kinetoscope, still bore the traces of its origin, but was soon replaced (in spite of numerous law-suits) by a more lasting one: the *Cinematograph*. The name was not the only thing to survive.

The first showing was followed by several private projection sessions, including one at the Sorbonne. Finally, on 28 December 1895, in the Indian Room of the Grand Café in Paris, a public per-

Louis Lumière (1864-1948): Train Coming into a Station, film projected at the first public showing of motion pictures, Paris, 1895.

"L'arroseur arrosé" (The Sprinkler Sprinkled), still from the first comic film, Paris, 1895.

formance was held, with a programme consisting of two short-reel films: *Train Coming into a Station* and *The Sprinkler Sprinkled*.

The Lumière brothers at once set to work on the production of films, and by 1897 their catalogue contained 358 17-metre strips, including several newsreels and documentaries. In 1898 a series of historical titles were added to the catalogue: *Faust, Nero, Napoleon*. The Lumière brothers opened cinema theatres and granted licences all over the world. A new industry was born.

Parallel with this development, Emile Reynaud, the inventor of the Praxinoscope, perfected the animated cartoon. On perforated gelatin strips he drew a series of pictures, breaking down movements and subjects. Some of his cartoons ran for fifteen minutes, and from 1892 his projection sessions at the Musée Grévin in Paris were a great success.

Thus modern man found himself perpetually confronted with movement, which gained the upper hand in life as in art, on the stage, and in his view of nature. Movement enlivened the work of

Georges Méliès (1861-1938): Still from the film "The Man with a Rubber Head."

Still from the French film "The Flea," 1900.

sculptors and painters, like Rodin or Degas, was embodied in the dances of Loie Fuller and Isadora Duncan, exploded on the cinema screen, and triumphed in the street with the appearance of the first motor cars. And the quest for speed led to the first great international athletic competitions with the revival of the Olympic Games in Athens in 1896.

The expression of movement is a vast field, the creation of the motion picture by the Lumière brothers and Edison being simply the ultimate stage of that analytical investigation into the reality of action that marked the second half of the nineteenth century. But with the cinema the aim was to produce the illusion of life itself, a development that could not fail to have an influence on painting.

At the same time, photography and the cinema were bringing man into renewed contact with nature. Until then, confrontation with reality had been direct, but it now began to be approached through the intermediary of the photographic film, which soon began to invade the principal information media—newspapers and books—through the technique of printed reproduction.

While the use of the medium of photography led to a loss in direct contact, it also brought about a spectacular widening of the spatial and temporal field of human vision and contributed to the extension of knowledge. The process of overprinting which permitted the superimposition of images and, above all, the freedom from the chronological order of events obtained by film

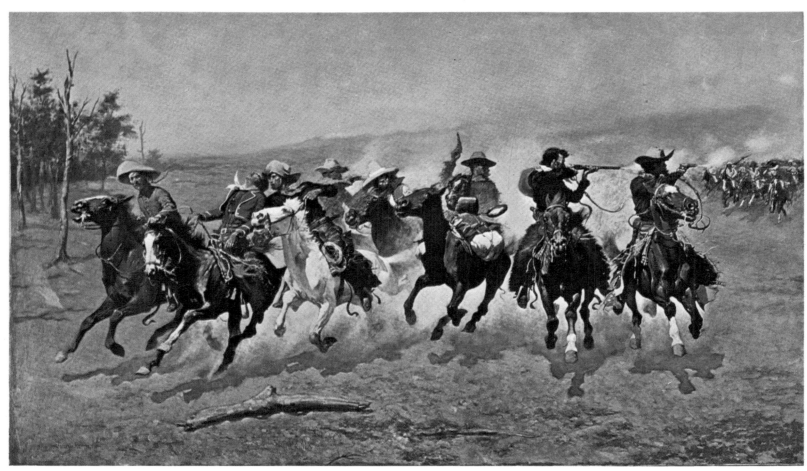

Frederic Remington (1861-1900): A Dash for Timber, 1899. Oil.

For instance, the American painter of frontier life Frederic Remington painted horsemen galloping past in the manner of the Western, which was to become such a popular genre in the cinema. But there were also artists whose reaction was to feel increasingly liberated from exigencies that were not specifically part of their own art. Academic painters might continue to go in for historical scenes on a heroic scale or for those fantastic "special effects" that the cinema was quick to imitate, but the rupture with the need to reproduce visual reality was complete. Working independently, painters and sculptors extended the possibilities of art, in accordance with their respective means of expression, right into the realm of the abstract, which they first entered round about 1910.

editing, and the marriage of the real and the imaginary by means of trick photography (of which Georges Méliès, the successor of the famous illusionist Houdini, was the brilliant pioneer)—all these innovations entirely transformed our perception of the outside world and heralded the ambiguous and complex imagery of the surrealist painters.

Breaking away from traditional unities of time, action and place, the cinema memorizes the present, which it captures and disseminates throughout the world, and brings the most hidden phenomena to light. Literally, it explores. This kind of "animated" awareness was bound to transform Western feeling, hitherto accustomed to halting phenomena in mid-career and isolating them so as to study them at leisure.

1900

The Paris World's Fair of 1900 should have made it possible to assess and take stock of the achievements of the nineteenth century. The Official Guide proudly declared: "The Exhibition, worldwide and universal, is the magnificent result, the extraordinary balance-sheet of a whole century, the most fertile in discoveries, the most prodigious in sciences, ever to revolutionize the economic order of the Universe." In fact, the Fair, which lasted some 200 days, did not achieve the expected success: the number of visitors, although larger than in 1889, fell far below the forecasts. A chronicler of the period, Gustave Babin, speculated on the reasons in his book *After Fiasco* (1902). "First, from the standpoint of the spread of ideas and inventions, the futility of exhibitions today is complete. At present there is no discovery, no new application of a known principle which, less than three months after coming to light, is not adopted throughout the civilized world, in all countries where it is ever likely to be

Paris World's Fair of 1900: Crowd in the Avenue Nicolas II, between the Grand Palais (left) and the Petit Palais (right). Photograph.

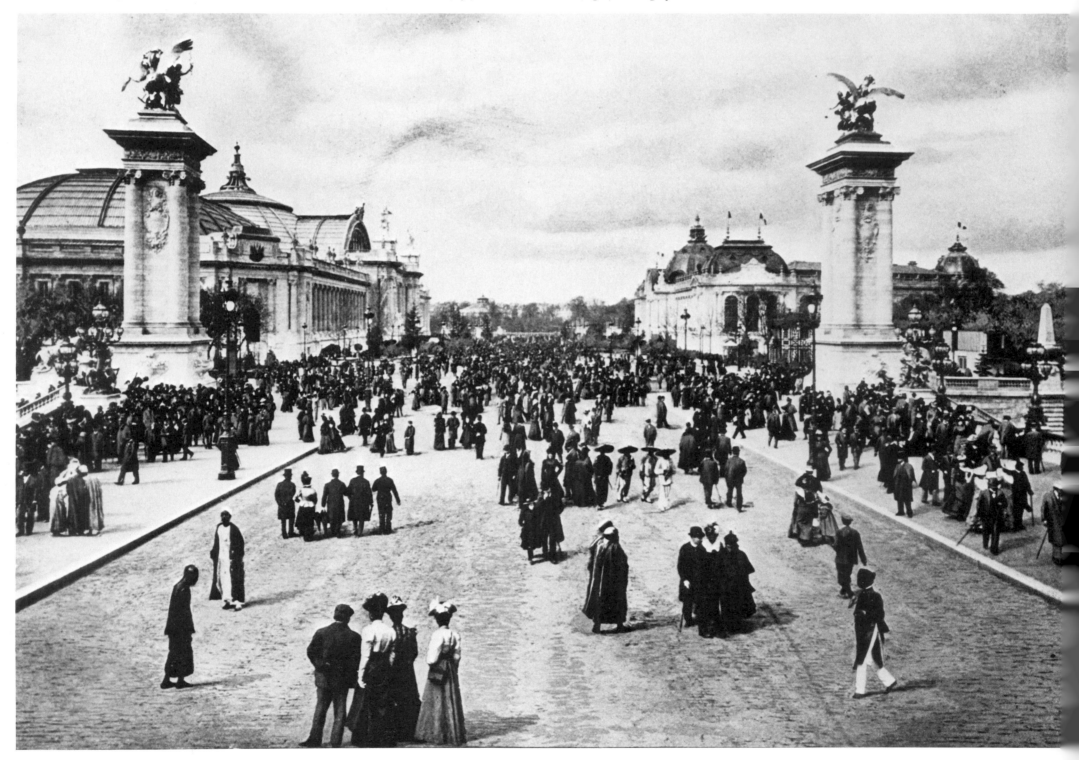

accepted. There are perhaps not two devices in the whole of this vast Exhibition which Old Europe is seeing for the first time, or which America is getting its first opportunity to see in our country." The achievements and inventions on view indeed were not as revolutionary as in previous shows: the era of scientific conquests, seemed to be drawing to a close; that of their exploitation was beginning.

The great drawing card of Paris was the opening of the Métro, the underground railway, a means of transport already existing in New York, Chicago and Vienna. From *L'Illustration* we take this lyrical description: "The stations are clothed in a modern décor at once gay, clean and hygienic. Electric light, moreover, is distributed in abundance. This lighting is not confined to the stations; it runs the whole length of the tunnel, and, added to that of the railway cars, gives a warm and reassuring feeling designed to remove all the apprehensions of those persons who fear underground journeys."

The public also enthused over the new competitions: the Paris-Toulouse round-trip car rally, 1,142 kilometres lasting from the 15th to the 28th of July 1900, with twenty of the fifty-three starters arriving at the finish line; the balloon contests at Vincennes—fourteen of them between 17 June and 9 October—based on duration of flight, altitude and accuracy of itinerary and landing. The winner of the final contest was Count De La Vaulx, piloting the *Centaur*, which landed at Kiev in Russia after travelling 1,900 kilometres in 35 hours. That same year, the German inventor Count Zeppelin put the finishing touches on his famous "flying cigar," 107 metres long and 11 metres in diameter. On its test flight over Lake Constance, the Zeppelin, equipped with a motor, made ten kilometres an hour. The conquest of the sky was beginning...

Photography reigned supreme. Of the 300,000 visitors each day to the World's Fair, 5,000 were armed with a camera. The picture postcard also had an unprecedented success. Certain applications of photography were making possible all kinds of experiments, such as clocking the speed of automobiles.

In architecture the taste for sumptuous decoration prevailed at the Fair over daring solutions to problems of construction; if the spectators had placed high hopes on America, whose skyscrapers were becoming famous, they could only be disappointed. The editor of *L'Illustration* lamented: "The great transatlantic Republic has missed a golden opportunity to show us that it possesses a national architecture... The art of men like Richardson, Burnham and Root did not seem official enough, did not seem sufficiently pompous, triumphant, imperial! What was called for was a majestic mass over which gilding could be spread; a sphere on which the American eagle could be poised with outstretched wings; a dome to support that sphere and a cubic mass to hold up that dome. The architects in charge of the United States pavilion were given the mission of repeating on the banks of the Seine the work of their predecessor who built the Capitol in Washington. They have conscientiously fulfilled it."

Among the new techniques in construction two are worth noting: the cast steel of which the Alexander III bridge is built, and above all the reinforced cement used in flagstones covering the underground railway cutting and carrying the exhibition pavilions, or in supporting pillars. The corbelled balconies of the exhibition were also in reinforced concrete.

The Grand Palais and the Petit Palais were illustrious temples of art, built for displays of prestige. In the first was the centen-

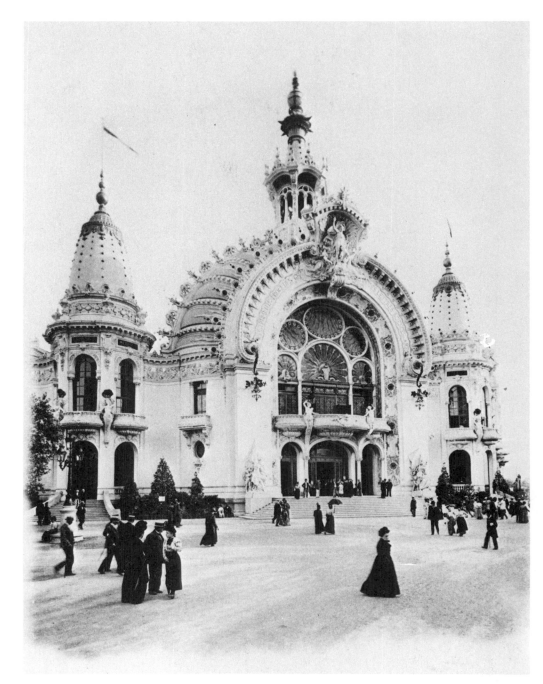

The Palace of Arts and Sciences at the Paris World's Fair of 1900. Photograph.

nial exhibition of French art and also the decennial—a kind of inventory of artistic creation during the previous ten years. The net result of the latter show, organized by Salon members, was crushing: in its entire catalogue there did not appear a single artist whose name would count in the century to come. On the other hand, the centennial exhibition, designed to illustrate French artistic creation between 1800 and 1899, was entrusted to Roger Marx who, despite some staunch resistance, exposed alongside all the great classical, romantic and realist names the few contemporary masters who in future would signify, including 3 Cézannes, 2 Degas, 1 Gauguin, 12 Manets, 14 Monets, 8 Pissarros, 1 Seurat, 8 Sisleys, 1 Vallotton and 8 Rodins. The Petit Palais held a retrospective of French art from its origins to 1800, where collectors discovered the beauties of folk art and handicrafts and above all the church treasures, virtually unknown to the public before then. It was for everyone a revelation of those arts called "primitive," which, so striking in their freedom of form, volumes and colours, were to arouse appeals and emotions of the highest importance for the evolution of taste in the years ahead.

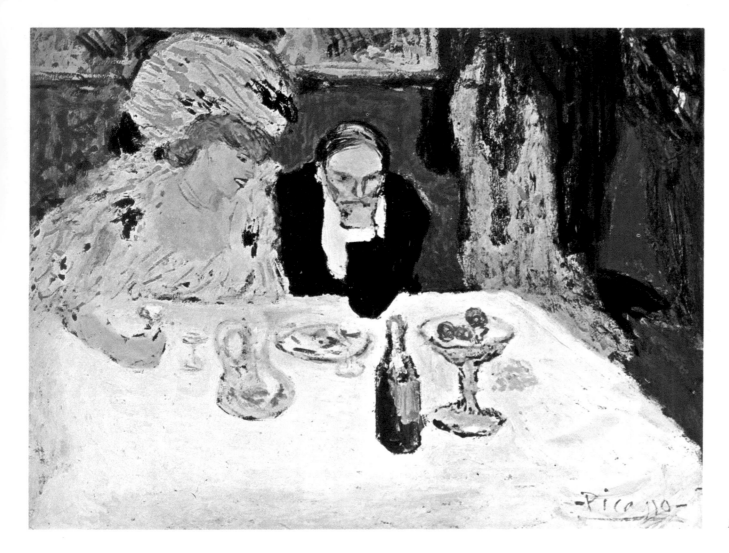

Pablo Picasso (1881-1973): Diners, 1901. Oil.

The Frieze of Life by Munch, which sums up an anguish that marked a number of *fin-de-siècle* creators, dealt once more with one of the Norwegian painter's main themes: it confronted modern man with love and death through the three ages of woman. If it is related by its subject matter to Gauguin's *Whence come we?...*, it differs from that Tahitian painting by its context and the answer it provides: the young girl, the alluring woman and the woman resigned after the fire of passion has gone out testify, in the violence of the colours and the cruelty of the landscape, to a world created out of screams and dread. Although Munch, through the power and purity of his artistic language, ushered in

the twentieth century, he was not in fact destined to participate in it. Stricken in 1908 by a severe nervous breakdown, he never recaptured, after his cure, the full intensity of his earlier work.

Picasso, born in 1881 in Malaga but working in Barcelona since 1895, was acquainted with the art of his time only through the architecture of Gaudí and the illustrations in Catalonian art magazines and on posters. During his first stay in Paris in 1900 he found a stimulating ferment of art trends which put him on his mettle. That excited handling of colour which for Van Gogh served to express "those terrible things, men's passions" opened a new world of painting to the younger men.

*Edvard Munch (1863-1944):
The Dance of Life, 1899-1900.
Oil.*

116

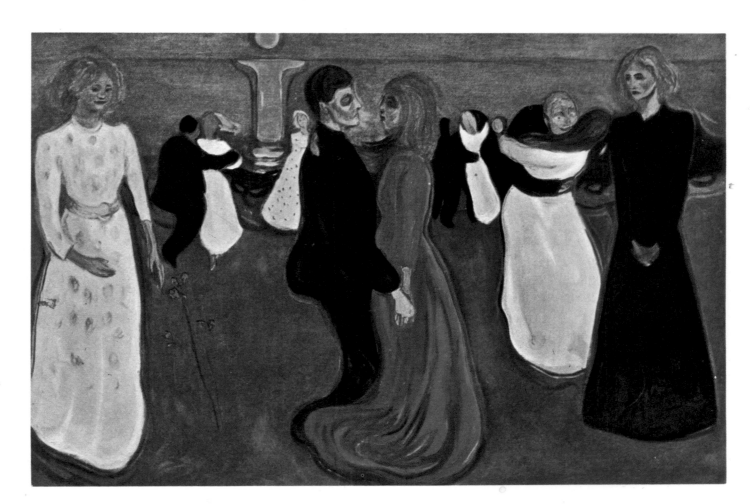

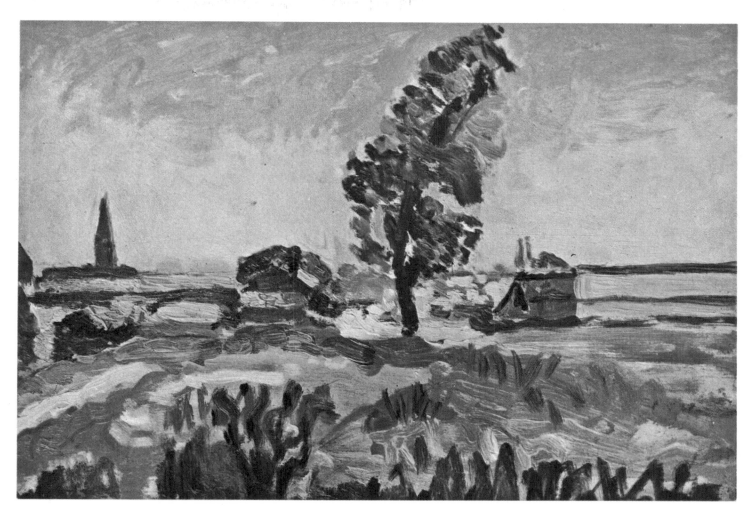

Henri Matisse (1869-1954): Landscape near Toulouse, 1900. Oil.

Appointed to a professorship at the Ecole des Beaux-Arts in 1892, Gustave Moreau had as his pupils some of the most promising painters of the younger generation: Matisse, Rouault, Marquet, Manguin and Desvallières. With great understanding, Moreau never imposed his own ideas on his students, leaving them free to assert their personalities. Rouault said of him, "He was not a professor in the commonly accepted sense, but a man whom it did you good to emulate," for he knew how to leave his mark on his students without transforming them into his disciples. In 1942 Matisse could still remember: "Gustave Moreau's great quality was to regard the mind of a young student as needing to develop continuously throughout his life, and not to push him to get through the various scholastic examinations."

Matisse was born on 31 December 1869 in Le Cateau-Cambresis in northern France. After a short time in the studio of Bouguereau at the Académie Julian in Paris he was admitted to Moreau's studio, where he remained until the master's death in 1898. In 1895 he became receptive to impressionist technique, which was fully revealed to him in 1897, when the Caillebotte Bequest was donated to the Luxembourg Museum. From then on his palette became brighter. However, he began using pure colour only a year later, during a stay in Corsica.

It was thanks to Moreau that Matisse, like his friend Albert Marquet, turned his attention to line—the elegant and supple brushstroke. Rouault, on the contrary, owed to the master his extraordinary muted, warm and mysterious tonalities, which throughout his life he intensified to exaltation. He told André Suarès, "Who could put into words what Moreau was for us, apart from his work; what he wished to bring into blossom in us. . . those admirable conversations in front of the Old Masters, his constant care to respect our tender egos?"

Like Marquet, Matisse often painted from the model and frequented the Académie Carrière, where he met Derain. He also studied sculpture. Signac's articles, appearing in the numbers of the *Revue Blanche*, encouraged him in the use of pure separated colours; meanwhile he became interested in all the questions of contemporary art, and, despite his great poverty, went so far as to buy a bust by Rodin, a small head by Gauguin, a drawing by Van Gogh and, above all, one of the series of Cézanne's paintings of *Bathers*. "I have drawn my faith and perseverance from him," he said, speaking of the master of Aix, to whom he felt united in the search for a synthesis of form and colours, which is the basis of his art. Matisse also joined in Cézanne's quest for autonomous painting that would be rid of all obligation of exactitude in description.

Like Marquet, Matisse systematically sought the opposition of cold and warm tones, and employed with admirable invention the most violent colour relations, thereby prefiguring the impending revolution of Fauvism. We can already detect in him the future painter of the joy of painting and of life. Paradoxically, it may be said that his daring liberties brought him close to a certain classical spirit. Moreau had taught him to study the great museum painters. In 1943 Matisse recalled this debt in telling Gaston Diehl: "By acting in this way he saved us from the prevailing trend at the school, where no one had eyes for anything but the Salon. It was almost a revolutionary attitude on his part to teach us the way of the museum at a time when official art, given up to the worst pastiches, and living art, attracted by the cult of open-air painting, seemed to conspire to turn us aside from that road." But Moreau also counselled his pupils: "Don't be content with going to the museum; go down into the street."

1901: Van Gogh revealed to the public

"On that day I loved Van Gogh more than my own father."

Vlaminck

"I work a lot and I work fast; in this way I try to capture the desperately swift passage of things in modern life," wrote Van Gogh in May 1890 from Auvers-sur-Oise, where he was staying with Dr Gachet, that good friend to painters. Time was running out, and he knew it. He had left Saint-Rémy and the asylum where he had gone voluntarily a year earlier, after the dramatic clash with Gauguin at Arles and the "sacrifice" of his ear. But the strong Provençal sunlight he had sought so eagerly became more and more difficult to bear, as did the deep loneliness of his existence. He finally gave up hope, even though there were one or two signs that his work was at last gaining recognition: a picture sold at the Salon des Vingt in Brussels and, in particular, Albert Aurier's article about him in the *Mercure de France* (January 1890). This was the first study of his work, and he was overwhelmed.

The peaceful setting of Auvers, a country town near Paris, was not enough to dispel his anxieties, and there were arguments with Dr Gachet. In particular, he was keenly and painfully aware of being dependent and a burden. He felt unwanted in his brother Theo's family circle, in spite of all the affection shown him by his sister-in-law Jo and the tenderness he felt for the baby, for whom he had painted the *Almond Branch in Blossom* with its background of "celestial blue" that seems to radiate hope. And yet, it was while painting this picture at Saint-Rémy that he had an acute breakdown.

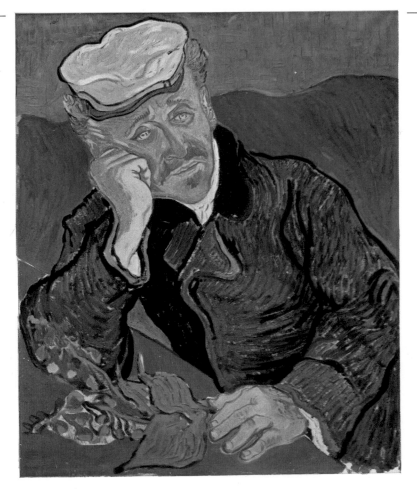

Vincent van Gogh (1853-1890): Portrait of Dr Gachet. Auvers, June 1890. Oil.

"For my own work I have risked my life. . . and my mind has half cracked under the strain," he wrote on 27 July 1890, before going out to a cornfield with a revolver and putting a bullet through his chest. He still had to struggle for two days "to find the peace he could never find on earth," to quote the words of Theo, to whom Vincent had murmured at the last: "There will never be an end to human sorrow."

The fate of Van Gogh's painting is familiar. Unrecognized during his lifetime, he remained little known outside Holland for a decade after his death. In Paris ten pictures were shown at the 1891 Salon des Indépendants, and seventeen in 1892 at the Le Barc de Boutteville Gallery (thanks to Emile Bernard), while that same year Amsterdam was already organizing an exhibition of 112 canvases. It was not until 1900 that his work made the decisive impact which future generations would never fail to acknowledge.

The showing of seventy-one works by Van Gogh at the Bernheim Gallery in Paris in 1901 is a key date. Young artists saw a kind of beacon in this elder painter who preached that "colour in itself expresses something," a statement Matisse echoed, much later, in saying, "If colours may serve to describe things or phenomena in nature, they nevertheless have in themselves, independently of the objects they serve to render, an important impact" (1951). It is understandable that Van Gogh's art had a shattering effect on the future Fauve painters; it came to Vlaminck and the others as a revelation.

The same year, the Berlin Secession organized the first German retrospective of his work. But it was not until 1905 that Van Gogh began to capture that large audience which would culminate in the popular triumph he enjoys today.

Vincent van Gogh (1853-1890): The Church at Auvers. June 1890. Oil.

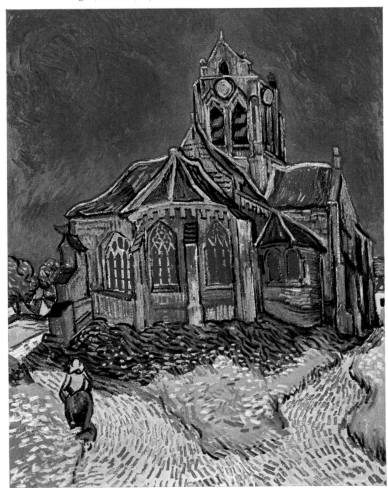

Lust for life

It is hard to imagine today what daring, force and perseverance young painters had to have at the turn of the century in the face of a public that had scarcely begun to accept the works of Cézanne's generation.

Their art, in fact, came as an explosion: far removed from the fits of melancholy and sophisticated anxieties of the Symbolists, they set out to conquer an art that was pure, total, outside all literary and metaphysical considerations. And in order not to limit their pictorial realizations to their retinal sensations they, like the Impressionists of 1870, studied nature. Matisse said, "An artist, when he reasons, must conclude that his picture is factitious; but when he paints he must have the feeling that he is copying nature. And even when he departs from nature, he should still have the conviction that he has done so only in order to render it more fully."

Former pupils of Moreau, Matisse and Marquet knew each other from the Ecole des Beaux-Arts, where they formed friendships with Manguin and Camoin. The latter, while doing military service at Aix, had the opportunity to get to know Cézanne, with whom he kept up a considerable correspondence until the old master's death in 1906.

But the teaching these young artists preferred was that of the street. "Come on then, let's go, we're going to draw some buses," Marquet would say. Matisse lived at 19 Quai St Michel, in a studio he occupied until 1907, and in which he produced many views of Notre-Dame. Without repudiating his experiments with colour, Matisse, like Marquet, explored the possibilities of the quick sketch, and concentrated on the study of volume. Their admiration for Cézanne made Van Gogh's impact richer by contrast; meanwhile, by multiplying their sketches from life, made in the street, they perfected a synthetic style which would later be termed Japanese. Their recognition of form in relation to its colour lies at the heart of that area of inquiry

"Blue eyes behind gold-rimmed spectacles and reddish beard. Henri Matisse looked serious and had a vague air of a Herr Professor. . . Here was a young fellow eager to inquire into everything connected with the art of painting, and certainly gifted."
Vlaminck

Henri Matisse (1869-1954): Self-Portrait, c. 1900. Pen and ink.

which, together with Fauvism, would liberate painters from the divisionist techniques that had been in force for twenty years.

This concern with form spurred Matisse to undertake his first sculptures; for that matter, all through his long career he would return to this pivotal stage in his development. There too began for him that pendulum movement, repeated so often afterwards, which compelled him to question what he had just achieved by attempting its opposite, before being able to proceed further. "It is good to begin by renunciation, to impose upon oneself from time to time a cure of abstinence. Turner lived in a cellar. Every day he had the shutters suddenly opened, and then—what incandescence! What dazzle! What a jeweller's window!" For Matisse this was also the period of his blue and carmine nudes, painted almost as if hacked out with an axe; yet such was his instinctive sense of colour relationships that while yoking together the most violent tones he managed to convey impressions of light grey.

From the summer of 1900 a deep friendship united Derain and Vlaminck; they shared a studio where they worked freely and ardently. Their common passion for Van Gogh brought them close to Matisse, who came to visit them at Chatou, not far from the Café Fournaise, once immortalized by Renoir. If Derain possessed a brilliant intelligence and a vast culture, Vlaminck, his elder by four years, was all instinct and violence. He earned his living as a racing cyclist or by playing the violin. "The discovery of the world for me dates from the bicycle," he would say. It gave him his "first sensations of space and freedom." Contrary to Matisse, for whom painting was an act that mobilized all the intellectual, sensory and sensitive faculties of the artist, for Vlaminck it was a way of shedding his inhibitions. "With my cobalts and vermilions I wanted to set the Ecole des Beaux-Arts ablaze, and I wished to translate my feelings with my brushes without thinking of what had been painted before" (Vlaminck, *Tournant dangereux*, 1929). It was after 1903 that he best attained this expression through colour: "I had neither jealousy

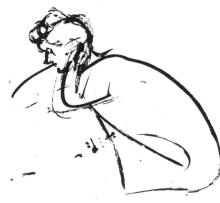

Henri Manguin (1874-1949): Figure in Profile, 1904. Drawing.

"Gustave Moreau advised his exceptional pupils not to waste their best years in his studio but to go down into the street every now and then and see what was happening there. Marquet above all felt at home in the street. At every step there were little dramas and comic or pathetic touches, not so much a matter of distress as of little troubles. Jotting down sketch after sketch, he and Matisse vied with each other in promptitude and dexterity, as Delacroix had recommended artists to do."

Georges Duthuit, *The Fauves*, 1949

nor hatred, but a raging desire to recreate a new world, a world that my eyes saw, a world for myself alone."

For Derain the approach to the problems of painting was more difficult. Kept back by his military service, he started using pure colour in 1904, but already in 1903 he had voiced his doubts: "As regards my painting, I think about it too much and too clearly. I see it too much. I see my form. My form is what destroys me. I try to immobilize my will between two already known forms. Then comes complete collapse." There, in embryo, lies the drama of this fascinating personality, who never produced the works all his friends had expected of him.

Natives of Le Havre, Friesz and Dufy, who knew each other from their teens, studied in Paris in Bonnat's studio at the Ecole des Beaux-Arts. Braque, also born in Le Havre, joined them in Paris in 1900. Their meeting with Matisse came later. It was at the Salon d'Automne of 1904 that Friesz had the revelation of the art of colour, whereas the same shock hit Dufy the following year at the Salon des Indépendants before Matisse's painting *Luxe, Calme et Volupté*. For Braque the revelation came still later, about 1906. As Friesz described it, "It was around 1904 that I felt what I then expressed by these words: Get away from the mediocrity of direct emotion; that is, find the way to put Painting in harmony with Nature. . . Colour appeared to me as a means of salvation."

Taken from a famous witticism by an art critic, the word Fauve ("wild beast") henceforth designated this group of painters. While it aptly conveyed their violence, their instinctive drive, the strength of their tonalities, it said less about the great intelligence and sensitivity which presided over their art.

After an exhibition at the Vollard Gallery in 1904, Matisse, together with his family, went to join Signac at Saint-Tropez on the Riviera. If Cézanne had stimulated him in the quest for architectural structure—as *The Terrace* indicates—Signac encouraged him to brighten up his palette and led him to reflect anew on the question of colour. This sojourn by the sea enabled Matisse, who had met Signac at the Salon des Indépendants, to have frequent and friendly contacts with his senior, as well as with Cross, who had also settled on the shores of the Mediterranean. One of Cross's paintings owned by Signac, *Evening Air* (1894), impressed Matisse strongly by its subject and composition; echoes of it may be found in Matisse's celebrated work *Luxe, Calme et Volupté*, which sums up in masterly fashion his experience of the summer of 1904. Here Matisse takes up the subject—a kind of theme-and-variations in Pointillism—by means of the scenery, which he painted on the spot and later peopled with harmoniously arranged figures. In September 1904 Cross wrote to his friend Theo van Rysselberghe: "We went to Saint-Tropez. The anxious, the wildly anxious Matisse! You will easily understand that I was as happy to chat with him as I was delighted to see the self-confidence of our friend Signac."

Matisse returned to Paris for the 1904 Salon d'Automne. The Signac and Cross exhibitions at the Druet Gallery in December 1904 and March 1905, then the impressive Seurat and Van Gogh retrospectives at the 1905 Salon des Indépendants, brought Pointillism back into the limelight. Signac, enthusiastic over Matisse's picture, hung it in the place of honour at the Indépendants, over which he presided, before acquiring it for himself. If *Luxe, Calme et Volupté*, in its title and theme, is still symbolic in spirit; and if it still remains in the impressionist tradition in its subject—an outdoor picnic—it also opens the way to an art of purely pictorial invention. Matisse isolated the pointillist touches by leaving a clear space around them, and ordered them so as to create arbitrary movements which broke with all naturalistic description. His colour completely reinvented space.

Maurice Denis brought out these qualities, which marked what was new in Matisse: "Properly speaking, it is the search for the absolute. And yet, by a strange contradiction, this absolute is limited by the most relative thing in the world: individual emotion." This aptly describes *Luxe, Calme et Volupté*, the summing up of all Matisse's efforts to date.

Towards Fauvism

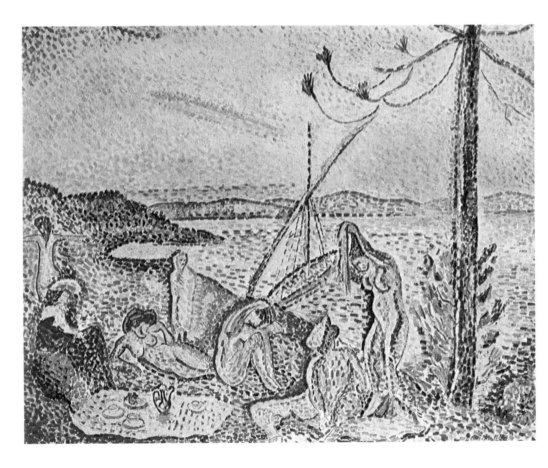

Henri Matisse (1869-1954):
Luxe, Calme et Volupté, 1904-1905. Oil.

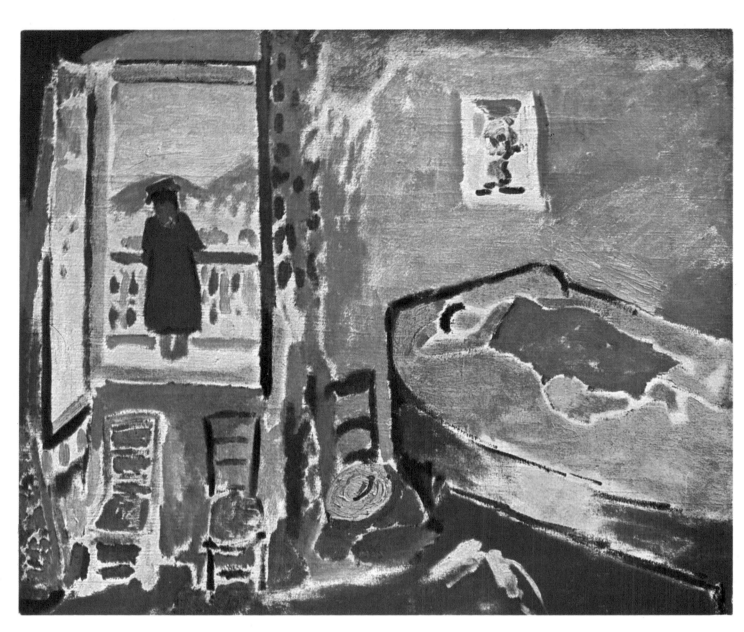

Henri Matisse (1869-1954):
Interior at Collioure, 1905.
Oil.

Encouraging Derain and Vlaminck to exhibit with him at the Salon des Indépendants of 1905, Matisse left for Collioure at the start of the summer with Derain, who, depressed by his military service, drew new inspiration from contact with the elder painter. Collioure became the cradle of Fauvism. Collioure, a little fishing port of the Eastern Pyrenees, where the sun rises as if bounding up from the ochreous rocks and orange-coloured earth, suggested to him an intense palette, combined with a bright and limpid atmosphere of rare purity. Confronted by dazzling natural surroundings, Matisse, with Derain following in his wake, went beyond the data of Pointillism. In his own words (recorded by Tériade in *L'Intransigeant*, 14 January 1929), he "shook off the tyranny of divisionism. It is impossible to live in a household which is too well kept, a household of provincial aunts. So you take to the hills to develop simpler methods for yourself which do not stifle the spirit. In those days there was also the influence of Gauguin and Van Gogh. Here are the ideas of that time: Construction by coloured surfaces; striving for intensity in the colour, the subject matter being of no consequence; reaction against the diffusion of local colour into the light. The light is not eliminated, but expressed by an accord of intensely coloured surfaces."

Matisse thereby allied science with instinct, and gave himself up to methodical experimentation with the data of painting, an approach which is the very foundation of his art. Derain, who like Vlaminck had until then given free rein to enthusiasm and instinctive violence, found in the new propositions of Matisse an echo of his own desire for a more organized and reflective art. In a letter to Vlaminck he wrote, "As regards painting, Matisse is passing through a crisis. But on the other hand, from the point of view of logic and psychological speculations, he is a much more extraordinary fellow than I would have believed..."

Matisse and Derain were dazzled by the quality of the light at Collioure, "blond and golden, eliminating shadows. It is frightfully hard work; everything I've done till now seems stupid to me" (Derain). Such luminosity could not be accommodated by the divisionist brushstroke, which attenuates the brightness of the colours in order to promote their blending. Instinctively, Matisse introduced large surfaces, intensely coloured, which he caused to vibrate luminously by setting them against their complementaries. If the contrast became too violent he softened it with the white of the canvas, which he allowed to show through the paints. *Interior at Collioure* displays the masterly freedom of expression he attained by organizing the colours no longer according to their natural order but to the necessities of light and, above all, of feeling. He entirely reinvents nature; we no longer know where the ground and the walls end, but already he has suggested the peace which reigns in the room, the harmony of the whole, growing out of the freshness and richness, the calm and brilliance of the forms and the tones. The colour is no longer descriptive, but allusive: its intensity and arbitrariness break with optical realism.

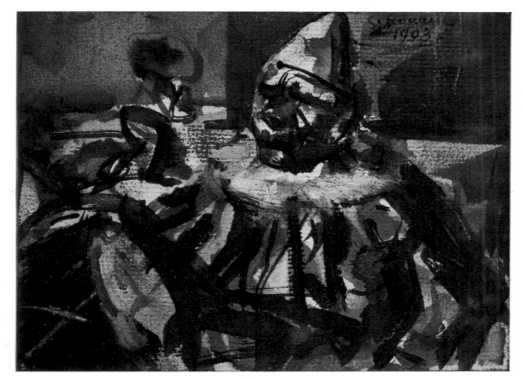

Georges Rouault (1871-1958). Tragic Clown, 1903. Watercolour.

The Fauves
at the 1905 Salon d'Automne

"People tell us: Why does *L'Illustration* devote a whole issue every year to the traditional Spring Salons and then ignore the new Autumn Salon? Your readers in the provinces and abroad, living far away from Paris, would be happy to have at least some idea of these works by little known masters which the most serious papers, even *Le Temps*, have so warmly praised.

"Recognizing the justice of this complaint, we now devote two pages to reproducing as best we can a dozen outstanding canvases on display at the Autumn Salon. We cannot unfortunately show them in colour, but the reader will at least be able to judge of the design and composition. If some readers have reservations about the selection we have made, we urge them to read the lines printed under each picture: these are the comments made by the most notable writers on art, and we take our stand behind their authority. We would only point out that, while there was a time when critics reserved all their praise for famous painters and all their sarcasms for the beginners and the seekers, that state of affairs has today very much changed."

From *L'Illustration*, Paris, 4 November 1905, special issue on the Salon d'Automne

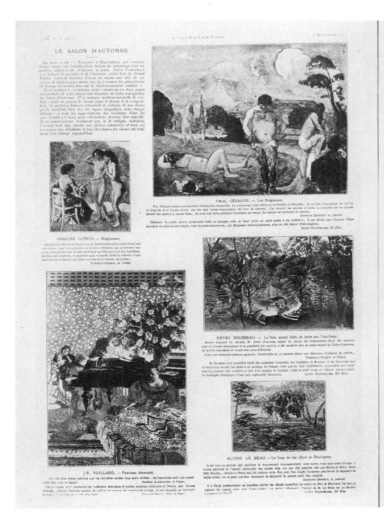
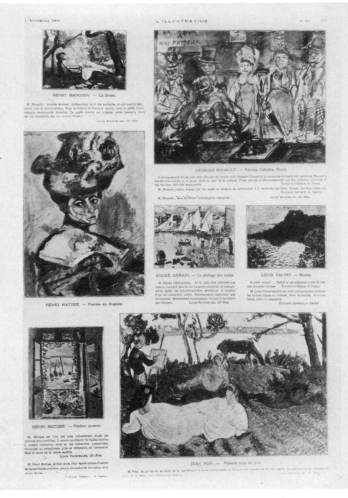

Double page on the Salon d'Automne, from "L'Illustration," Paris, 4 November 1905.

The art critic Louis Vauxcelles, visiting the 1905 Salon d'Automne, exclaimed in front of an academic sculpture by Marque which was in the same room with the flamboyant works of Matisse and his friends: "Donatello among the *fauves* (wild beasts)!" The name stuck: the painter Desvallières, a former pupil of Moreau, was responsible for its catching on. Vauxcelles himself used the word *fauve* for the first time in an article in *Gil Blas* on 17 October, but in a different sense: he congratulated Matisse, "for his picture, as he well knows, will suffer the fate of a Christian virgin delivered up to the wild beasts in the arena."

This "wild beasts' cage" caused a scandal. "A pot of paint has been flung in the face of the public," fumed Camille Mauclair. He was alluding to Matisse, Manguin, Derain, Vlaminck, Valtat and Puy, who were assembled in the same room. Elsewhere were to be found Rouault and two as yet unknown Russian colourists from Munich, Kandinsky and Jawlensky, who thus had the opportunity of meeting face to face the productions of their contemporaries. The work which gave rise to the greatest bewilderment was Matisse's *Woman With a Hat*. Francis Carco, the future art critic of *Gil Blas*, would speak of it as a revelation: "At last I was able to understand what my friends called a portrait. Nothing in it was physically human. You got the impression that the artist had been far more concerned with his own personality than with his model's."

But this picture which touched off the mockery and hostility of the public enabled Matisse to make the acquaintance of a rich American family, the Steins, who were to figure among his chief collectors and help him free himself from the straitened circum-

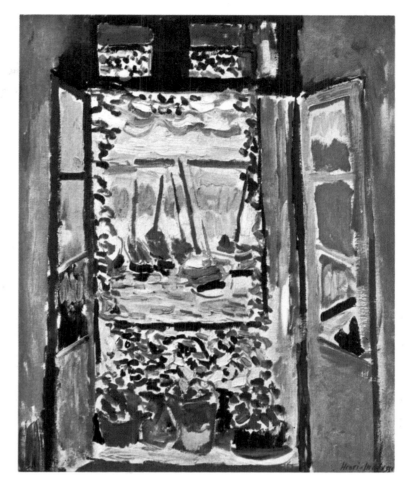

Henri Matisse (1869-1954):
Open Window at Collioure, 1905. Oil.

Henri Matisse (1869-1954):
Woman with a Hat (Madame Matisse), 1905. Oil.

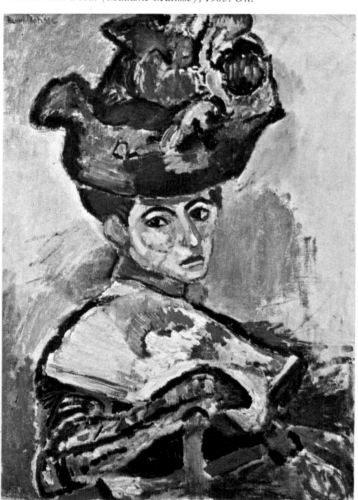

stances in which he lived. The Stein family included the brothers Leo and Michael, as well as Michael's wife Sarah, and above all Gertrude, the famous writer, who shortly afterwards introduced Matisse to Picasso.

The Douanier Rousseau, who had been regularly exhibiting at the Salon des Indépendants since its inception in 1884, found at the Salon d'Automne (through the reproduction of his work in the weekly paper *L'Illustration*) a response that to the present day has remained limited to a few artists and connoisseurs. Placed alongside the masters of the new painting he asserted himself in a revolutionary way in the direction of "naive," "primitive" or even "savage" art. His fantastic scenes, evoking neither a form nor a culture, fascinated Picasso and Apollinaire.

Rouault too was recreating a world of intense emotion. When he "left the museums and went down into the streets, he recorded daily life chiefly in the persons of clowns and prostitutes, whom he painted in forms unexampled in his earlier manner... Rouault, at about the same time as the Fauves, created for himself the same conditions of imaginative freedom in the handling of form that they did. Fittingly enough, he exhibited with the Fauves, though he never belonged to the group" (Lionello Venturi). And outside the Fauve room, he sent to the Salon d'Automne of 1905 a triptych, of which one panel was *The Couple: Monsieur and Madame Poulot*, characters taken from the novel *La Femme pauvre* (1897) by Léon Bloy. This Christian writer, whom Rouault had met in 1904, had a desperate thirst for the absolute, and by reason of his extremist and apocalyptic temperament Bloy exerted a real influence over the painter. Throughout his life Rouault expressed a vision composed of pity and vehemence, marked always by a deep faith.

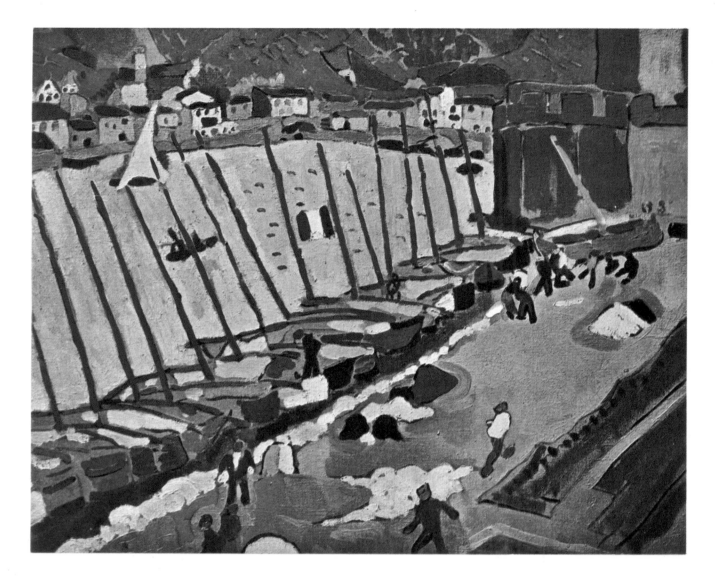

"Fauvism was for us the ordeal by fire. I have never lost touch with the old masters and at eighteen I was familiar with all available reproductions of the masterpieces. What is to be gained by lacking culture? There were certainly some underlying causes for our misgivings at that time, our need to paint something besides what anyone could see. That was the age of photography. It may have been a cause of influence and it counted in our reaction against anything that resembled a snapshot. No distance seemed great enough for us to take our stand in order to look at things and carry out our transposition at leisure. Colours were supposed to become so many cartridges of dynamite, and they were supposed to let off light. We liked the idea, so new to us, that everything could be lifted above and beyond reality. And we took the idea seriously. With our flat colours we retained a concern for mass, making a patch of sand, for example, heavier than it really is in order to emphasize the fluidity of the water and the lightness of the sky."

André Derain

André Derain (1880-1954):
Le Faubourg, Collioure, 1905. Oil.

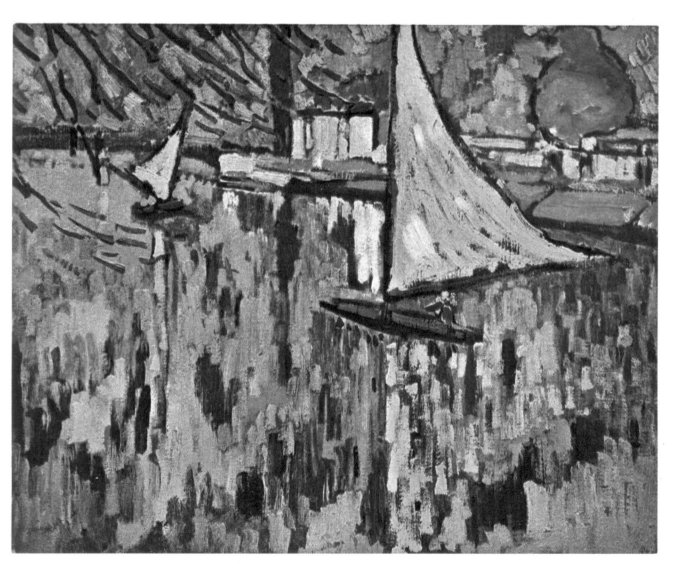

"Whenever I had spent a few days thinking nothing and doing nothing, I was taken with a keen appetite for painting. So I would go out and set up my easel in the sun. The sky was blue. Vermilion alone could render the glowing red tiles on the opposite hillside. The orange colour of the soil, the raw hard colours of the walls and the greenery, the ultramarine blue and cobalt of the sky, all harmonized to the utmost in a sensual and musical order. Only the whole range of colours on the canvas with all their orchestrated power and resonance could convey the coloured emotion of that landscape. Sometimes a storm would blow up. A gust of wind would topple over my easel, away my canvas would go and get a hole knocked in it. I would get home soaked to the skin, my canvas hanging slack, heavy and sticky with pigments."

Maurice Vlaminck

Maurice Vlaminck (1876-1958):
Boats on the Seine, 1905. Oil.

The Fauves and their excited handling of the paints

At Collioure, Matisse and Derain painted each other's portrait. Together with the one Vlaminck did of himself they testify to what degree expressive power had been mastered; with Matisse and Derain the coloured contrasts, almost brutal in their simplicity, situate the figures luminously and spatially, whereas with Vlaminck the colour is flung onto the canvas.

The shock of Gauguin's art gave unexpected encouragement to Derain and Matisse. During their stay in the South they made the acquaintance of a sculptor working at Banyuls, Aristide Maillol, who spoke to them with enthusiasm of the art of Gauguin; together they went to the nearby home of Daniel de Monfreid, who still possessed the Tahitian works, and to Fontfroide Abbey, where Gustave Fayet had assembled a large collection of Gauguins. The example of their prestigious senior strengthened the young painters in their quest for an organization of surface by colour and by rhythmically distributed flat tints. But this lesson would bear fruit only later, when the divisionist system had lost its hold. In his masterly portrait, *The Green Stripe*, Matisse not only succeeded in capturing what was essential in the form and colour; he also reopened, by recreating them, all the unsolved questions of warm light and cool shadow.

Whereas the painters of Collioure tended towards the exaltation of pure colour, Marquet sought expression through value relationships, and the subtle harmonies of tones which he inscribes in an incisive and synthetic design make him more of a luminist than a colourist. During the summer of 1905 he travelled to the South of France, to Saint-Tropez, where he rejoined Camoin and Manguin. Captivated by the intensity and purity of the light, they painted works of great quality, as exemplified by *The Fourteenth of July at Saint-Tropez* by Manguin; like the Impressionists before them they were attracted by the festive atmosphere of the decked-out streets.

During that same summer Vlaminck continued to paint in a violent manner, squeezing his colours straight from the tube onto the canvas (the influence of Van Gogh, fortified by the retrospective at the 1905 Salon des Indépendants, inspired him). He did not attain the luminosity of a Matisse, leaning rather towards German Expressionism, although he did not share its tragic sense. He also remained more naturalistic, and his successes hung on the luck of his instinct.

"Expression for me does not reside in passions glowing in a human face or manifested by violent movement. The entire arrangement of my picture is expressive: the place occupied by the figures, the empty spaces around them, the proportions, everything has its share. Composition is the art of arranging in a decorative manner the diverse elements at the painter's command in order to express his feelings. In a picture every part will be visible and will play its appointed role, whether a leading or a secondary one. Everything that is not useful in the picture is, it follows, harmful. A work of art must be harmonious in its entirety: any superfluous detail would replace some other essential detail in the mind of the spectator."

Henri Matisse, "Notes of a Painter," *La Grande Revue*, Paris, 25 December 1908

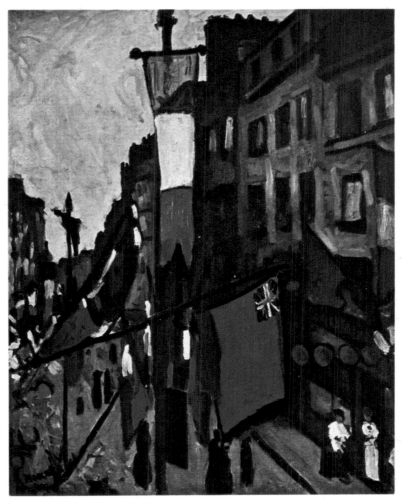

Albert Marquet (1875-1947): The 14th of July at Le Havre, 1906. Oil.

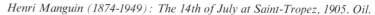

Henri Manguin (1874-1949): The 14th of July at Saint-Tropez, 1905. Oil.

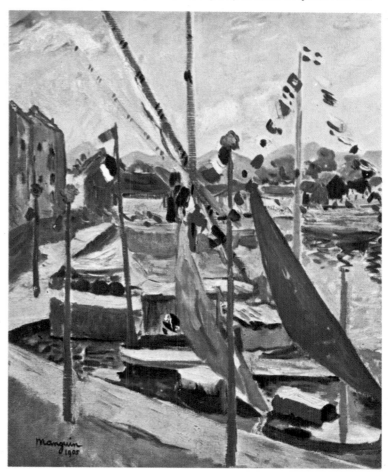

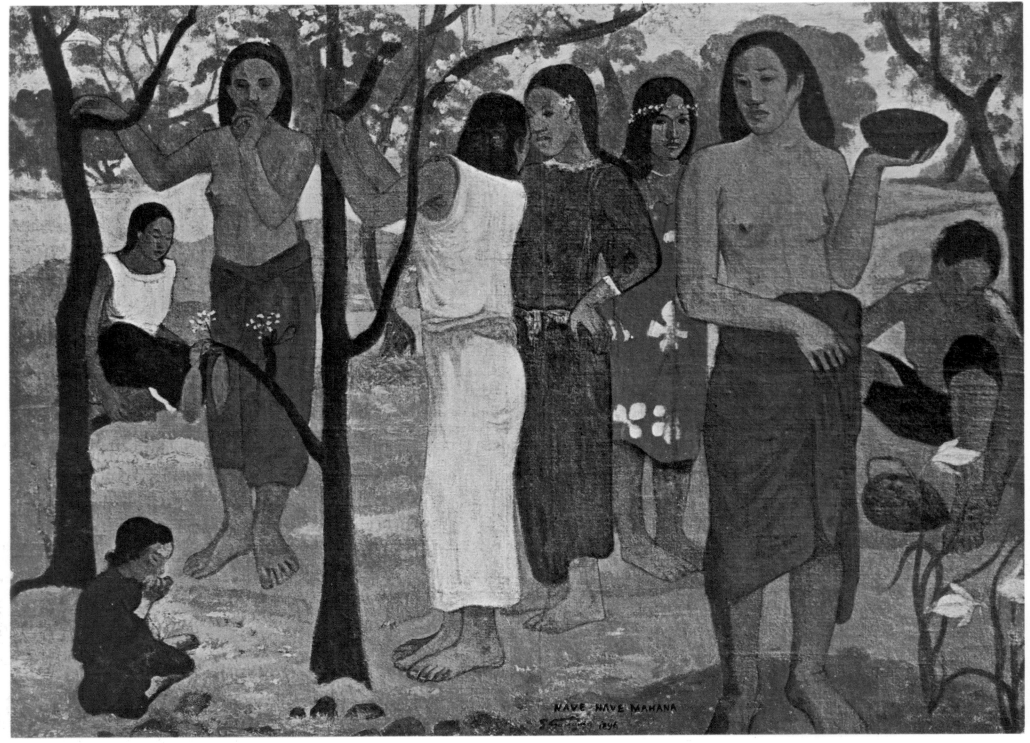

Paul Gauguin (1848-1903): Nave Nave Mahana (The Entrancing Sun), 1896. Oil.

Under Matisse's supervision, the Gauguin retrospective at the 1906 Salon d'Automne assembled 227 paintings, and coincided with the discovery of African art by European artists. Gauguin had already prophesied: "You will always find mother's milk in the primitive arts" (*Diverses Choses*, 1896-1897). During the next three years art freed itself from all academic tradition through the contact with primitivism presaged by Gauguin. Picasso and Matisse were the two artists who felt his influence most deeply.

Gauguin's strength lay in the sobriety and primitivism of his forms and in the manner in which he broke with all illusion of perspective while basing his compositions on large, unbroken areas of flat colour, rhythmically arranged. Dispensing with a model, he achieved distortions which accentuated correspondences between forms, and a mysterious atmosphere springing from the musical harmonies of a colour no longer related to description. With him there peremptorily asserted itself the autonomy of the painter's means—the chant of form, rhythms and

hues. And he affirmed the imaginary as well. Matisse, although influenced by him, recognized the distance separating Gauguin from the new generation. "What Gauguin needs in order to be included among the Fauves—and what he lacks—is a construction of space by colour, which he uses instead for the expression of feeling." No one, however, escaped the novelty and effectiveness of his solutions to creative problems.

At the time of this retrospective Gauguin had been dead for three years. In September 1901 he had left Tahiti and gone on to Hivaoa in the Marquesas Islands, settling in the village of Atuana and hoping by this change to find new sources of inspiration. "With landscapes remaining to be discovered—in short, among entirely new and wilder elements, I am going to do beautiful things. In Tahiti my imagination was beginning to grow cold." At Atuana he wrote two manuscripts, *Racontars d'un rapin* and *Avant et après* (not published till 1951 and 1918 respectively). Isolated in more primitive surroundings he built himself a hut,

Gauguin and the Fauves

which he called "La Maison du Jouir" and adorned with sculptures of an archaic power and sobriety directly prefiguring Picasso's woodcarvings inspired by African art. He painted with a freedom that testified to his "right to dare everything." Freed from all theory and obligation to describe, his painting became naturally one with the idea: "Here poetry comes out all by itself, and to suggest it all you have to do is give yourself up to reverie while you paint. I ask only two years of health and not too many money worries, which now have too strong a hold over my nervous temperament, to attain a certain maturity in my art. I feel that in art *I am right*, but will I have the force to express my conviction in a positive way? In any case I shall have done my duty, and if my works do not endure there will always remain the memory of an artist who set painting free from many of its symbolist idiosyncrasies (another brand of sentimentalism)."

When Gauguin died, on 8 May 1903, his work was only beginning to live. He had been conscious of working for the future. "The public owes me nothing because my pictorial work is only *relatively* good, but the painters who today enjoy this freedom do owe me something. It is true many imagine all that came about by itself; anyhow, I ask them nothing and my conscience is reward enough," he wrote to Daniel de Monfreid in 1902.

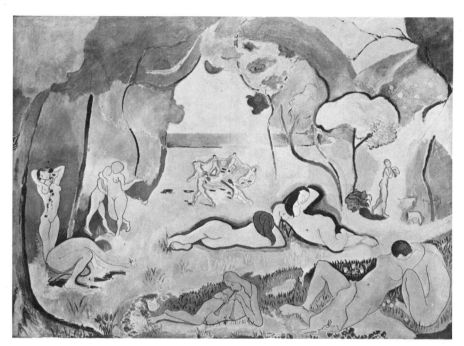

Henri Matisse (1869-1954): Joie de Vivre, 1905-1906. Oil.
(Copyright 1979, The Barnes Foundation, Merion, Pa.)

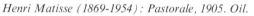

Henri Matisse (1869-1954): Pastorale, 1905. Oil.

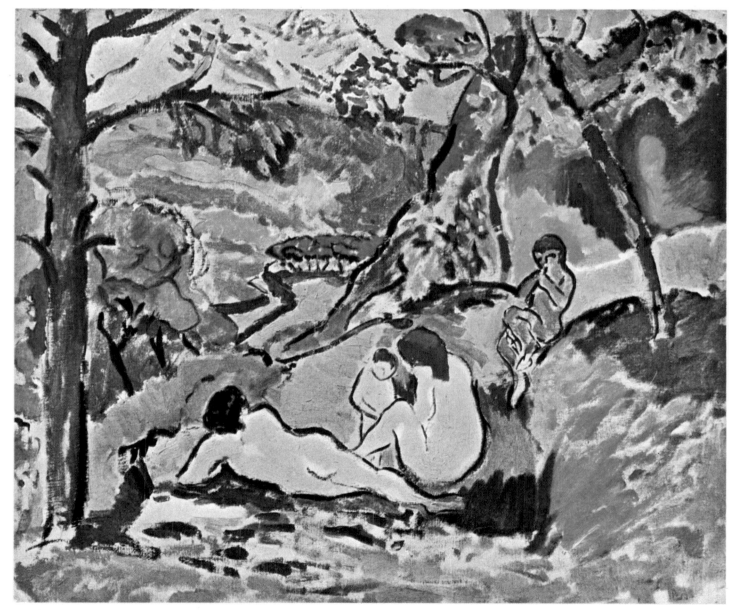

Taking up again the subject of his *Pastorale* and *Luxe, Calme et Volupté*, Matisse in *The Joy of Life* transposed the theme into a more classical key, in which he combined the bucolic ideal with a bacchanal. The picture can be followed from its beginnings, through a long series of varying studies which led Matisse from a world of vivid light and movement to the creation of an Arcadia of quietude and serenity. He originally called it *Le Bonheur de vivre*; it was later retitled *La Joie de vivre* by the American collector Dr Albert C. Barnes. It was painted in Matisse's studio in the Couvent des Oiseaux, a disused convent at 56, Rue de Sèvres, Paris. It was there, in 1908, that he opened an art school of his own, the Académie Matisse, which was attended by many young artists, mostly Americans (among them Max Weber and Patrick Henry Bruce), Germans and Scandinavians.

The Joy of Life marks a turning point in Matisse's work. Here appear the themes of dancing and music which were to be the subjects of his next big compositions. By the time he painted the final version of this canvas, Matisse had given up Divisionism and taken a new approach to the problem of form/colour, using now arabesques and thick black outlines. While losing none of the splendour of his palette, he created a new and subtle order of design.

1905: Early Expressionism and the Brücke

Ernst Ludwig Kirchner (1880-1938): Programme design for the Brücke group, 1906. Woodcut.

Karl Schmidt-Rottluff (1884-1976): Woman with a Hat, 1905. Woodcut.

Before Bismarck, Germany comprised 234 small feudal monarchies, whose independence and prerogatives prevented a modern economic and cultural unity. In that context, the philosophers and humanists had not been able to achieve a linguistic unity; and, scattered throughout the provincial capitals, each of them had imparted to his thought a theoretical character. This abstractness set them off from the English and French philosophers, who, committed to modern life, articulated the aspirations of the people in the face of the Industrial Revolution, democracy and the centralization of power.

After 1890, through the rapid and impetuous rise of industrialization and its consequences—displacement of peasant populations, massive urbanization, economic organization of labour and working hours, powerful and hierarchical centralization—the Germans were thrust brutally into this new world, and the ways in which they chose to express themselves, and which would give rise to Expressionism, reveal their need of escape from the present and an impulse to the negation of modern realities. An outsider to the inhuman system forced upon him, man, and *a fortiori* the artist, took refuge in the innermost recesses of his own being. In the words of the great writer, Oswald Spengler, "The human creature isolated from the forces of the countryside, chopped off, so to speak, by the pavement he tramps, grows weaker in proportion as sensation and intelligence are strengthened. . . In civilization begins senility. The old roots of being wither in the stony mass of the city. The free spirit—that fateful word—appears as a resplendent flame that rises into the air, where, suddenly, it goes out."

The aspiration to mystery which had always been intimately linked with the German genius grew exalted in reaction to such a context, and was paired with a longing to return to the "primitive"—a revolt against refinement, rationalism and utilitarianism.

The crisis between absolute power and the liberal reform movements backed by intellectuals found expression artistically in the creation of the so-called Secessions—exhibitions in which artists violently demonstrated their opposition to an ideal exemplified by the Academy and its absolute respect for authority and order. With the everyday world no longer providing a setting for his dreams, the artist took refuge in another world. As early as 1909 Freud wrote: "He [man] turns away from the real and withdraws into the happier world of his phantasies; in the case of neurotic illness he transforms the content of that world into symptoms; . . . if, on the other hand, he possesses the artistic gift, psychologically so mysterious, he may, in place of symptoms, transform his dreams into artistic creations." This passage from *Five Lectures on Psychoanalysis* already divines that fundamental source of art which artists would attempt to discover and liberate.

Jugendstil, the German counterpart of Art Nouveau, had represented an initial show of protest against the dehumanization, ugliness and debasement of industrial civilization; but in failing to free itself from the restraining force of naturalism it did not make the desired impact. It was in 1905, under the designation of *Die Brücke* (The Bridge), that the real artistic revolution was launched in Germany. The instigators were four young artists: Ernst Ludwig Kirchner, Erich Heckel, Karl

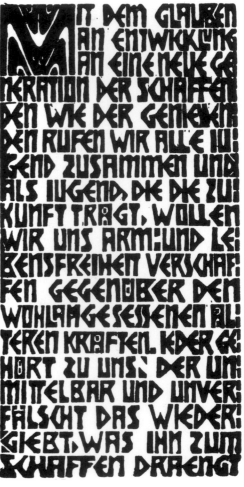

Ernst Ludwig Kirchner (1880-1938): Page from the Brücke programme, 1906. Woodcut.

Ernst Ludwig Kirchner (1880-1938): Nude with Loose Hair, 1908. Woodcut.

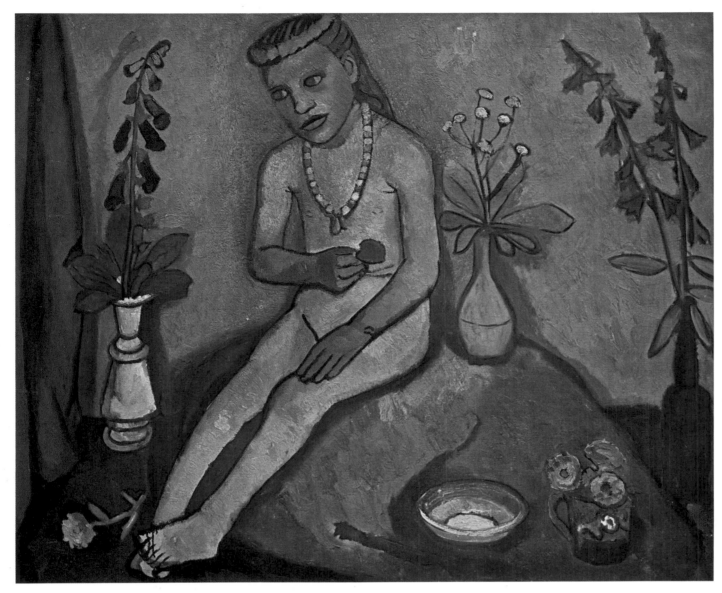

The art of Paula Moder-sohn-Becker shows already the main features of Expressionism. Born in Dresden in 1876, she died prematurely in childbirth in 1907. A close friend of Clara Westhoff, wife of the poet Rainer Maria Rilke (who commemorated her in his poem *Requiem für eine Freundin*), she made several trips to Paris, where she discovered Cézanne at the Vollard Gallery in 1900 and was much impressed by the Gauguin retrospective at the 1906 Salon d'Automne. From 1897 she worked at the artists' colony at Worpswede, near Bremen, where she achieved a highly personal style of antinaturalistic and symbolic expression. Paula Modersohn-Becker was instrumental in opening up Germany to modern art, which she had discovered for herself in Paris.

Paula Modersohn-Becker (1876-1907): Girl with Flowers, 1907. Oil.

What distinguishes the Expressionists from the Fauves is not the intensity of the colour employed (it is pure and unmixed in both cases), but the way of applying it. While Matisse and his friends emphasize its radiance by setting it off against the white of the canvas, Kirchner and the Brücke painters heighten its power by concentrating it on sharply contrasting surfaces. Paintings by Van Gogh were exhibited repeatedly in Germany from 1901 on, at the Berlin, Munich and Vienna Secessions, and also at the Arnold Gallery in Dresden in 1905: he opened the way to pure colour and his influence made for a more spiritual and sensorial rather than aesthetic and descriptive vision. His example showed the Germans the possibility of emotionally involving the spectator in the picture by means of high-pitched colours.

But it was Gauguin, through his suggestive return to primitivism and his search for a symbolic union between man and nature, who most deeply influenced the young painters of the Brücke group, who responded at once to the "folk" and "decorative" character of his art.

Ernst Ludwig Kirchner (1880-1938): Woman on a Blue Divan, 1907. Oil.

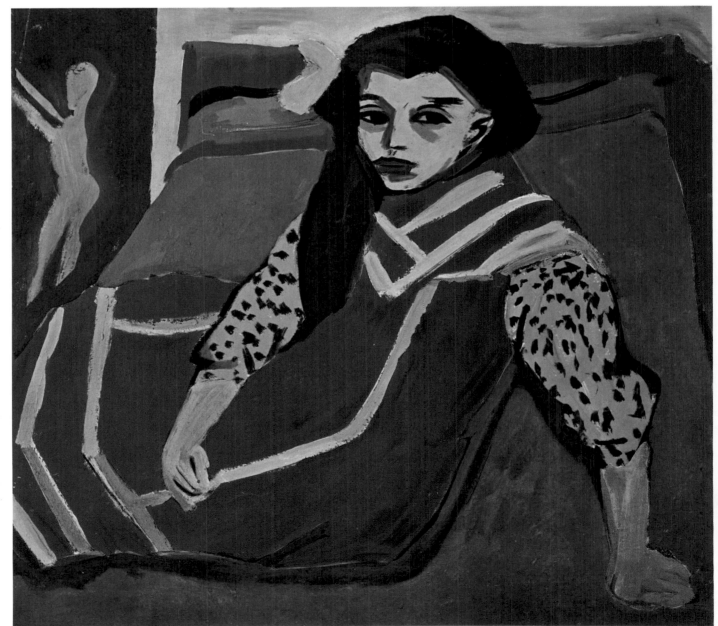

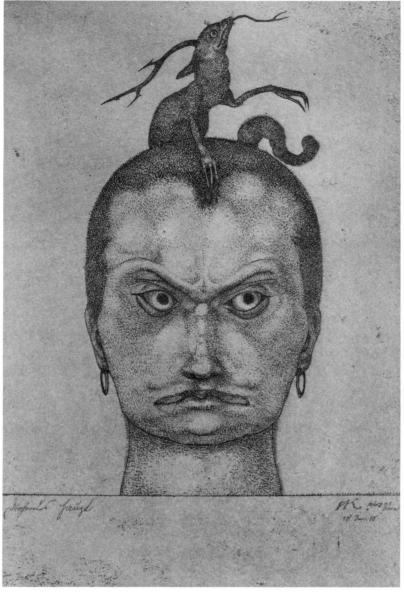

Paul Klee (1879-1940): Menacing Head, 1905. Etching.

wood-engraving, and the discovery of African art, like that of popular arts and the so-called "primitive" arts of the Middle Ages, put him in touch with emotional, non-descriptive creations. Munch, Van Gogh, and afterwards Gauguin and Cézanne left a deep impression on him and made him receptive to the language of colour.

Taking over Van Gogh's idea of an artists' commune, the members of the Brücke lived together as a community, worked and exhibited on the same premises, and gave each other stimulation and encouragement. The Brücke set out "to attract all elements of ferment and revolution" (Schmidt-Rottluff) and bring together all those who, "in a direct and authentic manner, recaptured the impulse which drove them to create" (Kirchner). Because its four founders had been trained as architects rather than painters, the group had much more freedom in the face of tradition; in their manifestoes they asserted their determination to break with the past.

"Inspired by faith in progress and in a new generation of creators and collectors, we call on youth to band together; and, like young people who bear the future within them, we want to conquer freedom of action and of life, opposing ourselves to the old forces that are so hard to uproot.

"We welcome all those who, directly and sincerely, reproduce their creative impulse" (Kirchner, *Chronik der Brücke*, 1913).

Kirchner focused his efforts chiefly on woodcuts, Schmidt-Rottluff on lithography and Heckel on woodcarving, but each instructed the others in the technique he had mastered best. Their studios were improvised in old warehouses near the railroad freight depot of Dresden-Friedrichstadt, and in summer they worked on the shores of the lakes of Moritzburg.

Munich, however, attracted more artists than Dresden. There, more than anywhere else, Art Nouveau and Symbolism triumphed and left their mark on the young painters who came from East and West to gain entry to the School of Fine Arts. There Kandinsky and Klee carried out their first experiments. Klee, born near Berne in 1879, arrived in Munich in 1898. On a journey to Italy he discovered Ravenna, which opened his eyes to the Middle Ages before he felt drawn to the art of the fantastic. In 1905 he went to France, where Fauvism made no impression on him; but he responded to the art of Redon, Ensor, Blake and Goya.

Wassily Kandinsky, who was born in Moscow in 1866, also came to Munich, in 1896; he pursued academic studies, from

Schmidt-Rottluff and Fritz Bleyl. Emil Nolde and Max Pechstein joined them in 1906. This group, one of the best organized, continued to be active in Dresden and Berlin until 1913.

Kirchner was born in 1880, the son of an engineer from Aschaffenburg; he came to Dresden in 1901 to study architecture at the technical college, where he met in turn Bleyl, Heckel and Schmidt-Rottluff, to whom he communicated his passion for art. He had already had a great deal of experience in the art of

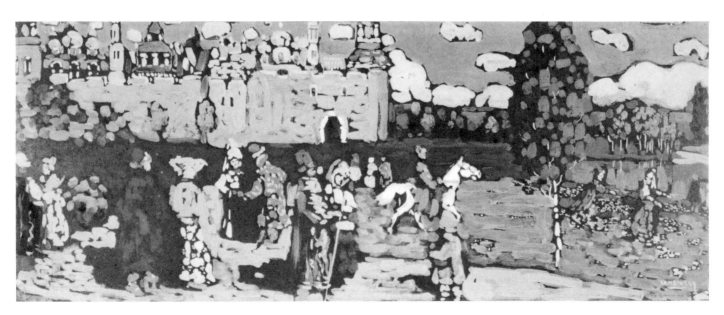

Wassily Kandinsky (1866-1944): Russian Scene, 1901. Oil.

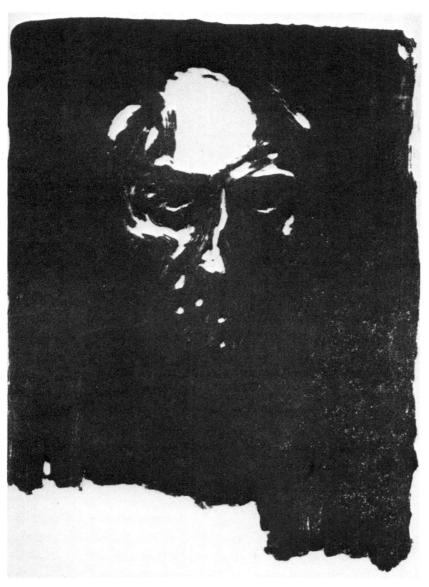

Emil Nolde (1867-1956): Self-Portrait, 1906. Lithograph.

Ernst Ludwig Kirchner (1880-1938): Invitation to the first Brücke exhibition at the Seifert Works, Dresden-Löbtau, 1906. Woodcut.

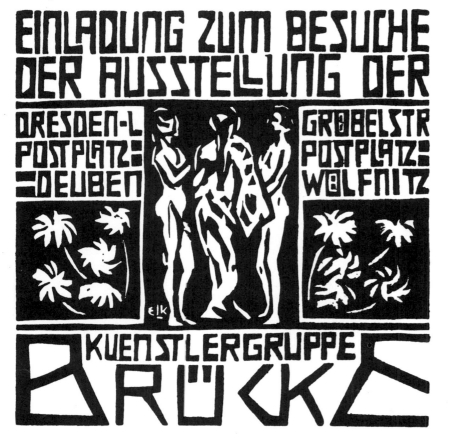

which he withdrew to take part in the exhibitions of the Berlin Secession. Although strongly influenced by Jugendstil he attached great importance to colour, which he discovered through the work of Monet and Van Gogh.

The word "expressionism" is ambiguous and can be used in quite different senses. It defines that tendency which, in every age, impels certain artists to prefer to express what they feel rather than what they see; for the revolutionary movements of the Brücke and the Blaue Reiter (Blue Rider) it was the key word, and from the day it was used in the Berlin review *Die Sturm*, it served for Germans to identify the whole of the avant-garde.

It was under the influence of Van Gogh, Gauguin and Munch that the founders of the Brücke were gradually led to prefer oil painting, although they still did not neglect printmaking, at which they excelled, and in which they saw a popular and democratic means of making their art more widely known. Besides Heckel, Schmidt-Rottluff, Kirchner and Bleyl, who were the original members, Nolde (his real name was Emil Hansen; he adopted the name of the town on the German-Danish border where he was born in 1867) was invited to join the group in 1906, after a show of his recent work in Dresden. He remained a member for a year and a half. That same year the group was enriched by the participation of Max Pechstein and the Swiss, Cuno Amiet.

In 1906 the Brücke group exhibited twice on factory premises, with one collection of prints and another of paintings, but with limited success; a woodcut by Kirchner set out their programme. From 1907 the Richter Gallery in Dresden showed their works, and from that time their audience grew.

The Brücke painters relied on printmaking to finance their experiments. They formed an association of collectors, whose dues entitled them to portfolios of prints which, between 1906 and 1908, chiefly featured the works of Pechstein, Heckel, Amiet and Schmidt-Rottluff, whose style and expressive power were enhanced by the art of wood-engraving, which they were learning at that time. The second series of portfolios, begun in 1909, was devoted to showing a collection of work by a single artist, introduced by the author of the publication to follow. The first set was thus dedicated to the work of Schmidt-Rottluff, but the cover was by Kirchner, who in turn created the portfolio of 1910. Heckel in 1911 and Pechstein in 1912 put together albums; but Otto Mueller, the youngest member of the group, had only time to draw the cover for Pechstein's series, which represented the Brücke's final publication.

As a general practice, the members of the Brücke turned out large numbers of posters, catalogues and manifestoes in order to capture the largest possible audience. This need to reach the public illustrates their conception of the fundamental role of art as a means of access for all to a new world.

For them art was a means of deliverance; it exorcised reality, freed the soul imprisoned by prosaic events, elevated the spirit. But before he could express himself freely, man had to free himself from all cultural habits by returning to a primitive state, attaining thereby a kind of ecstasy. Kirchner wrote in 1917: "The great secret hidden beneath all the things and events of the world around us sometimes becomes like a shadow, visible and perceptible, when we speak with someone, when we find ourselves in a country scene, when flowers and objects suddenly begin to speak to us."

The shock of primitive forms

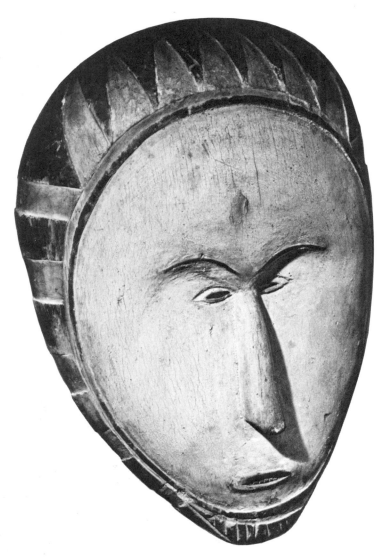

Fang mask (Gabon), woodcarving whitened with kaolin. Formerly owned by Vlaminck, then by Derain.

"The architecture of being springs from the internal dynamism which gives a man form, from the system of vital waves which he emits and which affect others, and which are the expression of his vital force. The rhythm of being springs from the vibratory shock and force which, through the senses, grips us at the root of the inner self. It is expressed by the most material and sensual means: lines, surfaces, colours and volumes in architecture, sculpture and painting, accents in poetry and music, movements in the dance. But in doing so it shapes all these concrete things towards the light of the spirit."

Léopold Sédar Senghor, *The Spirit of Civilization and the Laws of African Culture*

Bangwa roof-pillar (Cameroon). Woodcarving. ▷

Pablo Picasso (1881-1973): Figure, 1907. Woodcarving.

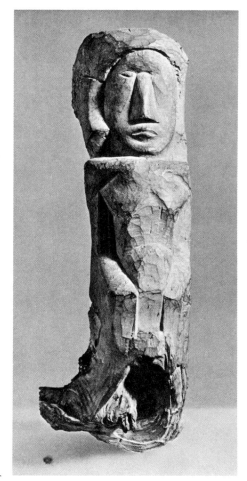

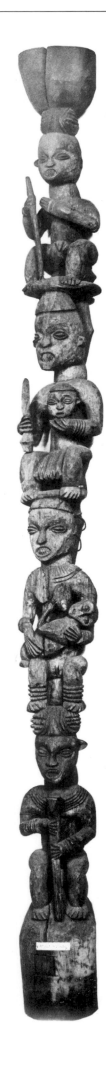

For nearly twenty years, as we have seen, the most fertile artistic expression had been consistently drawn from sources of primitive art. The fruitful encounter that took place during the first decade of the century between African arts and the most lively tendencies of modern art may thus appear to us today as part of a natural historical evolution. But at the time it was a shock which had the effect of a revolution. Jean Laude, in an excellent book, *French Painting and Negro Art*, rightly observes: "What modern artists discovered at the beginning of the century may not have been Negro art, but it was probably through becoming aware of Negro art that modern art revealed itself. Far from being something that was revealed, Negro art appeared as a *revealer*."

It was during the summer of 1905 that Vlaminck, struck by three African woodcarvings on display above the bar of a Paris café, suddenly had "the intuition of all the potential they carried within them." In spite of his previous visits to the "ethnographical curiosities" of the Trocadero Museum, it was only at that moment that he felt the full force of this "expression of an instinctive art." A white *Mask* which he owned for a while and which left him "delighted and disturbed" passed into the hands of Derain, who in turn showed it to Picasso and Matisse. Each of them was moved by this powerful form, enigmatic and revealing a totally alien mode of thought and feeling; all of them, for that matter, became collectors of African art.

At the same time, in Dresden, Kirchner experienced a comparable shock at the sight of primitive objects. The thirst for freedom and violence of the Fauves and Expressionists, and, even more, the Gauguin retrospective at the Salon d'Automne of 1906, had prepared the ground for this discovery; it is nevertheless curious to reflect that these painters discovered these often monochromatic woodcarvings at the very moment when they were seeking to express themselves through the purest and most violent colour. The importance of the primitive arts in fact was such that it led all painters to reconsider the third dimension; conversely, the efforts of contemporary sculptors were stimulated by the research of the painters.

The influence of African art on Picasso has seemed so strong that these creative years are referred to as the "Negro period." A short stay in Holland in the summer of 1905 set Picasso free from the concern with poverty of the Blue period and the melancholy subjects of the Rose period; he simplified his studies of women to rounded and massive forms. This new emphasis on volume led him to produce several modellings; at the same time he sought to give depth to his canvases by the opposition of light and shadow. In the spring of 1906 a large exhibit in the Louvre of ancient Iberian sculptures

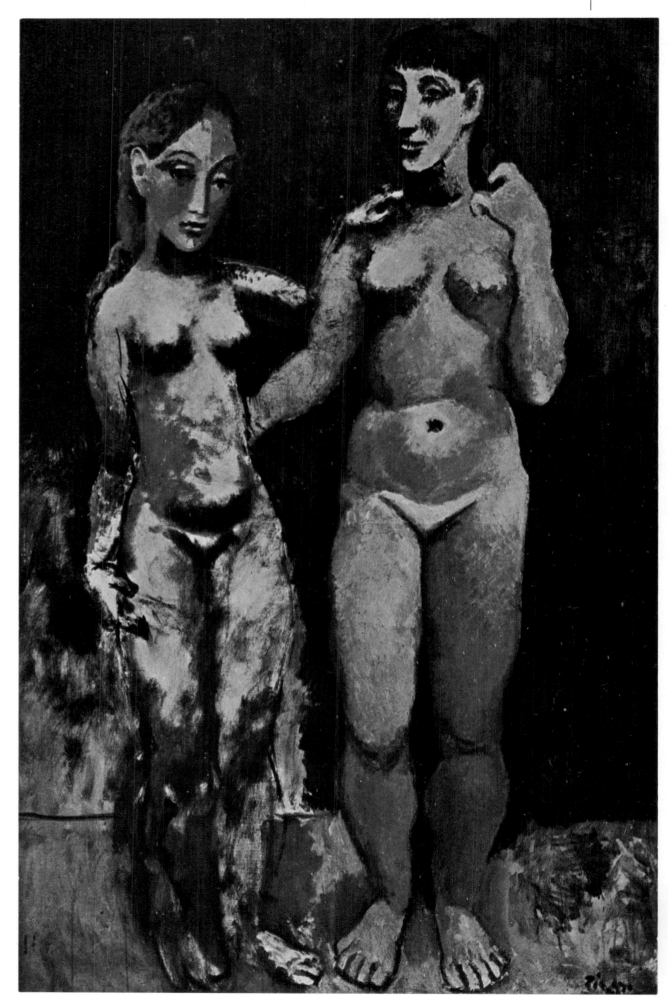

Pablo Picasso (1881-1973): Two Standing Nudes, 1906. Oil.

The shock of primitive forms

found in the excavations at Osuna (Andalusia) introduced him to another primitive language. His style developed rapidly while he was painting the portrait of Gertrude Stein, which he completed only after spending the summer in the little Catalan village of Gosol and bathing once more in the pure and arid atmosphere of his native soil. Gertrude Stein introduced him to Matisse, who showed him African works; he began to collect them.

Two Standing Nudes is dated 1906. Picasso, each time he was confronted by a new problem, placed the data in a vision so intransigent and global that it became revolutionary. And so, preoccupied at this time with volume, he grossly exaggerated the very weight of his figures; he stripped his models of all apparent attractions and focused his attention on volumetric analysis alone. Seeking what was essential, he simplified forms and accentuated their construction. This evolution towards an art more conceptual than descriptive prepared him to learn the most profitable lesson from African art, a lesson which also started him on the search for that space which he developed in Cubism.

In 1906 Matisse was also preoccupied with sculpture and volume. It was, besides, only an apparent paradox to say that it was after having studied and used Gauguin's flat colours that he set himself to create the third dimension on canvas by essentially pictorial methods. The friendship which, since 1905, united him and Maillol was perhaps not unrelated to this renewal. Today it is hard to see in this sculptor's harmonious volumes the provocative aspect they had when they first appeared. In spite of its "classical" appearance, Maillol's sculpture in fact broke with the impressionist and classical tradition of Rodin to attain, while effacing itself in the subject, a *reality* of form previously unknown. Maillol led sculpture back to that fundamental notion which, paraphrasing his fellow Nabi, Maurice Denis, might be formulated as follows: "a pure volume composed of masses assembled in a certain order."

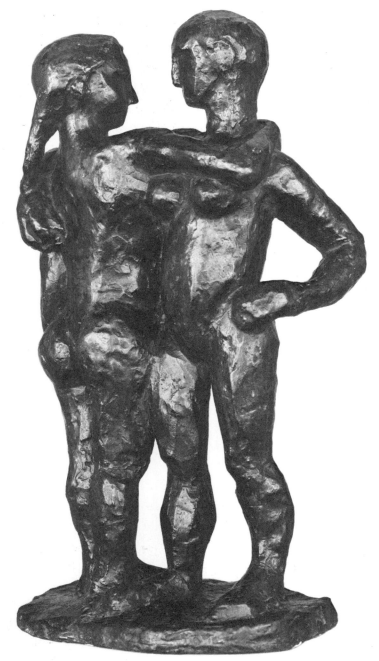

Henri Matisse (1869-1954): Two Negresses, 1908. Bronze.

"Modern art is an art of invention; its starting point is an outburst of feeling. So by its very essence it is closer to the archaic arts and the primitive arts than it is to Renaissance art."

Matisse

In addition to African objects, Picasso was also attracted by the archaic works of pre-Roman Iberian sculpture found in Spain in the Osuna excavations. References to them occur in his paintings and drawings of around 1906, which are characterized by a powerful monumentality and a concerted attempt to single out the essential features of a face. Confronted with "primitive" works of art, Matisse and Picasso responded in different ways. While Matisse found in the rhythm and boldness of certain distortions a lyrical means of suggesting movement, Picasso was prompted by them to tackle the problem of artistic creation anew, at its very basis. "Picasso decided to ignore the enormous mass of knowledge and experience which he had acquired, and he set himself to learn everything afresh, starting from scratch," wrote his friend the poet Pierre Reverdy in 1924.

Iberian acrobat from Osuna (Spain). Bas-relief found in the Osuna excavations of 1903.

During this period Matisse carried on his creative activity as much in the pictorial as in the sculptural field. For him African art was a stimulating example of liberty and simplification. To Apollinaire, who questioned him in *La Phalange* of 25 December 1907, he replied, "The hieratic Egyptians, the polished Greeks, the voluptuous Cambodians, the productions of the ancient Peruvians, the statuettes of the African Negroes, proportioned to fit the passions which inspired them, can affect an artist and help him to develop his personality." Matisse's first lithographs and woodcuts translated a freedom of conception found equally in his key painting *The Blue Nude*. To integrate the volume into the surface he simplified the forms, subjecting them to a dynamic rhythm; and to suggest depth in their distortion, he distended the body profile. At the same time he made colour an element of construction. "There is a necessary proportion of tones which leads me to modify the form of a figure or to transform my composition," he wrote in *Notes of a Painter* (1908). Executed at Collioure during the summer of 1907, the *Reclining Nude* is one of the most revolutionary sculptures by Matisse. The movement animating it no longer depends on the subject but springs directly from the rhythm and character of the masses that constitute it. Matisse's search for a purity of means—recalling less the form than the spirit of African art—and the dynamism of the construction and general rhythm (henceforth he went beyond the descriptive expression of movement he had admired so greatly in Rodin) are to be found in his painting as well as his sculpture.

Braque followed a parallel road in painting his *Nude*, in which can be seen the same reliance on savage and primitive arts. Braque carried out this work after having watched Picasso in his studio painting *Les Demoiselles d'Avignon*. Whereas Picasso responded to the static, hieratic and mysterious nature of African satuary, to Matisse and Braque it seemed to appeal rather by its internal dynamism of form; but all found in it the same liberating power, and a confirmation of the insight that a work of art achieves its effect more through the character of the elements composing it than through its subject.

All European artists were not affected by the same African objects. Each African people had an individual style, and the painters first came in contact with the art of countries administratively dependent on the one in which they lived. France, which possessed the largest colonial empire, administered by the colonial governments of French West Africa and French Equatorial Africa, extended its sway from Algiers to Brazzaville, from Dakar to Anglo-Egyptian Sudan. It filled its ethnographical museums with works coming essentially from French Sudan, the Ivory Coast, Niger and the French Congo. Belgium benefited from its immense Congo empire, while Germany, which moved into Africa only after 1880, numbered more modest colonies in Togo and the southwest and southeast Cameroons; but it had also acquired a large part of New Guinea. Paradoxically, the political and commercial phenomenon of colonialism travelled in the opposite direction in the cultural sphere; while the world was becoming Europeanized, European artists went primitive...

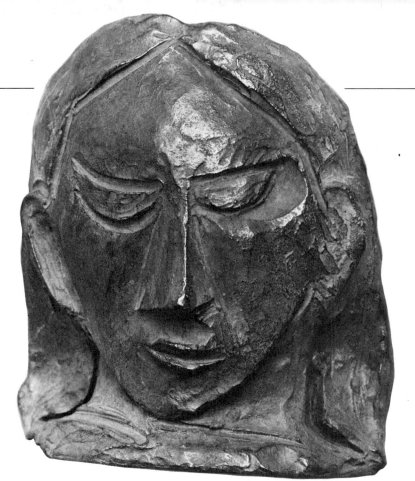

Pablo Picasso (1881-1973): Woman's Head, 1908. Bronze.

The *Woman's Head* of 1908 shows an approach which runs counter to that of Picasso's painting. In the bronze, monumental corporeality has been replaced by a "flattening out" of forms, a technical solution which Matisse too was experimenting with about the same time. Like the African carvers, Picasso gives the illusion of volume by its contrary, by false volumes and flattened planes. The eye socket is not hollowed out and the nose does not project forward. Seeing African art as an "object," Picasso was led moreover to conceive of the work of art as an independent creation with laws of its own. In painting, he now found himself before an alternative: either to flatten volumes onto the surface, thus losing the sculptural effect, or to accentuate the modelling by sharp contrasts of light, at the risk of cutting the object off from its containing milieu. The solution was worked out in the *Demoiselles d'Avignon*.

Henri Matisse (1869-1954): Blue Nude, 1907. Oil.

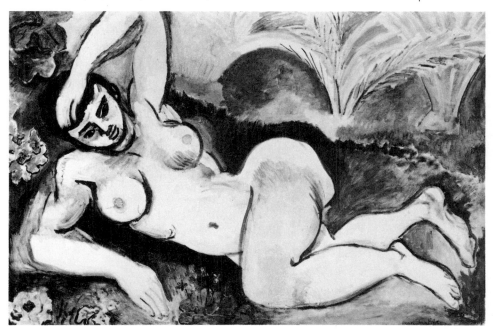

The shock of primitive forms

The *Demoiselles d'Avignon* exemplifies the comment made by Juan Gris on Picasso's work in general: "This painting is to other painting what poetry is to prose." In many preliminary studies he worked out the problems raised by this large, revolutionary canvas (reproduced on page 142), whose title was coined by the writer André Salmon: it is supposed to refer to the girls in a brothel in the Calle d'Avinyó (i.e. Avignon Street) in Barcelona, near which Picasso had lived. The aggressive distortions give a wild rhythm to the picture, whose different planes are rendered by streaks of colour. As in the Congolese mask below, the insistent repetition of parallel lines heightens the power of the volumes in a way completely different from the traditional illusionism obtained by chiaroscuro.

For Picasso "all previous illustrational or sentimental values were dissolved and converted into plastic energy" (Jean Leymarie). He thereby achieved an expressive power which gives his works a forceful and disquieting presence, comparable to that of African masks. The projection of the nose (a problem that preoccupied many painters from Chardin to Cézanne) was rendered by flattening its volume and slewing it round against the surface of the canvas. André Salmon, one of Picasso's closest friends in the Bateau-Lavoir period, saw the importance of facial features in Picasso's art in the early 1900s: "Soon Picasso tackled faces whose nose was usually treated as an isosceles triangle. The Sorcerer's apprentice took his cue from the Oceanian and African wizards."

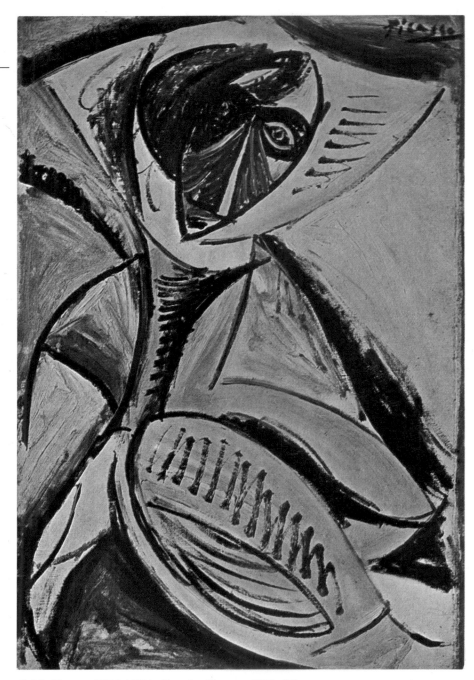

Pablo Picasso (1881-1973): Dancing Negress, 1907. Oil.

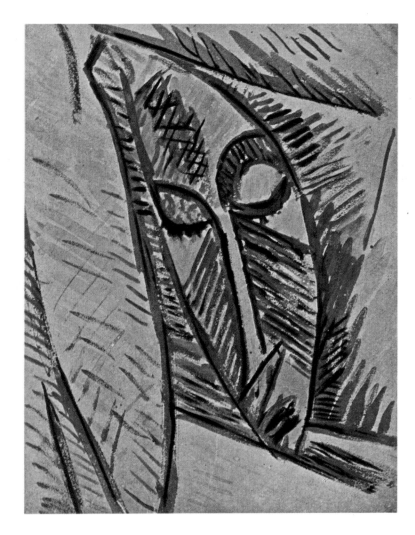

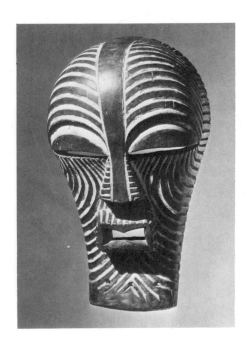

Songwe mask (Congo).
Painted woodcarving.

Pablo Picasso (1881-1973): Head,
1906-1907. Tempera and watercolour.

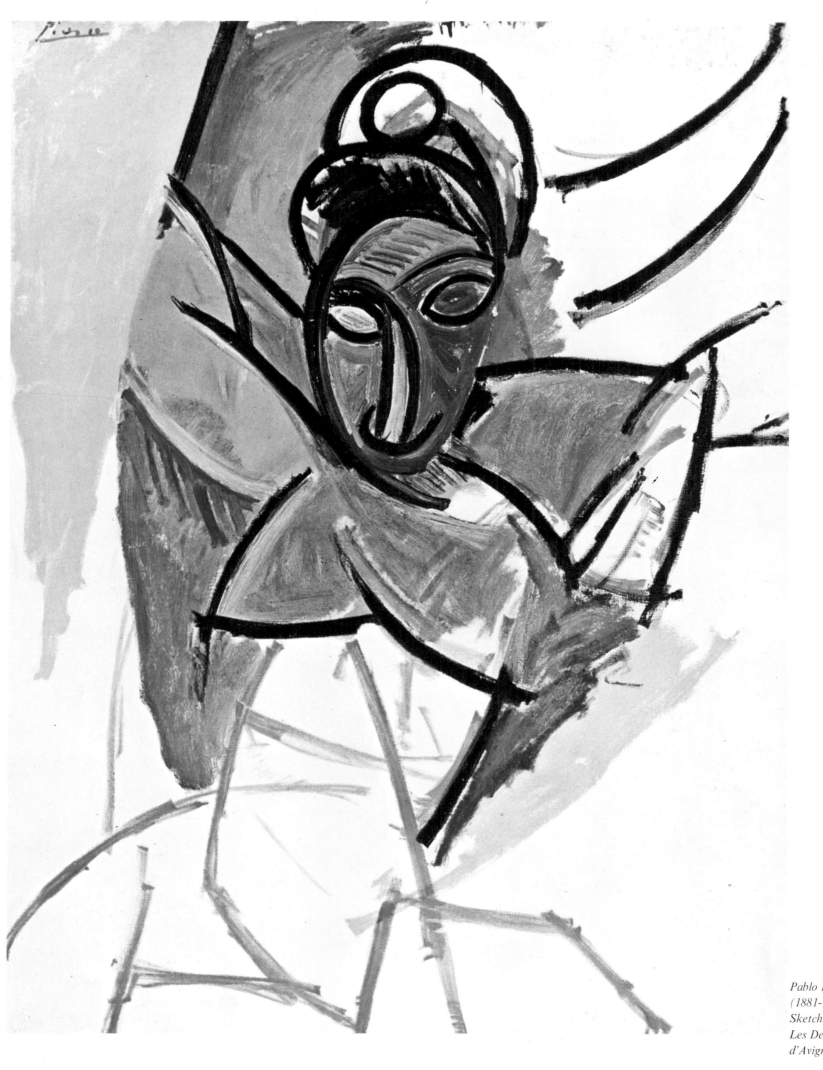

*Pablo Picasso
(1881-1973):
Sketch for
Les Demoiselles
d'Avignon, 1907.*

The shock of primitive forms

When African objects were first revealed to artists, there was no way of knowing their origin and significance. Their creators were anonymous, and their magical and religious meaning was unclear to the European. Whether magical masks or statuettes, they offered themselves in their immobility, their formal asceticism and their scorn of illusionism; they possessed an expressivity that never depended on an analysis of nature but on a disposition of forms and volumes of prodigious plastic invention. It must be kept in mind, however, that without the examples of Cézanne, Van Gogh or Gauguin the younger artists would never have responded to these forms; as Apollinaire said, it took "great daring of taste to go so far as to consider these Negro idols as veritable works of art."

If an African object had for its creator a well-defined specific function, generally of a religious nature, and if the style varied from region to region, that did not matter to Western artists, who interpreted the objects differently, according to their own diverse temperaments.

In Germany, where several towns possessed large ethnographical museums (Hamburg's dated from 1850), the younger painters were equally enthusiastic about the force and immediacy of African and Oceanic works: "their absolute primitivism, their intense, often grotesque expression of force and life in the simplest form" (Nolde). They found in them an example of truth independent of all concern with lifelikeness, and a corroboration of their expressionist research. However, except for Kirchner and Heckel,

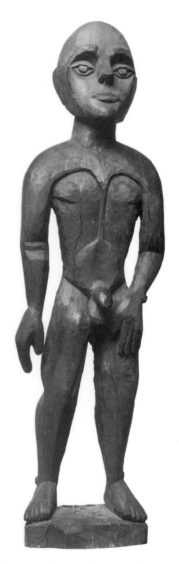

Ernst Ludwig Kirchner (1880-1938): Adam and Eve, 1912. Woodcarvings.

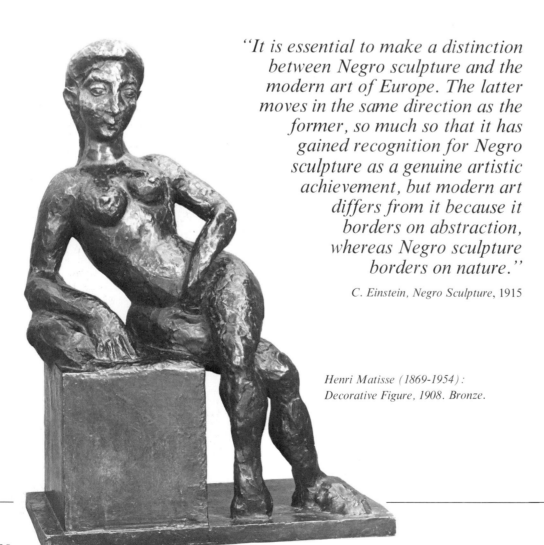

"It is essential to make a distinction between Negro sculpture and the modern art of Europe. The latter moves in the same direction as the former, so much so that it has gained recognition for Negro sculpture as a genuine artistic achievement, but modern art differs from it because it borders on abstraction, whereas Negro sculpture borders on nature."

C. Einstein, Negro Sculpture, 1915

Henri Matisse (1869-1954): Decorative Figure, 1908. Bronze.

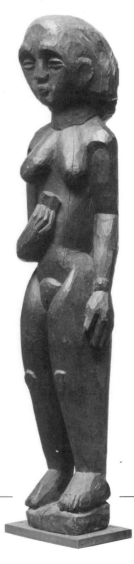

who each had a brother in Africa, it was only after 1910 and being settled in Berlin that the members of the Brücke used exotic allusions in their creative work. Then, however, in 1913-1914, Nolde and Pechstein would go to the length of travelling to the South Seas in search of more typical subjects.

Obviously, sculpture was profoundly affected by this influence; the experience of African art drove the sculptors towards a certain archaism which liberated them from naturalism and allowed them to keep their aesthetic distance when interpreting the reality of volumes. A Bambaran woodcarving that belonged to Matisse reveals the force and power of the metamorphosis, as well as the conceptual side of African objects.

The black artist expresses what he knows and not what he sees, to the point, as Matisse once remarked, of representing the pudenda of a woman on the underside of the chair on which she sits. This attempt to concentrate elements in an enclosed and autonomous form was again taken up by Derain in one of his very rare sculptures: *Crouching Man*. Derain simplified the subject until he produced a block that showed hardly any carving, thereby bringing out the necessity of conceptualization: "It's a matter of reproducing not an object but the active principle of that object," he declared (quoted by André Breton). Referring to the "origins of Cubism" Apollinaire wrote in *Le Temps* of 14 October 1912: "Maurice Vlaminck's taste for the barbaric woodcarvings of Negroes, and André Derain's meditations on those bizarre objects, at a time when the Impressionists had at last released painting from its academic shackles, was to have a great influence on the future of French art." Contrary to his friend Vlaminck, who saw in Negro art only an example of freedom, Derain found in it the affirmation of a transcendent reality enabling him to escape that "degeneracy" of the modern world which he would always denounce.

The sculptor Brancusi, in evolving a body of work poles apart from Derain's, began with the same search for simplified forms, which led him to a symbolic figuration on the threshold of abstraction. Born in Romania, he studied the art of his country at Craiova and Bucharest; then, in 1904, after a sojourn in Munich, he settled in Paris, where Rodin suggested to him that they work together. Brancusi refused, and from 1907 onwards he followed a solitary path which took him to the sublime expression of original, primordial forms, ranking among the purest manifestations of art during the first half of the twentieth century. Brancusi always denied having been influenced by African and archaic art; for him, even more than for the other artists, the question was not one of influence but of incitement. Incitement above all to simplicity, of which he said "that it is not an artistic goal, but is reached in spite of oneself by approaching the real meaning of things." But the "real meaning" is sometimes hard to discover, and other modes of expression can help the artist in that search. Such meaning appears, for example, in the vigorous yet vibrant mass of *The Kiss*, the subject of a gravestone erected in the cemetery of Montparnasse in memory of a young woman who died of love.

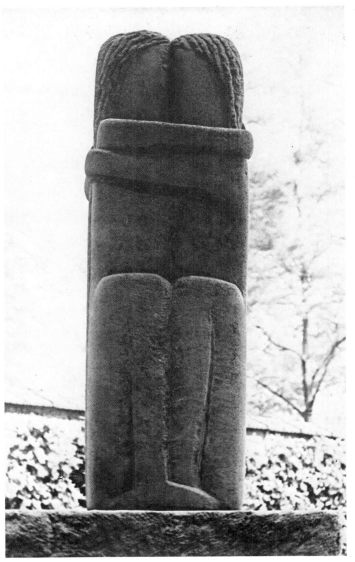

Constantin Brancusi (1876-1957): The Kiss, 1908. Stone.

André Derain (1880-1954): Crouching Man, 1907. Stone.

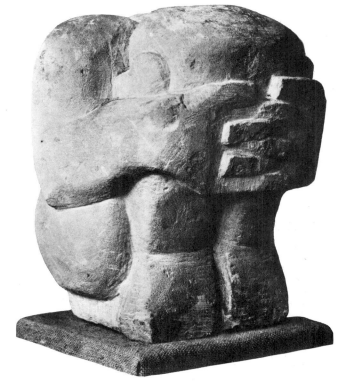

The art of Cézanne marked the future so decisively that it is possible to read into it all the tendencies that modern art has so far produced. If until the end of his life—he died on 22 October 1906 at Aix-en-Provence—he was regarded by the general public as a rich dilettante, highly gifted but with a difficult character, for the younger painters he was an example and an inspiration. Barely seven days before his death he could write to his son: "I consider the young painters much more intelligent than the others; the old ones can see in me only a disastrous rival." But could he suspect the echo his art would have in the future?

Ever since organizing the first exhibition of Cézanne's work in 1895, the dealer Ambroise Vollard had bought up all of the artist's output; but, prudently, he was parsimonious in showing it. Gertrude Stein met all manner of difficulties in trying to view Cézanne's paintings to decide which she wanted to buy. In 1900 Maurice Denis painted a famous *Homage to Cézanne* which, in a composition aiming at popularity, assembled the Nabi painters around a still life by the master. The entire room devoted to Cézanne at the 1904 Salon d'Automne aroused very strong interest; some years before, as we have noted, Matisse had bought Cézanne's *Three Bathers*. But in truth it was beginning with the large retrospective at the 1907 Salon d'Automne that his work left a deep imprint on the young generations. Fifty-six canvases and drawings were shown there; almost concurrently, the Bernheim Gallery showed sixty-nine of his watercolors. The *Mercure de France* of October 1907 then published some of his letters to Emile Bernard, chiefest among which was the one so often quoted of 15 April 1904, in which Cézanne explained:

"Allow me to repeat what I told you here: treat nature by means of the cylinder, sphere and cone, all placed in perspective so that each side of an object or a plane travels towards a central point. Lines parallel to the horizon give the breadth, whether it be of a section of nature or, if you prefer, of the spectacle spread before our eyes by the Pater Omnipotens Aeterne Deus. Perpendicular lines running to that horizon render the depth. Now

Paul Cézanne (1839-1906): Oranges on a Plate, 1895-1900. Watercolour.

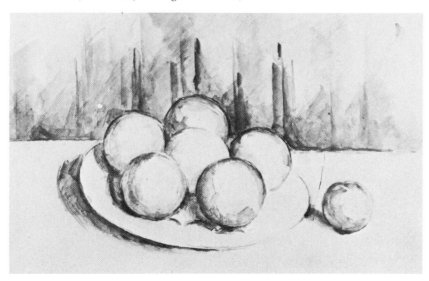

nature, for us humans, lies more in depth than in surface, whence the necessity of introducing into our vibrations of light represented by yellows and reds, a sufficient quantity of bluish tints so that the air may be felt."

After having recognized the autonomy and expressive power of the painter's means, Cézanne, from 1890 onwards, undertook an exceptional reconstruction of nature in painting, setting himself simultaneously the problems of the "reading of the model and its realization" (letter of November 1896 to Joachim Gasquet), problems of which he spoke to the young artists who came to consult him after 1900. On 22 February 1903 he wrote to Charles Camoin: "Everything, especially in art, is theory developed and applied in contact with nature," as if he foresaw the later conceptualization of Matisse, Picasso and the Cubists. However, he never sacrificed the appearances of reality and sought on the contrary a synthesis between his temperament and the observation of nature, "for if the strong sensation of nature—and I have it most acutely—is the necessary basis of every conception of art, upon which rests the grandeur and beauty of future work, the knowledge of the means to express our emotion is no less essential and can be acquired only by a very long experience" (letter to Louis Aurenche, 25 January 1904).

His attention to the external world was exemplary: "I proceed very slowly, nature offering herself to me in a very complex state; and there is always something more to be done. One must see one's model clearly and feel with great accuracy; and on top of that express oneself with force and distinction" (letter of 12 May 1904 to Emile Bernard). And as to his method, he explained very simply: "The literary man expresses himself by means of abstractions, whereas the painter, by means of his drawing and colours, concretizes his sensations and perceptions. One is neither overscrupulous, nor too sincere, nor too dominated by nature; but one is more or less master of one's model and, above all, of one's means of expression. Penetrate what is in front of you, and persevere in expressing yourself as logically as possible" (letter to Emile Bernard, 26 May 1904).

Thus he accomplished his revolution on the two fronts of construction and the use of colour; what the young generations saw in him was above all his power to recreate an order comparable and parallel to that of nature, but independent of it. Based on moderation and reason, his vision set out to restore a classical and absolute character to its place in painting, a character rendered still more necessary after the lyrical outpourings of Art Nouveau. On the level of colour that vision offered the example of a sensibility, richness and intelligence more concrete than atmospheric luminism. It introduced, above all, a new approach to a world where truthfulness and the fixity of appearances were being placed in doubt. If the image was not condemned, it was subordinated to the creation of the pictorial fact, and regulated subject to an order and a rhythm the importance of which had just been illuminated by Negro art.

"Cézanne was for us like a mother protecting her children."

Picasso

"Cézanne is the master of us all."

Matisse

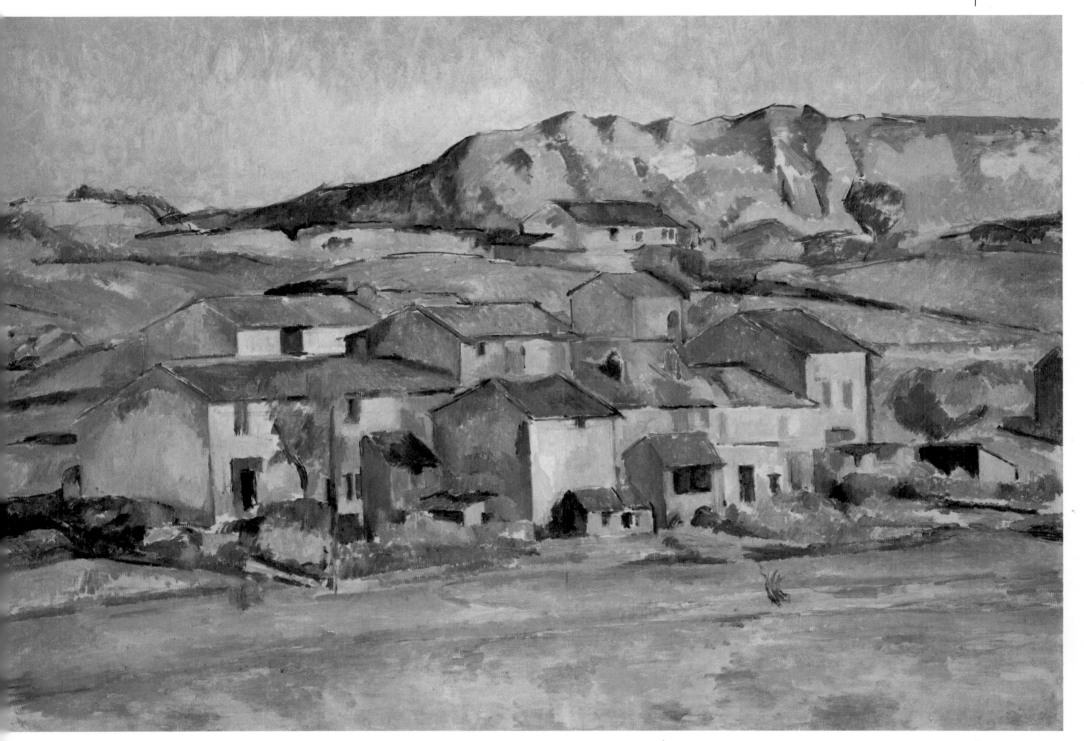

Paul Cézanne (1839-1906) : Mont Sainte-Victoire, Environs of Gardanne, 1885-1886. Oil.

"Nothing could have come more aptly than the works of Cézanne to confirm living art in its bold forward steps and at the same time to compel it to make a careful review of all the significant facts of art. . . Cézanne strengthened the conviction reached by Picasso that a picture is something very different from storytelling in pretty colours. He prompted Picasso too, not to exclude the subject from painting, but to reduce its prominence, and indeed to accept the subject at all only on the understanding that it should have no importance in itself and should have no other life but the poetic animation imparted to it by the painter."

Christian Zervos, *Picasso*, 1932

TOWARDS AN ARCHITECTURAL ART

Pablo Picasso: Nude With Raised Arm, 1907. Watercolour.

The *Demoiselles d'Avignon* by Picasso and *Le Luxe* by Matisse, both completed in 1907, were at once a summing up and a breakthrough. Although they reflected problems dealt with during previous years, these two often compared works had about them such an air of "masterpiece," such a multitude of intentions made perfectly explicit, of goals completely achieved, that they were immediately able to pass for revolutions. Picasso's friend Kahnweiler spoke of "incredible heroism" required by the painter, "whose moral solitude during that period was something frightful, for none of his painter friends had followed him. That picture he had painted seemed to everyone like something insane or monstrous. Braque, who had met Picasso through Apollinaire, had declared that to him it was as if someone had drunk oil in order to spit forth fire, and Derain told me personally that one day Picasso would be found hanging behind his great picture." As a result, the two works by Picasso and Matisse became—one perhaps in a fuller sense than the other—the "charters" of twentieth-century painting. The problem was the same in both: to invent a reality that was specifically pictorial. "I believe," wrote Matisse, "that the vitality and power of an artist can be appreciated when, directly impressed by the spectacle of nature, he is capable of organizing his sensations." In "organizing his sensations," the artist thus ventures further into an art that is architectural in character. Here Cézanne had set the example.

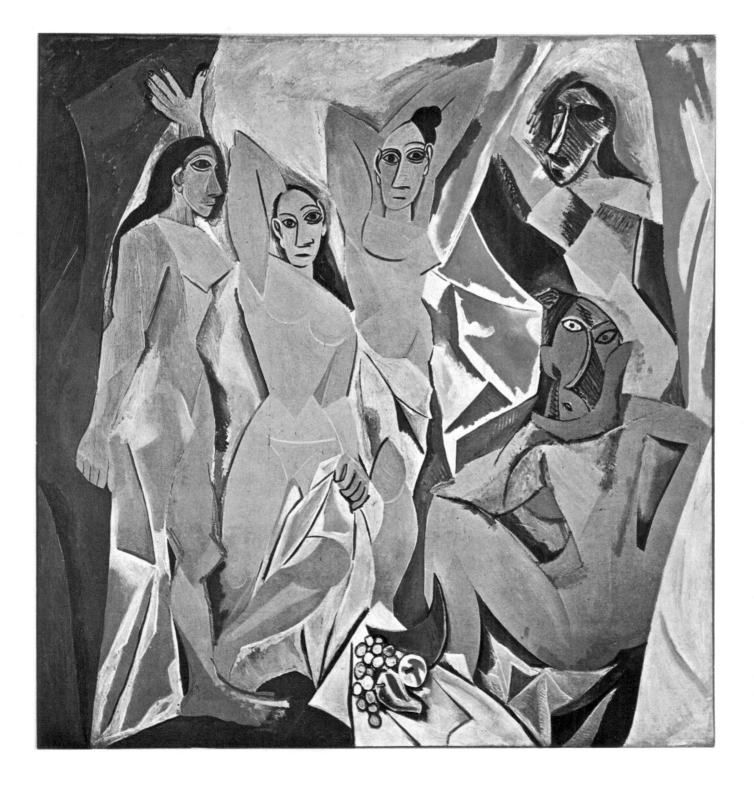

"What he is trying to do is to give us a total representation of man and things. The barbarian image-makers had the same end in view. But Picasso is a painter, his is an art of flat surfaces, and that is why he has to situate these counterpoised figures outside the laws of academic art, outside the conventional system of anatomy, and fit them into a picture space rigorously consistent with the unforeseen freedom of their movements."

André Salmon, *The New French Painting*, 1912

Pablo Picasso (1881-1973): Les Demoiselles d'Avignon, 1907.

In his study *French Painting and Negro Art*, Jean Laude writes: "The points of contrast between Fauvism and Cubism are so distinct that they are located on clearly specified formal, aesthetic and poetic levels. But these contrasts must not distract us: they are only apparent. Fauvism and Cubism must not be regarded as fully perfected styles, as closed formal categories clearly delimited in time, but as provisional solutions to a problem which is gradually accumulating more data. They are part of a process of integration of art into a society of which they tend to form certain ideal conceptions."

A brothel scene, *Les Demoiselles d'Avignon* is an unfinished work, and intended as such. It concentrates on one canvas three possible solutions to the problem confronting the painter: the left side is stamped by a certain archaism recalling the hieratic quality of Egyptian bas-reliefs and by flat, sharply enclosed colour areas; the two central figures are handled with more massive simplifications, whereas the right side of the painting, the most laboured, evinces the artist's concern with expressing volume on the flat surface. Picasso gives his picture such a dynamic articulation that it becomes a pure creation, but with an internal structure so strong that it retains a "plausible" character.

This problem of representing volume on a flat surface also preoccupied Matisse in *Le Luxe*, which he exhibited at the Salon d'Automne of 1907. Far from pursuing research in colour/light, Picasso utilized earth tones through an almost monochromatic spreading of the paints; Matisse also muted his palette, but made it a determining element of the general rhythm of the representation. Whereas Picasso broke up volumes into overlapping facets in order to render depth in the abstract, and based the general architecture of the canvas on the lines of intersection, Matisse reduced each form to a surface defined by a brushstroke, founded the composition on unity and distended the volumes in order to transcribe them into a rhythm of arabesques generating movement. Both Picasso and Matisse arrived on the threshold of a total power of reinvention; for them, as for the scientific thinkers of their day, the real was henceforth an "operational process."

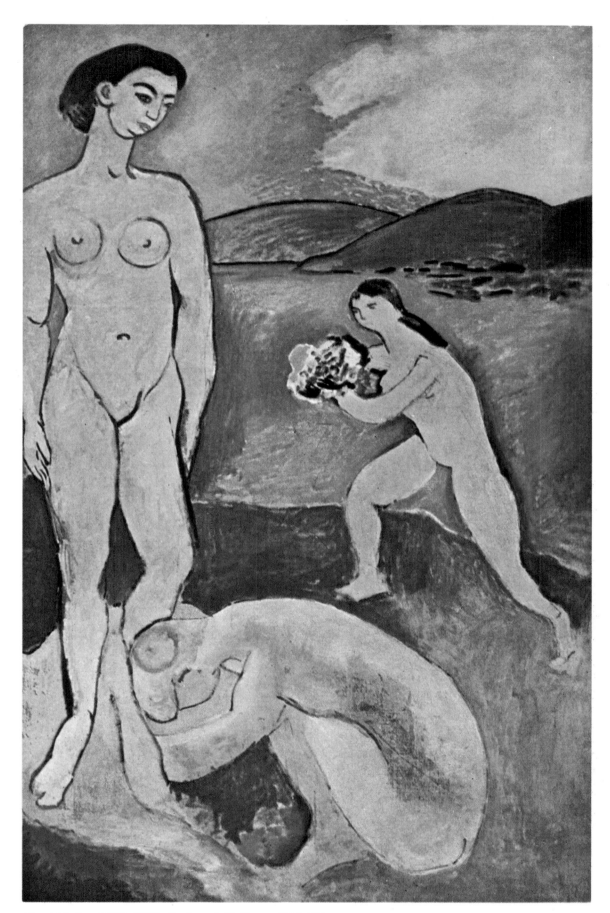

Henri Matisse (1869-1954): Le Luxe I. Collioure, 1907. Oil.

"*The simplest means are those which best enable the painter to express himself. If he fears the banal he cannot avoid it by appearing strange or by indulging in oddities of drawing or eccentricities of colour. His means of expression must almost of necessity derive from his temperament. He must have the simplicity of mind to believe that he has only painted what he has seen.*"

Henri Matisse, "Notes of a Painter," *La Grande Revue*, Paris, 25 December 1908

The birth of Cubism

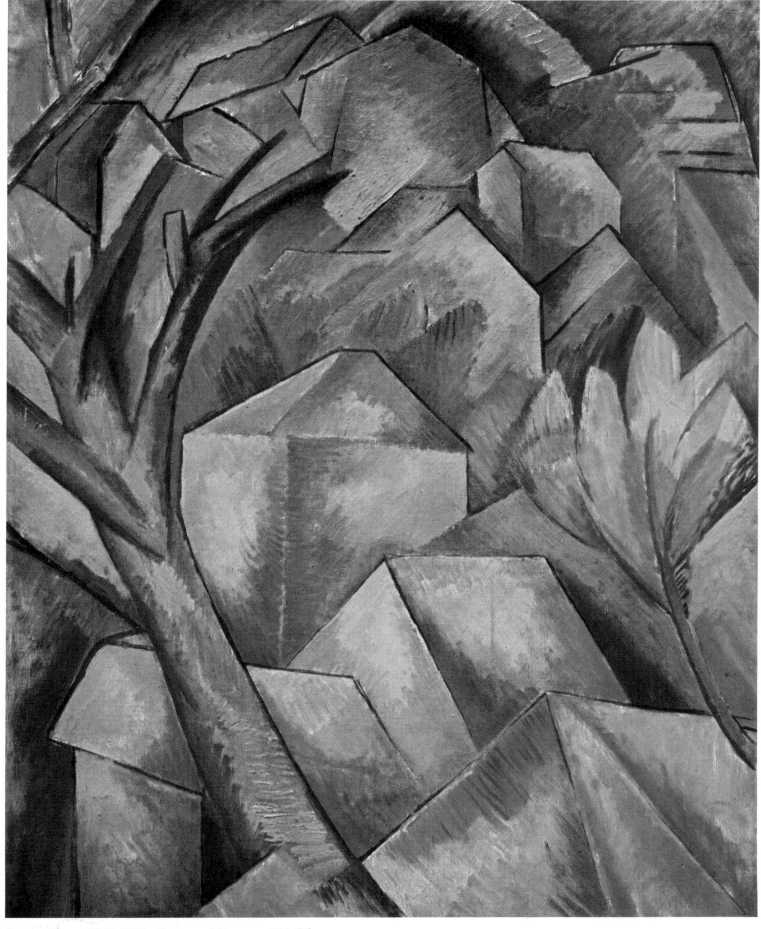

Georges Braque (1882-1963): Houses at L'Estaque, 1908. Oil.

Braque was brought to Picasso's studio by Apollinaire while Picasso was painting the *Demoiselles d'Avignon*. Thus, under a double incentive—the combined shocks of that work and the 1907 Cézanne retrospective—Braque gave up Fauvism, which he had carried to its highest pitch, to launch into an exploration of space founded on geometry. Shortly after his meeting with Picasso he painted *Standing Nude*, a testimony to those new preoccupations which crystallized more clearly in the canvases he created during the summer of 1908 at L'Estaque on the Riviera, using the very motifs of Cézanne, who had often painted there.

In order to render volume, Picasso interpreted the objects he used for models, trusting more in their abstract definition than in his illusion of them. "I paint things as I think them, not as I see them," he confided to Gomez de la Serna; or, once again, "If a painter asked me the first thing to do in painting a table I should tell him: take its measurements." Braque on his side explored space in the wake of Cézanne, gradually abandoning colour/light in response to the demands of the internal architecture of the picture. Both Braque and Picasso renewed contact with the real, which they liberated from all illusionism and even from effects of light: they eliminated visual distance in favour of a conceptual and tactile apprehension. The unity of the painting replaced that of the object.

During the summer of 1908 at La Rue des Bois, a village on the banks of the Oise, Picasso worked on rhythm and volume, the basic elements of the cubist dialectic of the future. In the Midi, Braque sought, in Cézanne's footsteps, to find the synthesis between perception and construction. He geometrized volumes, subjecting them to essential rhythms which united their disparity, while experimenting with the colour modulations intended to soften the contrasts of those volumes. The 1908 Salon d'Automne jury refused this latest output, and Braque exhibited at the new Kahnweiler Gallery from November 9 to 28, with a catalogue preface written by Apollinaire. It was on this occasion that the word *cube* was first used in connection with painting: Matisse is supposed to have suggested it to the critic Louis Vauxcelles—the father of the "Fauve" label—who, in *Gil Blas* of 14 November, wrote: "Braque paints little cubes." The same critic used the term again speaking of "Peruvian cubism" in his criticism of the Salon des Indépendants of 1909, the first manifestation of Cubism at which the general public was able to view Braque's pictures. Vauxcelles also noted on 14 November: "Monsieur Braque is indeed a daring young man;... the disconcerting example of Picasso and Derain has emboldened him. Perhaps he is also too much obsessed by the style of Cézanne and by reawakened memories of the static art of the Egyptians. He constructs metallic and distorted little figures simplified to an extraordinary degree. He despises form; reduces everything, landscapes, figures and houses, to geometric diagram, to cubes."

Beginning in the winter of 1908-1909 a close friendship united Braque and Picasso, and the kindredness of their thinking was so strong that they even decided to stop signing their pictures:

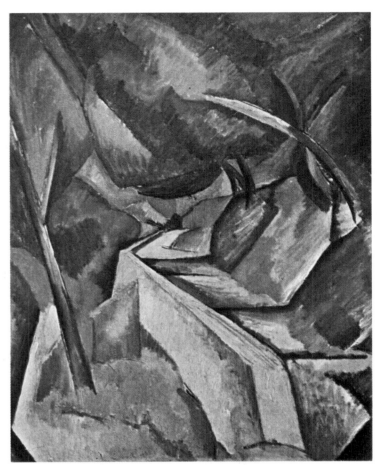

Georges Braque (1882-1963): Road near L'Estaque, 1908. Oil.
Pablo Picasso (1881-1973): La Rue des Bois, 1908. Oil.

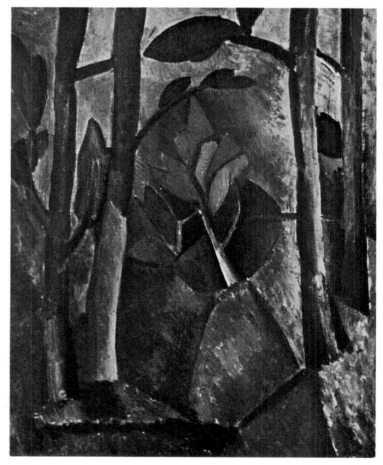

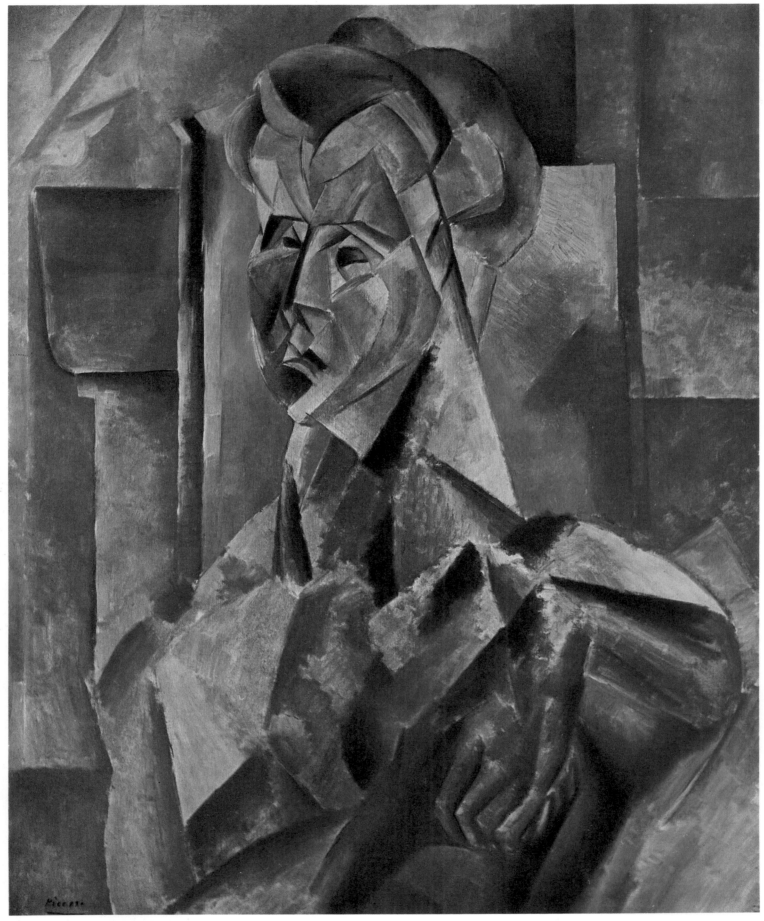

Pablo Picasso (1881-1973): Seated Woman, 1909. Oil.

"I considered that the personality of the painter ought not to intervene, and that consequently the paintings should be anonymous," said Braque. "As soon as someone else was able to do the same thing I did, I thought that there was no difference between the paintings." And as a matter of fact, some of the pictures of this period might have come equally from one or the other.

After having concentrated on analysis of the same objects, Picasso and Braque went off during the summer of 1909, one to Horta de Ebro in Catalonia, the other to La Roche-Guyon, not far from Paris: two sojourns which marked important dates in the evolution of their painting. For when they met again in autumn they embarked on what has been called "analytical" Cubism: palette under maximum restriction; lighting subordinate to the bringing out of volumes; objects and space defined by a system of folded-back planes leaving no suggestion of the surface of the canvas; departure from monocular vision depending on the vision of a subject at a fixed distance, in favour of a dynamic vision; a fundamental reappraisal of the truth of appearances by affirmation of the reality of structures; liberation of the object from its subjection by man (what matters is no longer to show what is seen, but to show what really exists). The configuration of things is independent of the spectator's gaze; what is represented is no longer the visible face of the object but all the faces that compose it, for they are all as real as the one that happens to be placed in front of the spectator.

First of all, Picasso and Braque went around the subject by superimposing the different profiles that defined it; then they gave their research a pictorial dimension by subjecting those profiles to sweeping pre-established rhythms encompassing all the elements of the composition, and even extending that composition beyond the limits of the subject: the correspondences between facets are reinforced by a subtle play of modulations. The affirmation of geometrical form, the decrease of naturalness in the colours, give to the works of this period an abstract, outstandingly hermetic character in which the traditional illusionism of depth is abolished but the volume entirely recreated. "Fragmentation enabled me to establish space and movement in space," said Braque. The harmony to which Cézanne aspired was freely and arbitrarily recreated in the new awareness of reality, where the truth of being replaced the illusion of appearance. Picasso insisted on the object, whereas Braque sought the relation between the object and its surroundings; but both artists denied perspective. In his outstanding book on Cubism, John Golding wrote: "The forms are severely simplified: tubular tree-trunks, heavily stylized masses of foliage and 'cubic' houses. Picasso's approach is hardier, more sculptural than Braque's... Braque, on the other hand, has used Cézanne's technique of opening up the contours of objects so that in his paintings the eye slips inwards and upwards from plane to plane without having to make a series of abrupt transitions or adjustments."

Seeking an equivalent for this approach in sculpture, Picasso gave a fresh turn to the problematics of that art. On his return from Horta de Ebro he sculpted a famous *Woman's Head* (cf. p. 189) which obliged the spectator to move all around the work, giving the appearance its freedom in the third dimension. In this way Cubism achieved a synthesis of the stimuli of primitive and savage arts and the art of Cézanne. From then on, giving up landscapes to devote themselves wholly to the human figure and still lifes, Picasso and Braque undertook still more systematic and thorough experiments.

Picasso and Braque move towards Analytical Cubism

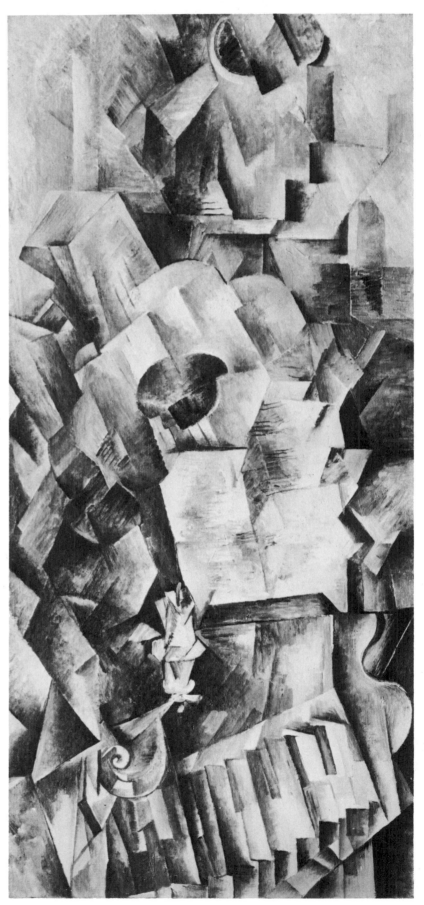

Georges Braque (1882-1963): Piano and Lute, 1910. Oil.

New references

*Ex-voto reproduced
in the almanac of
"Der Blaue Reiter,"
1912.*

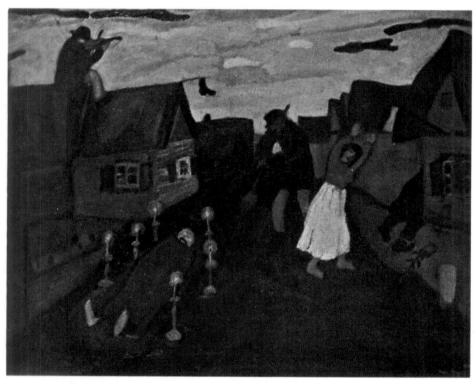

Marc Chagall (1887): The Dead Man, 1908. Oil.

On the other hand, the art of the Douanier Rousseau, which artists and poets had discovered and loved, and which had given rise to so many commentaries, aims at being rooted in its time; the painter himself had an inkling of this when he declared to Picasso in 1908, at a memorable dinner in the Spanish painter's studio assembling artists and poets in Rousseau's honour, "We are the two greatest painters of the period: you in the Egyptian manner and myself in the modern manner." "Rousseau represents the perfection of a certain line of thought," Picasso said of him in turn; and Robert Delaunay wrote in a book that was never finished, which he wished to dedicate to Rousseau, "Each picture is constructed, meant to be objective in its fashion; no system interferes to enslave the generous vision reaching out towards real beauty, in which the relations, the distortions, take on a stirring power, with the object being neither described nor imitated."

The Douanier Rousseau (1844-1910): The Snake Charmer, 1907. Oil.

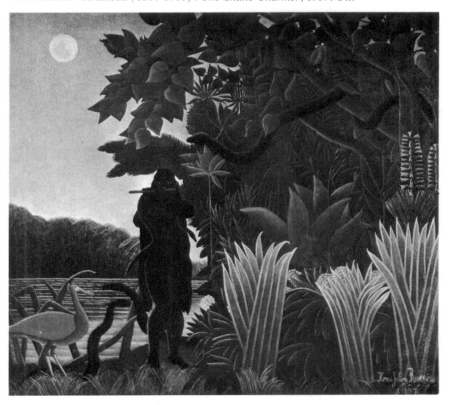

Along with the shock produced by archaic and primitive arts, folk art and so-called "naive" art touched off a deep response among artists. Russians and Germans used these references to facilitate their escape from the art of the court or the academy, which was triumphant in their countries; through the folk arts they sought to rediscover the very roots of their civilization, outside all cultural trends. There were several Russian artists whom the themes, colours and poetics of the people stimulated to set their own impulses free. Chagall was moved by the direct sensibility revealed in votive objects or signboard paintings, whereas Larionov and Goncharova, although they were not unaffected by Russian peasant mythology, turned more towards the colourful splendours and formal hieratism of the Byzantine artists. In *The Dead Man* of 1908, Chagall, like the naive German painter whose engraving is reproduced here, claimed the right to invent a space that emotionally echoed the scene portrayed.

148

Matisse
and the fascination of the East

The entire nineteenth century had been fascinated—even if the stimulations differed as much stylistically as geographically—by the Middle and Far East, and the attraction to exoticism was renewed in the twentieth century. Moslem art in particular appealed to Matisse. He sought in it less a change of culture, surely, than an answer to aesthetic problems. Out of their spiritual belief the Islamic artists had concentrated on a flat and decorative expression which they enlivened by a play of broad lyrical rhythms and exalted by the splendour of the colouring. It is easy to see that

Matisse found the dictates of his own intuition confirmed by such achievements.

By the account of his son-in-law and friend, Georges Duthuit, Matisse was keenly responsive to the Persian ceramics in the Louvre, the discovery of which in 1910 spurred him to make a journey to Munich with Marquet to visit the great exhibition of Moslem art. But the Arab world and the African light had already been revealed to him in 1906 on a brief trip to Biskra in Algeria. From 1912 to 1914 his visits to North Africa were frequent; Raymond Escholier, one of his first biographers and also one of his confidants, described them as "decisive journeys that never ceased to influence his work. From then on, the light of North Africa prompted him to simplify his composition, to eliminate all useless detail, every superfluous nuance. The light and the ceramics, the porcelain tiles of the mosques, made a permanent impression on him."

Henri Matisse (1869-1954): Still Life with Geraniums, 1910. Oil.

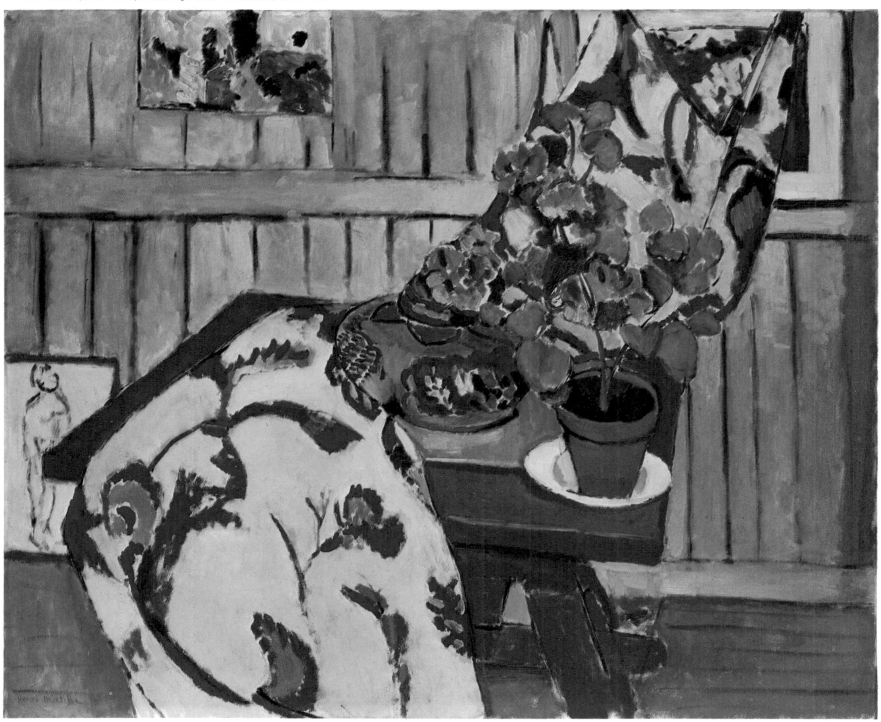

Architecture: volumes and transparencies

While the Cubists were subjecting vision to fresh questioning by geometry, architects, almost at the same time, were doing something similar. Without being indebted to pictorial experiments, they too achieved a revolutionary renewal of formal aesthetics. The utilization of a new building material, reinforced concrete, which after 1900 replaced iron and steel trusses, led builders to consider carefully and in depth the organization of the volume under construction; the possibilities offered by this material gave them a new vocabulary; freed them from the profusion of decoration that had been regarded as obligatory and had at last obsessed their inspiration, diverting it from the original goal of the building and its purposes. Concrete, by its rigorousness, asserted itself as a way of reacting against the floral overflowings of Art Nouveau, to which iron, on the contrary, easily lent itself; and the wall affirmed its function with simplicity.

Concrete was derived from the invention of cement (1824). In 1868, Joseph Monier, a French gardener, hit upon the principle of ferroconcrete, and this new process was applied from 1890 onwards. Among its first users, the engineer François Hennebique in building his house at Bourg-La-Reine, worked out the possibilities of this new means of construction, which he used in carrying out different industrial projects of vast dimensions in Switzerland and Italy as well as in France. A combination of cement and iron, reinforced concrete chiefly permitted different spans and bearings, cantilevered planes, deeper ledges or overhangs, freer stairways, flat roofs and full continuous surfaces freeing architecture from the excessive use of glass demanded by structures of iron.

Henry van de Velde (1863-1957): Weimar School of Applied Arts, 1908-1911.

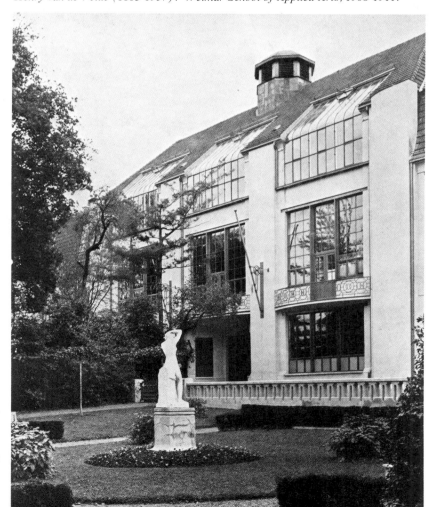

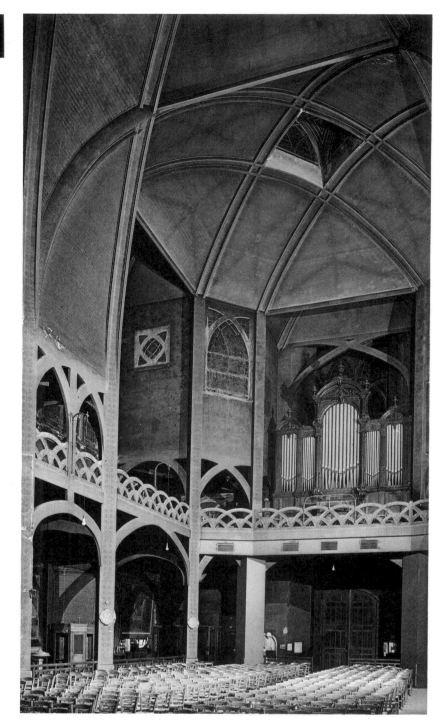

Anatole de Baudot (1834-1915):
Church of Saint-Jean de Montmartre, Paris, 1894-1904.

In the church of Saint-Jean de Montmartre, begun in 1894, Anatole de Baudot used the first large-scale armature of reinforced concrete. He admitted that he had resorted to it for reasons of economy. It proved, nevertheless, surprisingly effective and opened up new possibilities of design, by permitting architectural forms to be modelled as a fluid, continuous mass. Using reinforced concrete, Auguste Perret showed himself even more revolutionary in his apartment house in the Rue Franklin, Paris, which provided a stimulating example for several generations to come. The façade is mobile and airy, the design flexible and supple; the projection of the balconies is new; the orientation of the windows is well adapted to catch the sunlight, and their arrangement gives a fresh and attractive rhythm to the design. The impression of lightness seemed so pronounced at the time that the "experts" predicted an imminent collapse of the building and the banks refused to enter into any mortgage transaction.

"The greatness of our time lies in its very inability to invent a new ornamentation. We have gone beyond ornament; we have learned to do without it. A new century is coming in which the finest promises will be realized. Soon our city streets will be as resplendent as great white walls. The city of the twentieth century will be dazzling and bare, like Zion, the holy city, the capital of heaven."

Adolf Loos

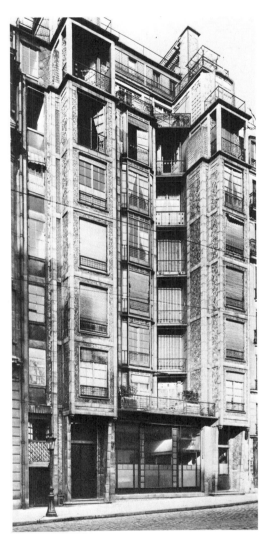

Auguste Perret (1874-1954): Apartment Block, 25 bis Rue Franklin, Paris, 1903.

Josef Hoffmann (1870-1956): Palais Stoclet, Brussels, 1906-1911.

Architecture: volumes and transparencies

The architecture of Antoni Gaudí carried into the twentieth century the decorative patterns of Art Nouveau. But he gave them a poetic dimension so characteristically personal that he transformed that heritage into pure creation. Gaudí carved out space with an entire freedom of imagination, proving himself at the same time so sound a builder that he ranks high among the great visionary architects. It is worth recalling that Le Corbusier, though an artist of completely different temperament, was one of the first to give his art its rightful place.

A born colourist, Gaudí devised a kind of collage of materials (glass mosaics, decorative ceramics, etc.); with a sculptor's eye he moulded his extraordinarily fluid and undulating forms; with the easy power of a visionary he introduced poetry into the city. The synthesis thus achieved was unusually rich and had profound repercussions, not only on architecture but also on painting and sculpture.

In an article in the art magazine *L'Œil* (Paris, February 1955), a famous contemporary architect, José Luis Sert, summed up the prophetic side of Gaudí's work as follows:

"In the recent work of several modern engineers and artists, an increasingly concrete use is made of lighter structures whose shapes often resemble shells and other elements of nature. Such forms, some of them out of true, will have a more and more important role to play in the future. In constructing our cities we cannot restrict ourselves forever to box-like buildings, inspired exclusively by the slab and pillar system. In the continuing evolution of modern architecture, it is probable that Gaudí's final experiments will assume a greater value and be more fully appreciated. His greatness as a pioneer and precursor will then be recognized."

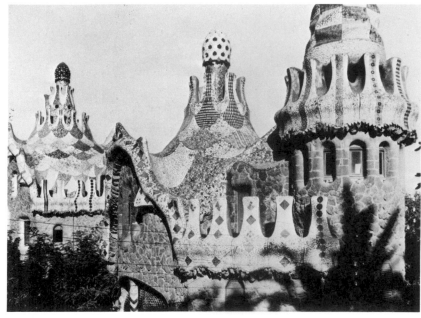

Antoni Gaudí (1852-1926): Roofs and ventilating shafts of the gate houses of the Güell Park, Barcelona, 1900-1914.

In France, Belgium and Austria, as in the United States, architects henceforth aimed at achieving a pure exterior volume; more rectilinear surfaces, punctuated by the rhythm of windows. They bound the architectural sheath to the interior space, stripping the façade of its "decorative" role to give it that of the envelope of the interior requirements it had to meet. Such was the conception of Auguste Perret when, in the Rue Franklin in Paris, he constructed the first apartment building in reinforced concrete. On his side, the Austrian Adolf Loos had upheld since the end of the nineteenth century "the rights of technique which demand honesty in the use of materials" against the flourishes of Art Nouveau. The utilization of reinforced concrete was also behind the thinking which led Tony Garnier to design an "Industrial City" in a manner revolutionary for the period.

Architecture, in those years which were so fruitful in the invention and application of forms, took two directions. In one, geometric style and functional demands led to a definition of the conditions of life in the abstract, a dream of forms to suit a society that did not yet exist but would be born, shaped by the research of harmonious architecture. In the other direction, the organic style was directly tied to the requirements of each individual, whose house became, as it were, the extension in space of his own individuality. The American architect Frank Lloyd Wright developed this second conception in the grand manner. Coming at the pivotal point between the tradition of the Chicago school and the conception of our own day, Wright gave up the construction of large buildings to devote himself to that of private homes, which he conceived as light shells protecting man and reaching outwards, flexibly, as man's own needs required.

On the other hand, diametrically opposed to this research dictated by the need for logical ordering, the lyricism of Art Nouveau burst forth and became magnified at Barcelona in the celebrated work of Gaudí. Working parallel to Fauvism and the Expressionism of the Brücke, Gaudí carried individualism to its height, projecting his mystical and pantheistic dreams to the point of total liberation of the plastic imagination.

Antoni Gaudí (1852-1926): Casa Milá, Barcelona, 1906-1910.

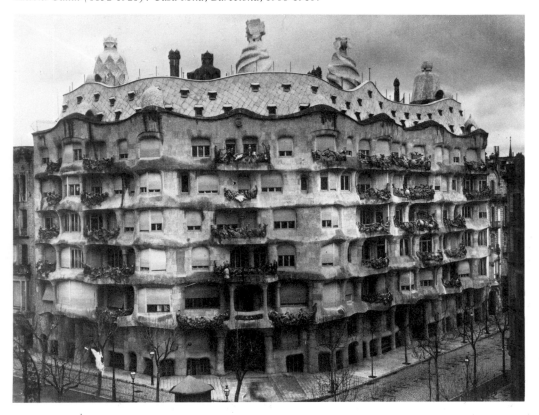

luminous accord, and also purity of tint. One particular feature: the colour was proportioned to the form. The form became modified in reaction to the coloured surroundings. For the expression comes from the coloured surface which the spectator grasps as a whole" (Matisse to Tériade, *L'Intransigeant*, 14 January 1929).

While Matisse was painting for his rich Moscow patrons, Russian dancing come to set Paris on its ears with the first performances in 1911 of the famous Ballets Russes: their sets sparkling with colours, their sumptuous costumes and the vitality of their rhythm revived the old mirage of the fabulous land of the Orient. Staged by Diaghilev, these ballets, which represented one of the most accomplished forms of a total spectacle, remained for almost twenty years in the forefront of artistic renovation. In *Remembrance of Things Fast*, Marcel Proust even spoke of "those great renovators of taste, of theatre, who, in an art perhaps a bit more artificial than painting, carried out a revolution as profound as impressionism."

The luxuriance and pomp which stirred Matisse and glittered in Diaghilev's dance spectacles, was equally dazzling in the work of the Austrian artist Gustav Klimt. Deeply marked by Viennese symbolism and the taste for Jugendstil, Klimt gave them a new dimension after his shock of recognition at the Byzantine mosaics he saw in Ravenna in 1903.

It was perhaps as a result of having felt the same fascination for the Orient that Klimt and Matisse ended by coming close to each other even in their drawing. The sensual movement of *Nude with Braid* directly recalls certain odalisques by Matisse. The elimination of any illusion of volume by the absence of shadows accentuates the power of the free linear pattern. Both Klimt and Matisse achieved a synthesis of form and light; both attained sinuosity of line and radiance of subject matter. Like Matisse, Klimt imparted great presence to his work by the refinements of his technique, the force of his contrasts, the richness of his ornamental invention and the subtleties of a palette of powerful sensuality. The subject remained more important for him than it was for Matisse, for it retained a symbolic significance; but Klimt kept so far from reality that he used his pictorial means almost like an abstract painter.

The son of a Viennese goldsmith, Gustav Klimt began his career as a decorative artist specializing in murals and received some important official commissions before joining the Vienna Secession group, which organized his first exhibition in 1898.

Emphasizing surface pattern even more sharply than Hodler (who influenced him in the parallelism of his figure compositions), Klimt went beyond Art Nouveau in the delicate intricacy of his patterning and the inner resonances which he rendered. His design is based on the juxtaposition of flat colours, but he renewed the rhythm of his picture surfaces with a great richness and originality of means. Klimt's decorative style remained extraordinarily sumptuous until the influence of the Fauves, following a visit to Paris in 1909, brought him back to a more naturalistic art. The years immediately preceding this trip to Paris, marked in particular by his decorative murals for the Palais Stoclet in Brussels, show his art at its most original and attractive.

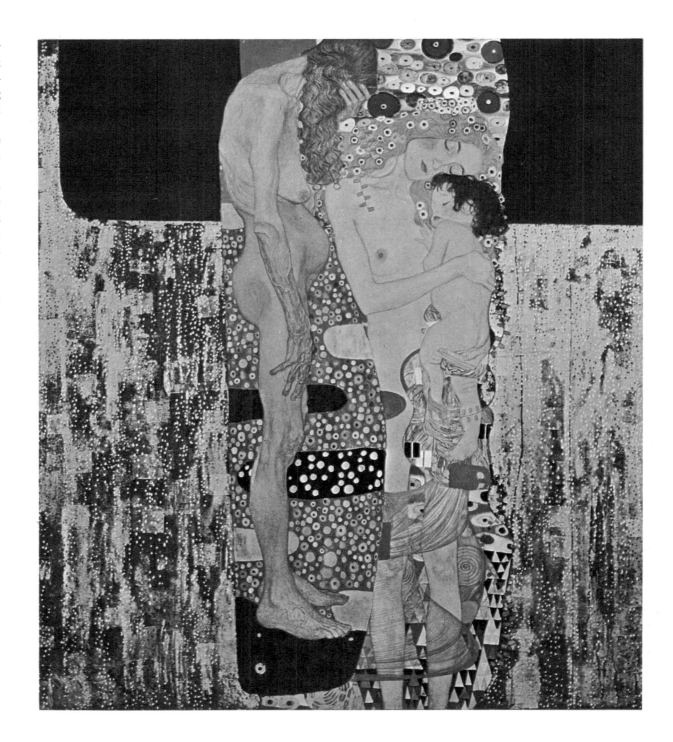

Gustav Klimt (1862-1918):
The Three Ages of Woman, 1905. Oil.

The invention of abstraction

The idea of an abstract art acquired material reality in 1910 through the creative output of several artists working independently. Its paternity, however, is usually ascribed to Kandinsky, who developed his ideas on abstraction simultaneously on canvas and in his writings, thereby proving his acute awareness of the problem.

The term "abstract" may have two different acceptations: it refers either to an art totally independent of nature and relying on putting into operation essentially invented and usually geometric means — which can equally be called concrete art; or to an expression which results from translating a natural impression, without any anecdotal or descriptive reference — also known as non-figurative art. Abstraction was nevertheless at the root of all the diversity of present modes of expression.

Herbert Read, in his *A Concise History of Modern Painting*, has authoritatively defined the break with the past produced by its invention in 1910: "This is the moment of liberation from which the whole future of the plastic arts in the Western World was to radiate in all its diversity. Once it is accepted that the plastic imagination has at its command, not the fixities of a perspective point of view (with the consequent necessity of organizing visual images with objective coherence) but the free association of any visual elements (whether derived from nature or constructed *a priori*), then the way is open to an activity which has little correspondence with the plastic arts of the past. Of course, there are basic correspondences in so far as the plastic arts are *plastic* — that is to say, concerned with the manipulation of form and colour. In this sense, art has always been abstract and symbolic, appealing to human sensibility by its organization of visual and tactile sensations. But the vital difference consists in whether the artist in order to agitate the human sensibility proceeds from perception to representation; or whether he proceeds from perception to imagination, breaking down the perceptual images in order to re-combine them in a non-representational (rational or conceptual) structure."

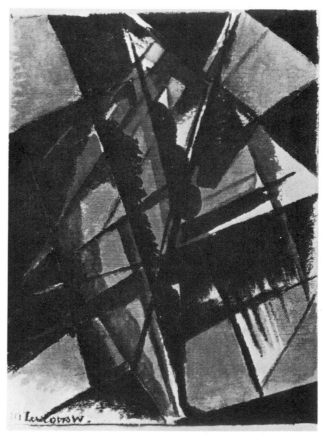

Mikhail Larionov (1881-1964): Rayonism, 1910. Oil.

Thus the artist is no longer an interpreter but a master-builder. In his book *Abstraktion und Einfühlung* (Abstraction and Empathy) Wilhelm Worringer in 1908 had already opened the way to abstraction, about which he spoke at length the following year to Kandinsky, who recognized him as one of the spiritual fathers of the new painting. For Worringer, abstraction marked a split between the artist and the world, whereas realism testified to a harmony; he regarded pure abstraction "as the only possibility of repose within the confusion and obscurity of the world-picture, and which creates out of itself, by instinctive necessity, geometrical abstraction." Kandinsky took up these same ideas but was less absolute. In his essay *On the Spiritual in Art* (1912) he brought out the dual reality of painting: its expression and its form. He recognized that "the artist gives birth to the work of art in a mysterious way. Once detached from him it acquires an independent life; becomes a distinct entity." For him, the work must remain expressive and never become "mere geometric decoration, comparable to a carpet or a necktie"; the forms and colours had to become the foundation of a symbolic language. The painter himself has described the chance occurrence which in 1908 brought him to an awareness of abstraction:

"I was coming back from sketching, plunged in my thoughts, when on opening the door to my studio, I was suddenly confronted by a picture of indescribable and incandescent beauty. Bewildered, I stopped in my tracks, fascinated by that work. The painting had no subject, portrayed no identifiable object and was entirely composed of bright patches of colour. Finally I went closer, and only then did I see what it really was—my own painting, lying sideways on the easel. . . One thing then became perfectly clear to me, that objectivity, the description of objects, had no place in my paintings and was even harmful to them."

At the same time as Kandinsky, both Picabia, with *Rubber*, and Kupka, who exhibited *Yellow Scales* at the 1910 Salon

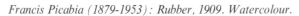

Francis Picabia (1879-1953): Rubber, 1909. Watercolour.

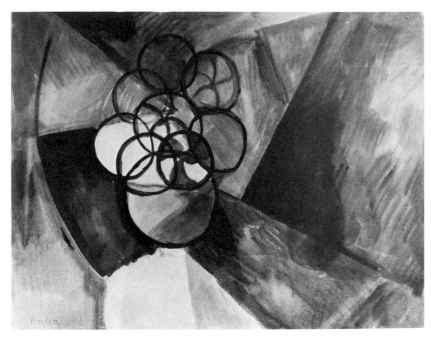

156

d'Automne, produced abstract paintings, less conscious ones perhaps, but definite in their form. It was also the period when the Italian poet Marinetti published in the *Figaro* of 20 February 1909 the Manifesto of Futurism, in which he called for the depiction of given facts of modern life that were real but invisible in the way they were apprehended, such as speed, pleasure or revolt:

"1. We shall sing of the love of danger, the habit of energy and daring... 3. Literature having hitherto glorified thoughtful immobility, ecstasy and sleep, we shall exalt aggressive movement, feverish wakefulness, the gymnast's stride, the perilous leap, the slap and the punch. 4. We declare that a new beauty has enriched the world's splendour: the beauty of speed. A racing car with its boot ornamented with great tubes like serpents breathing fire and smoke... a roaring motor car that seems to run on gunshot is more beautiful than the *Victory of Samothrace*. 5. We shall sing of the man at the wheel, of which the steering column runs in imagination through the centre of the Earth, itself also racing along the circular track of its orbit ... 8. We are on the outermost promontory of the centuries!... What is the use of looking back, at a time when we must smash through the mysterious doors of the Impossible? Time and Space died yesterday. Already we are living in the absolute, since we have already created eternal, omnipresent speed."

This *Abstract Watercolour* of 1910 is usually considered to be the first non-figurative work in the history of painting. By arranging forms and colours lyrically on the picture surface, Kandinsky raised at the outset the question which lies at the heart of the subsequent development of painting: if you set out your forms and colours freely, can the result be said to qualify as painting? Kandinsky's answer is Yes, and to make his experiment even more significant he relied on the automatism of his hand and gesture. He thus entered that free space, alive and boundless, in which all his later work unfolded.

This untrammelled lyricism is very different from the strict patterning of cubist canvases in which the means of expression are governed by a pre-established rhythm and overall harmony. But whether springing from an impulse of the free spirit or an austere sense of purpose, the painting henceforth included the new dimension of time. In Kandinsky that dimension is inherent in the sequence of the gestures. In Braque and Picasso it appears in the simultaneous interlocking and overlaying of transparent forms. In Delaunay it is implied by the multiplication of the angles of vision from which the same subject is seen.

Wassily Kandinsky (1866-1944): Abstract Watercolour, 1910.

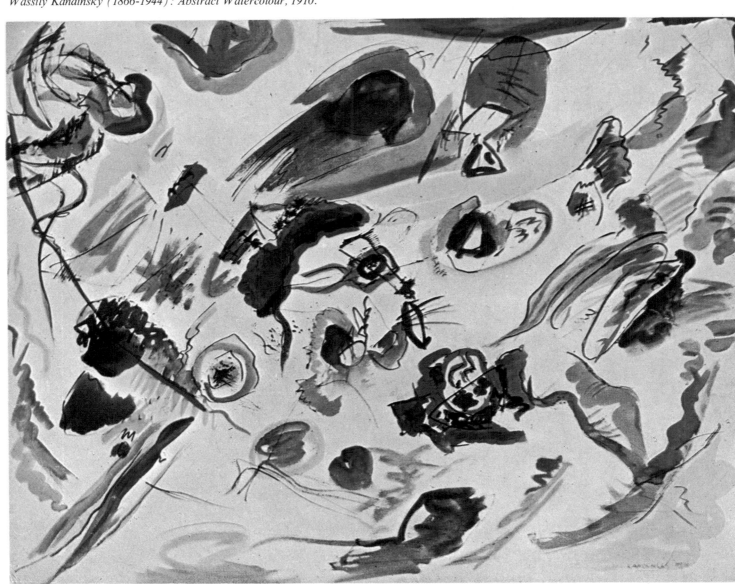

Marinetti's ideas took concrete form in the Manifesto of Futurist Painting proclaimed on 8 March 1910 at the Chiarella Theatre in Turin and signed by Boccioni, Carrà, Russolo, Balla and Severini: "Our growing need for truth can no longer be satisfied by form and colour as they have been hitherto understood," they observed, and advocated "that all forms of imitation should be despised and all forms of originality glorified; that there must be a revolt against the tyranny of the words *harmony* and *good taste* in order to give expression to *universal dynamism*."

This tendency towards abstraction burst out as well in the works of the Russian painter Larionov: "A starting point had to be found from which painting, while preserving real life as a stimulant, could fully become itself, the worn-out forms being penetrated by the creative spirit and the horizon made vaster. Painting had to adopt colour as its governing law, just as music had its real life in sound" (Rayonist Manifesto, Moscow, 1913). And Larionov also stressed the importance of structure which, in parallel with painting, became the purifying element of modern architecture.

That simplification by the study of structure was to be found equally in architecture, notably in the works of the Swiss engineer Robert Maillart, who revolutionized the formulas of building construction. In a Zürich warehouse, for example, he created the first "concrete mushroom" and eliminated the traditional roof beam that had seemed indispensable up until then. Maillart made the structure active, as did the Cubists who in their analytical paintings very soon arrived at an appearance of outright abstraction.

Each artist acquired so great a consciousness of the autonomy of his means of expression that he was obliged to test it to see the expressive possibilities of each of the terms of his language. The subordination of vision to painting, the subjection of the "painted object" to the "object-painting," became general. A painting had to impose its pictorial presence before the content which justified it. In Picasso's *Portrait of Kahnweiler* or Braque's *Candlestick*, the system of Analytical Cubism becomes so hermetic that it ends by effacing the simultaneous perception that gave it birth. Kahnweiler himself summed up the contribution of Analytical Cubism by stressing its plastic construction which often conceals from the spectator's eyes the "realist" motivations behind the pictorial approach, allowing only the "abstract" character of its execution to appear. "If I ask myself today what, after all, Cubism brought that was new, I find only one thing to say: thanks to its invention of signs to figure the external world, it gave to plastic art the possibility of transmitting to the spectator the visual experiences of the artist without illusionist imitation. It recognized that all plastic art is only a handwriting of which the characters are read by the spectator, and not a reflection of nature" (*The Rise of Cubism*, preface of 1958). Braque voiced the same feeling in these words: "The limit of the means of expression gives the style, engenders the new form and provides the creative stimulus. The early painters often owe their charm and force to their limited means of expression. On the other hand, extension of means brings with it the arts of decadence. An idea can be developed only by eliminating in advance everything that might interfere with that development" (quoted by Gaston Diehl in *Problems of Painting*).

Robert Maillart (1872-1940): Warehouse in the Giesshübelstrasse, Zürich, 1910.

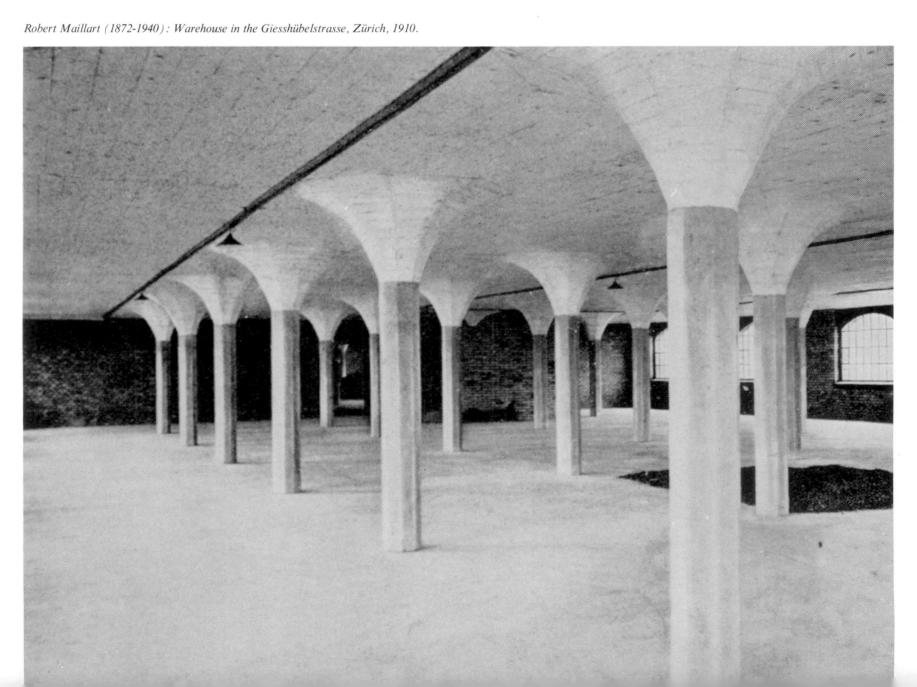

Getting down to fundamental structures

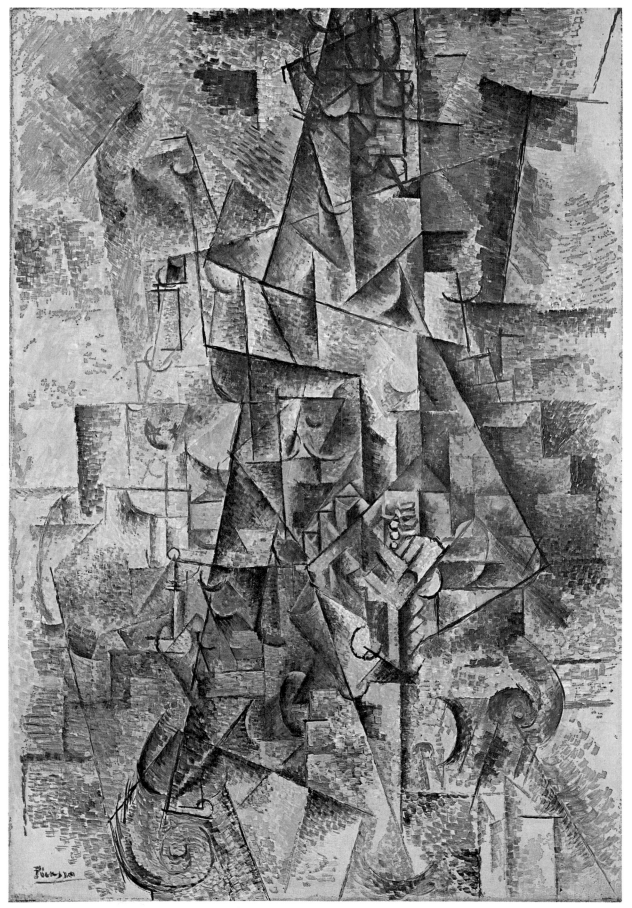

Pablo Picasso (1881-1973): The Accordion Player (Pierrot), 1911. Oil.

Kandinsky and Jawlensky break away

From its foundation in 1892, the Munich Secession brought together avant-garde artists around the German painters influenced by Impressionism, such as Slevogt and Corinth. It was in this context that Kandinsky and Jawlensky, on their arrival from Russia, discovered contemporary art simultaneously with Jugendstil. Alexei von Jawlensky, who was born near Moscow in 1864 of a noble family, began life as an officer in the Imperial Russian Guard. At sixteen, after visiting a great exhibition in Moscow, he devoted all his leisure hours to painting, and in particular attended the art academy in St Petersburg, where he became friends with the celebrated official painter Ilya Repin. In 1896 he went to Munich to study art. That year Jawlensky and Kandinsky found themselves working in the same Munich atelier. Kandinsky too was Russian, but from a completely different milieu. Born in Moscow in 1866, he studied law and political economy there before developing an interest in folk art. His calling as a painter did not declare itself until 1895, when "suddenly for the first time I found myself in front of a painting which supposedly represented a haystack, but which I did not recognize as such. This lack of recognition greatly bothered and disturbed me. It seemed to me that no one had the right to paint in such an imprecise way. I dimly felt that the work lacked a subject. But I observed with astonishment and confusion that the painting not only startled, but stamped itself indelibly in the memory and recomposed itself in the smallest details before the mind's eye. All that remained confused in me, and I could not yet foresee where this discovery would naturally lead. But what clearly emerged was the incredible power, until then unknown to me, of a palette that surpassed my fondest dreams. Painting appeared to me as if endowed with a fabulous power. But although I was unconscious of it, the 'object' as an indispensable element of the picture lost its importance for me" (*Rückblicke*, 1913). This conversion had as its origin one of Claude Monet's paintings in the series of *Haystacks*.

Jawlensky and Kandinsky were soon linked by deep friendship; both came under the influence of the triumphant Jugendstil, then were stirred by the work of Cézanne and Van Gogh shown at the Berlin and Munich Secessions, in which they both participated. Several trips to France made them responsive to the most recent artistic expressions. Kandinsky renewed his contact with non-Western arts by a stay in Tunisia during the winter of 1904-1905. Then, in 1906, he exhibited at the Salon d'Automne in Paris and the following year at the Salon des Indépendants. In 1905 Jawlensky was also able to witness the explosion of Fauvism in France.

Beginning in 1908 the two Russian painters often stayed at Murnau, a village in the Bavarian Alps near Munich, where Kandinsky and Gabriele Münter bought a house. Murnau rapidly became the rallying point for young artists who soon formed a group under the name of the Blaue Reiter (Blue Rider). After the Munich Secession in 1909 had rejected the canvases of the avant-garde artists, Kandinsky, Jawlensky, Gabriele Münter and Marianne von Werefkin launched as a protest the Neue Künstlervereinigung (New Artists' Association), which was soon joined by other artists such as Kubin, Franz Marc and even the French painter Le Fauconnier. The Thannhauser Gallery in Munich housed the group's first show in December 1909; the next year the exhibition was expanded by the participation of Picasso, Braque, Derain, Rouault, Van Dongen and others.

The Murnau landscape became a principal theme for the palette of Jawlensky and Kandinsky; its grandeur and wild power prompted a daring which is to be found as much in the simplification of the colours—almost flat tints—as in the organization of linear rhythms. This plastic research was never carried out to the detriment of the subject's legibility and spiritual content, haloed by romanticism. The German painters Franz Marc and August Macke, who had become friends at the beginning of 1910, often went to Murnau, where they were instructed in the theories worked out by Kandinsky in his book *On the Spiritual in Art*. Written in 1910 and published two years later, this book exerted a lasting influence by its profundity and richness of thought; henceforth Kandinsky's thinking gave direction to a large section of the avant-garde in Germany, and liberated painters once and for all from figuration.

Alexei von Jawlensky (1864-1941): Woman with Flowers, 1909. Oil.

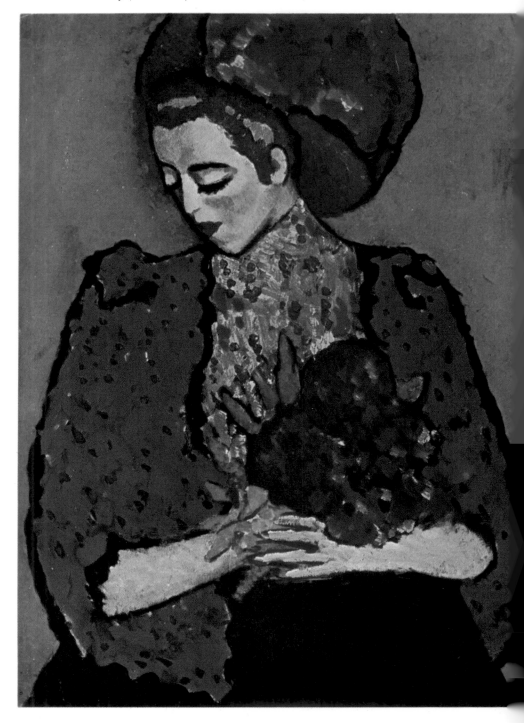

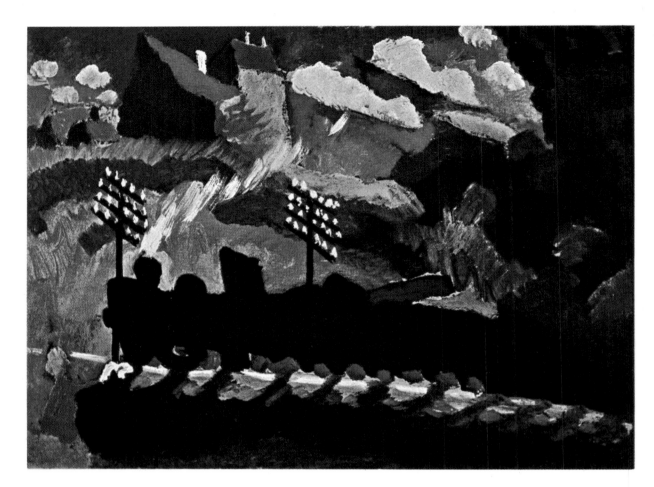

Wassily Kandinsky (1866-1944):
Railway near Murnau, 1909. Oil.

Between the painting of the Fauves and that of the Munich Expressionists, of Kandinsky and Jawlensky above all, there is no great difference in the systematic emphasis given to intense and vivid colours. But with the latter the dark outlines setting them off and the deeper, graver pitch of the colours give their pictures an inner resonance which is more spiritual than visual. In the *Railway near Murnau* (1909) Kandinsky already expresses clearly that deep sense of the renewal of life and the infinity of space which he consistently sought to convey in his later work. The landscape, traversed by the oblique movement of the railway, is rocked by it and destabilized. It appears to vacillate under the impact of the speeding train and its depth is dissolved in the fusion of the elements: the landscape is steeped in smoke, the village merges into the mountain, and the valley contrasts with the peaks which are swept up in a wave movement, an echo of the infinite.

Jawlensky was more interested in figure painting. Staider and more meditative, he testifies directly to the influence which Byzantine icons, through their symbolism and the simplicity of their forms, exerted on the artists of the Russian avant-garde.

"The fact remains that colour contains within it a force that is still little known, but one that is real and obvious and acts upon the whole human body.

"All the more reason then not to be satisfied with explaining the action of colour on the soul by mere association. Colour does indeed exert a direct influence on the soul. Colour is the keyboard, the eye is the hammer that strikes it, and the soul is the piano with many strings.

"As for the artist, he is the hand which, by touching this or that key, obtains from the soul the right vibration.

"*It is therefore evident that the colour harmony must rest only upon the principle of effective contact.* The human soul, touched at its most sensitive point, responds.

"This basis we shall call the *Principle of Inner Necessity*."

Wassily Kandinsky, *On the Spiritual in Art*, Munich, 1912

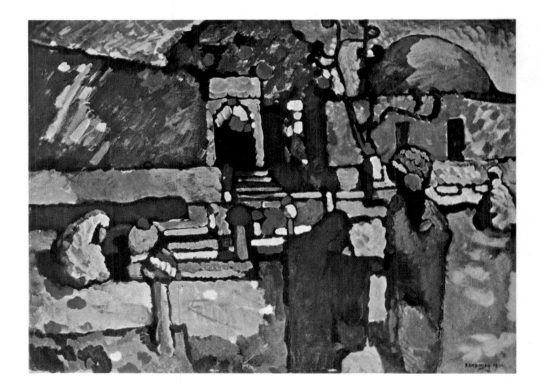

Wassily Kandinsky (1866-1944): Arab Cemetery, 1909. Oil.

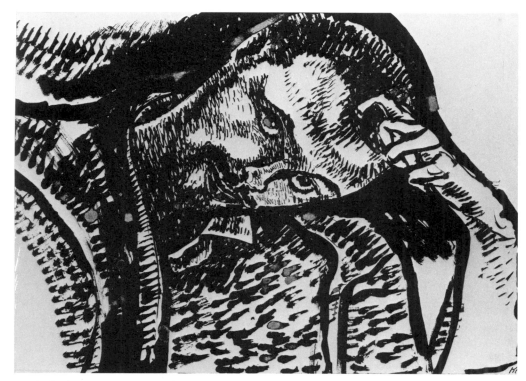

Paul Klee (1879-1940): Young Man Resting (Self-Portrait), 1911. Ink and brush.

In 1911 Kandinsky and Franz Marc founded the Blaue Reiter, which had its first exhibition in December of that year at the Thannhauser Gallery in Munich. Together with August Macke and Paul Klee, they became the leaders of a pictorial revolution. The position they adopted towards painting was very different from that of the Cubists. They set out, as Kandinsky said, to "transpose the impressions of nature into the most secret inner reality," and in an article published in the Berlin review *Der Sturm* in 1913 he added: "The inner element, that is, the emotion, must be there; otherwise the work of art is merely a piece of trickery. The inner element determines the form of the work of art." Kandinsky's dynamic element, his symbolic sense of colour, led him gradually from *impressions* produced directly by nature to *improvisations*—spontaneous, then spiritualized expressions of nature's underlying character.

In a counter-protest against Carl Vinnen's chauvinist manifesto, *Protest deutscher Künstler*, which aimed at rejecting foreign and especially French influence in art, Kandinsky, Marc, Macke and Klee together published the *Struggle For Art* in Munich in 1911. That same year the New Artists' Association split up: Kandinsky left the association with Kubin, Marc and Münter, while Jawlensky remained loyal to it.

On 18 December 1911 there opened at the Thannhauser Gallery the first exhibition by the Blaue Reiter group, bringing together the names of Kandinsky, Marc, Macke, Campendonk, Delaunay, Münter, the Douanier Rousseau, the Burliuk brothers, the composer Arnold Schönberg and Niestlé. Klee joined them soon afterwards. As for the origin of the group's name, Kandinsky related, "We both loved blue—with Marc it was horses, with me, riders. The name came by itself. . ." The Blaue Reiter artists gave further exhibitions in Munich as well as

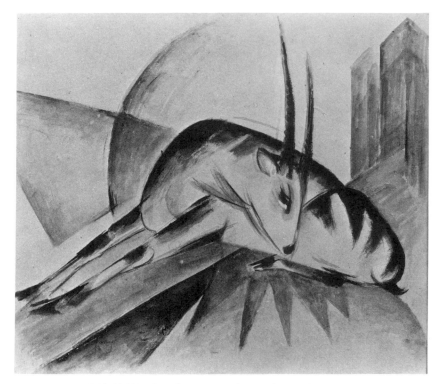

Franz Marc (1880-1916): Gazelle. Watercolour and Gouache.

Cologne and Berlin; they were soon joined by the Brücke painters and they also invited many foreign artists.

With the publication in 1912 of his book *On the Spiritual in Art* and the Blaue Reiter *Almanac*, written jointly with Franz Marc, Kandinsky provided the spiritual and theoretical justification for the plastic research of the group, attracting a very wide audience. The importance of popular, "naive" and primitive arts was fundamental, opening the way to non-descriptive expression. Marc wrote in the second edition of the *Almanac*: "We

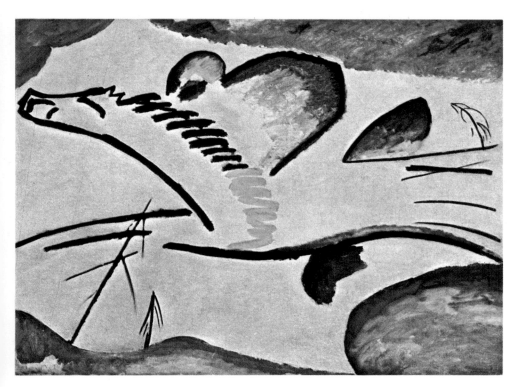

Wassily Kandinsky (1866-1944): Lyrical, 1911. Oil.

"Painting at the present time is in a new situation. It is breaking away from its close dependence on 'nature'. But its emancipation is only beginning. If colour and form have already acted upon the inner man, they have hitherto done so chiefly in an unconscious way. Some older arts, such as Persian art, have already known and practised the subordination of colour to geometric form. But to build on a purely spiritual foundation is a long and exacting labour. One begins by groping for one's way, one goes forward at random. Not only does the painter have to educate his eyes, his soul above all must be made capable of weighing colour in its subtle scales, of developing all its powers so that on the day when the work is born his soul may not only be capable of receiving external impressions (and at times arousing internal ones), but also of acting as a determining force...

"It may be said with certainty that we are now only a short distance away from pure composition."

Wassily Kandinsky, *On the Spiritual in Art*, Munich, 1912

have searched through the art of the past and the present with a divining-rod. We have shown only that art which lives untouched by the constraints of convention. Our love and devotion extended to all artistic expression born of itself, living on its own merits without supporting itself on the crutches of custom. Every time we have detected a crack in convention we have called attention to it, in the hope of finding a force beneath which will someday come to light."

And here is a statement from an article by Marc which appeared in the Berlin magazine *Pan* on 7 March 1912: "Today we are seeking things hidden behind the veil of external appearances... We seek and paint this spiritual side of ourselves in nature... Nature shines forth in our paintings as in all forms of art. Nature is everywhere, within us and outside ourselves; only one thing exists which is not completely nature but rather the mastery and interpretation of nature: art... Art is the bridge to the world of the spirit."

Kandinsky in fact cut every remaining connection with nature symbolism, and in a pure hymn of pictorial creation arrived at his *Compositions*. He concluded his book by heralding the reign of pure painting: "Let us observe in conclusion that every day we are coming closer to the time when consciousness, intelligence, will play a greater and greater part in pictorial compositions; when the painter will take pride in explaining his works by analysing their construction (the reverse of the attitude of the Impressionists, who boasted of not being able to explain anything), when creation will become a conscious process; finally, let us say that this new spirit of painting is organically and directly linked to the advent of the new Reign of the Spirit in preparation under our eyes, for this spirit will be the soul of the age of the Great Spirituality."

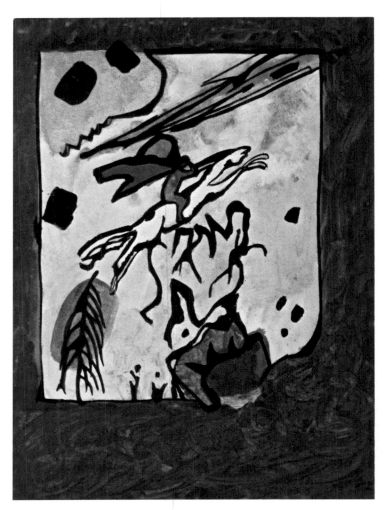

Wassily Kandinsky (1866-1944): Watercolour for the cover of the almanac of "Der Blaue Reiter," 1911.

Rhythm and action

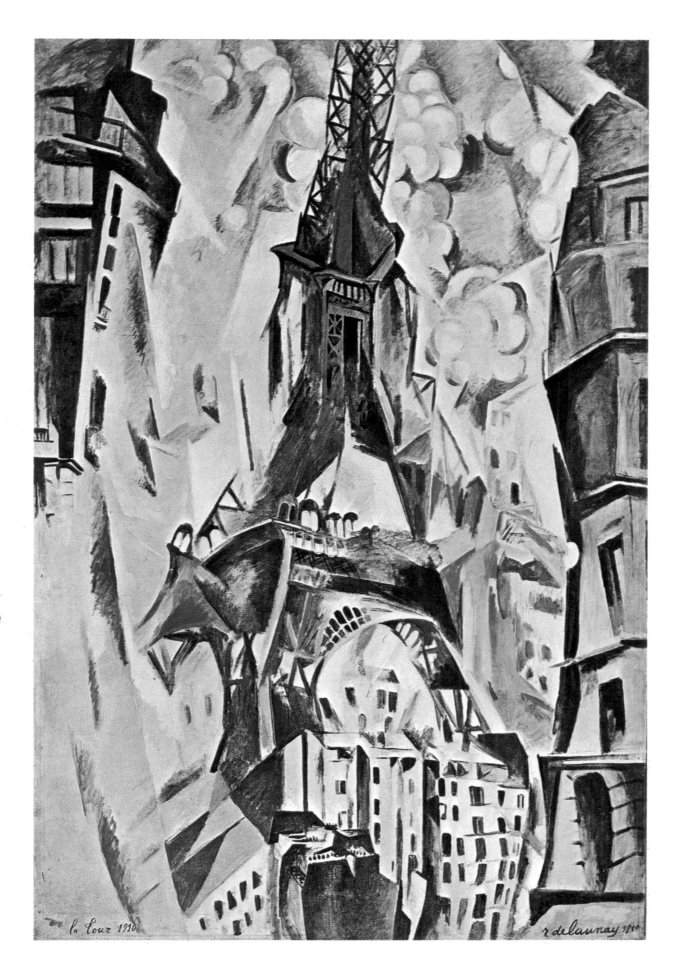

"Assigning new value to neglected sites and objects; replacing static figuration (limited to the representation of immediately recognizable things from given angles and in a given setting) with images combining significant fragments seen from different points of view in order to obtain an intimate and qualitative knowledge of figurative objects carved out of reality according to the needs of the mind rather than those of action; inserting speed among the values which determine qualities and make it possible to identify signs; using differential combinations to materialize the spatial and temporal ambivalence of phenomena and to indicate that one and the same sign may belong to several sets of signs momentarily brought into existence either by action or by the mind: these are some of the characteristics of contemporary painting and architecture, and these characteristics are precisely connected with certain aspects of present-day technology and science."

Pierre Francastel, *Art et Technique aux XIXᵉ et XXᵉ siècles*, Paris, 1956

Robert Delaunay (1885-1941):
The Eiffel Tower, 1910. Oil.

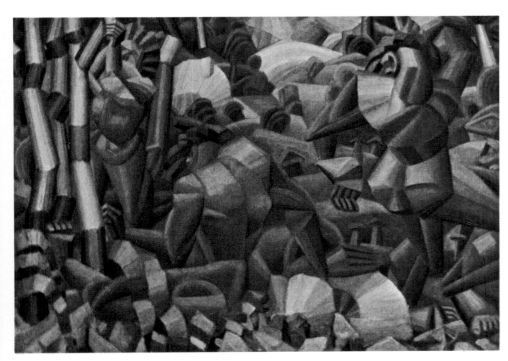

Fernand Léger (1881-1955): Nudes in the Forest, 1909-1911. Oil.

The 1911 Salon des Indépendants

The Salon des Indépendants of 1911 exhibited the work of a large number of young painters who in different ways all came out of the cubist experience: Gleizes and Metzinger, Le Fauconnier, Picabia (later one of the promoters of Dada), the sculptor Archipenko, Robert Delaunay, whose style Apollinaire called "Orphism," and Fernand Léger, whose *Nudes in the Forest* (1909-1911) caused a sensation.

Reviewing the Salon, Apollinaire said in his column in *L'Intransigeant* that Léger "creates, if I may say so, cylindrical painting, and he has not escaped giving to his composition a wild appearance of heaped-up automobile tires." Cézanne's influence was decisive, but for the young Léger it was solely a battle of volumes: "I had sensed that I couldn't make colour hold up. Volume was enough for me," he said, but that volume was also pervaded by movement. Léger had his work shown at the Kahnweiler Gallery, where, he afterwards related, "we saw with big Delaunay what the Cubists were doing. And Delaunay, surprised to see their grey pictures, shouted out, 'But these fellows paint with cobwebs!'"

From his beginnings, Delaunay in fact had never given up colour. With the *Eiffel Tower*, a favourite theme of his, he achieved a daring synthesis of colour and line and explored the possibilities of a new dynamic space. He himself has explained what prompted him to take this approach: "After they [i.e. the Cubists] had broken the fruit dish, they were unable to stick it together again—and there you have the great weakness of this period 1909-1911: that weakness lies in their expressive technique of destruction. They have all been marking time in this state of affairs with a great deal of talent, no doubt about that; but they have no guiding idea. The pieces of the fruit dish lingered on, kept coming back, presented in every possible way like a piece of surgery. But there was no life left in it; the object was quite dead. . . After line had been broken up—line, something in art that goes back very far—there was no piecing it together again. Because, in fact, there was something else that needed doing, another state of Mind that had to be found, for historically speaking a change of understanding had taken place."

It was Delaunay's research into construction by colour that estranged him from Cubism, which he reproached with having lingered too long over analysis, over the break-up of forms, whereas "the only summit in art is synthesis." But that research drew him towards Kandinsky, whose works he discovered at the 1911 Salon des Indépendants; and in December of that year Delaunay was invited to the first show of the Blaue Reiter in Munich. Both artists were looking for the same thing, as shown by a letter from Delaunay to Kandinsky in 1912 in which he observed, "This research into pure painting is the problem today. In Paris I don't know any painters who are really seeking this ideal world. The cubist group whom you mention is doing its research only in line, relegating colour to a secondary and non-constructive role." Kandinsky could only agree with this view of the spiritual significance accorded to art, having in his book *On the Spiritual in Art* himself seen in the artist the man who "possesses a power of 'vision' mysteriously inherent in him. He sees what will be, and makes others see it. Sometimes he would like to be free of this sublime gift, this heavy cross beneath which he falters. But he cannot. . ."

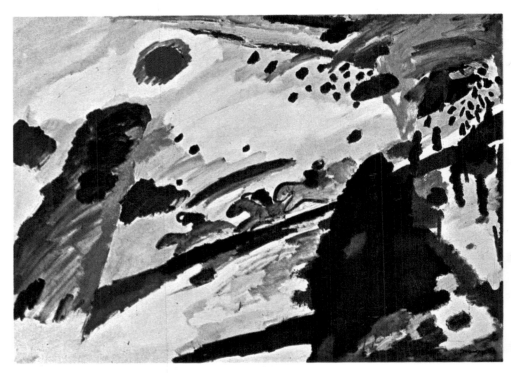

Wassily Kandinsky (1866-1944): Romantic Landscape, 1911. Oil.

The role of artistic ferment played by Paris between 1910 and 1914 passed thereafter into history and even more into legend. Its climate of liberty, its light, the Seine, the narrow streets of Montmartre, the art studios and cafés of Montparnasse ended by forming that "purifying bath" spoken of by Chagall, in which all Europe came to steep itself. But, looking further back, ever since Impressionism, followed by the Fauves, Cubists and all the literary and artistic events it hosted or gave rise to, Paris was the privileged meeting place of all avant-garde movements.

The Impressionists had loved Montmartre; the younger generation of the early twentieth century settled there. In the tumble-down and now famous Bateau-Lavoir in the Rue Ravignan lived Picasso, Max Jacob, André Salmon, Kees van Dongen and Juan Gris, who came together with so many others, including Apollinaire and Braque. "The artists and poets whose good or evil star had brought them to Montmartre were no richer than those questionable characters with whom they lived in the intimacy of a brutal and colourful Bohemia. Some of them did not escape unscathed; there were those who were sucked under for ever; others died in their prime," tells us an observer of the period, André Warnod, showing indeed that this moment of time, freely and often idealized, did not lack its tragic aspects. Even so, the friendly warmth, shared poverty, fervent arguments, and the landmarks of certain ateliers or cafés like Frédé's Lapin Agile or the Ami Emile in Montmartre, created a stimulating climate for creative invention. It is difficult to convey, without becoming anecdotal, the extraordinary mixture of passion and joking, of work and jauntiness that formed the texture of artistic life on the Butte. At the Lapin Agile the writer Roland Dorgelès, just for fun, got up an immense hoax by contriving to have Frédé's donkey paint with its tail a *Sunset on the Adriatic*, which he exhibited at the Salon des Indépendants of 1910. One winter evening in the same café, Pierre MacOrlan met Salmon and Apollinaire; the latter, an imposing figure with large blond moustaches, recited a poem from *Alcools*. Another great friend of Picasso, Max Jacob, a spellbinding and tormented poet, charmed and disquieted his friends by his practical jokes and his brooding misgivings.

If today we can no longer speak with Max Jacob of "the century of Apollinaire," it is a fact that the role played by the poet's rich and contradictory personality was of prime importance and incalculable value. A great lover of Paris, this "stroller on both banks," as Michel Decaudin called him, "knew all its secrets and all its charms: cafés where friends met, Criterion and Closerie des Lilas, Napolitain and Deux Magots, Départ and Crucifix; high places of art, literature and journalism, the Latin Quarter, Montmartre, Montparnasse, Saint-Germain-des-Prés; mysterious itineraries. . ." With his astonishingly open mind, at once pervious and persuasive, Apollinaire was able to recognize the greatest artists from their earliest beginnings and to support them with his unfailing enthusiasm and friendship. Not only in his volume of writings, *Les peintres cubistes, méditations esthéti-ques*, published in 1913, but also in his many articles and columns in the daily paper *L'Intransigeant*, on which he served as critic from 1910 to 1914, in his catalogue prefaces and his lectures, and in the reviews *Montjoie* and later *Les Soirées de Paris*, of which he was the editor and moving spirit, Apollinaire spoke of his painter friends in terms so poetic and telling that they are referred to even today to throw light on the art of that time. His tumultuous love-life may also have contributed towards making him a personage to whom no yardstick applied. For a time passionately in love with Marie Laurencin, he sang the praises of her "elegant and refined art. . . And I imagine that when Mlle Laurencin paints, the Graces and the Muses stay close by to inspire her." For us, her paintings are too mannered to touch us, except as evidence of a need for stylization which appears in many artistic experiments, notably in the masterly linear elongations of Modigliani's figures. It was also perhaps by its radical simplification that the art of the Douanier Rousseau attracted Apollinaire, who met Rousseau and Picasso in 1906. A much celebrated banquet in Rousseau's honour in 1908 brought together all the leading painters and poets in the Bateau-Lavoir atelier. "I twice had the honour of being painted by Rousseau, in his bright little studio in the Rue Perrel," said Apollinaire, who in *Comoedia* (25 April 1909) told of his sittings for the *Muse Inspiring the Poet* and how Rousseau wanted to symbolize the foreground by sweet-william, the poet's flower, but "owing to the shaky science of the botanists of the Rue Vercingetorix. . . who mixed them up, he painted gillyflowers instead."

Apollinaire and Max Jacob introduced the cubist outlook into poetry. Naturally they called on their painter friends to illustrate their poems, but they themselves multiplied the space of the poem by the simultaneity of their images, the superimposing of feelings and the contrasts of vision which had the effect of collages. Finally, Apollinaire was the promoter of the "poem-drawing," a collection of which was published in 1918 under the title *Calligrammes*.

With a certain time-lag, Montparnasse came to represent the other artistic pole of Paris. As Apollinaire wittily said: "Montparnasse here and now replaces Montmartre. One kind of alpinism in exchange for another, it's still mountaineering—the summits of art. . ." And André Warnod remembered: "Montparnasse, the Dôme, the Rotonde, the art schools, freedom. The promised land that implants a fatal nostalgia in those who have left it and of which those who know its legend dream throughout the world. Montparnasse. Brightly lit cafés, full of bustle like the platforms of a railway station or the quays of a harbour, swarming with travellers and emigrants in the uproar of arrivals and departures. You wait for a steamer that will never arrive. You settle down comfortably in the provisional to chat about painting and the second-hand trade around brandies and coffee with cream." In the years before the war all the future great names of painting hobnobbed there: Chagall and Zadkine from Russia, Soutine and Lipchitz from Lithuania, Modigliani from Italy, Kisling from Poland, Pascin from Bulgaria, Brancusi from Romania, while from the United States came Max Weber, a great friend of the Douanier Rousseau, their studios being next door to each other.

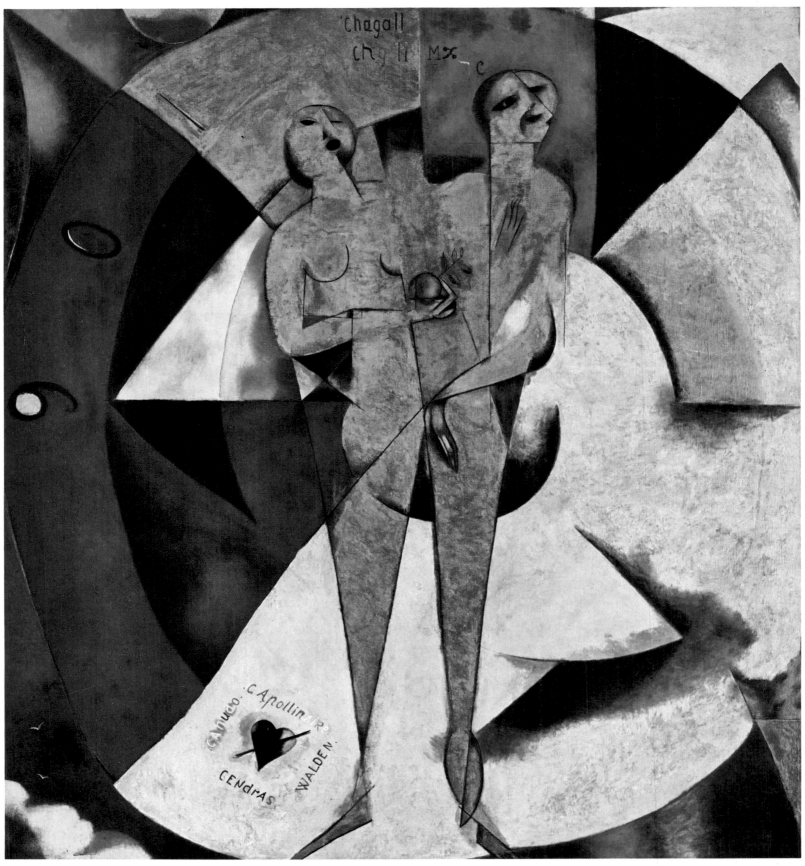

Marc Chagall (1887): Homage to Apollinaire, 1911-1913. Oil.

It was in 1910 that Marc Chagall arrived in Paris from his native Vitebsk in White Russia. He settled in Montparnasse in the famous "hive of studios" known as La Ruche and lost no time in forming friendly ties with Léger, Delaunay, La Fresnaye, Apollinaire, Max Jacob and Blaise Cendrars. Some thirty years later, in a lecture given in the United States, he said: "So I arrived in Paris. As if driven by fate. Into my mouth flowed words that came from my heart. They almost choked me. I was stammering. The words were in a hurry to come out, anxious to enjoy the light of Paris, to preen themselves with it. I arrived with the thoughts and dreams that you can only have at twenty... The sun of Art shone only in Paris, and it seemed to me and seems to me still that there is no greater revolution of the eye than the one I found in 1910 when I arrived in Paris."

Futurism

The new means of visual expression represented by the cinema could not help exploding the vision of the painters, who—contrary to the cameramen who extended their action in time—henceforth sought to represent the unfolding of an action in the closed and simultaneous space of the painting. But they did not rest with depicting a movement from one place to another; the representation of movement led to a new consideration of space. For them it was a question of analysing a displacement which revealed the immateriality of reality in movement, and furthermore to produce testimony of the multiple sensations inspired by that movement in the actor or the spectator.

"We shall sing of the great crowds stirred up by work, pleasure or revolt; of the multicoloured, polyphonic surge of revolution in modern capitals; the nocturnal vibrations of shipyards and construction sites beneath their harsh electric moons; the gluttonous railway stations gulping smoking serpents; factories hanging from the clouds by the strings of their chimney-smoke" (Marinetti, *Manifesto of Futurism*).

Despite the redundancy of the tone, Marinetti served notice that, by around 1910, an artist no longer depicted a situation but experienced it; that he no longer illustrated an everyday setting but used it; his references were no longer to the kingdom of nature (animal, vegetable or mineral), but to industrial and mechanical elements.

Hitherto the painting had been a reality outside the spectator; henceforth the spectator became actor and was thrust with more or less violence into a dynamic reality that assaulted him from every side. The introduction of movement into the figurative system transformed perspective: space became the field of action. In parallel with the scientists who no longer conceived of space as a static and fixed entity, the artists linked movement with depth. "From now on space and time, taken in isolation, are doomed to disappear like shadows. Only the union of the two concepts will retain an existence of its own," wrote the mathematician Hermann Minkowski, in a famous speech which he delivered in 1908. Thus a fourth dimension was born: time; and movement became measurement of space.

It must not be forgotten that the public was also confronted by another materialization of movement: the cinema. The invention of the cartoon film, then just in its beginnings (Emile Cohl, its inventor, projected his *Phantasmagoria* in 1908) was a further exploration of it.

While the Italian Futurists applied themselves more to the depiction of movement than to the search for its pictorial equivalent, the attitude of the Cubists was more moderate, even if Apollinaire spoke of their "cinematic art" in his review of the Salon des Indépendants of 1911. For all of them, however, space, properly so called, no longer existed. "Indeed, the pavement of the street drenched by the rain under the shine of electric lamps, scoops out an immense hollow, all the way to the centre of the Earth. Millions of kilometres separate us from the sun; that does not prevent the house before us from being built into the sun's disc," the futurist painters declared in their manifesto of 1910. Thus it became important to catch the relations existing between things. Said Braque: "What is between the apple and the dish must also be painted. And, my word, it seems as difficult to paint the space between as the thing itself. It is precisely the relation of these objects between themselves and of the object with the space between that forms the subject."

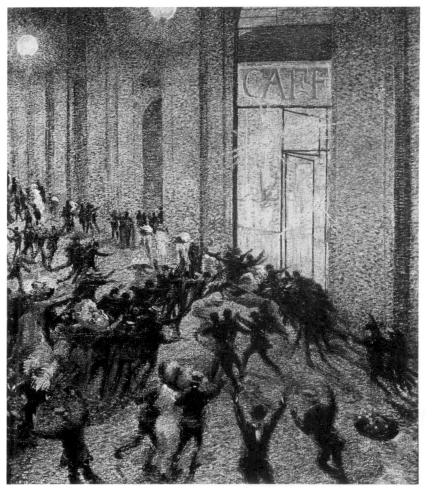

Umberto Boccioni (1882-1916): Brawl in the Galleria of Milan, 1910. Oil.

Carlo Carrà (1881-1966): The Funeral of the Anarchist Galli, 1910. Drawing.

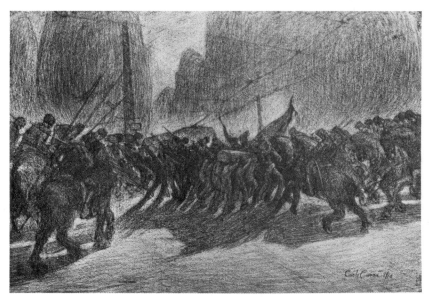

168

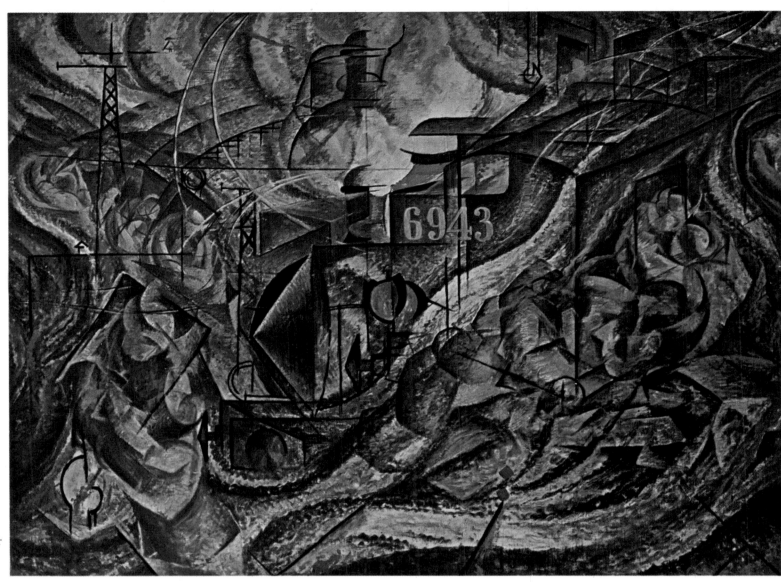

Umberto Boccioni (1882-1916): States of Mind, I: The Farewells, 1911. Oil.

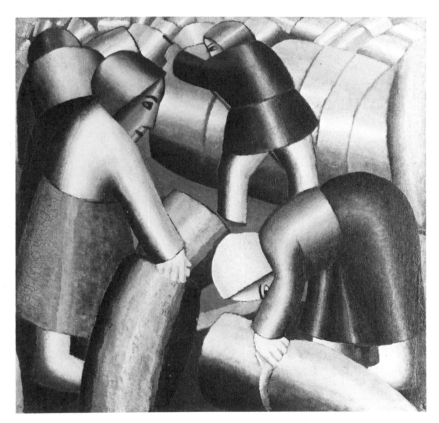

Kasimir Malevich (1878-1935): Harvest Time, 1911. Oil.

From then on the Italian Futurists wanted to place "the spectator in the centre of the picture," in other words at the centre of life; and painting according to them had to be "total." In an article published in *Lacerba* (1913) Carrà said: "This seething and this cyclone of forms and resounding, uproarious and odorous colours was rendered by me in *Funeral of the Anarchist Galli* and *Jolts of a Hackney-Coach*, by Boccioni in *States of Mind* and in *Forces of the Street*, by Russolo in *The Revolt*, by Severini in *Pan-Pan*... This seething implies a great emotion and almost a delirium on the part of the artist who, in order to portray the whirlpool, must himself be a whirlpool of sensation, endowed with a pictorial force and not a cold logical intellect." It is worth noting that by the very titles of their pictures the Futurists set out to express the importance they placed on everything that moved, even if, in fact, it was difficult for them to escape from the literary implication of their subjects.

Similar developments were under way in Russia, where there appeared what was called Cubo-Futurism, a trend which, despite its name, declared its independence from all parallel movements in Western Europe. Avant-garde shows brought together several artists, among them Tatlin, Malevich, Larionov and Natalya Goncharova. In 1911 Larionov displayed works representing Rayonism, the manifesto of which he issued in 1913.

Movement of the spectator and painting of movement

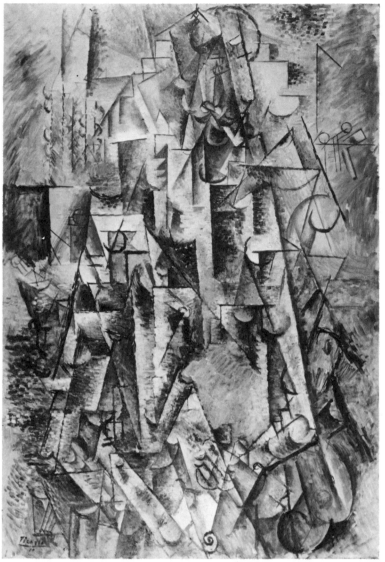

Pablo Picasso (1881-1973): The Poet, 1911. Oil.

Mikhail Larionov (1881-1964): Red Rayonism, 1911. Gouache.

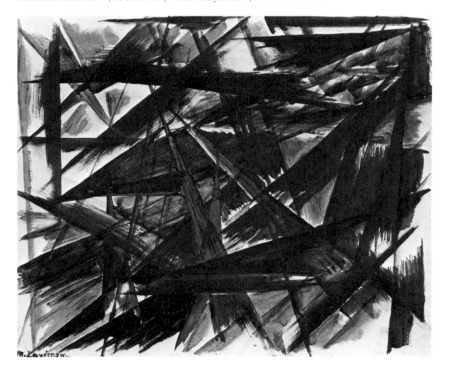

The Futurists, in seeking to transform the spectator into an actor plunged by them into the very heart of the picture, were not so far removed from the Cubists who, like them, presupposed an active spectator; their differences lay in the choice of subject and the significance they gave it.

Braque and Picasso, during the year 1911, worked in complete spiritual communion; they spent their holidays together at Céret, a village in the Pyrenees to which they regularly returned until 1913. Both concentrated on representing reality; they selected motionless subjects, the static object giving them the possibility of going further ahead with their analysis of perception. With complete freedom from the demands of description they sounded the depths of a pictorial language in which they eliminated any allusion to the subject they represented.

As a matter of fact, in this affirmation of the means of representation they never went against the expression of reality. That affirmation sprang of necessity from the desire first of all to paint but also to gather more data on an object which could be fully apprehended only by demanding the lateral and vertical displacement of the witness—painter or spectator. "Picasso does not deny the object; he illuminates it with his intelligence and his feeling," declared Metzinger (1910).

The Italian Futurists, as we have seen, wished to paint life itself and above all to evoke the resonance that movement produces in feeling and consciousness. Therefore they mobilized a whole network of lines of force which aimed at recreating the constant flux that surrounds us.

Contrary to the Cubists, the Futurists wanted to paint movement directly: "The gesture we want to reproduce on canvas will no longer be a frozen instant of universal dynamism. It will be simply the dynamic sensation itself," they declared in their 1910 manifesto; and that sensation was not only physical but also emotional, even symbolic, as shown by the three paintings of *States of Mind* by Boccioni, perhaps the most daring artist of the group.

Moreover, whereas cubist experiments imposed discipline in the use of colour, purifying it to the single tones of monochrome painting, the Futurists, like the Orphists and Rayonists, employed simultaneous contrasts of colour which, according to scientific observations themselves, reinforced the illusion of movement. Further, whereas Braque and Picasso extended the linear rhythm of the object the better to blend it into the space that contained it, the Futurists, although they used a similar formula, gave another justification to breaking the object asunder: "Each object influences its neighbour not by reflections of light (the basis of impressionist primitivism) but by a real struggle of lines and real battles of planes, in keeping with the emotional law which governs the painting (the basis of futurist primitivism)" (preface of 1912). The extension of lines of force in fact allowed both schools to achieve an aesthetic unity and to affirm the painting as an independent and autonomous object, subject to its own laws.

The Russian Larionov carried the research into spatial dynamics still further by concentrating on the study of what exists between objects. In 1913 he published the Rayonist manifesto, at the time of the Target exhibition in Moscow: "The style of the Rayonist painting which we have imagined," he said, "has for its object the spatial forms resulting from the crossing of reflected rays emanating from various forms and objects chosen by the artist. The ray is conventionally represented by a

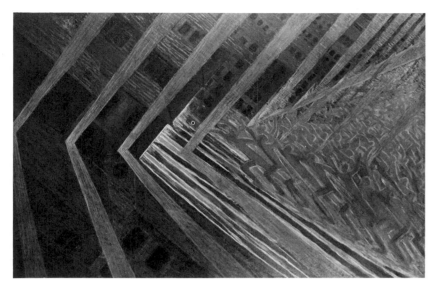

Luigi Russolo (1885-1947): The Revolt, 1911-1912. Oil.

coloured line. The essence of the painting lies in a combination of colours carried to the point of saturation, in the relation of coloured masses and in the intensity of the whole."

Even if the presence of Marinetti in Moscow around 1909-1910 is disputed by Russian historians, there is no doubt that artists in Moscow were able to read the translation of his Futurist Manifesto soon after its appearance in French in 1910. But it was Mikhail Larionov who galvanized the creative forces in Moscow and exalted their daring feats by organizing several shows between 1910 and 1914. Well informed about the experiments in Paris and Munich, in 1911 he broke with the Knave of Diamonds group where French and German influence prevailed and organized The Donkey's Tail in 1912 and The Target in 1913. The perspicacity of his ideas, the force of his analysis and the revolutionary independence of his creations carried Malevich and Tatlin along in his wake. Larionov and Goncharova left Russia in 1914 to follow Diaghilev and the Ballets Russes, in which, by their conceptions of stage sets and costumes, they revolutionized the traditional dance spectacle.

Umberto Boccioni (1882-1916): The Forces of a Street, 1911. Oil.

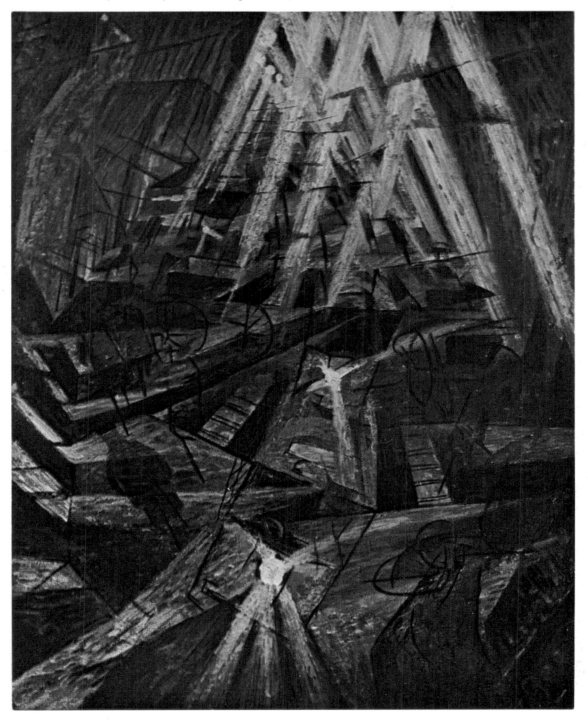

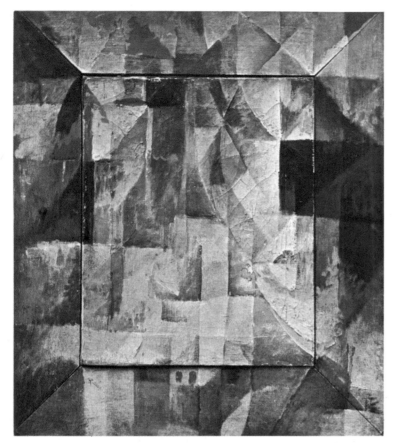

Robert Delaunay (1885-1941): Simultaneous Windows, 1911. Oil.

The window opens like an orange
The beautiful fruit of light.

Guillaume Apollinaire, 1913

Fernand Léger (1881-1955): The Smokers, 1911. Oil.

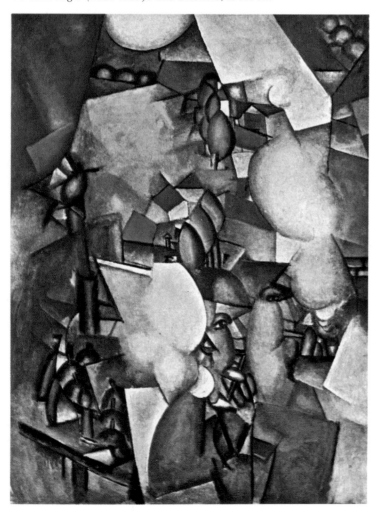

The paths of Cubism

The 1911 Salon des Indépendants saw the first great public showing of the group of cubist painters, even if Picasso and Braque did not feel in complete solidarity with their enthusiastic "disciples." In one and the same room were hung the works of Gleizes, Metzinger, Le Fauconnier, Delaunay and Léger; and at the Salon d'Automne of the same year the ranks of those henceforward called Cubists by admirers and critics were further swelled by the names of Marcel Duchamp, Jacques Villon and Picabia. All of them, along with the poets and literary figures Apollinaire, Max Jacob, Salmon, Allard, Reverdy and Raynal, met regularly at the café La Closerie des Lilas, at the home of Alexandre Mercereau, a young socialist writer and the moving spirit of a kind of phalanstery of artists, at the Créteil Abbey, of which Gleizes was a collaborator, or in the studios of Gleizes and Le Fauconnier. At Puteaux, in the western suburbs of Paris, the studios of the three Duchamp brothers, who exhibited under the names of Marcel Duchamp, Raymond Duchamp-Villon and Jacques Villon, also became an important rallying centre. There, under the name of the Golden Section or of the Artists of Passy, a group was formed including Kupka, Archipenko, Marcoussis, Herbin and above all Juan Gris.

Gleizes and Metzinger, the most dogmatic Cubists among them, started from tangible data furnished by the research of Braque and Picasso and developed an aesthetic theory set forth in a volume called *On Cubism* (1912). Like Gris, they clung to rhythmic and volumetric expression. Delaunay and Léger, on the contrary, were preoccupied above all with movement and colour.

The investigation of space was the keystone of the art of Delaunay; if the subject of *The Eiffel Tower* enabled him to transform perspective by discovering in the dislocation of the line a dynamic possibility of simultaneous portrayal, in his *Windows* he gave first place to colour in the pictorial construction. Apollinaire described this approach as Orphic Cubism.

After his research into volume, Fernand Léger also inserted primary colours, like collages, into his formal reconstructions; more volumetric than those of Delaunay, his landscapes were based on intuition: Léger was drawn by the external world, the bustle of the street, modern life... He shared this love with the poet Blaise Cendrars, to whom he was very close: "He's like me. He picks everything up in the street. With him I got tangled up with modern life," Léger said. He made thick puffs of factory-chimney smoke one of his favourite subjects: their lightness as opposed to the weight of stone was one of the points of departure for his ideas on contrasts that were to mark his later works.

"Colour for me was a necessary tonic. Here again Delaunay and I were far apart from the others. They painted monochrome, we painted polychrome. And then after that came the battle with Delaunay himself. He was following up the line laid down by the Impressionists by using complementary colours one beside the other, red next to green. I had no further intention of putting two complementary colours next to each other. I wanted to arrive at tones that held aloof from each other, a red very red, a blue very blue. If you put yellow beside blue, that gives you at once a complementary, a green. So Delaunay was moving towards the nuance and I was going straight towards forthright colour and volume, towards the contrast. A pure blue remains a pure blue if it is next to a grey or a non-complementary tone. If it contrasts with orange, the relationship becomes constructive but does not colour."

Fernand Léger

A key to seeing

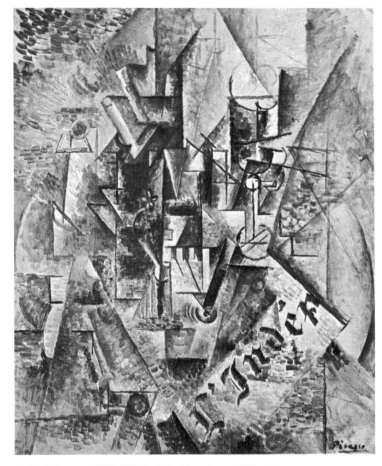

Pablo Picasso (1881-1973): L'Indépendant, 1911. Oil.

Georges Braque (1882-1963): Man with a Guitar (entire and detail), 1911. Oil.

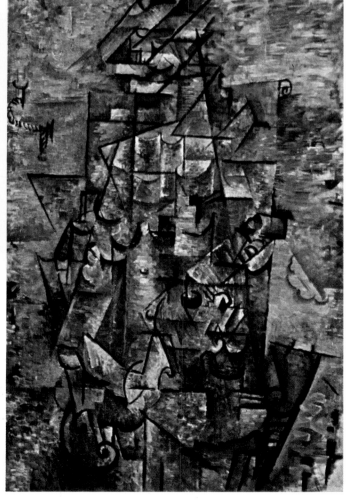

As they developed the demands of their language and the necessities of perception, Braque and Picasso arrived at an occult system of representation which made the subject of their exploration practically illegible, while on the pictorial level they attained a kind of classical serenity. But they went on to reconsider that harmony itself in order to provide the spectator with a key enabling him to identify the subject. By the end of 1910 Braque had introduced a few naturalistic details, and in spring of the following year, in *The Portuguese*, he incorporated stencilled letters and numbers: "Always desiring to approach reality as closely as possible, in 1911 I introduced letters into my pictures," he explained later in *Painting and Us*. Picasso, whose intransigence had led him to greater abstraction, saw the usefulness of such adjuncts, and adopted them. Thus they both managed, while suggesting the real, to recreate it in a form attesting a presence that was simultaneously

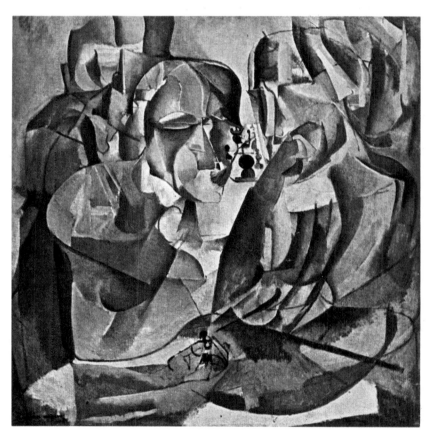

Marcel Duchamp (1887-1968): Portrait of Chess Players, 1911. Oil.

visual and tactile. The string and nail motif in *Man with a Guitar* by Braque and the newspaper letterpress and flower in Picasso's *L'Indépendant* asserted themselves in their material reality to the reader who automatically recognized them; the picture then became an association of heterogeneous images, a different world, totally recreated. The incorporation of the printed letter and of objects—which heralded the collage—transformed the picture space by emphasizing its plane. Referring to this conquest, Braque said: "They were forms which needed no distortion because the letters, being flat tints, were outside space and their presence in the picture made it possible, by contrast, to distinguish the objects located within the space of the picture from those that lay outside" (*Painting and Us*).

The Futurists in Paris

The Italian futurist painters did not limit themselves to problems of painting, but took on the task of shaking modern man free from his ancestral moral, visual and aesthetic habits. In order to convey the world typified by the new "beauty of speed" they referred to the latest scientific data. To give concrete form to the great axioms of their first manifesto—"All used-up subjects must be swept aside in order to express our whirlwind life of

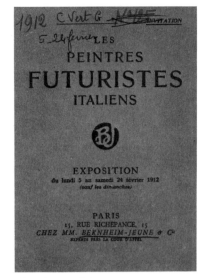

Catalogue of the Futurist exhibition, Galerie Bernheim-Jeune, Paris, 1912.

steel, pride, fever and speed," or "universal dynamism must be rendered in painting as dynamic sensation" or again "movement and light destroy the materiality of bodies"—they relied on the still recent experiments by Marey with motion-analysis photographs, on the distortions of movement by speed shown with snapshot photography and on the breakdown of movement into its component parts achieved by the cinema. Although at first they used juxtaposition of movements, beginning with 1912 they managed to bring out the invisible lines joining up the different instantaneous images which constitute movement.

"The force-form, by its centrifugal direction, is the potential of the really living form. Thus in my sculpture form is perceived in a more abstract way. The spectator must construct an ideal continuity (simultaneity) suggested to him by the force-forms equivalent to the expansive energy of the bodies... We must completely forget the figure enclosed by its traditional outline and on the contrary produce the figure as a centre of plastic thrusts into space," said Boccioni in the preface to the catalogue of his exhibition at the La Boétie Gallery in Paris in June 1913.

Those statements were of capital importance for the future of art. Today Boccioni and Balla appear as the two great innovators

Grand Prix of the Automobile Club of France, 1912. Photograph by Jacques Henri Lartigue.

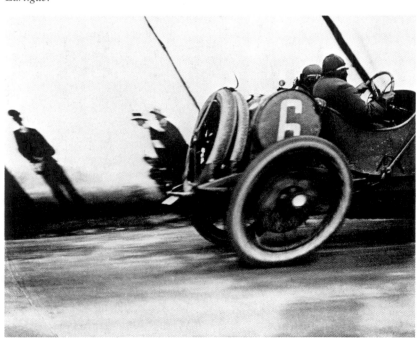

of the futurist group: the first, the more violent and sensitive; the second, a passionate seeker of abstract structures capable of rendering to the full the primary dynamism of the world (at times relating to the research of Delaunay) and in which colour played a leading role.

Beyond its provocative character, the Futurists' attitude proved fertile for the times to come, but it obviously could not fail to generate clashes with the other avant-garde movements. The first great confrontation took place in Paris in 1912, on the occasion of the futurist exhibition which opened on 5 February at the Bernheim-Jeune Gallery. The essential principles of their research—lines of force, dynamic penetration of the object into space, and the determination to explode the purely visual problem in order to include auditory and olfactory sensations—were a far cry from the severity and intransigence of the Cubists' probings. Apollinaire immediately reacted: "They want to paint forms in

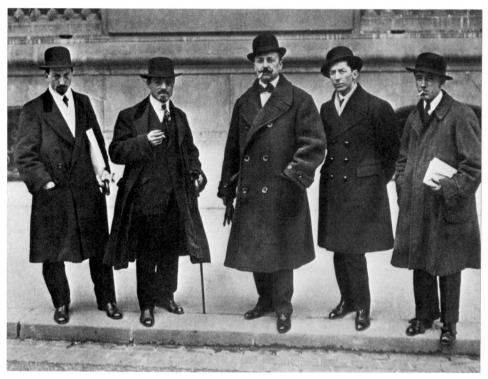

The Italian Futurists in Paris, 1912: Marinetti, Severini, Boccioni, Carrà and Russolo.

Giacomo Balla (1871-1958): Wheels in Movement, 1912. Pencil study.

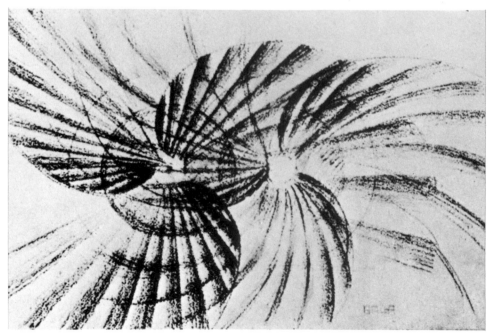

movement, which is perfectly legitimate, and they share with most academic painters the mania for painting moods... The Futurists are young painters who would inspire confidence if the boast-fulness of their declarations, the insolence of their manifestoes, did not rule out the indulgence we might be tempted to have for them," he wrote in *L'Intransigeant* of 7 February 1912, and two days later in *Le Petit Bleu* he said sarcastically: "The exhibition of futurist painters will teach our young painters to have more nerve than they have had until now. Without nerve, the Futurists would never have dared to expose their still so unfinished attempts..." Nevertheless it was to the Italian Futurists that Apollinaire attributed the pater-nity of simultaneous painting, which did not fail to irritate Delaunay and touched off a great literary polemic in the Berlin review *Der Sturm*. And yet Delaunay too was attracted by move-ment; in 1938 he still acknowledged: "Life is movement! Let's forget the past! Everything must be stirred up; images must follow one upon the other. For the embalmed corpses of the Museum and the Libraries we must substitute modern life, with autos, planes, cannon, machine-guns, dreadnoughts. Nothing must remain at rest; rest is death..."

But the bombastic and exasperating verbal mannerism of the Futurists also antagonized Kandinsky, who wrote in a letter of 12 November 1912 to Herwarth Walden, editor of *Der Sturm*: "If possible, refrain from 'pushing' the Futurists overmuch. You know my view of them and the latest manifesto (painting sounds, noises and smells—without grey! without brown! etc.) is still dottier than the previous ones. Don't hold it against me, Herr Walden. I don't like to speak of it either. But art, after all, is something sacred which cannot be treated so lightly. And the Futurists do toy with the most important ideas, which they put forward here and there. But everything is so little reflected upon and so shallowly felt! Things like that pain me. I know it is all part of our present life, which is infinitely varied and which creates subjects of an unheard-of variety. But nevertheless I have the right not to give my direct support to elements which are antipathetic to me. It is enough that I don't actually combat them."

Futurism could only show a favourable balance-sheet when, after all the polemics, the paths it succeeded in opening could be seen. Its ideas, however, did not fail to shake all of Europe during the three years which preceded the First World War.

Giacomo Balla (1871-1958): Dynamism of a Dog on a Leash, 1912. Oil.

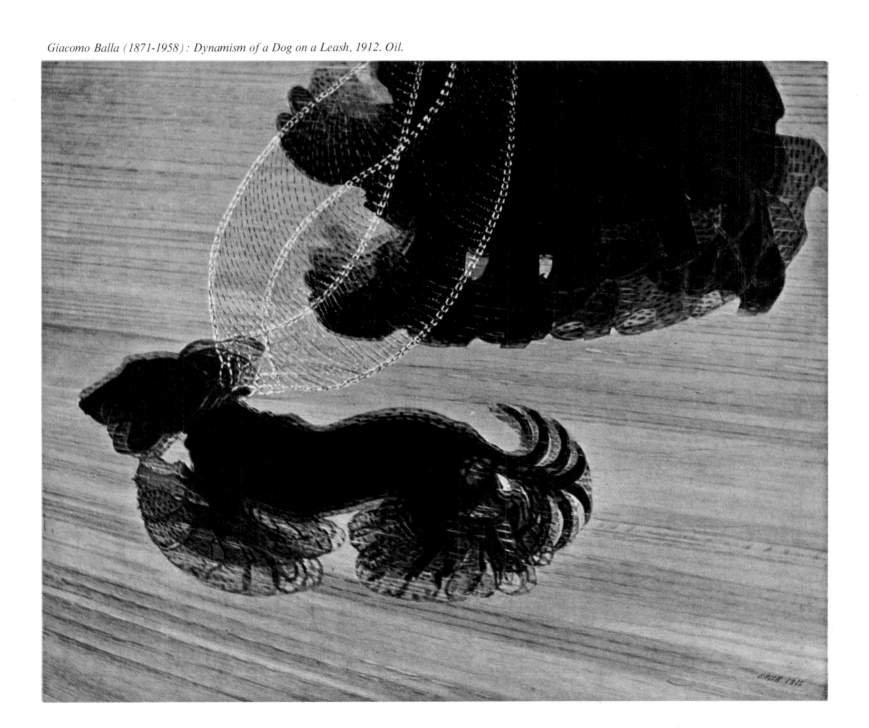

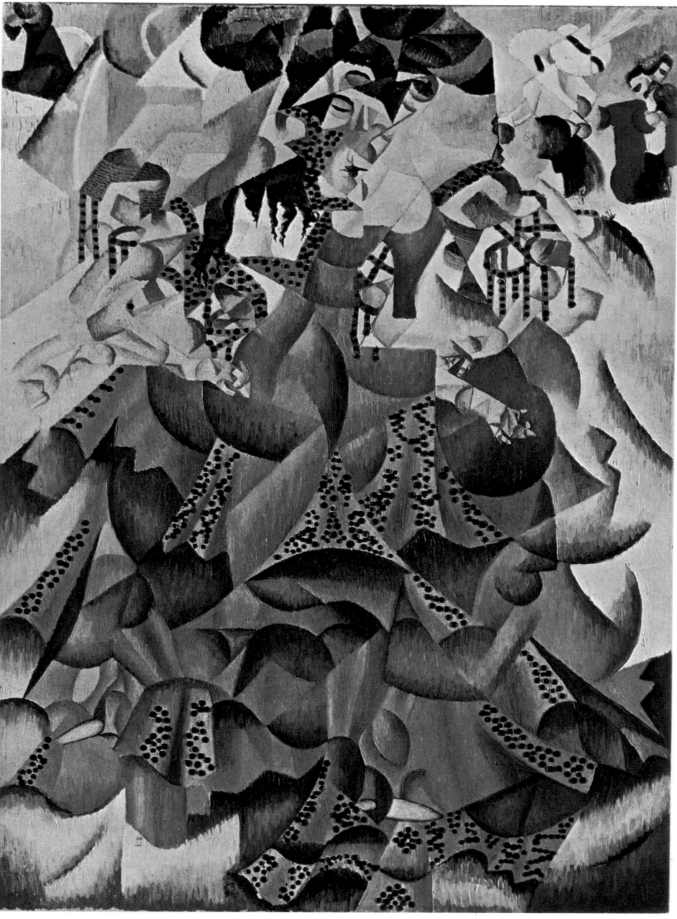

Gino Severini (1883-1966): Blue Dancer, 1912. Oil.

"From now on, in our age of dynamism and simultaneity, you cannot separate any reality from the memories or pictorial affinities or aversions which its *expansive action* evokes *simultaneously within us* and which are so many abstract realities and reference marks which help us towards the total action of the reality in question.

"And the spiralling forms and the fine contrasts of yellow and blue discovered by our intuition one evening *by watching the action of a dancer* can be re-experienced later, by pictorial affinity or contrast, *in the circling flights of an airplane or the headlong rush of an express train.*"

Gino Severini, *The Pictorial Analogies of Dynamism*, September 1913

The Golden Section

It was in 1912 that the cubist movement reached the general public on the theoretical as well as the practical level. *On Cubism* by Gleizes and Metzinger appeared in August. Apollinaire published in *Les Soirées de Paris* a number of articles which he reprinted in March 1913 in his book *The Cubist Painters*, and Hourcade published two articles taking stock of the evolution of art. Meanwhile Cubism, which exploded massively at the 1912 Salon des Indépendants, again emerged as the dominant movement at the June Salon of Rouen and above all at the Salon d'Automne (where the cubist house of André Mare and Duchamp-Villon was shown).

In October of that same year 1912 the La Boétie Gallery held the first exhibition of the Golden Section group—the direct reply of the French to the Italian Futurists' show. Jacques Villon was responsible for the title of this event. He and his two brothers, strongly attracted by mathematical research—Marcel Duchamp was a friend of the mathematician Maurice Princet, a kind of guardian spirit whose role is still vaguely defined but whose name crops up in all the chronicles of the period—helped to give Cubism a scientific basis. The Golden Section exhibit, of which the nocturnal private preview remains a legend, assembled more than two hundred works mainly by Metzinger, Gleizes, Villon, Duchamp, Duchamp-Villon, Picabia, Gris, Lhote, La Fresnaye, Marcoussis, Archipenko and Léger. Despite the absence of Braque and Picasso, it was an impressive demonstration of cubist theory and practice at that time.

All the participants showed awareness of the problem of movement and of the quest for an autonomous language, which at that time could still seem so revolutionary that it provoked a speech in the French parliament by the Deputy Jules-Louis Breton. He protested against the harbouring by museums of exhibits "of such a clearly antiartistic and antinational character." In reply, the Socialist leader Marcel Sembat, a great friend of Matisse and a passionate lover of contemporary art, said: "When you find a painting bad you have an indisputable right: that of not looking at it and of going to look at others. But you don't call the police" (*Journal officiel*, sitting of 9 December 1912).

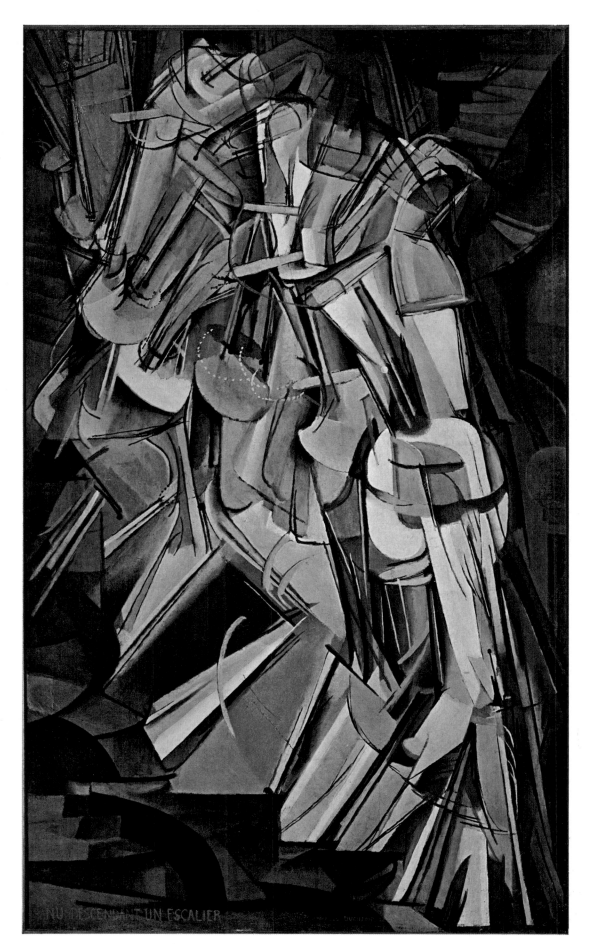

Marcel Duchamp (1887-1968): Nude Descending a Staircase, No. 2, 1912. Oil.

The letter and the object

The desire of Braque and Picasso to make the subject of their canvases more intelligible led them from the representation of certain objects in *trompe-l'œil* to that of the printed letter, of which newspapers and advertisements furnished daily examples. The incorporation of printed letters seen on another scale and from a diferent angle than the rest of the picture made it possible to multiply the spatial vision and emphasize the flat plane of the surface to be painted.

In cubist painting the letter made its appearance in 1911 in the representation of certain objects and rapidly attained such power that it soon acquired a presence of its own. Its forcefulness as a sign did not escape the attention of advertising artists who, working along parallel lines, stripped the advertising poster of illustration to emphasize its sign power and strengthen the presence of the object in a context reduced to essentials. Russian artists had already had recourse to lettering: icons and popular images had made them familiar with this interpenetration of the painted and written sign. From 1911 onwards the letter indeed occupied a privileged place in the work of Larionov and Goncharova, a place also given it by Chagall in his *Homage to Apollinaire*, in which the painted words served to slow down time. The same sense of removal from familiar surroundings was sought by the Futurist Severini, who utilized letters as identifying signs of his epoch.

This usage of the letter marked the passage from Analytical Cubism to what was called Synthetic Cubism because—as Juan Gris showed in *The Washstand*—each object was synthetically displayed in the gamut of its appearances and in the simultaneity of its materials, all the tactile virtues of which were exalted.

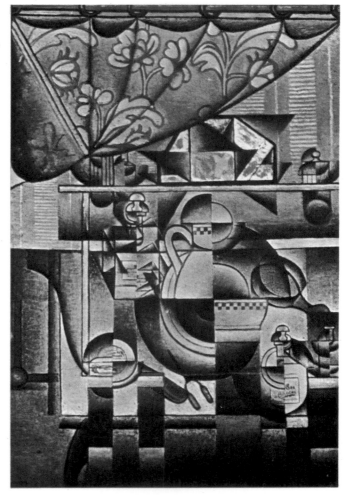

Juan Gris (1887-1927): The Washstand, 1912. Oil.

Natalya Goncharova (1881-1962): Laundry, 1912. Oil.

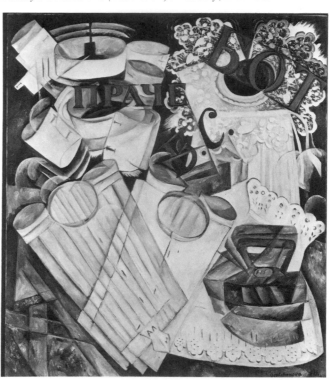

Mikhail Larionov (1881-1964):
Spring, 1912. Oil.

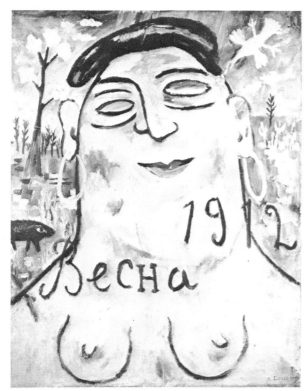

Walter Buhe (1882-?):
Publicity design for
a fountain pen. Berlin,
before 1911.

Hans Rudi Erdt (1883-1918): Opel poster. Berlin, 1911.

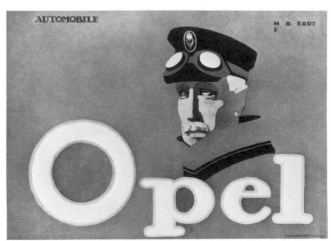

A Challenge to Painting was the title given by Louis Aragon to the catalogue preface for an exhibition of collages in Paris in March 1930. The invention of the collage was of prime importance in the development of twentieth-century art; this technique was the first to break the traditional monopoly of the classical media of painting: oil, watercolour, pastel, etc. And when we think of all the new substances called upon by artists today we can easily see how revolutionary must have appeared the simple act of including a raw material—paper, cardboard, Metro ticket—just as it was in the context of the picture.

"Picasso first of all introduced into a painting, in order to imitate the caning of a chair, a piece of paper which he covered with paint where the wood of the chair was represented. He found it useless to imitate laboriously what already was entirely imitated; then to imitate an object if the object itself could be used. And it pleased him as well to stick in place a bit of an old newspaper, add a few strokes of charcoal, and call that his picture," Aragon said in a note to his preface, and continued, "Extreme, arrogant poverty of materials always charmed him." There, perhaps, lay the key to the importance of the collage, less strictly linked with technical discovery than with the attitude which the artist thereafter adopted towards the object. With the collage, the artist (and the spectator) succeeded in weaving wholly new relations with the external world, and as a result, the artist's power became that much freer; the notion of illusion was thus totally transformed.

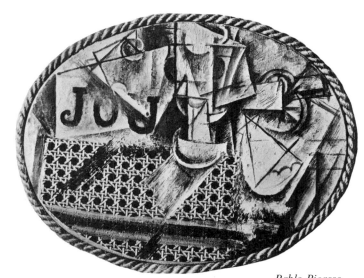

*Pablo Picasso
(1881-1973):
Still Life with Chair
Caning, 1911-1912.
Oil and collage.*

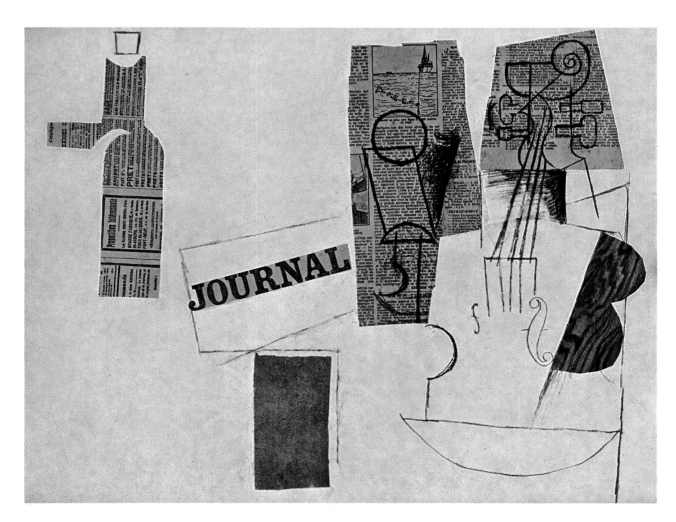

*Pablo Picasso (1881-1973):
Papier collé, 1913.*

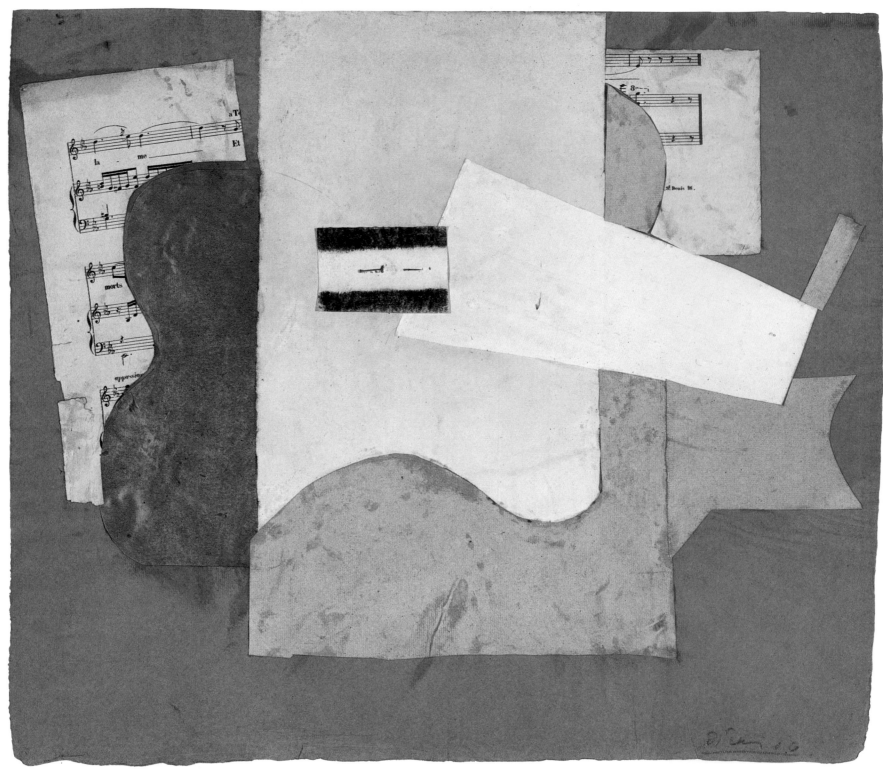

Pablo Picasso (1881-1973): Sheet of Music and Guitar, 1912-1913. Pasted paper.

Synthetic Cubism

In his book *La jeune sculpture française*, published in 1919 but written before the war, André Salmon alludes to a discussion between Braque and Picasso: "If you paint a figure holding a newspaper, should you go to the trouble of painting in the words PETIT JOURNAL or simplify matters by sticking the actual newspaper onto the canvas? Both of them spoke highly of those practised house-painters who can so skilfully imitate the graining of marble or wood. . ."

Braque himself was the son of a house-painter and as such he had done an apprenticeship as a painter-decorator. He was up to all the tricks of the trade and showed Picasso how to imitate marble and wood in his paintings. It is pointless trying to determine which of them was the first to employ collage (i.e. "pasting" of news cuttings, letters, etc. on the surface of the canvas). Picasso's *Still Life with Chair Caning* dates from the winter of 1911-1912; here he pasted a strip of oil cloth directly on the canvas. A few months later, in his *Washstand*, Juan Gris stuck a piece of mirror on the canvas, and from September 1912 the use of pasted elements became general. Braque during his stay at Sorgues, near Avignon, used strips of wallpaper and simulated wood-graining.

Picasso's views on collage were recorded by his friend Jaime Sabartés: "We were trying to express reality with materials which we did not know how to handle, and which we appreciated precisely because we knew that their help was not indispensable and that they were neither the best nor the best suited." Braque had this to say: "We gained control of colour when we started using pasted papers. . . We thus contrived to dissociate colour from form and to set it on an independent footing with respect to form, for with us that was the crux of the matter. Colour acts simultaneously with form, but has nothing to do with form."

Collage renewed the poetry of the picture: it replaced the painted object (see the actual music score pasted on the picture in Picasso's *Sheet of Music and Guitar*) or it served to represent something else (like the newsprint Picasso used for the wood of the violin). With collage Picasso extended his range of forms, and his powers of invention were stimulated. Braque concentrated on the problem of colour/space, and both he and Picasso, and Juan Gris as well, thereby succeeded in achieving a close likeness of treatment, an anonymity which at that time was one of their principal aims and innovations.

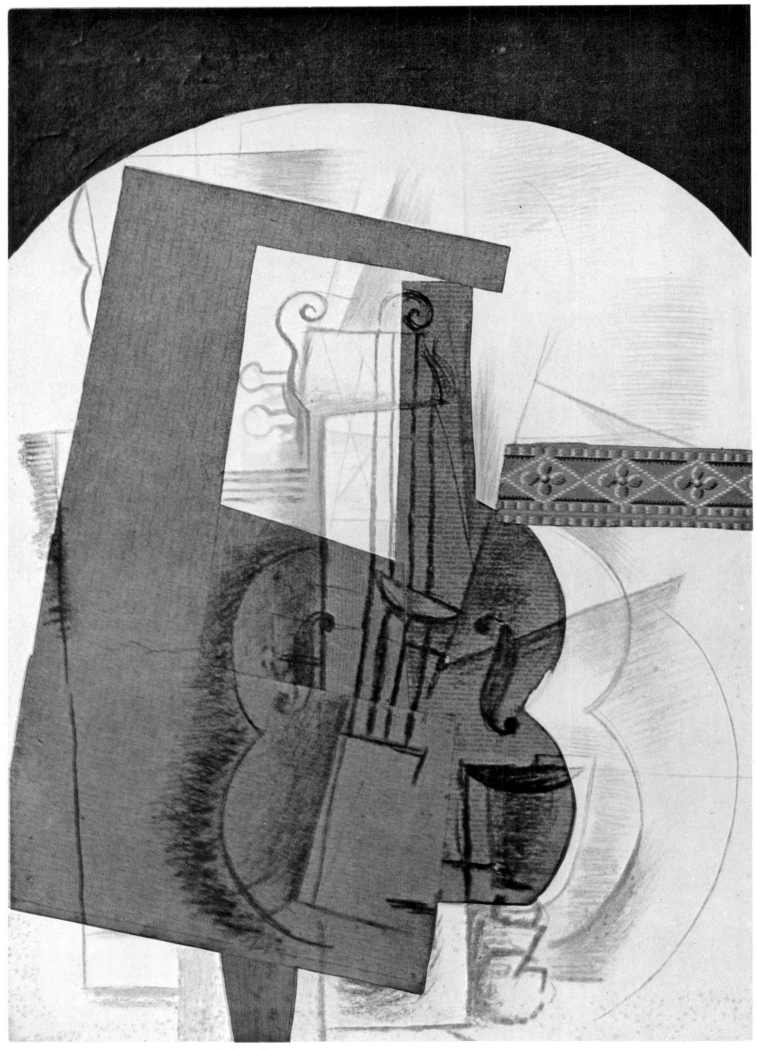

Georges Braque (1882-1963): Guitar, 1912. Pasted paper.

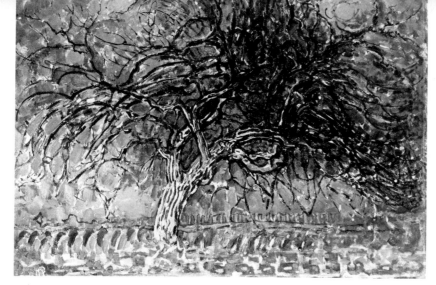

Piet Mondrian (1872-1944): The Red Tree, late 1908 (reworked 1909-1910?).

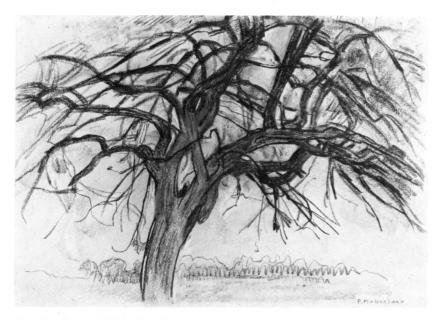

Piet Mondrian (1872-1944): Tree I, 1909-1910. Black chalk.

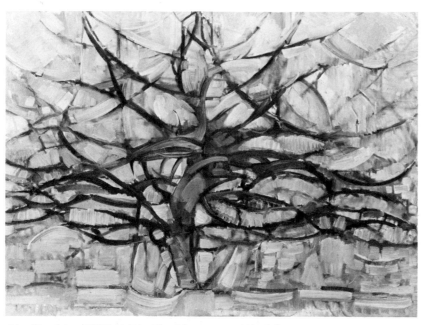

Piet Mondrian (1872-1944): The Silver Tree, 1912. Oil.

Piet Mondrian (1872-1944): Apple Tree in Blossom, 1912. Oil.

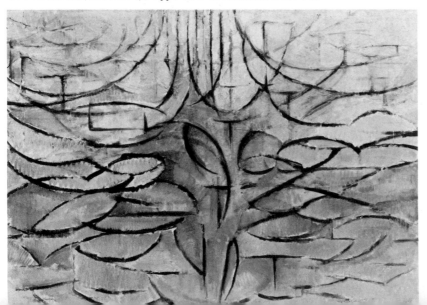

In October 1911 at the Municipal Museum of Amsterdam opened a large exhibition organized by the Circle of Modern Art and dedicated to Cézanne and the Cubists; for the Dutch painter Piet Mondriaan it was a revelation. Soon afterwards he settled in Paris and henceforth spelled his name Mondrian. In his *Essay in Autobiography*, published in 1941, he explains: "After several years of work, my painting turned further and further away from the natural appearance of reality. This took place unconsciously as I worked. I didn't know very much about the Moderns. What I knew of them I admired; nevertheless I had to find my own path." In other words he was inwardly ready to receive the shock of the Amsterdam exhibition, which opened his mind to abstraction.

Born in 1872 at Amersfoort in Holland, Mondrian was about ten years older than Picasso and his friends. After a few lessons from an uncle he pursued academic and classical studies at the art school in Amsterdam. His first works showed the influence of that romantic realism habitually found in Nordics, even in the Van Goghs and the Ensors when they start out. "By moonlight I sketched cows lying down or standing motionless on the flat meadows of Holland, or houses with their windows extinguished, as if dead. But I did not paint as a romantic; I observed with the eyes of a realist" *(Essay in Autobiography).* He was certainly not ignorant of the art of Van Gogh, nor of the movements then in fashion, Pointillism or Symbolism, but he was still far removed from the avant-garde.

From 1909 on he belonged to the Theosophical Society in Amsterdam; through it he sought an explanation of the meaning of the world which would express its symbolic permanence and reconcile the rational with subjective feelings. His intuition of a supernatural order found confirmation in the theories of Dr Schoenmaekers, with whom he formed close ties after the outbreak of war in 1914 obliged him to return to Holland. "We want to penetrate nature in such a way that the inner construction of reality shall be revealed to us," the Theosophist would say, or again, "As lively and capricious as nature may be in its variations, fundamentally it always functions with absolute regularity." Already in 1908 Mondrian was in search of precisely that regularity: the dunes on the seashore, the tower, the tree were subjects that lent themselves to it. Thus, from a mode of representation filled with the echoes of impressionism—as much in the brightness of the colour as in the freedom of gesture—he arrived by successive decantations at a fundamental order, at purity. For him, art was the means of finding definite and stable relations in the living disorder of nature.

Still Life with Pot of Ginger is a decisive work, a hinge between two opposed forms of expression: one based on pure subjectivity and the other ordered by reason. Before then, Mondrian had painted mainly landscapes and a few figure studies; the example of Cézanne and of the Cubists brought him back to the still life—the classical subject of Dutch painting. This second version of the composition, fully elaborated, attests the perfect mastery by which he transformed material supplied by the Cubists to give it a totally personal vision. "That impulse of the

Mondrian:
"The destruction of volume and the use of planes"

Cubists to represent volumes in space was contrary to my concept of abstraction, based on the belief that the space in question must be destroyed. It was in that endeavour to bring about the destruction of volume that I began to use planes." *Still Life with Pot of Ginger* effectively reveals this eviction of volume; the space is the surface of the canvas; the objects are simplified to just their geometric profiles, repeated in outline rhythmically over the whole of the painted surface. The direction lines are reduced to the essential: the curve, the horizontal, the vertical.

Mondrian also applied this system of construction to landscape. *The Silver Tree* and *Apple Tree in Blossom*, dated 1912 and painted in Paris, show that he wiped out every reference extraneous to the structure he had set up. It was no longer a question of painting a tree but of constructing an order that transcended and, in its harmony, justified nature. From Analytical Cubism he went on to reach a degree of abstraction so great that the subject could no longer be identified by anyone who had not followed all the stages of its evolution towards final equilibrium.

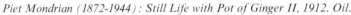

Piet Mondrian (1872-1944): Still Life with Pot of Ginger II, 1912. Oil.

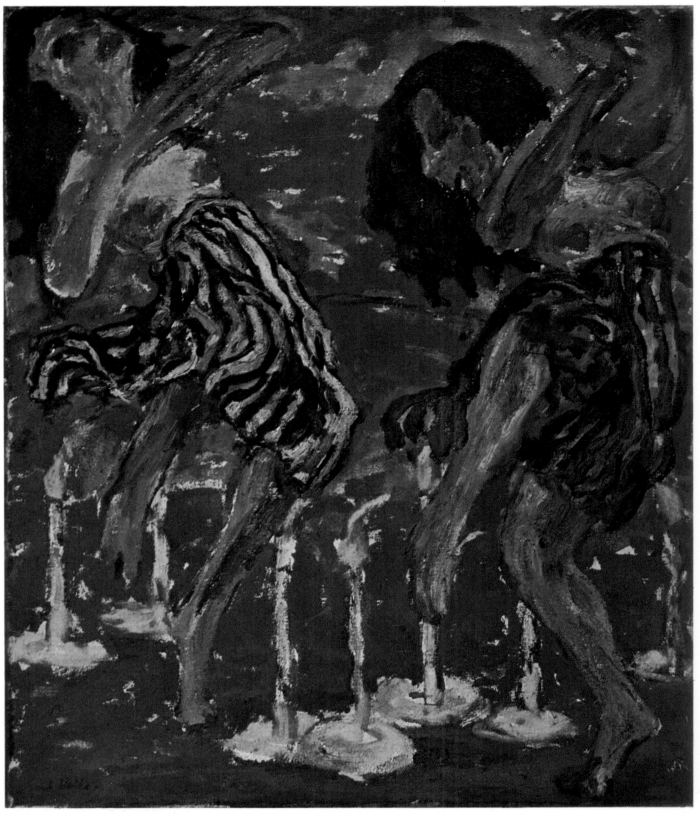

Emil Nolde (1867-1956): Candle Dancers, 1912. Oil.

The year 1912 was a productive one for the German Expressionist Emil Nolde. After a serious illness in 1909, he resumed work with a passionate intensity, as if to make up for lost time: "I painted without a let-up, scarcely knowing whether it was day or night, whether I was a person or a painter. I saw my picture in my mind's eye when I went to sleep, during my sleep, and when I got up it was still there before me" (*Jahre der Kämpfe*, 1934). He successfully achieved a powerful unity between line and colour. After a trip to Holland and Belgium which brought him into renewed contact with Van Gogh's work and enabled him to meet James Ensor, he executed in 1912 a series of religious pictures and several figure paintings, among them the *Candle Dancers*, in which he materialized his mental images with a rare power of form combined with an arresting intensity of colour. Although Nolde considered himself "a self-willed hermit condemned to solitude by the necessity of art," he took part in the International Exhibition of the Sonderbund in Cologne in 1912.

The Sonderbund in Cologne

The previous decade had seen the birth of so many inventions and artistic revolutions that the need was felt to take inventory of them and draw up a balance-sheet. Several artists and museum curators organized confrontations on a worldwide scale: the Sonderbund in Cologne in 1912 and the Armory Show in New York in 1913 were among the most famous. There was nothing artificial about them; they gave material proof of the many points of contact between different artists, schools and cultures, showing open-mindedness above all. Indeed, perhaps never before had creative artists shown themselves so open and receptive to every innovative trend.

In 1912 a junction was effected between Expressionists and Cubists: Klee, Marc and Macke made a long stay in Paris, where they formed a friendship with Delaunay, who was highly influential. They also visited the retrospective of the Douanier Rousseau at the Bernheim-Jeune Gallery, which opened a road to them towards "pristine freshness." For his part, Kandinsky made the acquaintance of Picasso and had the opportunity of seeing the astonishing canvases which Matisse had brought back from Morocco in 1912-1913; no one had ever gone so far in the utilization of colour to translate light and feeling at the same time; rarely had an ensemble of forms and colours been carried to such a degree of simplicity and splendour.

At the Cologne Sonderbund all movements were represented; the Expressionists of the Brücke and the members of the Blaue Reiter held a privileged position, but Symbolism was still present. The decoration of the chapel was entrusted to Kirchner and Heckel, while the stained-glass windows were created by Thorn-Prikker. The presence of Hodler proved that the elders also attained an expressive freedom in the use of form and colour.

Among over a thousand items sent in response to invitations were also works by independent artists such as Barlach, Kokoschka and Rohlfs.

Ferdinand Hodler (1853-1918): The Grand Muveran, 1912. Oil sketch.

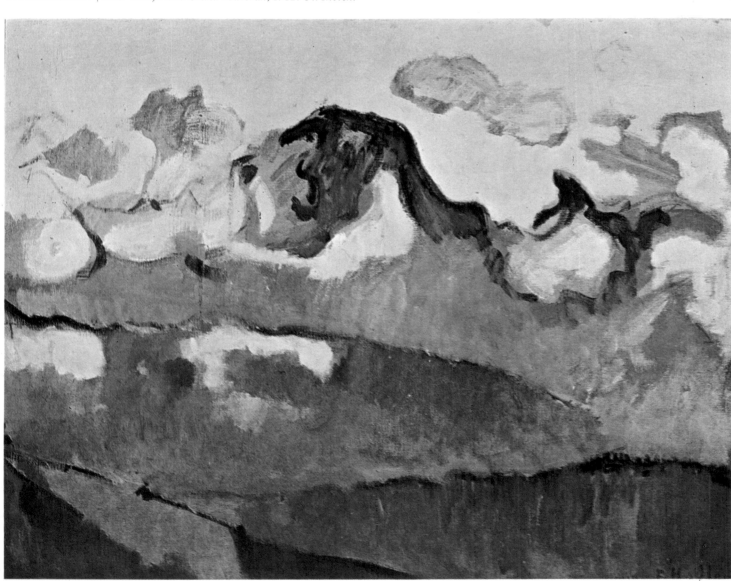

Art becomes its own subject

Between 1912 and 1913 the rupture with art as it had been conceived since the Renaissance became complete and irrevocable. Art became its own subject; it sought its justification no longer in the external world but in itself, all figurative references dropping away accordingly. Abstraction had become total; it appeared as rhythmic and luminous construction in Delaunay, lyrical and gestural outpouring in Kandinsky, animistic concentration in Franz Marc or as object in the work of Marcel Duchamp. But for all of these men, the work of art had no other reality than its physical presence and the thought which gave it life. Until then abstraction had been the end result of a slow decanting of the external world; henceforth it represented a starting point from which artists might once again lay siege to the real.

In their book *On Cubism* Gleizes and Metzinger perfectly defined the demands and the possibilities: "The painting carries within it its own reason for existing. It may be moved with impunity from a church to a salon, from a museum to an ordinary room. Essentially independent, necessarily total, it does not need to satisfy the mind immediately, but on the contrary to draw it little by little into the imaginary depths where the light of order keeps vigil. It doesn't fit in with this or that set of things; it fits in with the whole of things, with the universe: it is an organism."

The authors go on to stress the impossibility of a collective and general vision. Each man is confronted by a space which is changing, by a universe in movement which he progressively discovers. "There is nothing real outside ourselves; there is nothing real but the coincidence of a sensation with an individual turn of mind. Far be it from us to think of casting doubt on the existence of objects which impinge on our senses; but we can only have reasonable certitude with regard to the image which they produce in our mind."

Robert Delaunay (1885-1941): Disk, 1912. Oil.

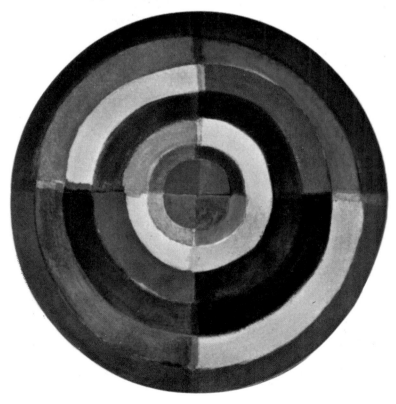

Of primary importance are the clarity and pre-eminence of pictorial language and its inner justification, to which Kandinsky unflaggingly returns in *On the Spiritual in Art*. "The artist has not only the right but the duty to manipulate forms in the way he deems *necessary* to reach *his* goals. . . The unlimited freedom authorized by that necessity becomes criminal the moment it is not founded on that necessity itself." And this feeling is also found throughout Paul Klee's *Journal*: "Art does not reproduce what *is* visible; it *makes* visible." Even if he tends towards the expression of the infinite, of chance and the undetermined, the creator must rely on an exact knowledge of the means at his command and their expressive range. Delaunay, in a note written in 1913 concerning his circular paintings, said: "The dynamism of colour-contrasts in which the linear element no longer exists—that is the form itself, resulting from the contrasts of colours in simultaneous vibration, which is the subject—the total mobile form—not descriptive, nor analytical as in early Cubism.

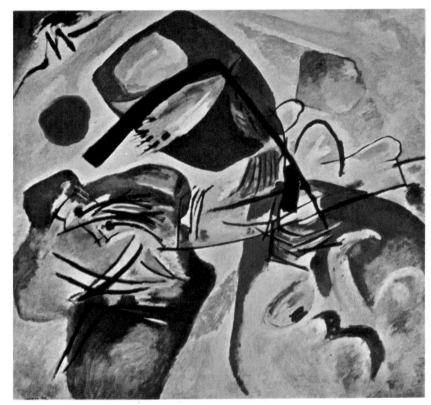

Wassily Kandinsky (1866-1944): With the Black Arch, 1912. Oil.

It is form in movement, static—and dynamic. . . This form is not the result of deductions, of analysis of the visual form provided in nature. In this connection, Apollinaire spoke in his day of supernaturalism. . ."

This supernaturalism which must allow man wholly to find himself once more, alone justifies the work of art, as Kandinsky further testified: "After the period of materialist temptation to which it outwardly succumbed but which, notwithstanding, it set aside as an evil snare, the soul emerges, purified by struggle and suffering. Simple feelings like fear, sadness, joy, which during the period of temptation might have served as the content of art, now have little attraction for the artist. He will try to awaken feelings of a finer shade, as yet nameless. He himself lives a finished, relatively refined life, and the work born of his brain will inspire in the spectator capable of feeling them, emotions more delicate than our language is capable of expressing" *(On the Spiritual in Art*, 1912).

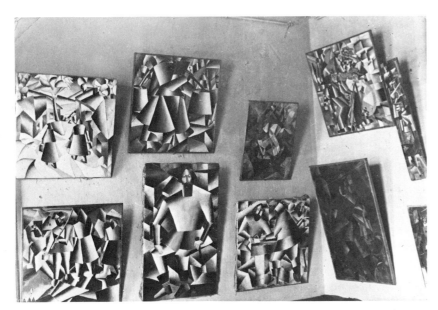

Two of the main Russian groups, opposing each other, were the Knave of Diamonds (the Russian Futurists) and the Donkey's Tail (the Rayonists). According to Larionov, the first was analytic and the second synthetic. According to Malevich, who in 1912 was still a Rayonist and took part in the Donkey's Tail exhibition of that year: "Goncharova and I were working on rustic themes in preference to others. Each of my works had a content which, though expressed in a primitive way, showed a social interest. This is the great difference between us and the Knave of Diamonds group which was working in the line of Cézanne."

1913 was the high-water mark of avant-garde art in Russia, which could then show an astonishing variety of innovations and experiments in all fields of art. Larionov organized the first rayonist exhibition, under the title of The Target, and published a rayonist manifesto signed by eleven artists. Tatlin and Malevich joined the Russian Futurists and took part in the big exhibition sponsored by the Youth Association in St Petersburg: it opened on 13 November 1913. Malevich was then painting mechanical men in a semi-abstract style, but soon created the movement known as Suprematism and marked by the outright abstraction exemplified in Malevich's *Black Square on a White Ground*.

Paintings by Malevich exhibited at the Youth Association in St Petersburg in late 1913. Among them is the Woman Carrying Water reproduced below.

Kasimir Malevich (1878-1935): Woman Carrying Water, Dynamic Arrangement, 1912. Oil.

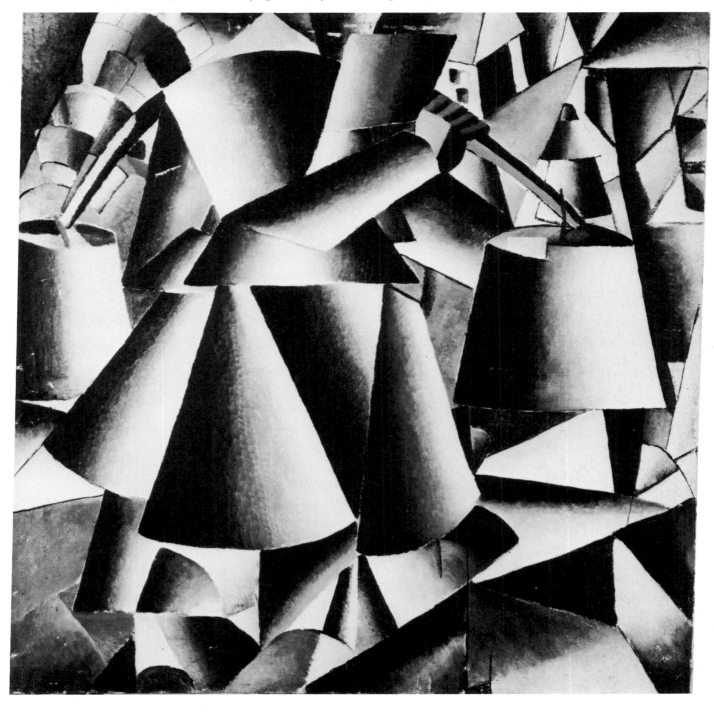

The new breakthroughs in sculpture

Henri Matisse (1869-1954): Jeannette III, IV and V (Jeanne Vaderin), 1910-1913. Bronzes.

Raymond Duchamp-Villon (1876-1918):
Portrait of Baudelaire, 1911. Bronze.

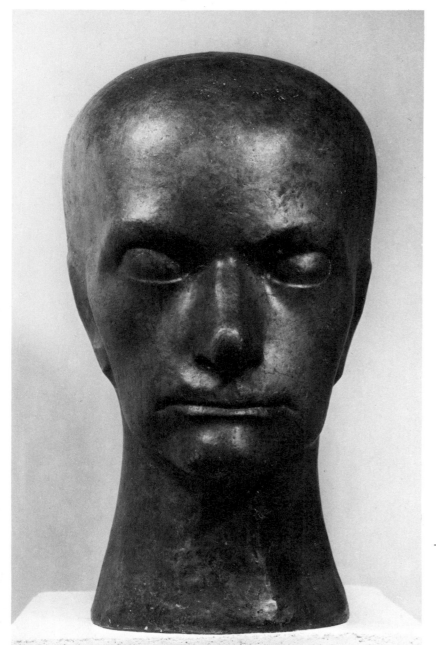

The portrait was a key subject for modern sculptors; and the art of portraiture, as they well knew from what they had seen in the museums, was not so much a matter of rendering the sitter's personality as of asserting their own way of seeing and feeling. At the same time, the revelation of archaic and primitive masks renewed their interest in the study of the face for its own sake, as a particularly rich and complex volume composed of different masses of opposing character. This subject was therefore fundamental to the problematics of the new sculpture. The approach to it had been renewed by Picasso and Matisse, and further innovations were made by Archipenko who took the portrait as the starting point for an abstraction, a reinvented assemblage of forms and volumes. Parallel to this revolutionary reshuffling of volumes, other artists pursued a psychological line of investigation; of this, one of the finest examples is Duchamp-Villon's *Portrait of Baudelaire*. The brother of Marcel Duchamp and Jacques Villon, Raymond Duchamp-Villon first studied medicine, then embarked on his career as a sculptor, dramatically interrupted by the First World War. At first he followed in the footsteps of Rodin, then gradually broke away from him under the influence of Maillol and archaic Greek sculpture. The *Portrait of Baudelaire* is one of his earliest works. While still respecting the traditional distribution of masses, he nevertheless achieved an unusually powerful expression of volume in general. His simplifications owed nothing to Cubism but sprang from his own need for synthesis and absoluteness. Henri Laurens, for his part, showed that a return to essential forms could lead to a heightened and liberating power.

Dating to 1909, the *Woman's Head* by Picasso is a momentous work. This vigorously modelled bronze originated from certain canvases of Analytical Cubism. In it, unlike Brancusi and the archaic and primitive sculptors, Picasso did not simplify volumes but broke them up into a succession of rhythmically ordered and dynamically oriented facets. The rugged mass has been slashed and carved, and the movement of interlocking planes emphasizes the core of the sculpture which appears to turn on its own axis, in that spiral movement soon to be so characteristic of modern sculpture.

After having experimented with the expressive power of the curve developed in depth, Matisse grappled with one of the fundamental problems of sculpture in the five versions of *Jeannette* dating from 1910 to 1913. Here the rhythm springs from the contrast and opposition between the different parts. Matisse sacrificed the accuracy of details in order to convey the overall nature of the head, which he did by radical simplifications and distortions which heighten the concentration of volume.

Speaking of the need he felt to turn to sculpture, Matisse explained himself quite clearly in a conversation with Pierre Courthion: "I have taken up sculpture because what interested me in painting was the effort to put some order in my brain. I simply changed my medium, using clay in order to get a rest from painting in which I had done absolutely everything I could for the time being. My aim in turning to sculpture was, as always, to organize. It was a way of ordering my sensations, of working out a method which would suit me absolutely. Once I had found it in sculpture, it would also serve for painting. It was, as always, a way of gaining possession of my brain, of arriving at a hierarchy of all my sensations, which would enable me to come to a conclusion."

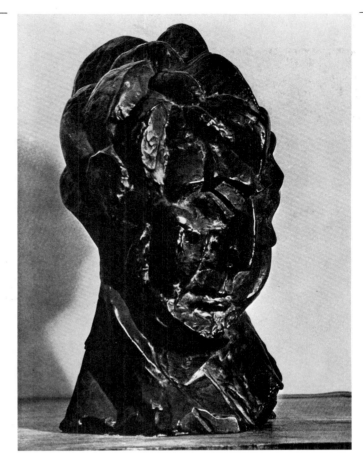

Pablo Picasso (1881-1973): Woman's Head, Paris, 1909. Bronze.

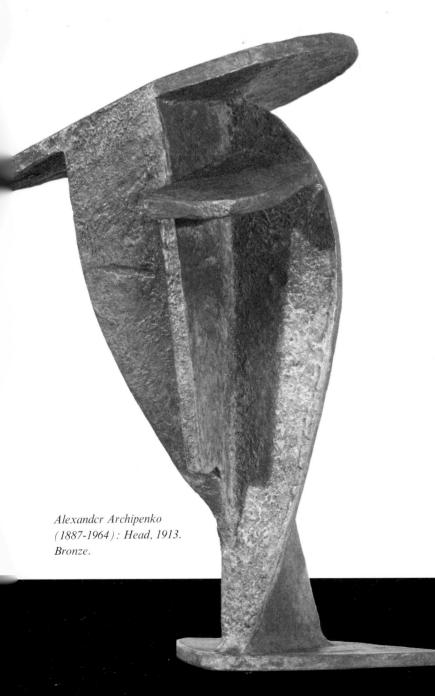

Alexander Archipenko (1887-1964): Head, 1913. Bronze.

No artist played the role in starting the revolution in sculpture, which took place between 1910 and 1915, that a Cézanne, a Van Gogh or a Gauguin had played in the development of painting. But once pictorial space had been freed from the bondage of description and from all conventions, the world of sculpture too was inevitably transformed. Its transformation was all the more violent in that it occurred at lightning speed, and the experiments which two painters, Matisse and Picasso, carried out in this field acted like a detonator. To be sure, Maillol and Bourdelle had had full awareness of the demands of sculptural form, but they had never freed it from its naturalistic frame of reference. The discovery of archaic, then primitive statuary, and above all the success of African objects, made the gaze of sculptors attentive to a radical invention of forms and gave them a new tactile sensibility. The *Woman's Head* by Picasso and the *Jeannette* sculptures by Matisse detached themselves henceforth from natural models and won recognition by their freedom of interpretation. Picasso as well as Matisse took up modelling without any prior training in order to try out the spatial and volumetric solutions suggested to them by their intuition in painting. Even if their creations were not on display in their exhibitions, they were seen in their studios.

Little by little, carving lost its importance; stone and wood were used less than bronze, the techniques of modelling and casting turned out to be more adapted to the new experiments. A young, international generation of sculptors made its presence felt in Paris: Brancusi, Archipenko, Duchamp-Villon were its leaders, as was the Futurist Boccioni, who achieved in volume creations of perhaps more novelty than in painting. It goes without saying that the difficult problem of expressing movement within a static structure was at the heart of their searching: hence the many interpenetrations that arose between painting and sculpture.

The new breakthroughs in sculpture

The need for a treatment direct enough to speak spontaneously to the eye, coupled with a certain return to order, resulted for many painters and sculptors (usually the painter and sculptor were one and the same) in a search for stylization which verged on archaism. What Apollinaire said of Derain (commenting on his exhibition at the Paul Guillaume Gallery in 1916) might hold true for many other artists: "In the works of André Derain on exhibit today, there will be recognized a daring and disciplined spirit. Derain's entire recent work bears the traces, always moving to see, of the efforts that were needed to reconcile these two tendencies. He is close to attaining his goal, which is a harmony filled with beatitudes, realistic and sublime. It is the goal of order. But for that, much selflessness is required." Even if Derain's art is far today from finding the same audience it enjoyed among his contemporaries, his personality remains highly important. Beginning in 1909 he kept his distance from Cubism, which he criticized for its conceptualization and an analysis that, according to him, resulted only in division; art, he thought, must be a synthesis and not a process of addition. After a stay at Cadaqués in 1910 with Picasso, he searched for a stable form, of which he saw one interpretation in Gothic art: he then associated light with form—a sculptor's manner of proceeding—and the mannerism towards which he tended derived from the search for a style revitalized by the primitives and by the quest for another understanding of the external world, linked essentially to the pure forces of life.

A similar move towards stylization may also be found in sculpture. The concentration of Archipenko's *Woman with a Cat* and the symbolism of Lipchitz's *Encounter* are present as well in the volumes of Modigliani and Brancusi, which also tend towards a primitive, rhythmically ordered simplification. From 1909, when he took a studio in the Cité Falguière and became friends with Brancusi, until around 1912, Modigliani devoted himself to sculpture—and to drawing—joining forces with his friend, under whose influence he chose to create closed, self-contained forms. The discipline demanded by sculpture inspired him to the creation of volumes in which the contrasts and tension of transitions had an elegance and finesse not exempt from archaism. Working with the highest respect for his materials Modigliani sought to create a type of feminine beauty by an elongation of rhythmical and dynamic curves that would later reappear in his painting.

The Romanian Brancusi, a powerful personality who dominated the world of sculpture of his day, went in search of pure volume, the noble subject, a "whole"; his approach might be summed up in his own words: "Beauty is absolute equity," or "In each thing there is but one end; to reach it you must get out of yourself." But Brancusi reached this depersonalization, a form of anti-expressionism, through an extreme sensitivity to form and materials; for him direct carving was only one means of striving towards greater perfection. His insistence on technical

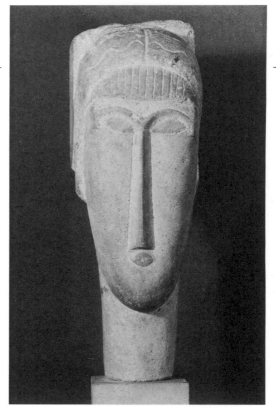

Amedeo Modigliani (1884-1920):
Woman's Head, 1913. Limestone.

Alexander Archipenko (1887-1964):
Woman with a Cat, 1911. Alabaster.

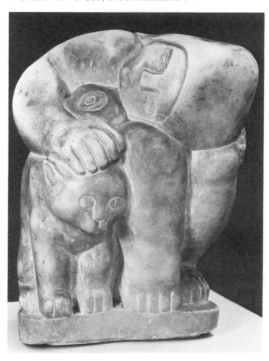

perfection also led him to the polishing of bronze. This process, which would be adopted by others after him, was then totally unappreciated: Lipchitz, who worked in the neighbouring atelier, became annoyed at it. Brancusi replied sarcastically: "Polishing is a necessity imposed by the relatively unyielding forms of certain materials. It is not obligatory. It is even entirely inadvisable for those who cut beefsteaks." This bronze polishing enabled him to attain, in his *Magic Bird*, the purity of marble, but also to renew the very space of sculpture. Polished, the bronze reflected like a mirror and concentrated the exterior lights before flashing them back. Virtuality was thus also acquired by sculpture which, by means of light reflections, became an open volume while remaining perfectly enclosed. Furthermore, Brancusi gave importance to the pedestal, an architectural consideration which opened a new domain for sculpture.

The great renewal of sculpture began just before the First World War, in 1912-1913. Thereafter, like painting, sculpture was set free from nature imitation and gained its autonomy. It integrated movement and conquered space; moving away from the hieratic and static tradition, it sought to escape from gravity. Inasmuch as previous experiments had borne essentially on the analysis of articulations and interlockings, sculptors went on now to engage in a new dialogue based on the contrast arising from the opposition of a central core bursting outward and the envelope containing that pent-up force. Like the engineer and the architect, the sculptor drew inspiration from the machine.

Giving up his medical studies for sculpture in 1900, Raymond Duchamp-Villon had a short but momentous career, culminating in the famous *Horse* of 1914. Some parts of it are reminiscent of a locomotive; others have the supple but tense curves of a leaping animal. This work (like those of the Cubists) not only achieves expression in the simultaneity of its superimposed and spiralling profiles, but also includes movement in the tension of its volumes. "One might almost say that the sculptor gradually brings immaterial creation down to earth, crystallizing it in matter," wrote the artist. Duchamp-Villon died prematurely of an illness contracted during wartime service in the French army.

Raymond Duchamp-Villon (1876-1918):
Horse, 1914. Bronze.

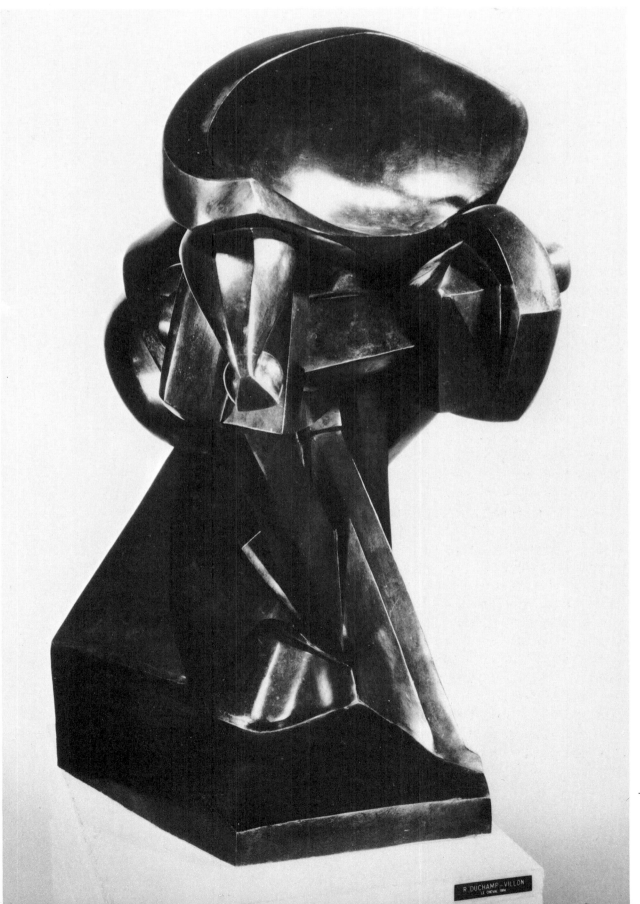

Constantin Brancusi
(1876-1957): Magic Bird
(Paserea Maiastra), 1912.
Marble, with three-part
limestone base.

The new breakthroughs in sculpture

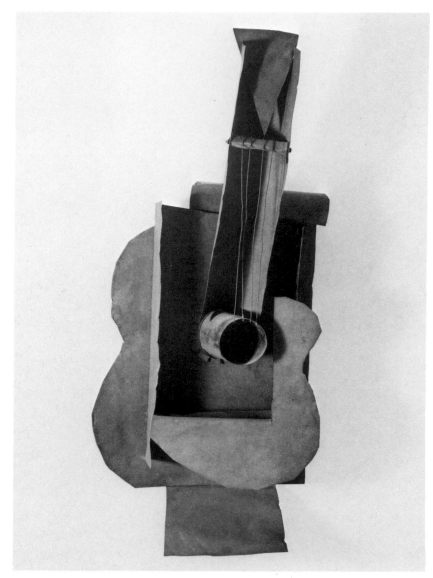

Pablo Picasso (1881-1973):
Guitar, Paris, 1912. Sheet metal and wire.

The works of Picasso, Matisse, Boccioni and Archipenko posed the problems of sculpture anew, whereas Brancusi pursued his exploration along a more traditional path, but brought it to its conclusion with incomparable mastery and power of formal invention. Casting off that static and architectural monumentality—justified by the "duration" reserved to statuary and reflected even in the quality of its materials—, sculpture became often aerial, light, transparent; sometimes even ephemeral or mobile.

The use of collage, which gave birth to Synthetic Cubism, brought Picasso back in 1912 to sculpture, or rather to three-dimensional constructions, for which he used different materials such as wood, paper, wire, sheet metal, etc. Already, in the *Head* of 1909, he had intuitively translated volumes by hollows and given a certain ambivalence to his forms, which took on several meanings according to the angle from which they were seen. In his constructions of 1912-1913 his invention became still more revolutionary. Less a volume than a relief, his *Guitar* is the result of a free construction obtained by superpositions and contrasts of surfaces. Picasso, who often emphasized the character of the materials he used, and brought in colour, thereby imposed the idea of an assemblage-sculpture, which has had a lasting success in the twentieth century; soon afterwards it was taken up by the Russian Constructivists.

In his Manifesto of Futurist Sculpture of 1912, Boccioni also advocated the use of different materials and of colour, but Picasso not only asserted the sculpture as object; he innovated by imposing illusion and virtuality. In *Guitar*, the centre-hole of the resonance chamber is not a hollow but a metal box jutting outwards, which, by an optical illusion, is perceived now as a protuberance, now as a cavity (this device was perhaps inspired by a Wobé mask, as John Golding and Jean Laude suggest). Henceforth what the appearance signified was dependent on the mobility of the spectator himself. This liberty and power of illusion were ferments for the soaring rise of sculpture: the limits between painting and sculpture finally disappeared through resorption.

Matisse, in his series of *Backs*, used the power of light in a different way but with equal daring. His experience of simple form and his sensitivity to lighting enabled him to attain a powerful monumentality while using only the faintest relief.

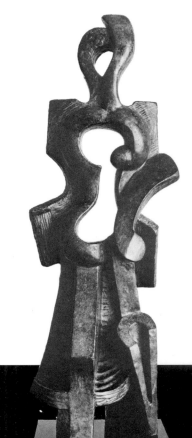

"There is no concave form without convex form; there is no convex form without concave form. The two elements are merged into one significant whole. In creative art, as in life itself, the reality of the negative is the conceptual imprint of the missing positive."

Archipenko

Alexander Archipenko (1887-1964):
Woman Walking, 1912. Bronze.

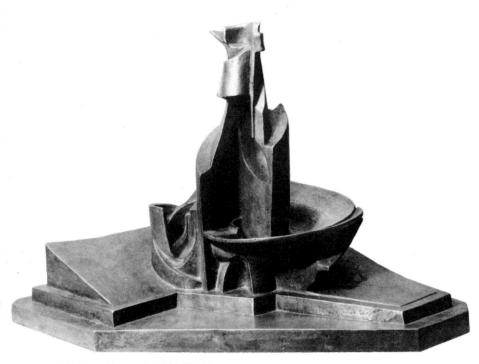

Umberto Boccioni (1882-1916):
Development of a Bottle in Space, 1912. Bronze.

"The raised and the hollow are mutually complementary. It is exactly the same as in music; each note has a psychological significance while at the same time being tied to all the other notes and rests of the composition. Similarly, in my sculpture the hollows have a significance at once optical and psychological while still being connected to the other parts in relief."

These years were the most fertile and inventive for this artist, who also applied himself to the problems of polychromy and assemblage-sculptures. We arrive thus at that "sculpto-painting" which was one of the most fruitful options of the period. "The latest and most graceful work submitted is, in my opinion, that of Archipenko, a polychrome sculpture made of different substances; glass, wood, iron are combined in it in the most happy and novel way," wrote Apollinaire in *L'Intransigeant* of 28 February 1914, referring to the sculptor's submission to the Salon des Indépendants. Shortly afterwards, in the preface written for the exhibition at the Gallery Der Sturm in Berlin, he again stressed Archipenko's role as a precursor.

A comparable urge towards construction and the utilization of space can be seen as well in the productions of the Czech sculptor Otto Gutfreund, who at times, as in the *Cubist Bust*, did not completely renounce Expressionism.

Other sculptors made use of the avenue opened by Picasso, Boccioni, Archipenko and Duchamp-Villon. Vaguely labelled as Cubist sculptors (Laurens, Lipchitz, Zadkine, Csaky) or Constructivists (Tatlin, Gabo, Pevsner), all of them, in ways that differed according to their personalities, gave wings to the language of sculpture, which pursues its prestigious flight with authority down to the present day.

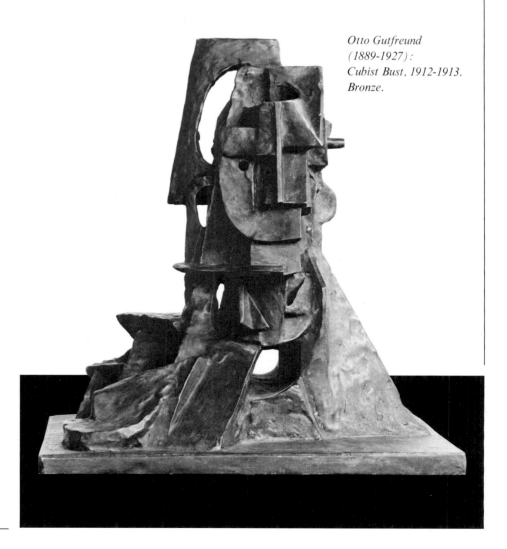

Otto Gutfreund
(1889-1927):
Cubist Bust, 1912-1913.
Bronze.

It was also in 1912 that Archipenko introduced the concave-convex dialectic into the problematics of sculpture. Born in Kiev in 1887, Archipenko became associated with the Cubists shortly after his arrival in Paris in 1908. Taking a studio in the old tenement known as La Ruche (The Hive), he developed a style characterized by a dynamic figuration and strongly simplified. Solid volume and above all the articulations between forms occupied all his attention and led him by easy stages to abstraction. In 1910, in his *Silhouette*, a sculpture which unwinds like a helix, he launched out in one of the main directions to be taken by contemporary sculpture; namely, the spiralling form that imparts a vertical movement at the same time as an asymmetrical equilibrium.

Archipenko gradually arrived at the creation of daring equilibriums based on the cantilever principle, and went as far as using empty space in *Woman Walking* (1912). Sculpture was no longer a volume; it became a space defined by the relation of the solid to the empty. Unthinkable a few years before, these scooped-out cavities are by now so frequent that it is difficult to assess all the boldness Archipenko needed to recognize this active value of space. In *Woman Walking* a whole system of counter-volumes—close to those Picasso used in *Head* or *Guitar*—accompanied the central cavity. Indeed, the materialization of a form can be expressed by its contrary—a volume by a hollow—, the phenomena of contrast and virtuality renewing the illusion under the effect of a frontal illumination, and particularly when the surfaces are shiny. Archipenko himself said:

Killed in action in 1916, at the age of barely twenty-eight, the futurist architect Sant'Elia had no time to do any actual building and the designs he made in 1914 bore no fruit until many years later. Influenced by the ideas and spirit of Otto Wagner, founder of the Vienna school of architecture, Sant'Elia drew up plans for a *Città Nuova* in which the form of each building counted less than the spirit presiding over the whole. As a Futurist, he was preoccupied by the expression of time and movement; these he conveyed by emphasizing the lines of communications and intensifying the spirited rhythm quickening the overall plan. In 1914 he published an important futurist manifesto summing up his views.

A town planner rather than a builder, Sant'Elia today cuts the figure of a prophet, with his stepped-back skyscrapers and traffic lanes running on different levels. Another pioneer in the expression of movement was Max Berg, city architect of Breslau, where he built the Jahrhunderthalle (Centenary Hall) in 1912-1913. Its huge cupola, with a diameter of over 200 feet, was one of the boldest reinforced concrete structures of its time. It focused attention on one of the basic features of twentieth-century architecture: the quality of the internal space and its relation to the external form. "Each building combines the creation of two spaces: the internal space, completely defined by the building itself, and the external space or urbanistic space enclosed between this building and the neighbouring buildings" (Bruno Zevi).

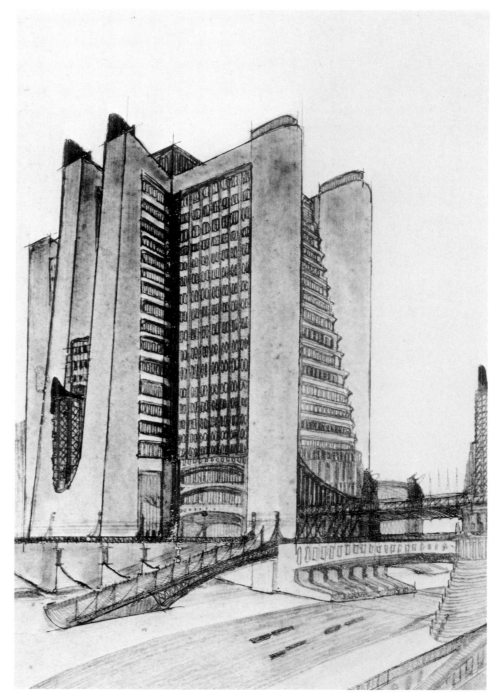

Antonio Sant'Elia (1888-1916): Design for The New City, 1914. Watercolour.

"We have to invent and rebuild the futurist house, which will arise like a gigantic machine from an immense building site. . .

"The street will no longer extend underfoot on the level of house entrances, but people will descend to a depth of several storeys where the city traffic will flow. These levels will be connected with each other by metal footbridges and escalators, making it possible to move about freely in all directions. . .

"I proclaim that architecture is not an arid combination of the practical and useful, but remains an art, which means synthesis and expression. . .

"Decoration alien and opposed to the architecture is an absurdity. *On the use and general arrangement of the bare or brightly coloured materials depends the decorative value of futurist architecture.*"

Antonio Sant'Elia, *Futurist Architecture*, Milan, 11 July 1914

One of the fathers of modern German architecture, Peter Behrens began as a painter and graphic artist, only turning to industrial design in 1898 at the age of thirty. He emphasized the functionalism of structure and design, and in his Berlin office were trained some of the greatest builders of our time: Mies van der Rohe (1908-1911), Walter Gropius (1907-1910) and Le Corbusier (1910-1911). From 1907 on Behrens was employed as both architect and product designer by the AEG (German General Electrical Company).

Even more influential were the buildings and the role of Walter Gropius. His designs for the Fagus Shoe Factory at Alfeld (1911) came as a manifesto of modern architecture. To the monumentality of Behrens he opposed transparency: "the role of the wall, rising between pillars, is now limited to forming a screen against rain, cold and noise," he said. A building for Gropius was nothing unless it acted as "a stimulus to clear thinking and right feeling." Unity of design and function, of art and technics, was the guiding aim of the architectural philosophy which he developed throughout his long life. As he put it in later years: "The creation and love of beauty not only enrich man by giving him happiness, to a large extent, but also bring to fruition the ethical faculties within him." Similar views were expressed by Léger, Le Corbusier and Mondrian.

Peter Behrens (1868-1940): AEG Small-Motor Factory, Brunnenstrasse, Berlin, 1910-1911.

The spirit of purity and geometry which dominated European architecture between 1918 and 1939 was propagated by the Bauhaus, the De Stijl group and the Purists, but that spirit had in fact been created in Germany in the years just before the war, largely by the Deutscher Werkbund movement launched in 1907: it was an attempt (taking over where William Morris had left off) to revive the older standards of craftsmanship in the arts of everyday life, "to unite artists and industry in an effective association for the purpose of improving the technique and taste of German workmanship." The movement culminated in the great Werkbund exhibition of industrial art held in Cologne in 1914.

As director of the Weimar School of Applied Arts (1906-1914), the Belgian architect Henry van de Velde also played an important part in these developments in Germany. For him the great necessity was to go beyond purely technical data, differing in this from Adolf Loos for whom "all the forms of applied technique are dictated by the progress of practice." But Van de Velde, like Loos and Behrens, laid stress on the quality of the workmanship and the purity of the overall design: the Werkbund Theatre in Cologne (now destroyed) exemplified the sobriety he aimed at, his concern with pure form that should be "perfectly simple and simply perfect." The work of the American architect Frank Lloyd Wright also exerted considerable influence in Germany, thanks to the publication in Berlin in 1910 of a monumental book on his buildings and designs to date, followed in 1911 by a smaller book on him which enjoyed a wide circulation in Germany, the result being that in Europe Wright's influence became far stronger than it ever was in the United States until many years later.

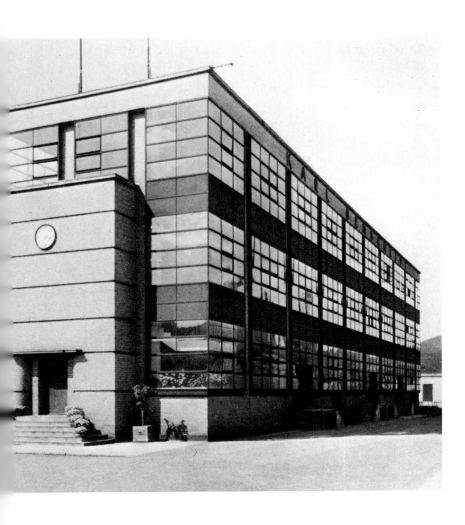

◁ *Walter Gropius (1883-1969):*
Fagus Shoe Factory at Alfeld-an-der-Leine, 1911.

▽ *Henry van de Velde (1863-1957): Werkbund Theatre, Cologne, 1914.*

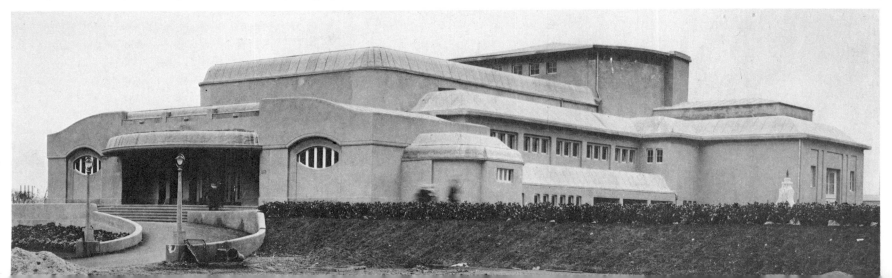

1913: The Armory Show in New York

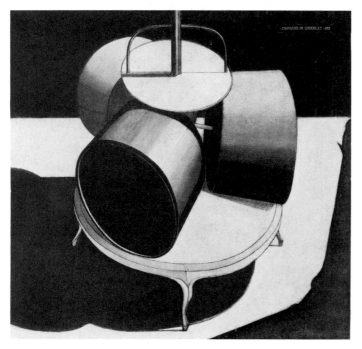

Marcel Duchamp (1887-1968): Chocolate Grinder No. 1, 1913. Oil.

Marcel Duchamp (1887-1968): Ready Made (Bicycle Wheel, Metal and Wood), third version, 1951. (The original of 1913 and the second version of 1916 are lost.)

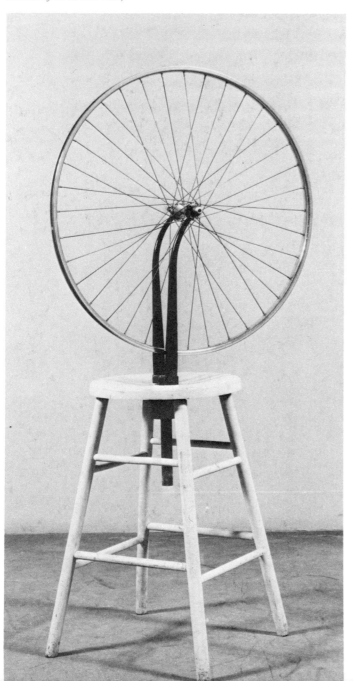

America had remained generally indifferent, if not actually hostile, to public showings of contemporary art before the Armory Show, which triggered off a scandal with multiple repercussions. Alone, Alfred Stieglitz, director of the Gallery 291, had presented contemporary art in New York and defended it in his review *Camera Work*. But he had touched on only a small elite of painters (John Marin, Marsden Hartley, Arthur G. Dove, Max Weber), the same ones who suffered from general disapproval.

It was in the circle attached to this gallery that the idea of a vast International Exhibition of Modern Art (its official name) was born; organized by the Association of American Painters and Sculptors, it was called the Armory Show because it was held in the 69th Infantry Regiment Armory in New York. It opened on 15 February 1913, displaying over eleven hundred works. Starting with Ingres, Goya and Delacroix, it included the Impressionists and, across a rather general panorama of new movements, continued with the Fauves, the Cubists and their followers. Sculpture was widely represented; on the other hand, the Brücke, the Blaue Reiter and Futurism had the smallest share in the exhibit. Marcel Duchamp, on the contrary, was remarkably in evidence.

But the exhibition caused a scandal; it was in a veritable mood of riot that over 200,000 visitors packed in to see the *Nude Descending a Staircase*. The *Art News* ran a competition for the best explanation of this picture, which was derisively dubbed *Explosion in a Tile Factory* or *Rush Hour in the Subway*. Duchamp's work quickly became the symbol of the decadence of contemporary art. Even if other artists had found indisputably new forms of expression in the representation of movement (although the Futurists or Kirchner, for example, did not participate in this show), it was nevertheless this painting by Duchamp which had the effect of a manifesto.

America found itself brutally faced with the choice between tradition and the avant-garde: artists rallied to the cause of the latter, along with some very important collectors who, it may truthfully be said, opened up America to the modern spirit. The

Marcel Duchamp (1887-1968): Study for The King and Queen Traversed by Quick Nudes, 1912. Pencil, watercolour and gouache.

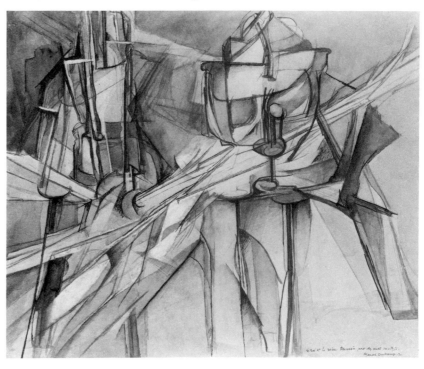

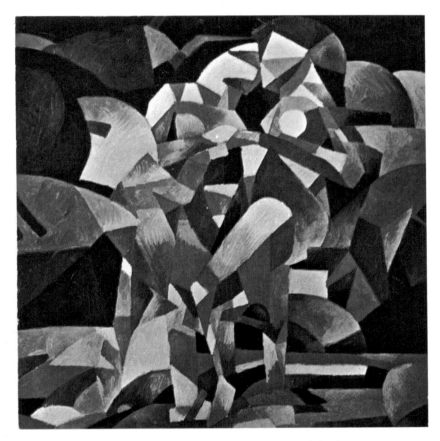

Francis Picabia (1879-1953): Dances at the Spring, 1912. Oil.

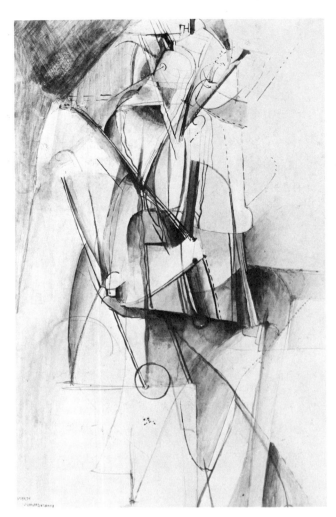

Marcel Duchamp (1887-1968): Study for The Virgin, 1912. Pencil and watercolour.

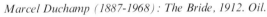

Marcel Duchamp (1887-1968): The Bride, 1912. Oil.

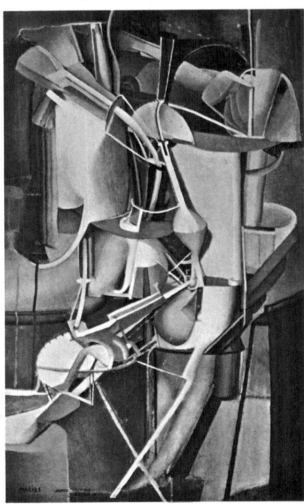

writer Walter Pach, one of the organizers of the show, invited Marcel Duchamp to come and see for himself the enthusiasm aroused by his works (all of them sold), making him the spokesman of the avant-garde. "I myself did not realize the importance that this success might have in my life," Duchamp later said. "It was on my arrival in New York that I noticed I was not in the least a foreigner."

By the end of 1911 Marcel Duchamp was preoccupied with the expression of movement. The *Chess Players* and *Nude Descending a Staircase*, the latter already shown in Paris at the 1912 Salon des Indépendants, from which it had to be withdrawn, enabled him to give an original interpretation of the problems raised by Cubism and Futurism. To the romantic and sentimental answer of the Italians, he opposed a cold, mechanical and depersonalized statement announcing his purpose of arriving at the representation of the anonymous subject, which he achieved in *The Chocolate Grinder*, for example, an intermediate stage on the way to the ready-made. For him, the representation of movement was less a question of space than of time. Apollinaire already observed that, "preoccupied with energy," he had "detached himself from aesthetic concerns."

He himself recognized that detachment in the explanation of the *Nude* which he gave in 1920: "In this picture the question is no longer one of painting but of the organization of kinetic elements, of an expression of time and space through the abstract presentation of movement. A painting, wholly of necessity, is a presentation of two or more colours on a surface. I have purposely restricted the *Nude* to tones of wood so that there can be no question raised of *Persian* painting. . . If I want to show an airplane taking off, I try to show what it is doing; I don't turn it into a still life. When the vision of the *Nude* appeared to me I knew that it would break forever the chains that bound painting to naturalism."

197

THE LANGUAGE OF ART SET FREE

Painters and sculptors went boldly forward in 1913 and 1914 with their most recent experiments, trying to press from them their utmost consequences. The transition from investigation and discovery to a working out of all their implications led on to a wealth of innovations. The ferment of newly invented forms and styles soon passed beyond the doors of the artist's studio-laboratory and entered the decor of everyday life.

In his *Staircase* Léger came to grips with the problem of the subject and reached a very different solution from that of Marcel Duchamp in his *Nude Descending a Staircase*. While forms are mechanized and suggest movement in their metallic articulations, the picture space is complex in its simultaneous surface patterns and the colours are vivid. Even though (like all the artists of his generation) he reduced expression to its simplest level, Léger, like Sonia and Robert Delaunay, did not limit himself to the geometricization of volumes. In his colour scheme he achieved the same limpidity; he restricted his palette to an absolute contrast of values and the three primary tones; this is what he called realism.

In 1914, discussing "the achievements of present-day painting" in an article in *Les Soirées de Paris*, Léger set forth his views on the relation between art and modern life: "Modern man registers a hundred times more impressions than did the artist of the eighteenth century; so true is this that, for one

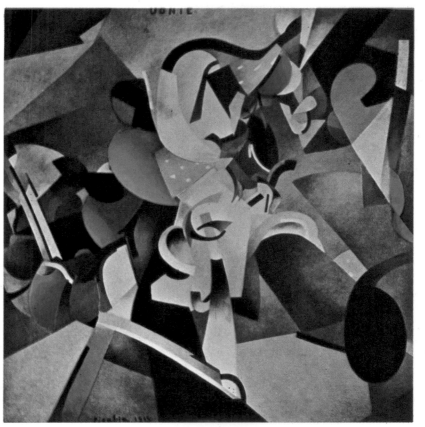

Francis Picabia (1879-1953):
Udnie (American Girl or The Dance), 1913. Oil.

Fernand Léger (1881-1955): The Staircase, 1913. Oil.

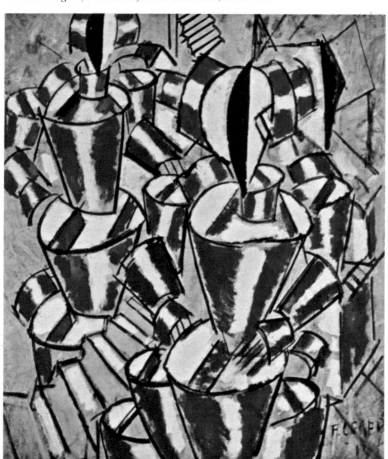

thing, our language is full of diminutives and abbreviations. The condensation of the modern picture, its variety, its break-up of forms, is the result of all that... Many superficial people rail against anarchy when they see these pictures, because they cannot follow in the field of art the whole evolution of common life which that art records. They think there is a break of continuity when, on the contrary, painting has never been so realistic, so responsive to its period, as it is today. A realistic form of painting in the highest sense of the term is beginning to come into existence and there is no stopping it."

Something of this realism was forcefully expressed by Picabia in *Udnie*. He visited the United States and exhibited in the Armory Show in 1913. In New York he was welcomed as one of the ambassadors of the avant-garde and there he did his first machine drawings, which with characteristic humour he called "daughters without a mother." In March and April 1913, at the 291 Gallery on lower Fifth Avenue, Alfred Stieglitz held an exhibition of Picabia pictures inspired by the artist's visit to New York.

Echoes of Picabia's American trip are to be found in *Udnie*, also called *American Girl*, which he painted that same year on his return to France. Exhibited in Paris at the 1913 Salon d'Automne, this composition, which is essentially non-figurative, is an outstanding example of Orphism, a short-lived movement launched by Robert Delaunay and focusing on experiments in

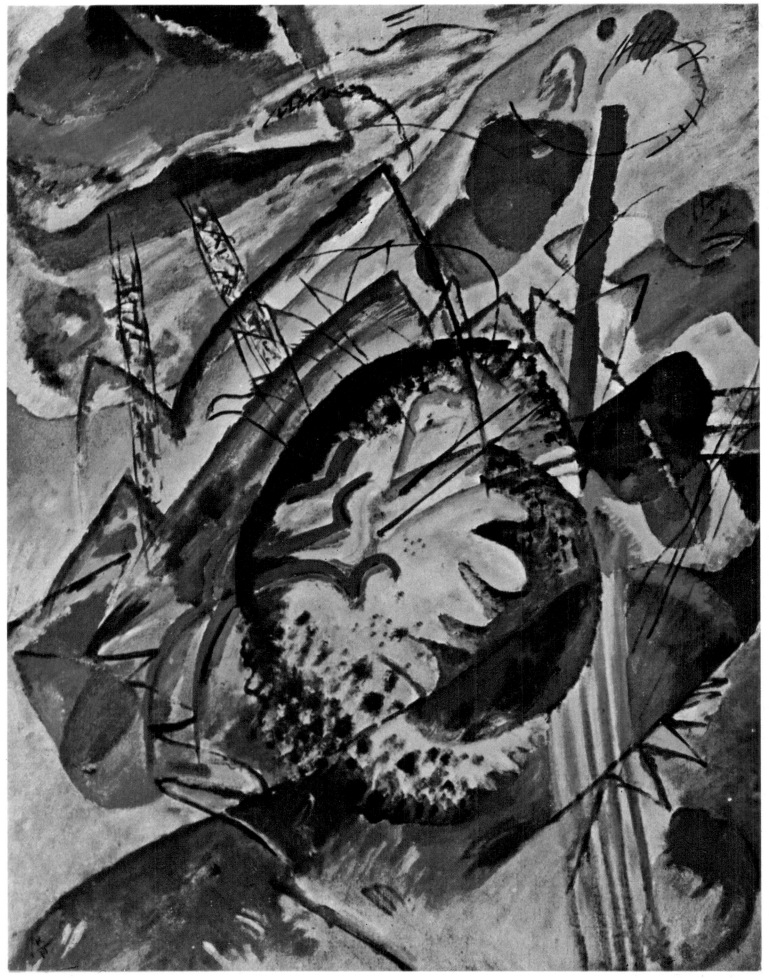

Wassily Kandinsky (1866-1944): Composition, 1914. Oil.

The rights of the image

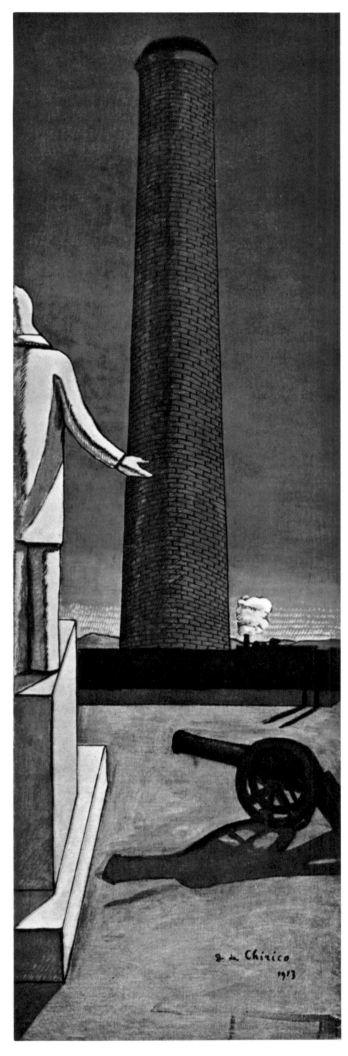

Giorgio de
Chirico (1888-1978):
Smokestack, 1913.
Oil.

The discovery of the expressive possibilities inherent in each element of the painter's language, followed by the systematic experimentation with them and the affirmation of the work of art's autonomy, did not mean the end of figurative painting. While Mondrian and Malevich developed the realities of abstraction to their utmost limit, other painters—Chirico and Matisse foremost amongst them—sought to make use of those realities without renouncing the suggestive or representational power of the image. The opposition between figuration and abstraction is by no means so clear-cut or absolute as is commonly supposed. Whether representational or not, art is before all else an object (creation) and a system (use of language), a work and sign, and not a symbol or fragment of reality.

Giorgio de Chirico renewed figurative painting by the uncanny atmosphere of mystery which he cast over his pictures. Born in Greece of Italian parents in 1888, he studied painting in Munich (1906-1909) and was deeply influenced by his discovery there of the German romantics and symbolists, like Caspar David Friedrich, Max Klinger and Arnold Böcklin. He came to Paris in 1911, after having lived in Milan, Turin and Florence where his eyes and senses had been attuned to "that mysterious and powerful feeling which I had discovered in the books of Nietzsche: the melancholy of fine autumn days, of afternoons in Italian towns." Not timebound like the Futurists, Chirico escaped from the present through dreams, by turning his vision inward. While he respected the reality of visual appearances, he gave them a new meaning by imagining reality as a mirror of the unconscious mind. From his stay in Paris (1911-1915) date his first pictures of a magical or enigmatic quality, showing up "the fatal character of modern things" (Apollinaire). He continued to develop this fantastic world of his after his return to Italy, and the poetry emanating from his metaphysical paintings found an echo and response in the work of Carrà and Morandi.

The expression of solitude is Chirico's main theme, a solitude which he always associates with shadows: "A statue is always present by itself. In the solitude of the statue, time, through the seasons, yields only one fruit: its shadow. Its shadow is the reflected life of the statue, its magical mobility," he wrote in an article in the Italian art magazine *Valori Plastici*. He still resorted to classical perspective in order to convey his nostalgia for a world of harmony and peace, from which modern man is excluded; and yet the foundations of his inspiration are not very different from those of an artist like Mondrian. "The deeper

"Sometimes the horizon is defined by a wall behind which rises the noise of a train speeding away in the distance. All the nostalgia of the infinite is brought home to us behind the geometric precision of the square. We experience unforgettable emotions when certain aspects of the world, whose existence is quite unknown to us, suddenly confront us with the revelation of mysteries which all the while were close at hand, which we cannot see because we are too short-sighted and cannot feel because our senses are undeveloped. Their dead voices speak to us from near by, but they seem to us like voices from another planet."

Giorgio de Chirico

work," wrote Chirico, "will be drawn by the artist from the uttermost depths of his being; there no murmuring brook, no bird song, no rustling foliage is audible. The great task today is to rid art of all that it now contains of known and familiar. Every subject, idea, thought and symbol must be put aside." But he added: "One of the strangest sensations bequeathed to us by prehistory is the sensation of presage. It will always exist. It is like an eternal proof of the meaninglessness of the universe" (*The Mystery of Creation*, 1938). The sense of presage, of foreboding, dominates the uncanny and disquieting art of this master who in 1914 painted a famous portrait of Apollinaire showing him with a head wound in the very place where in fact he was wounded by shrapnel at the front two years later.

With Matisse, figurative painting answered to equally strong but very different needs. He could not give up the representation of the motif which justified his creative work by heightening his "sensorial intensity," but he was not indifferent to the synthetic spirit and austerity of Cubism. Thus in several canvases of this period he reduced his architectonic design to the masterly simplification illustrated in *The French Window* and in some of his *Studios*. This concentration of form is accompanied by a drastic simplification of colour which, for all its containment and restraint, loses nothing of its extraordinary power of suggestion. Unlike the Cubists, Matisse always proceeded from the sensation to the idea, but in *The French Window* the transposition is so radical as to border on abstraction.

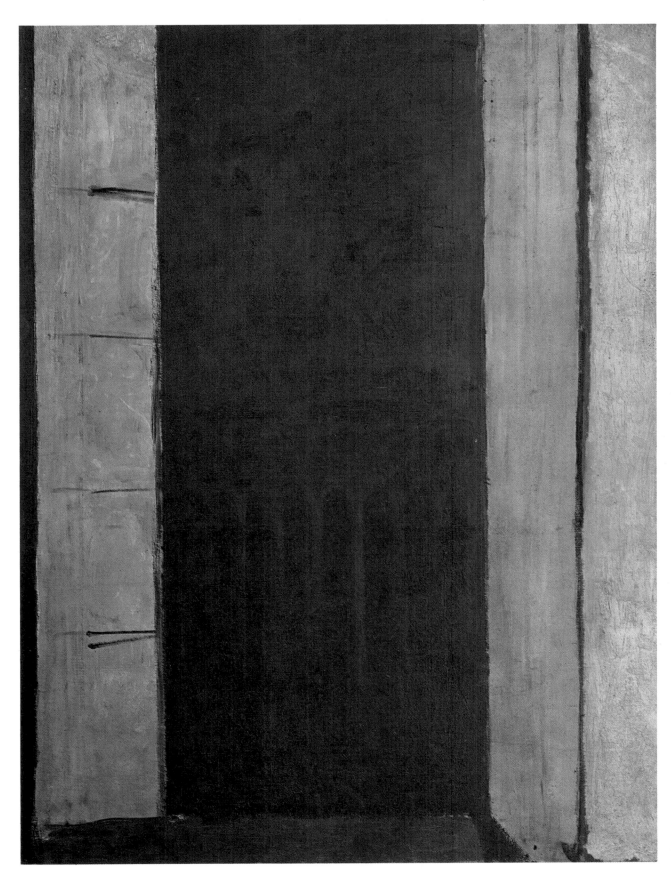

"The French Window *by Matisse (1914), the most mysterious of pictures ever painted, seems to open on that 'space' of a novel which the author has begun but of which as yet he knows nothing, just as one knows nothing of the life in this dark house, nothing of its inmates or what they are like, nothing of their memories, dreams and sorrows."*

Louis Aragon, *Je n'ai jamais appris à écrire*, Geneva, 1969

Henri Matisse (1869-1954):
The French Window at Collioure, 1914. Oil.

From more to less

The great aspiration of painting, and of architecture, on the eve of the First World War was to express essentials and nothing else. No one pursued that aim more intently than Mondrian, whose work followed a steady evolution towards geometrization and purity. With him it amounted to a mystical pursuit of the Absolute.

Moving to Paris from his native Holland in 1911, Mondrian there achieved by 1913-1914 a decisive liberation, parallel to that described by the Dutch theosophist Schoenmaekers: "We learn now to translate reality in our imagination by constructions which can be controlled by reason, in such a way as later to retrieve those same constructions in the 'given' reality of nature, thus achieving a penetration of nature by means of the plastic vision." This was the underlying principle of the work of the De Stijl group in Holland, founded in 1917 by Mondrian, together with J.J.P. Oud, Georges Vantongerloo, Theo van Doesburg and Bart van der Leck.

In canvas after canvas the starkness of the design was accentuated, every memory of or reference to visual reality being eliminated. *The Cathedral, The Pier* and *The Ocean* came as revealing examples of his determination to reduce everything to the relation between vertical and horizontal, generally inscribed in an oval frame. Through a searching analysis of the external world, Mondrian arrived at a simplification which he summed up as follows in his notebooks of 1911: "In this landscape, the horizontal in relation to us is expressed only by the horizon line. Only a single position is therefore positively expressed. Neither the contrary position (i.e. the vertical) nor any other is exactly expressed in this landscape, I mean in a linear manner. And yet the opposition is expressed by the sky, which in its raised position appears as a vast plane. An indeterminate plane, it is true, but one on which the moon marks an exact point. The plane of the sky is thus defined from this point to the horizon. This definition is a vertical line, even though this line is not apparent in nature. All it remains for us to do is to draw that line in order to express positively the opposition of the horizontal."

Since the world can be reduced to this opposition between the vertical (expression of will) and the horizontal (symbol of rest), it is enough for the artist to multiply this opposition over the whole of his picture surface, since this relation sums up the entire universe and is not limited to the horizon line. This approach is facilitated by the fact that the artist passes at the same time from an overall vision to an ever more centred view, "in close up." The curve of the oval picture frame symbolizes the movement of life, as perceived in the tree or the wave, and refers back to the shape of the earth.

Returning to Holland in July 1914 on the outbreak of war, Mondrian continued at home his pursuit of abstraction. By now he had realized that, since he arrived at the same result whatever the subject he took, no subject was necessary; indeed it was pointless. He accordingly concentrated his efforts on the structural creation of the picture space in which he gave equal prom-

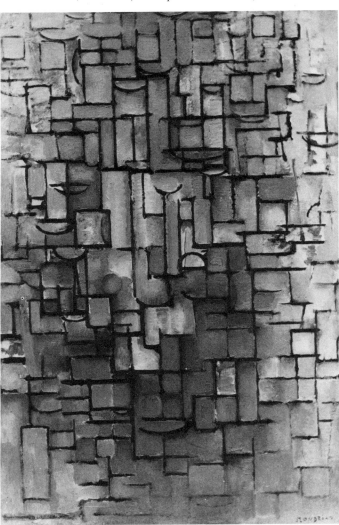

Piet Mondrian (1872-1944): Composition No. XIV, 1914. Oil.

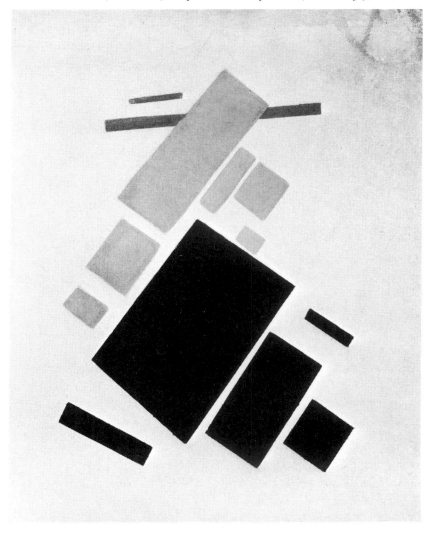

Kasimir Malevich (1878-1935): Suprematist Composition (Plane Aloft), 1914.

206

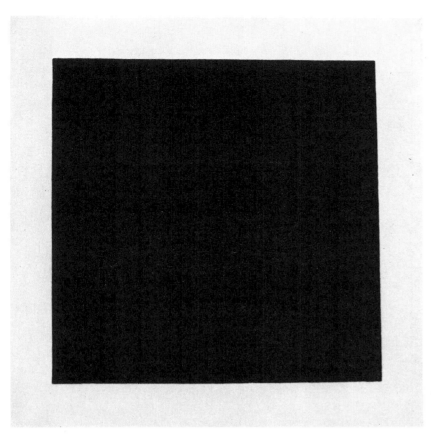

Kasimir Malevich (1878-1935): Black Square on a White Ground, 1913. Oil.

inence to solids and voids. "Man evolving towards the equilibrium of his duality will be led more and more (in life as well) to create equivalent relations, i.e. equilibrium," he wrote later in *Cercle et Carré* (Paris, 1930). This preference for the *universal* over the *personal* was further developed in the inaugural manifesto of the De Stijl group.

At the same time, at the other end of Europe, a group of Russian artists headed by Kasimir Malevich were moving in the same direction, with unbridled vehemence. His famous *Black Square on a White Ground* of 1913 is a total abstraction which laid the basis for a new objectivity. It was just then, shortly before the war, that Malevich brought his Cubo-Futurist period to a close with works like *An Englishman in Moscow* which already heralded Dada and Surrealism. In this canvas, whose composition takes the form of a collage, everything is held up to ridicule: letters and images are mixed together helter-skelter and reduced to nonsense. Art here, wrote Malevich, "goes straight towards the end which it has fixed for itself: the domination of the forms of nature."

It was in 1913, while designing sets for the futurist opera *Victory over the Sun* by Kruchenik and Matyushin, that Malevich achieved abstraction in the form of Suprematism, exemplified by his *Black Square on a White Ground.* In December 1915 he showed thirty-five suprematist pictures at the "0.10" exhibition organized by Jean Pougny in St Petersburg. At this exhibition Malevich read his suprematist manifesto: "In giving titles to some of these paintings, it was not my intention to point out the form to be found in them, but rather to indicate that real forms were conceived as the basis of formless masses capable of being used in a picture and unrelated to any forms existing in nature." The break with traditional painting was so sharp that, coming under attack in 1915, Malevich explained his views as follows: "I too have felt a certain timidity and I have hesitated with

anguish in my heart when it came to the point of quitting *the world of the will to representation* in which I have lived and whose genuineness I believed in. But the sense of satisfaction I felt in freeing myself from the object led me ever further into the wilderness, until I reached a point where nothing more was genuine but sensibility alone. And so it was that feelings became the essence of my life. The square that I exhibited was not an empty square, but a sense of the absence of the object."

In the Suprematist Manifesto of 1915 Malevich took an even more extreme and absolute stance: "The artist's sensibility is all that matters and it is by this path that suprematist art arrives at pure expression without representation. Art moves into a 'wilderness' where nothing more is recognizable except sensibility alone. The square of the Suprematists and the forms deriving from it may be likened to the sign language of primitive men."

Kasimir Malevich (1878-1935): An Englishman in Moscow, 1914. Oil.

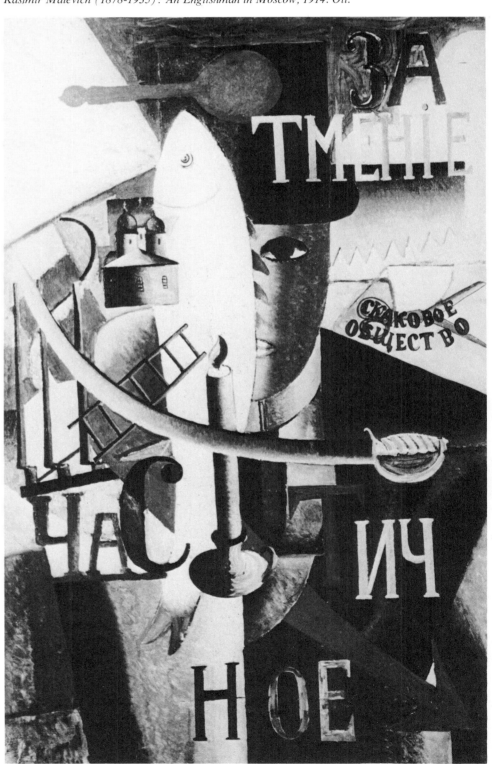

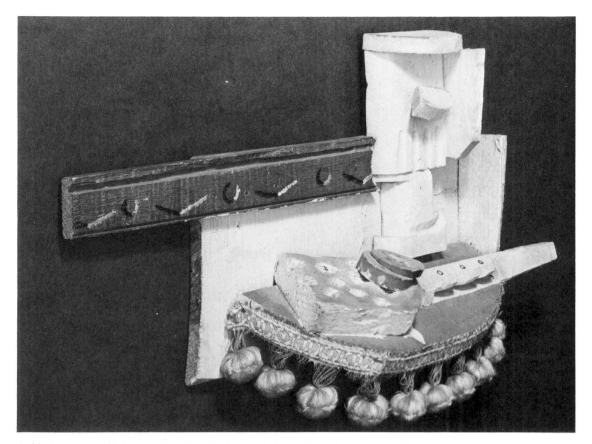

Pablo Picasso (1881-1973): Still Life, Paris, 1914. Painted wood and curtain fringes.

Vladimir Tatlin (1885-1953): Bottle. Tin.

Modernity was no longer a question of subject matter (as it had been in the nineteenth century). Now it lay in the need to discover new relations between the data of reality and those of language. Whether analytical or experimental, the new approaches to art met and mingled in the awareness of the work as an independent object in which imagination, sensibility and intelligence converged.

"Any artist should be able to make a picture out of blotting paper alone, provided that he is capable of making an Image," wrote Kurt Schwitters, one of the most famous collage makers of the postwar period. The collage certainly offered one of the most fruitful alternatives open to artists, since it permitted them to escape from the traditional problematics of oil painting by offering them a completely different standpoint. A signal example is Carlo Carrà's *Interventionist Manifestation* of 1914.

"I work with the elements of the mind, with the imagination. I try to make concrete what is abstract. I proceed from the general to the particular; by this I mean that I start from an abstraction in order to arrive at a real fact," wrote Juan Gris who, as early as 1914, began using pasted papers in a highly complex manner.

Picasso, in his painted pieces of wood of 1913-1914, reinvented reality with a free hand. He made virtuoso use of the counter-relief and brought forth a new relation between form and colour which led him on to a kind of figuration whose impact and echoes could still be detected fifty years later in Pop Art. This figuration is characterized by an extreme tension between the plastically created form and the object taken over from reality. Thus art retrieved reality without losing anything of its autonomy. "Inventing new inventions" was Picasso's way of describing this approach.

The Russian artist Vladimir Tatlin, founder of Constructivism and maker of abstract constructions, paid a visit to Paris in 1913 and met Picasso. On his return to Russia he produced his first "relief paintings," of which *The Bottle* is a characteristic exam-

ple. Here Tatlin analyses not only forms and volumes but the quality of materiality itself. The transparency of glass is rendered by a wire mesh permitting us to *see through*, and the gleaming brightness of glass is rendered by a piece of polished tin. He also uses space as a component part of his works. He thus opened the way to some of the most decisive experiments of contemporary sculpture.

A similar freedom of imagination is to be found in the work of the Russian artist Jean Pougny (Ivan Puni), who at this same period created still lifes by sticking together real objects; also in the works of the Italian independent, Alberto Magnelli, who made abstract constructions in which he integrated real objects without any transposition, as shown in his *Still Life Sculpture* of 1914, consisting of lead and objects.

Alberto Magnelli (1888-1971):
Still Life Sculpture, 1914.
Lead and objects.

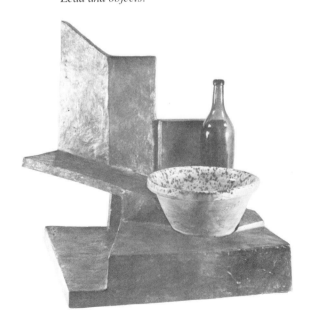

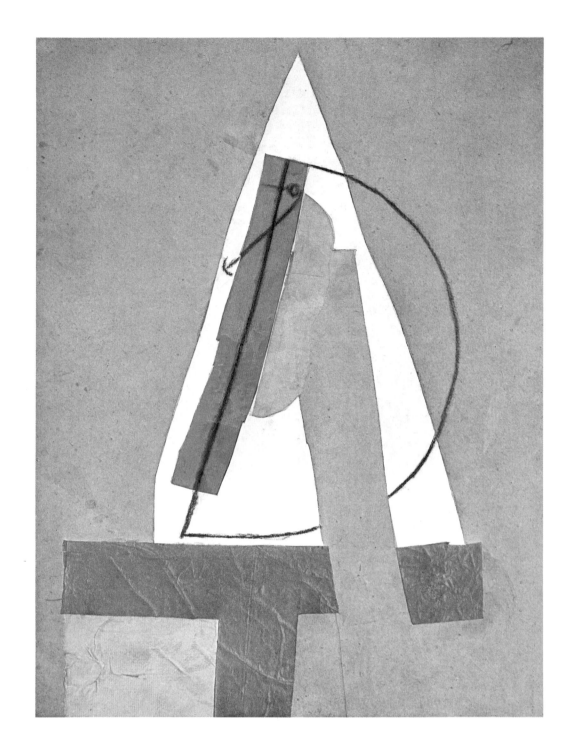

Pablo Picasso (1881-1973):
Head, 1914. Pasted paper and charcoal.

In the eventful trajectory of artistic creation from the countri-fied scenes of Seurat to the bottle rack of Marcel Duchamp, there was neither progress nor decline, but ceaseless invention. These inventions, in their unfailing resourcefulness, brought about a radical renewal of the artist's outlook and proceeding. Here it was Marcel Duchamp who set the most influential exam-ple. After the *Nude Descending a Staircase* (1912), he gave up painting altogether. He renounced the métier of artist and all that it involved in the way of virtuosity, but he did not renounce the object. As early as 1912-1914 he was preparing a project entitled *The Bride Stripped Bare by her Bachelors, Even* ("The Large Glass"), a composition in lead wire, oil paint and lead foil on glass, on which he worked from 1915 to 1923. Already at the end of 1914 he had produced his *Three Standard Stoppages*, an assemblage of wire, canvas and glass enclosed in a croquet box. The method he used here, and developed for the rest of his life, is the one he described as "putting chance in a tin can." He ridiculed the rational and reasonable rules which, until he ap-peared, had presided over the games of life and art. Taking inspi-ration (like Picabia) from the aesthetics of the machine,

Duchamp went in for "precision painting," limiting the presence of the work to the idea alone and doing away with colour, composition, emotion and sensibility. It was in this context that he created his first ready-made, a bicycle wheel mounted on a kitchen stool, followed by the bottle rack bought in a Paris department store and then by a urinal which he entitled *Fountain* and signed R. Mutt. Anti-art could go no further.

"On 2 August 1914 I accompanied Braque and Derain to the railway station in Avignon and I never saw them again." This famous quip by Picasso, tinged with melancholy, expresses the shattering break-up of the art world caused by the Great War. Summing up the thirty eventful and momentous years from 1884 to 1914, when *art went modern*, we may say that the First World War marks an all-important watershed. After that ordeal the spirit of man and the spirit of art were both transformed. On the eve of war a few artists, Marcel Duchamp above all, had her-alded that new spirit and had begun to restate the problem of art in the new terms which were taken up by the postwar move-ments. It was left to the latter to break away for good from the traditional methods and imagery.

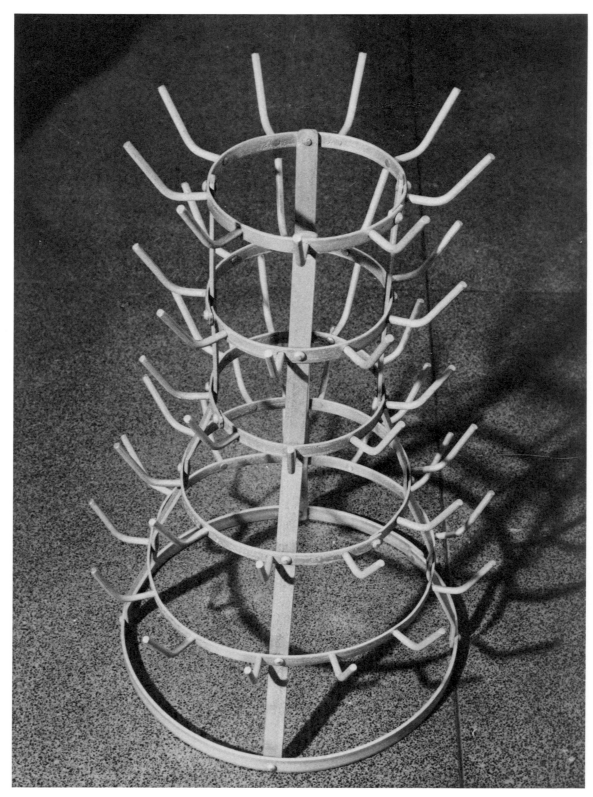

Marcel Duchamp (1887-1968): Bottle Rack, Ready Made (second version), 1961. (Original of 1914 lost.)

However free and abstract was the handling of his spare and arresting collages, Picasso never lost confidence in the power and effectiveness of his means of expression, i.e. in his art. With Marcel Duchamp it was different. By 1914 he had repudiated all the traditional values of art. "I consider painting as a means of expression," he said, "but not as an end in itself. One means of expression among many others, but not as an end in itself capable of occupying a man's whole life." If one compares those words with Van Gogh's dramatic statement: "As a man who suffers I cannot do without something which is greater than myself, which is my whole life: the power to create," then one sees how deep was the cleavage opened up between the nineteenth and the twentieth century approach to art. After thirty years of inventions and discoveries, the artist of 1914 found

himself free, perhaps all too free. That freedom prompted him from now on to rely more on intelligence than emotion, more on chance than calculated harmony, more on the turbid and unknown world of the unconscious than on clear and luminous visions of nature. "In other words, painting must not be exclusively visual or retinal. It must appeal also to our grey matter, to our appetite for understanding. I should say the same of everything I love. I have never wished to limit myself to a narrow circle and I have always tried to be as universal as possible," wrote Marcel Duchamp. So fruitful and stimulating were the three decades from 1884 to 1914 that they opened up to twentieth century art a field of action of incalculable resources and possibilities, capable of giving full expression to "universal man."

List of Illustrations
Index of Names and Places

List of Illustrations

217

Index of Names and Places

PUBLISHED JUNE 1979

PRINTED BY
IMPRIMERIES RÉUNIES S.A., LAUSANNE

BINDING BY
H. + J. SCHUMACHER A.G.
SCHMITTEN (FRIBOURG)